Chicana Art

OBJECTS/HISTORIES

Critical Perspectives on Art, Material Culture, and Representation

A series edited by Nicholas Thomas

Published with the assistance of the Getty Foundation

Chicana Art

the politics of spiritual and aesthetic altarities

LAURA E. PÉREZ

Duke University Press Durham and London 2007

© 2007 Duke University Press

All rights reserved
Printed in Italy on acid-free paper ∞
Designed by C. H. Westmoreland
Typeset in Adobe Garamond and Verdana by Tseng Information Systems, Inc.
Library of Congress Cataloging-in-Publication Data appear on the last
printed page of this book.

Duke University Press gratefully acknowledges
the support of the Hellman Family Faculty Fund, which provided
funds toward the production of this book.

I thank

all that which has

seemed to me good, beautiful, and

brave, and all that which at first has

not appeared to be so, but that has

also nurtured, sustained, and taught

me. May this work be for the

greater good.

contents

list of illustrations ix

acknowledgments xiii

note to the reader xvii

introduction : Invocation, *Ofrenda* 1

1 Spirit, Glyphs 17

2 Body, Dress 50

3 Altar, Alter 91

4 *Tierra*, Land 146

5 Book, Art 205

6 Face, Heart 257

conclusion : Self, Other 297

notes 309

works cited 347

index 381

illustrations

1 a, b. Still images from Frances Salomé España's *Nepantla* 38–39

2 Yreina D. Cervántez, *Nepantla* 40

3 Yreina D. Cervántez, *Mi Nepantla* 42

4 Yreina D. Cervántez, *Beyond Nepantla* 43

5 Ester Hernandez, *Mis Madres / My Mothers* 47

6 Ester Hernandez, *Cosmic Cruise / Paseo Cósmico* 48

7 Yolanda M. López, *The Nanny* 53

8 Ester Hernandez, *Immigrant Woman's Dress* 58

9 Amalia Mesa-Bains, *Vestiture . . . of Branches* 64

10 Amalia Mesa-Bains, *Cihuateotl (Woman of Cihuatlampa)* 65

11 Diane Gamboa, *Cutting Through* 71

12 Diane Gamboa, *Butterscotch Twist* 73

13 Diane Gamboa, *Little Gold Man* 76

14 Diane Gamboa, *Pinch Me* 77

15 Diane Gamboa, *Altered States* 78

16 Diane Gamboa, *Madonna Whore Complex* 79

17 Yreina D. Cervántez, *Big Baby Balam* 83

18 Amalia Mesa-Bains, *Venus Envy Chapter One* 102

19 Amalia Mesa-Bains, *Venus Envy Chapter II* 103

20 Carmen Lomas Garza, *Don Pedrito Jaramillo* 105

21 Carmen Lomas Garza, *Barriendo el Susto* 107

22 Santa Contreras Barraza, *Untitled* 109

23 Santa Contreras Barraza, *Trinity* 111

24 Patricia Rodríguez, *The Sewing Box* 113

25 Barbara Carrasco, *Modern Day Altar* series: *César* 119

26 Barbara Carrasco, *Modern Day Altar* series: *Diana* 120

27 Barbara Carrasco, *Modern Day Altar* series: *Mother Teresa* 121

28 Rita González, still image from *St. Francis of Aztlán* 126

29 Christina Fernandez, *Untitled* (Woman's Back), from *Oppression* series 131

30 Christina Fernandez, *Untitled* (Man Tied Up), from *Oppression* series 133

31 Delilah Montoya, *Teyolia* 135

32 Delilah Montoya, *La Guadalupana* 137

33 Kathy Vargas, *State of Grace* 139

34 Kathy Vargas, *Miracle Lives: Juanita's Heart* 140

35 Celia Herrera Rodríguez, *Red Roots / Black Roots / Earth (Tree of Life)* 142

36 a, b, c, d. Celia Herrera Rodríguez, *Before Columbus, Colonialism, After Columbus* 154

37 Yreina D. Cervántez, *La Ruta Turquesa* 162

38 Consuelo Jiménez Underwood, *The Sacred Jump* 165

39 Consuelo Jiménez Underwood, *Virgen de los caminos* 167

40 a, b. Consuelo Jiménez Underwood, *Land Grabs—500 Years* series 170

41 Alma Lopez, *California Fashions Slaves* 172

42 Alma Lopez, *Juan Soldado* 175

43 Alma Lopez, *Lupe & Sirena in Love* 177

44 Celia Alvarez Muñoz, *Fibra y Furia: Exploitation Is in Vogue* 179

45 Celia Alvarez Muñoz, *Prom Queen (La Sirena / Siren)* 180

46 Laura Alvarez, *Undercover Letter* 183

47 Laura Alvarez, *Prime Time Sirvienta* 185

48 Patricia Rodríguez, *When I Am No Longer on Earth / Cuando Ya No Esté en la Tierra* 188

49 Patricia Rodríguez, *My Home Land Forever / Mi Tierra Para Siempre* 190

50 Juana Alicia, *Earth Book* 194

51 Juana Alicia, *Auto-Vision / Self-Portrait* 195

52 a, b. Celia Alvarez Muñoz, *La Honey*, and detail of *La Yodo. Enlightenment* series #9 208–9

53 Celia Alvarez Muñoz, *Breaking the Binding / Rompiendo la Liga* 210

54 Celia Alvarez Muñoz, *If Walls Could Speak / Si Las Paredes Hablaran* 212

55 a, b. Delilah Montoya, *Codex Delilah: 6 Deer. From Mexica [or Mexicatl] to Chicana* 216

56 a, b. Yreina D. Cervántez, *Black Legs: An Education* 220

57 Sandra Ortiz Taylor, *Family Room* 227

58 Isis Rodriguez, *Lupita Tee* 234

59 Isis Rodriguez, *Virgin LMA* 235

60 Isis Rodriguez, *Freedom* 236

61 Laura Molina, *Cihualyaomiquiz: The Jaguar* 239

62 Ana Uranga-Gomez, *Cosmic Dancer*, interface detail from Ana Garcia, Elba Rios, and Alma Cervantes, *Coyolxauhqui: An Ancient Myth, Chicanas Today* 248

63 Irene Perez, *Coyolxauhqui Last Seen in East Oakland* 251

64 Alma Lopez, *Our Lady* 265

65 Patssi Valdez as Madonna, detail of *Walking Mural* 268

66 Ester Hernandez, *Libertad / Liberty* 270

67 Ester Hernandez, *La Virgen de Guadalupe Defendiendo los Derechos de los Xicanos / The Virgin of Guadalupe Defending the Rights of the Xicanos* 271

68 Yolanda M. López, *Portrait of the Artist as the Virgin of Guadalupe* 274

69 Yolanda M. López, *Margaret F. Stewart: Our Lady of Guadalupe* 275

70 Yolanda M. López, *Victoria F. Franco: Our Lady of Guadalupe* 276

71 Yolanda M. López, *Nuestra Madre* 277

72 Yolanda M. López, *Love Goddess* 278

73 Ester Hernandez, *Full Moon / Luna Llena* 279

74 Juana Alicia, Miranda Bergman, Edythe Boone, Susan Kelk Cervantes, Meera Desai, Yvonne Littleton, and Irene Perez, *Maestrapeace* 282

75 Yreina D. Cervántez, *Homenaje a Frida Kahlo* 283

76 Yreina D. Cervántez, *Danza Ocelotl* 285

77 Laura Aguilar, *Stillness #15* 287

78 Laura Aguilar, *Motion #57* 288

79 Santa Contreras Barraza, *Virgen con Corazón y Maguey* 290

80 Santa Contreras Barraza, *Corazón Sagrado I* 291

81 Maya González, *The Love that Stains* 293

82 Celia Herrera Rodríguez, *My Little Wound* 294

All images are used by permission of the artists, who retain copyright to their work.

acknowledgments

I wish to thank the many friends, family, and colleagues who have kindly been a source of support and wisdom during the process of researching and writing this book. I would like to thank the visionary Ken Wissoker, Anitra Grisales, and Katharine Baker at Duke for their enthusiastic support of this project, and Lynn Walterick for her attentive copyediting. I would also like to thank Theresa May, at the University of Texas Press, for her interest in this book, and Deena Gonzalez and Antonia Castañeda, in particular, who provided thoughtful comments on a much earlier version of *Chicana Art*. May their "Chicana Matters" series flourish there. Other attentive readers whose comments enriched this work are Rosa Linda Fregoso, Shifra Goldman, Alicia Gaspar de Alba, Irene Lara, and Luis León. For their intellectual camaraderie throughout the years, I warmly thank Norma Alarcón, Alfred Arteaga, and Chela Sandoval.

It meant a great deal to me to discuss this work with other intellectuals when it seemed a dangerous topic. I was blessed with students for whom the politics of spirituality was stimulating, rather than embarrassing, territory. Their brilliance and human warmth were an unfailing source of support in the unfolding of this book's project. For their friendship and intellectual rapport, I want to thank Irene Lara, Christina Grijalva, Karina L. Céspedes, Angelina Villafañe, Delberto Ruiz, Gustavo Guerra, Roberto Hernández, Daphne García Taylor, Luis Alberto de la Garza, Irene Nexica, and José Navarro. In addition,

I was fortunate to count on the research assistance of Anna Fenner, Juliana Martínez, Susana Loza, Jennie Estrada, Roberto Hernández, Christina Grijalva, Denise Velasco, Lainie Chaney, María Huerta, and Melody Sandoval.

I have been extraordinarily blessed to count on the intellectual support of my colleagues in the Department of Ethnic Studies at the University of California, Berkeley, all of whom have had the courage to teach, publish, and research in areas that have been groundbreaking while profoundly engaged with our times. To work by their side was a constant reminder of scholarship and teaching for the highest purposes. I name them all: Norma Alarcón, Robert Allen, Alfred Arteaga, Mario Barrera, Ramón Grosfoguel, Nimachia Hernández, Patricia Penn Hilden, Elaine Kim, Nelson Maldonado-Torres, David Montejano, Carlos Muñoz, Evelyn Nakano Glenn, Michael Omi, Celia Herrera Rodríguez, José David Saldívar, Alex Saragoza, Ron Takaki, Katharya Um, Ling-chi Wang, and Sau-ling Wong. I would also like to thank José Rabasa, Gwen Kirkpatrick, Julio Ramos, and Francine Masiello for their early support of my work in Berkeley, their own inspiring scholarship, and their ongoing efforts to incorporate the U.S. Latina/o experience into the study of Spanish-language literature. Among my Religious Studies colleagues elsewhere in the nation, special thanks go to Luis León, Miguel de la Torre, Lara Medina, Gastón Espinosa, and Anthony Stevens-Arroyo for their friendship and for their own important work.

I am grateful to the Committee on Research at the University of California, Berkeley, for generously supporting my research throughout the years and to the Hellman Family Faculty Fund for a grant that helped make possible the publication of this book's color images.

It also gives me great pleasure to thank friends whose companionship has filled my life with kindness and affection throughout the years of this book's gestation, especially Bernadette Smyth, Graciela Lechón, Daniel Peckham, Valerie Maynard, Kathleen Marien, Zelda Artsen-Crichlow, Ayala Emmet, Susan Overhauser and the Goldens, and from my childhood Logan Square, Monique Barwicki Kozlowski. I owe a

large and happy debt to my sister Silvia especially, and to the extended Pérez, Manetti, Strohmeier, Sinner, and Tinajero clans for their familial embrace. For their constant example of wit, generosity, and goodness, I lovingly thank my parents, David Pérez Ordaz and María Elisa Tinajero Pérez. Throughout the years, the unfailing support for my work and person of John Philip Strohmeier, my gregarious spouse, has been a blessing. I dedicate this book, in the spirit of clear faith in the future, to Maya Elisa Pérez Strohmeier, my lovely, kind, and dazzling daughter.

This book expresses what it has meant to me to be in the world with the companionship not, fortunately, of dead authors who are kindred spirits, but of the women I have been gifted to study and know in the pages that follow. Special, special thanks must go to Yreina D. Cervántez, an individual whose artistic gifts are matched by those of her spirit. Her support of other artists is a model of generosity. Finally, I thank each and every one of the women whose work is studied here, for they are a mighty, awesome, and glorious bunch.

The artists and writers discussed in this book have occasionally used unusual spelling and capitalization practices in the Spanish titles of their works. I have chosen to respect these practices and reproduce these titles without correction or modification.

Invocation, *Ofrenda*

Ring the bells that still can ring.
Forget your perfect offering.
There is a crack in everything.
That's how the light gets in.

—Leonard Cohen, "The Future"

The seed of this book was planted in the early 1990s, when I observed to a friend that a well-meaning scholar had attempted to be inclusive in her recounting the history of feminist theory by discussing the work of a Chicana feminist writer but had effaced, remarkably, one of the most salient characteristics of the writer's work: its insistence on the importance of the spiritual.[1] This consignment of the spiritual to the intellectual borderlands, typical of well-lettered and political activist circles, was, I argued, a patronizing act of kindness, particularly given that the Chicana writer in question had baldly declared her belief in spiritual essences, even impiously declaring that she knew things older than Freud. The suggestion that she was getting such information from

somewhere other than bibliographic or experimental research was a challenge perhaps viewed as an embarrassing intellectual faux pas best ignored.

My friend's response that I write about this was met with an "I don't think so" that expressed my sense of the matter as a minefield. But eventually my resistance gave way to fascination, and what initially felt like dangerous intellectual ground became a spontaneous attraction, and then a passionate pursuit, as I increasingly came to note the presence of the spiritual in post-1960s work to which I was drawn, its absence in scholarly discussions of that work, and the more general marginalization of the spiritual in mainstream art and scholarship of this period outside its historic areas of study in sociology, anthropology, and theology.[2]

When I began this research in the mid-1990s, I found the concern with the spiritual in the work of many Chicana artists quite striking given its absolute absence in my own intellectual milieu and in many fields of interest in which I read, scholarly and otherwise.[3] Because it seemed that the only progressives actively trying to take spirituality seriously sold their spirit-channeled, Shaktipat-inspired, and goddess-oriented revelations in New Age bookstores, I began a closeted investigation of the spiritual literature produced in the post-1965 period and earlier "classics" read by that generation. Though I read many a book I am glad to have forgotten, and others I wish I could, it seemed, nonetheless, that this broad spectrum of writings expressed a spiritual longing in what was felt to be an increasingly duplicitous and materialist culture and an endangered natural environment. These religiously unorthodox and, in many cases, non-Western-identified readings enabled me to begin to approach the culturally hybrid, often do-it-yourself, noninstitutional spiritualities that I was seeing in many California- and Southwest-based Chicana artists' literary, visual, and performance arts as a gesture of yearning and *ofrenda*, or offering, toward greater personal integrity, empowerment, and social justice.

To these feminist artists, in successive generations and in a variety of media from the early 1970s through 2000, this offering mattered politically in many ways: As a voice of dissent to a Eurocentric, intellec-

tually recolonizing, post-Enlightenment atheist mandate. As a rebuttal to unexamined Darwinian cultural evolutionary thought, consigning non-Western spiritualities to the tail end of the march of progress. As a new resource for a politics by which to guide the healing of the unjustly socially marginalized and of the increasingly polluted environment. As an expression of cultural hybridities, received both from family traditions and through the local coexistence of Hindu ashram, Buddhist temple, Afro-diasporic Latina/o *botánica*, neo-Mexica-Aztec sweat lodge, Christian church, and Jewish synagogue. And, finally, as a recirculation and reinterpretation of different and ancient notions of artist and artmaking.

In various genres, Chicanas were engaging the spiritual alongside more familiar areas of social struggle (gender, sexuality, class, "race"[4]) as another terrain upon which to challenge the cultural blind spots in mainstream values, in our assumptions and dismissals, in our pretensions to the universality and superiority of our beliefs, and in our anti-religiosity or religious dogmatisms. It seemed to me that the faultlines in our problematic views on gender, sexuality, class, cultural difference, and, ultimately, what gets to count as "real" or useful knowledge were strikingly well illuminated through reference to spirituality. In the work of these Chicana artists — none of them especially religious, some atheist — spirituality and religion had nonetheless become areas of scrutiny, reclamation, and reinterpretation, and not merely zones of unexamined acceptance or indifference, or smug, "intellectual" dismissal.

In some of this work, the histories and effects of institutionalized religiosities were considered, and a more general, unaffiliated spirituality was reclaimed as a healing force, not as an opiate of the ostensibly brain-dead masses that numbed people into acceptance of their unfortunate and unenlightened lot in life but rather as a constitutive element of personal, social, and environmental well-being. It seemed to me that in the work of Chicana artists making reference to the religious, whether through the use of elements of traditional or more hybrid spiritualities, what mattered most were the tangible effects of such beliefs and practices.

Numerous Chicana writers and visual artists, from at least 1972 to the

present, have reinterpreted traditional religious symbols used to control female sexuality in more egalitarian ways, crossing already culturally syncretic Virgins with goddesses, superwomen, and everyday, racialized women. Others have made use of pre-Columbian mythology and art history ironically and for fun, as in the pre-Columbian superwoman who beats up the neo-Nazi skinhead in Laura Molina's comic book, *Cihualyaomiquiz: The Jaguar* (1996), or have used them as props marking cultural difference and racialization, as, for example, in the spywork of a secret agent disguised as a domestic, in Laura Alvarez's multimedia work of the 1990s.

Some Chicana artists have used the pre-Columbian to destabilize its use in Chicano masculinist nostalgia for a romanticized but dead past, to show both that it isn't dead and that the solidification of patriarchal family and nationalist ideologies were not what Chicana feminists, straight or queer, had in mind when they embraced their ethnic and cultural Indigenousness. What I saw in Chicana feminist work with the Indigenous went beyond what for some in the initial Chicano movement had been a rather shallow war of symbols with Eurocentric culture to a genuinely more decolonizing struggle at the epistemological level, where being, existence, meaning, and of course knowledge are defined.

Still others, unwilling to throw spirituality out altogether in the face of the sexism, heteronormativity, and historical racism of institutionalized religions, have joined their generational peers in creating an amalgam of their own device, beyond the acquired or hereditary traditions of their forebears. What began to emerge for me, through the work of the more than forty visual, performance, and literary artists examined here, was a picture of a politicizing spiritual hybridity, sometimes accompanied on the formal level by alternative, culturally crossed artistic languages which joined Western and Euroamerican canonical and popular literary and visual art dialects with those of Mexican American popular, folk, and Native American art, and with the social imaginaries or worldviews within which these were shaped.

Thus many Chicana artists were, like their mainstream peers, working in the medium of "installation," but were inspired by the home

altars of their grandmothers; in "found object" art, but influenced by traditional *cajas* or *nichos*; in painting, but in the ex-voto "*retablo*" style; in multimedia, through Indigenous weaving and needlework traditions; and in book art, but based on the pictographic pre-Columbian screen-fold book or "codex." They also were reflecting on performativity, and on the emptiness of particular institutionalized religiosities, through ritual-like performances that exposed expectations of the Indigenous as stereotyped and static. Chicana artists were making photography-based art that questioned the camera's claim to objectivity and truth, investigating the cultural conventions that overdetermined the how and why of its subjects and centering racialized gendering in their inquest of the medium. They were pondering the camera's collusion with condescending, "tragic" renditions of objectified individuals symbolizing poverty, crime, and inferiority. They were reversing the camera and "shooting the tourist" instead, or photographing themselves as actors in blatantly fictional but historically inspired soap opera–like narratives that blew apart racial stereotypes of abject marginalization, disempowerment, and lack of "culture."

In other photography-based or video work, Chicana artists were wrestling with their medium as a vehicle to capture the interior life of a subject, her hidden histories, to paradoxically record the presence of memories and unseen feelings beneath appearance, and likewise, the socially spectral lives and neighborhoods within the cityscape. Popular and traditionally male-dominated mass media forms such as comics, animated cartoons, and detective fiction were taken up as artists toyed with racialization, gender, and the history of sexual objectification in them.

Whether artists were innovating with new technologies, new subject matter, or new approaches, in a spectrum of media that also included different forms of written literature and book hybrids, spoken-word sound recordings, interactive CD-ROM, and "paper fashion" body art and performance, I perceived a language of the ephemeral, the unseen, and the half-present that expressed the spiritual as a reference either to the divine or to that which is socially ghostly—certain bodies,

desires, cultures, even locations. In this sense, the artwork itself was altar-like, a site where the disembodied—divine, emotional, or social—was acknowledged, invoked, meditated upon, and released as a shared offering.

In the context of the historical marginalization of native peoples of the Americas since the European invasions, and of Mexican Americans since the seizure of more than half of Mexico's national territory by the United States in the mid-nineteenth century, and in light of the gendered, racialized, and economic inequities that survive to this day, the work of these Chicana artists could not help but thematize oppressed cultural differences. As women who personally experience discrimination from both the well-meaning and the brutish, they must speak to these social realities, but in the work included here they do so not by countering one ethnocentrism with another but by blowing apart stereotypes and refusing to replace them with newer ones. Subjectivity and agency in this work are complex, and desire and identity are approached through telling ambivalences rather than the pretense of control and omniscience. And yet, braving the pitfalls of idealism, many of these artists have dared to search for alternative models of greater human and social integrity, and to begin envisioning and imagining them in their work.

In this sense, I see their work as sacrificial *ofrenda*, as transmutation of social or personal suffering into penetrating visions of the present and brave sightings of hopeful, better futures. The pun in the subtitle of this book, *The Politics of Spiritual and Aesthetic Altarities*, thus refers to these works as offerings on the altar where the material and the still disembodied are invoked, and where the embodied is reminded of its ultimate identity with the socially or culturally disincarnate that it would "other" or relegate to the realm of seeming nonexistence. The Chicana art in the chapters that follow extends itself, offering what to many are still "foreign" and suspect, and thus unintelligible, knowledges: the cultural "differences" of the non-Western, the female, the queer, and the poor. These knowledges, which are as old as humanity, and which have outlived pseudoscientific and culturally parochial phi-

losophies that rationalize imperialist capitalism and racism and consign the non-Western to the primitive prehistory of civilized "man," remain as alternatives to the growing solitude, alienation, despair, and illness of too many in today's societies of rampant consumerism, spiritual emptiness, ethical confusion, and the visible crimes and duplicities of government, big business, and institutional religion.

Like an altar at which one invokes, mediates, and offers homage to the unseen but felt presences in our lives, whether these be deities, ancestors, or the memories of our personal, familial, and collective pasts, this book endeavors to bring into greater visibility the vibrant if seemingly ghostly body of writing, visual, and performance art produced by a spectrum of Chicana artists alongside the few catapulted to stardom or financial security by their creative gifts and the generous arts funding of the 1970s and the brief multicultural mandate of the mid-1980s and early 1990s. Equally important as documenting this collective work's presence and its many *ofrendas* is bringing into view Chicana artists' development of culturally hybrid aesthetic and spiritual idioms that form a unique part of the rethinking of the meaning of spirituality and of art in our times. "Aesthetic" here refers not to culturally and historically specific elitist European and Euroamerican values in narrowly defined notions of taste or beauty but, more generally, to the conceptual and formal systems governing the material expression of the activity within societies that we refer to as artmaking. The definitions of "art" and "artist" are understood to be problematic, nonuniversal terms, insofar as their European-language variations evolved within Western cultural histories, in ways not fully translatable to describe similar practices among popular classes, let alone among non-Western cultures. Similarly, "spiritual" is meant only to indicate the system of beliefs, institutionalized or not, about the nonmaterial component of human nature and/or the natural world that may encompass what in the Westernized world we describe as the divine, and about the life of the conscious and unconscious mind, as I describe in further detail in chapter 1.

The work of Chicana artists invoked here knowingly faces exotifying stereotypes of the presumably predictable relationships between irra-

tionality, spirituality, ahistoricity, non-Western cultures, and women, rationalized as these have been by the self-inflating ethnocentric and sexist ideologies that have co-produced cultural evolutionary thought and ongoing patriarchal and heterosexist cultures.[5] In so doing, Chicana visual, performance, and literary artists do their part in the collective demystification, or exorcism, as it were, of such post-"Enlightenment" mythologies of racial, cultural, gender, and sexual superiorities within the collective social imaginary from which we draw the bulk of visual, verbal, and bodily languages of artistic practices, as well as that of intellectual discourse. This is, as I argue more fully in chapter 1, decolonizing, *curandera*, or healing work, for such pseudoscientific mystifications have rationalized the brutal, racialized, gendered, and sexed rapacity of imperialist wars of conquest and military, economic, and cultural intervention during the last five hundred years in, and then from, the Americas.

Chicana intellectuals and artists from the 1960s to the present have self-consciously referenced spiritual beliefs and practices as culturally complex and contested social terrains where dominant cultural understandings of gender, "race," and sexuality are reproduced or rescripted. As feminists, they scrutinize the racialized gender and/or sexuality politics of European and Euroamerican Christianity, Chicano "folk" Catholicism, and Mexica ("Aztec") and other Indigenous beliefs, *santería*, Buddhism, and so on.[6]

Chicanas are at minimum bicultural twice over, first as the offspring of Mexican Indigenous — that is, Native American — and European ancestry, then as U.S. citizens, shaped further by the many ethnic minority and majority cultures of the United States. As they increasingly gain access to the multiple forms of art and media, we see that they are often mixtures sometimes of not simply one but several different Indigenous peoples, some from the south of the continent, some from the north, some historically distant, some as recent as a parent. Their Native American ancestries include the Mexica ("Aztec"), the Maya, the Purepecha, the Huichol, the Kikapoo, the Tepehuan, the Opata, the Yaqui, and countless other "northern" tribes. In addition, some have

been culturally adopted, so to speak, and taught under the direction of spiritual teachers of tribes not of their own lineages, on both sides of the U.S.-Mexico border.

They come as well from various generations of different Europeans. They count among their distant and recent forebears African and Asian (Chinese, Japanese, Indian, Filipino) peoples, and embrace more recent multiethnicities, as part Irish, Anglo, Italian, Puerto Rican, Russian, African American, German, Lebanese, East Indian, and so on. Likewise, in terms of religious cultures, Chicanas descend from followers of Judaism and different Protestant Christian faiths, as well as "folk" Catholicisms, which in some cases are highly Indigenized. Chicanas have also been shaped in religiously multicultural and spiritually hybrid cities such as San Francisco, Los Angeles, and Chicago during the post-1960s, engaging in African diasporic, Buddhist, Hindu, do-it-yourself feminist, goddess, and New Age spiritualities, which for younger Chicanas now form part of the traditions they inherit from their own families.

Finally, the racialized gender and sexual identity inequities that Chicana women experience in the patriarchal ethos of both Mexican American and mainstream U.S. cultures create yet other sensibilities with respect to difference from the legal, social, religious, art-world, and academic norms. The literary, visual, and performance arts form an integral and interconnected part of the history of Chicana feminism, which, like Chicana feminist journalistic essays and scholarship, is present from the beginning of the Chicana/o movement, and not, as some have assumed, relegated to the second half of the seventies or even the eighties. As the early Chicana feminists Anna NietoGomez, Marta Cotera, and Elizabeth "Betita" Martinez pointed out in the late sixties and early seventies, there has been a long and uninterrupted legacy of feminist thought and female resistance to oppressive Anglo and Mexican patriarchal cultures that dates to the period of annexation of the Mexican territories in the mid-nineteenth century and that is rooted in the history of Native American and *mestiza* (mixed blood) women's resistance first to European and then to Euroamerican violence against them and their families (A. García 1997; Rebolledo 1995).

Chicana intellectuals, whether through various art forms or scholarly essays, have always led the decolonizing project of the Chicano/a movement for full civil rights and equity in the areas of labor, education, scholarship, and the arts in the United States. Their impact is now felt in Mexico and Europe as well. The contributions of Chicana thinkers to the development of more egalitarian notions of gender, sexuality, family, community, spirituality, and society are historically foundational, constant, and ongoing, as the following chapters make plain.

In their own irreducible way, the various arts are a form of highly developed thought, each through the languages of its own medium. At its best, art is nothing less than philosophy and cultural theory. The writing, visual, and performance art of Chicana women of the sixties to the present, along with their scholarship, is a vital part of this legacy of productive, visionary thought and social practice. Chela Sandoval, in *Methodology of the Oppressed* (2000), has illuminated the intellectual and ideological kinship and alliance between European poststructuralist and postcolonial thinkers such as Frantz Fanon on one hand, and the politics and strategies of third world and civil rights struggles, on the other. Indeed, she has argued that the former are fundamentally indebted to, and enabled by, the latter, and that, likewise, today's postmodern and progressive thinkers have much to learn from the liberatory thought of U.S. ethnic minority intellectuals and writers, not least among these Chicanas. Like Sandoval's, my own work is greatly inspired by, indebted to, and in dialogue first and foremost with women writers of color, but in my case, also visual and performance artists, especially Chicana artists, to all of whom this book pays homage. These are intellectuals whose work embodies theories of resistance and visionary ideals of social change.

Likewise, the theoretical underpinnings of this book are inspired by the conceptual artistic projects of the historical avant-gardes of Europe and Latin America, those of the first four decades of the twentieth century, as they carefully critiqued, and in some cases attempted to address, the intellectual, social, economic, religious, and aesthetic bankruptcy of the Western culture they had inherited. My

doctoral dissertation on the literary, cultural, and political activities of Nicaragua's avant-garde in the 1920s and 1930s bears witness to that apprenticeship. The work of their heirs in the domain of philosophy, scholarship, and art—the Dada-, Cubist-, Surrealist- and other *vanguardia*-inspired poststructuralist, postcolonial, and postmodern thinkers—and the spiritually guided, courageous social justice work of such nonviolent activists and gender-bending intellectuals as Mohandas Gandhi, Martin Luther King Jr., César Chávez, and Mother Teresa of Calcutta, as well as countless others committed to midwifing a finer humanity and a better world, are the unseen marrow of this book. I have been fortunate to have as my *calmecacs*, my schools of higher learning, the University of Chicago, Harvard, and as a freshly minted Ph.D., the University of Michigan at Ann Arbor, and then the University of Rochester, the California State University at Long Beach, and the University of California at Berkeley. The other *calmecacs* that have perhaps most divinely attuned my heart and face—as the Nahuas referred to the struggle toward integrity and higher purpose—were the community and campus struggles of the eighties and nineties against U.S. intervention in Central America, against South African apartheid, against Latina/o voter discrimination, for Jesse Jackson's Rainbow Coalition, for the cultural broadening of a Eurocentric curriculum, for the support and development of ethnic studies focusing on oppressed minorities, and against male-centrism and homophobia.

Likewise, the Chicana art included here, like other art in the United States and elsewhere of the same historical period, has responded, in greater or lesser measures, to the rise of particular social, economic, and political forces. Some of the most salient of these have been the rise of postindustrialist, digital-based production and distribution systems enabling accelerated, transnational flows of information; the restructuring of business and labor; the disempowerment of workers and the growing relocation of unskilled manual labor jobs in manufacturing industries from the United States to the third world and elsewhere, including the Mexican side of the border; the independence movements in former third world colonies; and ethnic, gender, sexual, civil rights,

and student movements. All these forces have shaped post-1965 Chicana/o cultural production and their concerns to some degree.[7]

I have focused on post-1965 artwork, especially that produced between 1985 and 2000, by women who identify themselves as Chicanas —not as a synonym for Mexican American, Mexican, Latina, Hispanic, or Latin American, but rather in dialogue, if not complete identification, with the concern for social justice of the Chicana/o, and other, civil rights movements. The terms "Chicana" and "Chicano" came into widespread usage in the 1960s as part of the Chicana/o civil rights movement. Unlike the ethnic description "Mexican American," these terms signaled a decolonizing political ideology critical of anti-Mexican sentiment and melting-pot ideals of assimilation into Eurocentric culture. Some scholars use the terms "Chicana" or "Chicano" retroactively, to refer to the first Mexican Americans who came into being as a result of the United States' war of expansion against Mexico (1846–48), particularly since cultural and political resistance to Anglo-American domination has been recorded since then, right through until 1965, when a broad Chicana/o movement of students and labor began to coalesce in support of the United Farm Workers' strike. My use of "Chicana/o" as a noun and an adjective, however, refers to the post-1965 historical era, and to the social, cultural, economic, and political realities that have contextualized the widespread emergence and circulation of the word and its derivatives. Most importantly, I use "Chicana" as a term that artists identified with the ongoing, albeit shifting, shape of civil rights struggles have applied to themselves and their work, as artists decisively shaped in the United States, resistant to the racism against their Mexican and Native American cultures and the discrimination against a still largely pauperized, economically exploited, and culturally stereotyped and marginalized body of citizens. "Chicana/o" in this book, therefore, does not refer to U.S. Latina/os in general, nor does it refer to Mexican national artists temporarily in the United States who sometimes show their work in U.S. Latina/o and Chicana/o art exhibitions and publications, or in mainstream shows.

This study does not pretend to be comprehensive, nor to have se-

lected "the best" among all the work of Chicana artists, nor does it mean to suggest that Chicana artists in general are concerned with the spiritual or the religious, or that the specific artists included are religious in their orientation. Rather, this particular selection of work, arrived at idiosyncratically and in not altogether clear ways, has come together through my perception in it of different approaches to the spiritual as an emerging or re-emerging terrain of discussion, alongside abiding concerns with racialization and gender, sexuality, and class inequities. It is neither a literary nor an art history but rather a broader cultural studies approach to different art forms as thoughtful practices whose meaning is embedded in their own times and in the histories of the social locations of the artists and the subjects of their work. Though neither a history nor a survey, the book no doubt will function as a historical record bearing witness to a small sliver of the rich body of work that post-1965 artists have produced through 2000. And while not pretending to be a new chapter of religious studies, it is nonetheless a document testifying to the efforts and discoveries in this realm of one sector of the Chicana/o communities, that of some of its female artists.

Chicana Art is, in effect, the first book dedicated primarily to the broad range of visual artwork produced by Chicanas, alongside the literary and performance arts, the latter of which have generated significant book-length studies to date.[8] Like the pre-Columbian glyph-making scribes and the modern-day artists inspired by them, I am a *tlacuilo*-like literary and visual thinker, and I have hoped to provide *tlamatinime*-like interpretive performances, decodings, or readings of this dialoguing mixture of different art forms, not only to give voice to my own fascination and what it has helped to produce in me but also to contribute to a new, more universal scholarship grounded, where relevant, in both European/Euroamerican and non-Western aesthetics and philosophies. It is my hope that this study, alongside the many essays and manuscripts presently in production on related topics, will consign to distant memory both the exclusion from, or the merely tokenistic inclusion of Chicana art in, visual studies, art history, literature, religion, and philosophy, as well as museums and art galleries. Each of the more

than forty artists whose work is discussed here easily merits her own monograph. This book is but a beginning, but may it be a fruitful one, contributing to the flowering and expansion of greater knowledges of the arts, and of the art of peaceful and wise coexistence that the best of it inspires.

This book was conceived as an altar-like structure itself—a structure marking the meeting of the embodied and the disembodied, the visible and the invisible, the formal and the conceptual—and strewn with a handful of important objects: here, central themes in Chicana feminist art. Thus, it is organized around concepts and themes that recur in contemporary Chicana art that make use of the various languages of spirituality, some of which are metaphors of social realities rather than religious ones. The chapter titles, expressed through a unique Nahua literary trope that invokes a third element through the yoking of two others, the diphrasm or *difrasismo*, are meant to keep present the sometimes culturally untranslatable coexistence of non-Western and otherwise noncanonized aesthetic systems and the philosophies and larger social imaginaries in which these are embedded, alongside new meanings which their recirculation among Chicana artists creates through yoking together two different artistic languages, whether the high and the low, the Mexican and the Euroamerican, the European and the Mesoamerican, the popular and the pre-Columbian, the high-tech and the *rasquache* (tacky or improvised), the spiritual and the profane.[9] The chapter title *difrasismos*, attempting to identify thematic or formal keystones, convey not only the idea of multiple conceptual, and therefore ideological, frameworks through which one can approach Chicana art, politics, and spirituality, but also that these are not always and only in relations of identity or complementarity to each other. Ultimately, as a poetic figure of speech, reflecting a frame of mind attempting to balance differences, the diphrasm conveys the insufficiency of signifying systems, whether alphabetical, hieroglyphic, or pictographic, to fully capture meaning, not least when what is referred to is of an especially unknowable nature to humans, such as spirituality and the divine, or unknowable because unfamiliar to us, as in cultural difference.

The diphrasm's comma in its English-language rendering is not precisely the either/or slash, nor the Derridean slash that marks the constant slippages and undecidability of meaning in language as a historically constituted and rich vehicle of expression, though it is conceptually akin to these to some degree. The comma of the *difrasismo* marks the coexistence of meanings, identities, and beings, rendering plain the collective and cumulative nature of the production of meaning, the richness of signification as evocation rather than the literality of denotation, and the potential of unexpected pairings of poetic expression to illuminate truths.

The first chapter, "Spirit, Glyphs," discusses in more detail the concept of decolonizing, culturally hybrid spiritualities and aesthetics introduced here, and the general intellectual vindication of Indigenous epistemologies that characterized much of the thought and art of the Chicana/o movement, itself the heir in this respect to the great intellectual and artistic generations of the 1920s through the 1950s in Mexico. The tropes culled and elaborated from these traditions and transformed into feminist and queer idioms, such as glyphs, codices, and the artist as *tlamatinime*, are traced in the more recent work of the 1980s and 1990s by the writers Gloria Anzaldúa, Cherríe Moraga, Ana Castillo, and Sandra Cisneros, and the visual artists Frances Salomé España, Yreina D. Cervántez, and Ester Hernandez.

Chapter 2, "Body, Dress," meditates on the gendered and racialized body as social garment or social sign through the installation work of Yolanda López, Ester Hernandez, and Amalia Mesa-Bains; the performance/disposable sculpture of Diane Gamboa's paper fashions and her "urban royalty" drawings and paintings; and the painting of Yreina D. Cervántez. "Altar, Alter," the third chapter, studies popular religious-inspired art forms, including altar-installation, reliquary-style found-object art boxes, and ex-voto–inspired paintings, as well as photography and video work structured through some of these traditional media. The altar-installations of Amalia Mesa-Bains and Carmen Lomas Garza, the performance art of Celia Herrera Rodríguez, and the paintings of Lomas Garza, Santa Contreras Barraza, Patssi Valdez, and

Barbara Carrasco, as well as the videos of Lourdes Portillo and Rita González, and the photography-based work of Christina Fernandez, Delilah Montoya, and Kathy Vargas, are all studied in this chapter.

The fourth chapter, "Body, *Tierra*," looks at work that recalls national and cultural histories of occupation, and patriarchal and heterosexist ideologies, as these colonize subjectivities and bodies, in the light of abiding desire for a sense of belonging or homeland, whether in our own skins, in society, or on the planet. Chapter 5, "Book, Art," considers the ephemeral in relation to the book and its hybrids, including book art proper, and book-style installations, comics, spoken-word sound recordings, and CD-ROM. Chapter 6, "Face, Heart," turns to the efforts of Chicana artists to bring integrity to themselves, the viewer/reader, and thus the social body, particularly through self-portraiture or works using their or other racialized bodies marked as "other"; through work thematizing the Sacred Hearts of Jesus and Mary, and the Nahua concept of the divinized heart (*yolteotl*); and through work recuperating the sacred for everyday women through Virgin of Guadalupe and related goddess iconography or literary metaphors. The book's conclusion, "Self, Other," is a meditation on the cultural and economic politics of the art world today, the place of Chicana art within it, and our collective responsibility to advance and nurture the arts as an irreplaceable site of spiritual, ethical, intellectual, social, cultural, and political reflection.

Spirit, Glyphs

Fruto del diálogo sostenido con su propio corazón, que ha rumiado,
por así decir, el legado espiritual del mundo náhuatl, el artista comenzará
a transformarse en un yoltéotl, "corazón endiosado," o mejor, movilidad
y dinamismo humano orientados por un especie de inspiración divina.

—Miguel León-Portilla, *Los antiguos mexicanos a través*
de sus crónicas y cantares

But what, or who, can emerge intact from such traumatic crossings,
in response to the passionate call of the originary language, figured
by the drum? Only the black trickster.

—Henry Louis Gates Jr., *The Signifying Monkey*

The journey of this writing is as much a journey into the past as it is into
the future, a resurrection of the ancient in order to construct the modern.
It is a place where prophecy and past meet and speak to each other.

—Cherríe Moraga, *The Last Generation*

It seems that what individuals and groups represent as the spiritual—that having to do with the s/Spirit(s)—is a field of differences and contention, resonances, and crossings.[1] Notions of the spiritual circulate unevenly, and with differing political significance. Thus, though we might be able to generalize about the nature or meaning of the spiritual, doing so runs the risk of collapsing cultural differences when that conversation is a cultural monologue rather than a dialogue with perspectives rooted in different cultural assumptions. The notion of the spiritual that I wish to discuss here, as it is invoked in contemporary Chicana writing and visual art, derives its inspiration primarily from Mesoamerican, other American Indian, African diasporic, and feminist critiques of traditional religiosities emphasizing the belief that there exists an essential spiritual nature, and thus an interconnectedness, of all beings, human and nonhuman. Interestingly, this view is also present in "mystical" and esoteric traditions of Christianity and Judaism even as it has been ascribed significant cultural difference in more orthodox or culturally mainstream Euroamerican thought.

Beliefs and practices consciously making reference to the s/Spirit(s) as the common life force within and between all beings are today largely ignored in serious intellectual discourse as superstition, folk belief, or New Age delusion, or when they are not, they are studied directly as exemplars of "primitive animism" or previous ages of gullibility. To speak about the spiritual in U.S. culture, even approaching it as a field articulated through cultural differences, is risky business that raises anxieties of different sorts.[2] Yet the very discomfort that attends talk of the spiritual outside authorized and institutionalized spaces alerts us to a tender zone constituted by the clash of culturally different and politically significant beliefs and practices.

To speak of the spiritual with respect to the cultural practices of politically disempowered communities, particularly the work of women, is perhaps even more fraught with dangers. Given this loaded landscape, the invocation of the spiritual in the work of contemporary Chicana

writers and visual artists, as a part of an oppositional politics, is especially provocative and ambitious. As Ana Castillo writes in *Massacre of the Dreamers: Essays on Xicanisma*,

> our long-range objective in understanding ourselves, integrating our fragmented identities, truly believing in the wisdom of our ancient knowledge is to bring the rest of humanity to the fold. That is, today, we grapple with our need to thoroughly understand who we are—gifted human beings—and to believe in our gifts, talents, our worthiness and beauty, while having to survive within the constructs of a world antithetical to our intuition and knowledge regarding life's meaning. Our vision must encompass sufficient confidence that dominant society will eventually give credence to our ways, if the world is to survive. Who, in this world of the glorification of material wealth, whiteness, and phallic worship would consider *us* holders of knowledge that could transform this world into a place where the quality of life for all living things on this planet is the utmost priority; where we are all engaged in a life process that is meaningful from birth to death, where we accept death as organic to life, where death does not come to us in the form of one more violent and unjust act committed against our right to live? (1994, 148–49)

The linkages within imperialist and racist thinking between the spiritual, the female, and peoples of color are what make the conditions for talking about women, particularly women of color, and the spiritual, especially difficult. For, as Marianna Torgovnick writes in *Primitive Passions: Men, Women, and the Quest for Ecstasy*, "bit by bit, thread by thread, the West has woven a tapestry in which the primitive, the oceanic, and the feminine have been banished to the margins in order to protect—or so the logic went—the primacy of civilization, masculinity, and the autonomous self" (1997, 212). Regardless of intention, then, it might seem that connections made between the spiritual and women of color reproduce dominant narratives about these as inferior opposites to the rational, Christian, Western European, and male.

The stakes involved in the struggle over these narratives are not small.

With respect to the ascription of the magical to Indians in the Putumayo region of Colombia, Michael Taussig has commented: "This magical attraction of the Indian is not only a cunningly wrought colonial *objet d'art*; it is also a refurbished and revitalized one. It is not just primitivism but third-world modernism, a neocolonial reworking of primitivism" (1987, 172). Nonetheless, addressing the politics of spirituality from the perspective of the "Indian," as an other of Eurocentric cultures, and of reclaiming a belittled spiritual worldview, is crucial to many, particularly if it is a personally and socially empowering worldview, and especially so for women.[3] In the work of the Chicana artists under study here, citations of the spiritual, whether Western, non-Western, or in newer, hybrid forms, are brought into view as social discourse, for their manifest effects in the social and human bodies, and the natural environment. Spirituality in this work is inseparable from questions of social justice, with respect to class, gender, sexuality, culture, and "race."

The "spirit work" of Chicana visual, performing, and literary artists studied here counters the trivialization of the spiritual, particularly of beliefs and practices from non-Western traditions, as "folk religion," "superstitious," or "primitive." It attempts to derail Eurocentric cultural evolutionary arguments in the sphere of religious belief or disbelief that demean that which is culturally different as inferior. Cultural evolutionist thought helps to rationalize social and economic inequities as the "natural" outcome of "developed" and "underdeveloped" cultures or peoples. In the work of the women studied here the "spiritual" is not an abstract or romantic notion, reproducing the idea of a binary split between a baser material, physical, and social reality and a nobler, separate realm of spirit, ideals, and intellect. For some, the references to the spiritual function as a metaphor of that which is spectral, neither fully present, nor absent, such as memory, or marginal social being. Chicana artists whose work concerns itself with the intersections of the spiritual, the political, and the aesthetic call attention both to what counts as respectable religion and to the more ghostly status of egalitarian forms of spirituality in U.S. culture.

Conjuring and reimagining traditions of spiritual belief, traditions whose cultural differences have been used by discourses of civilization and modernization to justify subjugation and devaluation, are conscious acts of healing the cultural *susto*: that is, the "frightening" of spirit from one's body-mind in the colonial and neocolonial ordeals, the result of which is the "in-between" state of *nepantla*, the postconquest condition of cultural fragmentation and social indeterminacy.[4] Put in more familiar terms, these conscious acts work toward the reintegration of the psyche fragmented by the internalization of loathing of the native self, which Frantz Fanon described as vital to decolonizing practice in *Black Skin, White Masks* (1967). In responding to the fact of cultural discontinuity with ancestral Amerindian traditions, and opposing a history of vilification and attempted destruction of the "pagan" Indian, African, and Asian philosophical and spiritual worldviews, many contemporary Chicana writers and artists seek to remember, reimagine, and redeploy ideas and practices culled from these as critique and alternative to male-dominated, Eurocentric, culturally or religiously Christian, capitalist, and imperialist cultures. As Norma Alarcón puts it:

> For many writers the point is not so much to recover a lost "utopia" nor the "true" essence of our being, although, of course, there are those who long for the "lost origins," as well as those who feel a profound spiritual kinship with the "lost"—a spirituality whose resistant political implications must not be underestimated, but refocused for feminist change. The most relevant point in the present is to understand how a pivotal indigenous portion of the *mestiza* past may represent a collective female experience as well as "the mark of the Beast" within us—the maligned and abused indigenous woman. By invoking the "dark Beast" within and without, which many have forced us to deny, the cultural and psychic dismemberment that is linked to imperialist and sexist practices is brought into focus. (1990, 251)

From this perspective, the Chicana artists whose work is studied in the chapters that follow engage in *curandera* (healer) work, reclaiming and reformulating spiritual worldviews that are empowering to them as

women of color and reimagining what a more serious social role for art and the artist might be.[5] In this spirit work, Chicana writers and artists interrupt the reproduction of gendered, raced, and sexed politics of spirituality and art. From a perspective of concern for social justice and environmental responsibility, and a belief in the political effects of art practices, this kind of artwork rejects politically disempowering modern and postmodern Western narratives about the socially useless (i.e., economically unproductive) and thus generally marginal role of the writer/artist (Bürger 1984); the commodification of sanctioned art as signifier of cultural capital (Bourdieu 1984); and artwork as potentially high-yielding economic investment.

In numerous ways that include the invocation and reworking of pre-Columbian Mesoamerican notions of art and art making represented in glyphs, codices, and the Mexica ("Aztec") figures of the *tlacuilo* (glyph-maker) and the *tlamatini* (sage, decoder of the glyphs), these artists are "spirit tongues" of a metadiscourse of art whose social role is more broadly conceived and engaged than that of much presently celebrated contemporary art in hegemonic Euroamerican and Euro-dominated cultures.[6] The writers and artists studied in the pages that follow structure their work like the painter-scribes of Mesoamerica, particularly those of the immediate aftermath of the Spanish invasion, in that the glyphs they trace, like those painted by the Nahua *tlacuilo*, are signs that always point beyond the sign system itself to things that cannot be fully figured. Chicana work inscribing culturally different and politically challenging views of art and spirituality points beyond Euro-dominated languages and worldviews to the necessity of a more complex hermeneutics, one that is cross-cultural, interdisciplinary, and beyond racist, sexist, and heterosexist myopias.

What is particularly relevant and unique to the "spirit glyphs" of Chicana artists citing or constructing culturally hybrid spiritualities in their work is their mapping of pathways beyond the alienation and disempowerment of the nepantlism of today's cultural and geographical de-territorializations. Indeed, they map pathways *back*, not to some mythical Eden, sign of a hierarchical, jealous, punitive, and male God, but to an essential sense of personal wholeness, communal interdependence,

and purpose in the social, global, and cosmic web. The conscious identification with the culturally "different" spiritual beliefs and practices of socially marginalized and politically disempowered peoples enacted in some Chicana art is hardly nostalgic or reproductive of racialist essentialisms, as some fear. It is part of a broader attempt to interrupt unbridled capitalist and imperialist visions of reality that benefit crucially from our exile from the field of spiritual discourse.

'Membering the Spirit

The politics of the spiritual for many Chicana/os is linked to a politics of memory. This tactic of remembering has been understood in the work of the women in this study not as a politically paralyzing nostalgia for the irretrievable past but as a reimagining and, thus, as a reformulating of beliefs and practices. It is perhaps more precisely a politics of the will to remember: to maintain in one's consciousness, to recall, and to (re)integrate a spiritual worldview about the interconnectedness of life, even if it is fragmented, circulating, as its pieces have, through colonial and neocolonial relations. Amalia Mesa-Bains, an artist, art critic, and scholar, perhaps best known for her altar-installations, considers that

> It is through memory that we construct the bridge between the past and the present, the old and the new. The spiritual memory reflected in the works of contemporary Latino artists is a memory of absence constructed from losses endured in the destructive project of colonialism and its aftermath. This redemptive memory claims a broken reality that is made whole in the retelling. In this context, contemporary art is more than a mirror of history and belief, it is a construction of ideology. Art becomes social imagination through which essential worldviews and identities are constructed, reproduced, and even redefined. Memory becomes the instrument of redefinition in a politicizing spirituality. (1993c, 9)

The hybrid spiritualities evident in the work of some Chicana artists, paradoxically, are themselves appropriations. And while the traditional

or contemporary practices of American Indian, broader U.S. Latina/o, Latin American, and African diaspora cultures from which they draw are also politically oppositional to (neo)colonizing cultural and religious systems, they may not have been received directly or fully through their own families' cultures. And bearing in mind nonetheless that some of these traditions have not been altogether interrupted in the memory or practices of Chicana/o culture itself,[7] such cross-cultural borrowing and refashioning[8] is the effect of a kind of a "minority"/third-world, post-nationalist environment from which kindred forms are recycled from (neo)colonization's "waste" to give expression to what is perceived at heart to be a common pre-Christian worldview: the spiritual nature of all being, and thus its unity. Such a view is ultimately at odds with European imperialism in the Americas and elsewhere in the "third" world, and now with the reigning transnational practice of extreme exploitation of the planet and of an unskilled labor force that is disproportionately female and "of color."[9]

For Gloria Anzaldúa, in *Borderlands/La Frontera: The New Mestiza*, a "new mestiza" spirituality is inclusive and affirming of her multiple positionings as a feminist Chicana lesbian writer.[10] The spiritual worldview, like the aesthetic of her book, "seems an assemblage, a montage, a beaded work with several leitmotifs and with a central core, now appearing, now disappearing in a crazy dance" (1987, 66) of diverse American Indian, African, and African diaspora beliefs and practices, recoded patriarchal Christian and Aztec symbols and translations of archetypal psychology (expressed in her formulation of "the Coatlicue state"). Similarly, in the face of traditional, patriarchal Catholicism, Ana Castillo speaks of the right to craft spiritual practices from any traditions that make us "feel better, that is, stronger willed and self-confident" (1994, 147), including elements from that same belief system. In his essay in *Ceremony of Memory: New Expressions in Spirituality among Contemporary Hispanic Artists*, Tomás Ybarra-Frausto observes:

> Creative reorganization of traditional religious systems from Indigenous and African religions continues in a dynamic process throughout the Spanish-speaking world. Within the United States, artists accen-

tuating spiritual domains re-examine, reinterpret and redefine ancestral religious forms with multiple impulses; as counterparts to socio-political commentary, as symbolic and iconographic systems united to autobiographical exploration or as primal icons that illuminate and foreground social conditions. Contemporary artists reworking spiritual canons augment their power and beauty. New forms of spirituality reverberate with the presence and potency of an ancient living ethos expanded with modern signification. (1988, 12)

Whether remembered through surviving traditional practices, or re-imagined and fused together from chosen traditions, the invocation of the spiritual in the work of Chicana artists studied here is politically significant, socially transformative, and psychically healing. We are pushed by such work beyond the increasingly familiar, if still relevant, observations about the survival, resistance, and opposition of the socially abject other. For what also calls for reckoning in the work of these and other Chicana *tlamatinime*, as many of them are redefining this word, is the relevance of the spiritual, whether understood as the sacred and interconnected nature of self and world, or conversely as the beliefs and practices of politically oppressive religious institutions. In such work, the reality of a socially and materially embodied s/Spirit is consciously re-membered, which we are called to witness and act upon, alongside other historically specific and related issues of "race," gender, sexuality, and class.

Spirit Tongues:
Glyphs, Codices, and *Tlamatinime*

Art practices self-consciously identified with Chicana/o aesthetics and ideologies are historically rooted in the 1960s reclamation of the spiritual within the Chicana/o movement, as evidenced in the manifesto *El Plan Espiritual de Aztlán*, the poetry of Alurista, the spiritual *mitos* of Teatro Campesino, Rudolfo Anaya's novel *Bless Me, Ultima*, and countless pre-Columbian–themed murals and other visual art of that period.

The birth of Chicana/o consciousness for many through the reclamation and reimagining of the colonially despised Indian self and beliefs is well known in Chicana/o art and scholarship.[11] The work of Miguel León-Portilla has been particularly important in Chicana/o artists' and other intellectuals' attempts to reintegrate the indigenous. His studies of the philosophy and artistic traditions of the Nahua peoples, and his translations of pre- and postconquest codices recording Nahua belief and practices greatly influenced Chicana/os in books such as his *Aztec Thought and Culture* (Spanish edition 1956; English translation 1963) and *Los antiguos mexicanos a través de sus crónicas y cantares* (first published 1961, reprinted 1988).[12] Distinguishing between the new tradition of the imperialist Aztecs who burned codices of conquered peoples, rewrote histories, and appropriated cultures and the older, Toltec tradition which they had displaced, and to which they were related, León-Portilla writes:

> Alejados de la visión místico-guerrera de Tlacaél, fueron estos tlamatinime nahuas quienes elaboraron una concepción hondamente poética acerca del mundo, del hombre y de la divinidad. . . . Valiéndose de una metáfora, de las muchas que posee la rica lengua náhuatl, afirmaron en incontables ocasiones que tal vez la única manera posible de decir palabras verdaderas en la tierra era por el camino de la poesía y el arte que son "flor y canto." . . . La poesía y el arte en general, "flores y cantos", son para los *tlamatinime*, expresión oculta y velada que con las alas del símbolo y la metáfora puede llevar al hombre a balbucir, proyectándolo más allá de sí mismo, lo que en forma misteriosa, lo acerca tal vez a su raíz. Parecen afirmar que la verdadera poesía implica un modo peculiar del conocimiento, fruto de auténtica experiencia interior, o si se prefiere, resultado de una intuición. (1988, 124, 126)[13]

Walter Mignolo has pointed to the cultural misperceptions that are present in postconquest translations of pre-Columbian codices into European sixteenth-century concepts *"libro"* and "book." In his view,

> the Spanish and the Mexica had not only different material ways of encoding and transmitting knowledge but also—as is natural—differ-

ent concepts of the activities of reading and writing. The Mexicas put the accent on the act of observing and telling out loud the stories of what they were looking at (movements of the sky or the black and the red ink). The Spanish stressed reading the word rather than reading the world, and made the letter the anchor of knowledge and understanding. Contemplating and recounting what was on the painting (*amoxtli*) was not enough, from the point of view of the Spanish concept of reading, writing, and the book, to ensure correct and reliable knowledge. (1994, 253)

With respect to the distinction between the *tlacuilo* ("*escritores*"/"scribes") and *tlamatinime* ("*sabios*"/"wise men"), also sometimes erased in translation, he writes:

> Was the *tlamatini* also a *tlacuilo*? Apparently not. Those who had the wisdom of the word were those who could "look" at the sky or at the painted books and interpret them, to tell stories based on their discerning of the signs. The oral narrative of the wise men seems to have had a social function as well as a rank superior to the *tlacuilo*, who was placed by Sahagún among those who were skilled craftsmen." (252)

While the crucial question of cultural differences Mignolo is mindful of does not seem to have been lost on writers like Anzaldúa and Cherríe Moraga, or artists like those in the exhibition catalog *The Chicano Codices: Encountering Art of the Americas* (Draher 1992), interestingly, they have appropriated these concepts in ways that suggest the return of what may have been lost in Eurocentric translations. More often than not, they conflate the Nahua concepts of the *tlacuilo* and *tlamatinime* in their reimagining of writers, visual, and performance artists as glyph-makers, that is, as makers of signs that point beyond themselves, to significations that are spiritually and politically interdependent and simultaneous, and that hold ancient but relevant alternative knowledges. Chicana/o artists' collapse of glyph-makers and their sage readers, the *tlamatinime*, operates through their perception of both through the metaphor of the divinely attuned artist as a "Toltec," wise beyond technical mastery to a deep sense of the sacred purpose of

her or his material practices, and therefore able to assist those who behold the work in the lifelong process of "making face, making soul."[14] The "Toltec" or artist is in this way engaged in teaching and healing, in the sense of mediating the spiritual growth and well-being of the beholder.[15] Thus, the question raised by much Chicana/o writing and art citing these pre-Columbian practices is the reverse of that posed by Mignolo: Was the *tlacuilo* perhaps not also a *tlamatini*? And a corollary: Within the worldview of Nahua culture that crucially informed "art" practices, did the social role of the artist exceed that of merely glyph-maker?[16] León-Portilla's translations suggest that guiding the work of conscientious *tlacuilo* and *tlamatini* alike was concern for the ultimate meaning of their life's work. In this interpretation, the worthy *tlacuilo*, the "good" glyph-maker, must by necessity also be a spiritually guided sage. Conversely, the codices suggest that the *tlamatini* was also a *tlacuilo*, schooled in the painting of glyphs, like other select members of society.[17]

When writers and artists refer to themselves as *tlamatini* and to their work as glyphs or codices of our own times, as do Anzaldúa in *Borderlands*, some of the artists in the *Chicano Codices* show, and Moraga in "Codex Xeri," they are reimagining art and artist along broader social parameters, for in themselves glyphs, codices, and the words "*tlacuilo*" and "*tlamatini*" point beyond contemporary, Eurocentric cultural conceptions of art and artist. They point to different systems of reading visual signs, that is, to different ways of knowing, and even more, to the insufficiency of one system of signs (visual, oral, performative) to convey meaning and "truths" fully. Old and new glyphs point to semiotic counterparts. They call for broad cultural readings, like those constituted in the *tlamatini*'s performance of decipherment that takes into account the space and occasion, as well as the knowledge specifically coded in the pictographs or ideograms.[18] Glyphs rooted in Mesoamerican worldviews point to that which is outside of verbal and visual language, to the realm of the spiritual, for example, or to culturally different ideas of non-European cultures. Creative writing and visual art by artists such as Gloria Anzaldúa, Cherríe Moraga, Yreina D. Cervántez,

Santa Contreras Barraza, and Delilah Montoya, in particular, attempt to access the codices on some or all of these registers, as signs of alternative spiritual and material knowledges and practices.

Recent scholarship criticizing Eurocentric histories of writing that culminate in alphabetical systems has begun to consider the difference of Native American writing systems more positively and to consider its implications for modern Western ways of knowing. In the estimation of Gordon Brotherston, for example, "*tlacuilloli*, that which is produced with a brush-pen by the painter-scribe . . . integrat[es] into one holistic statement what for us are the separate concepts of letter, picture, and arithmetic, [Mesoamerican iconic script] positively flouts received Western notions of writing" (1992, 50). Even more suggestively, the philosopher and magician David Abram observes: "The glyphs which constitute the bulk of these ancient scripts [Chinese and Mesoamerican] continually remind the reading body of its inherence in a more-than-human field of meanings. As signatures not only of the human form but of other animals, trees, sun, moon, and landforms, they continually refer our senses beyond the strictly human sphere" (1997, 6).

Most pre-Cortés *amoxtli* (painted, screenfold "books") were destroyed during the Spanish conquest in a devastation that has been compared to the burning of the library in Alexandria.[19] Most of the codices that are held in the West were written after the conquest. Schooled in both their traditional Nahuatl culture and the Renaissance culture of written and visual representation in which the missionaries wished them to record their traditional knowledges (Gruzinski 1992), newly Hispanized "scribes" wrote and painted amid the devastation and transformation of their cultures and their identities, indeed of their art and social function, in the postconquest state of *nepantla*. However, if the processes of colonialism in Mesoamerica involved the cultural and psychic alienation of the native self through the Catholic Church's "deployment of the penitential system, with its sacramental confession, and most importantly, its imposition of self-forming tactics of introspection," as Klor de Alva argues (1999; 1988, 74), the rebirth, so to speak, of their descendants, the Chicana *tlamatinime*, keepers and in-

terpreters of native knowledges persecuted by institutionalized powers, is facilitated by "confessions," which map pathways beyond nepantlism. These confessions, like those of their Nahua ancestors, may be read as testimonies of the failure of Eurocentric imperialist government and religion to fully displace native culture and belief systems and reconstitute their subjectivity through colonization.

<div align="center">

Beyond the *Susto* of *Nepantla*:
Culture Cures

</div>

Much of the Chicana art that cites pre-Columbian pictographic conventions hybridizes the different cultural meanings and functions of preconquest "books," or *amoxtli*, postconquest codices, and contemporary books and art work. As in the stylistically hybrid works of the first-generation, postconquest codices described by Serge Gruzinski, in such Chicana artwork we see the complex reworkings of the technologies and belief systems of the imposed dominating culture and the parallel inscription of alternative knowledges and practices.[20] What follows are sightings of the different ways in which *la cultura cura*, culture cures, in contemporary "spirit glyphs" of Chicana writing and visual art practices.

In Anzaldúa's *Borderlands*, image and written or spoken word are inseparably linked, as image and spoken word are in the functioning of the Mesoamerican glyph (pictograph/ideogram). In a chapter titled "*Tlilli, Tlapalli*/The Path of the Red and Black Ink," she writes that "to write, to be a writer, I have to trust and believe in myself as a speaker, as a voice for the images," and that when writing "it feels like I'm creating my own face, my own heart—a Nahuatl concept. My soul makes itself through the creative act" (73). "The stress of living with cultural ambiguity" also allows her, as a "mestiza writer," to be a "*nahual*, an agent of transformation, able to modify and shape primordial energy and therefore able to change herself and others into turkey, coyote, tree, or human" (74). From Anzaldúa's perspective, writing is an image-making

practice that can shape and transform what we imagine, are able to perceive, and are able to give material embodiment. Understood, therefore, is the great responsibility and sacredness of the very real and consequential "transformative power" wielded by the image-makers, which literally "makes face, makes soul" in a reading process understood to be part of a larger performance. Following Robert Plant Armstrong's study (1981) of the cultural difference and "power of affecting presence" of African masks and statues, Anzaldúa speaks of her work as "invoked art," a being imbued with spiritual presence and power, unlike art that concerns itself primarily with aesthetic and technical virtuosity:

> My "stories" are acts encapsulated in time, "enacted" every time they are spoken aloud or read silently. I like to think of them as performances and not as inert and "dead" objects (as the aesthetics of Western culture think of art works). Instead, the work has an identity; it is a "who" or a "what" and contains the presences of persons, that is, incarnations of gods or ancestors or natural and cosmic powers. The work manifests the same needs as a person, it needs to be "fed," *la tengo que bañar y vestir.*
>
> When invoked in rite, the object/event is "present"; that is, "enacted," it is both a physical thing and the power that infuses it. It is metaphysical in that it "spins its energies between gods and humans" and its task is to move the gods. This type of work dedicates itself to managing the universe and its energies. . . . Invoked art is communal and speaks of everyday life. It is dedicated to the validation of humans; that is, it makes people hopeful, happy, secure, and it can have negative effects as well, which propel one towards a search for validation.
> (1987, 67)

Anzaldúa understands the image-making process not only through the sacred and shamanic aspects of the *tlamatinime/tlacuilo*'s path of writing and wisdom that the red and black inks signify but also through James Hillman's archetypal psychology in *Re-Visioning Psychology*, from which she selectively draws in conceptualizing identity as multiple and in reimagining the role of art and artist. In an interesting resonance

with Mesoamerican thought, for example, Hillman writes: "Because our psychic stuff is images, image-making is a *via regia*, a royal road to soul-making. The making of soul-stuff calls for dreaming, fantasying, imagining . . . to be in touch with soul means to live in sensuous connection with fantasy. To be in soul is to experience the fantasy in all realities and the basic reality of fantasy" (1992, 23). Like Hillman, Anzaldúa is interested in the image both as sign of the language of the soul and as mediator of growth of the soul or soul-making.

Her book may itself be thought of as a glyph pointing beyond the cultural and psychological location of *nepantla*, the sense of being culturally torn, by seeing that "in-between" space *al revés*, in reverse—as powerful, as emblematic of the nature of being and meaning. Her perception of the greater meaning of the resonances in different kinds of experiences of marginalization (geographical, cultural, psychological, spiritual, and sexual) is a reenvisioning of interrelated cultural discourses of history, location, and identity that produce hierarchical orderings of difference. As the title of her book suggests, the borderlands are not invoked as yet another valuable but peripheral resource in the center's production of meaning. Rather, "borderlands" becomes a sign of the centrality of the marginalized, the mutable, and the unarticulated in the construction of fuller knowledges and identities. Thus, through the glyph of the borderlands, Anzaldúa points away from too literal an identification with the signs of individual and collective identities, toward ways of knowing that allow for the complexity of that which exceeds language and which, crucially, allows us to reenvision other versions of self and reality. To this end, she also returns to the center of our vision the importance of marginalized ways of knowing through our spirits. *La facultad* and other forms of "inner knowledge" affirm the "divine within" (1987, 50), as well as the "supernatural" (49) or "the spirit world" (38), and represent alternative forms of perception ("seeing"; 39, 42, 45) and "other mode[s] of consciousness" (37), and thus, other epistemologies and paths of knowledge (37, 42) than the rational as it is understood and privileged in Euroamerican and European dominant cultures.[21]

The widely circulating *Woman Hollering Creek and Other Stories* by Sandra Cisneros offers another interesting refiguration of the glyph. The story "Little Miracles, Kept Promises" itself functions as an ex-voto, the visual and written sign left by the faithful as material testimony of the miraculous, that is, of the presence and intervention of spiritual power.[22] The story is thus made up of the different testimonies of faith in the spiritual as represented by various saints, including the mestiza Virgen de Guadalupe, long since redefined by Chicanas through the Mesoamerican goddess Tonantzin, an aspect of Coatlicue.[23] One such testimony is crafted by the character Chayo, disaffected from Catholicism, and particularly from its oppression of women through the image and discourse of "Mary the mild." She writes a letter to the Virgin of Guadalupe, bearing witness to the *milagrito* (little miracle) of a new-found and empowering faith: "I don't know how it all fell in place. How I finally understood who you are. . . . When I could see you in all your facets, all at once the Buddha, the Tao, the true Messiah, Yahweh, Allah, the Heart of the Sky, the Heart of the Earth, the Lord of the Near and Far, the Spirit, the Light, the Universe, I could love you, and, finally, learn to love me" (1991, 128).

Perhaps because the recuperation of a spirituality that is empowering to women is not one of the usually celebrated miracles in Latin American and U.S. Latina/o communities where mestizo identity sways toward the Eurocentric and the patriarchal, Chayo cannot choose from the common stock of human body part and animal medallions referring to the afflicted and now healed self or property, but must create her own image, or *milagrito*, to accompany her letter of gratitude. Thus, in an eloquent and feminist glyph, Chayo offers her braid of hair, symbol of her body's gendering and racialization, in a sacrifice that, understandably, leaves her "heart buoyant" (125).

Cherríe Moraga's "Codex Xeri," published originally in *The Chicano Codices* (Draher 1992) and then in *The Last Generation* (Moraga 1993), offers another important rearticulation of pre-Columbian notions of art and art making. Moraga identifies herself and her writings with the last generation of conquest-era *tlamatinime* that not only witnessed the

subjugation of their world but, more positively, succeeded in transmitting their worldviews through the codices they left. In the introduction to *The Last Generation*, Moraga figures her writing as prayer, codex, prophecy, "a resurrection of the ancient in order to construct the modern," as picture book, as "queer mixture of glyphs," and as writing that responds to the political urgency of the times. For her, the prophetic, or seeing with the mystical third eye (137), is the politically resonant heart of writing and art making, particularly in the present times where selfishness, violence, and greed could make this the planet's last generation. Thus, she writes, "As a Latina artist I can choose to contribute to the development of a docile generation of would-be Republican 'Hispanics' loyal to the United States, or to the creation of a force of 'disloyal' americanos who subscribe to a multicultural, multilingual, radical re-structuring of América. Revolution is not only won by numbers, but by visionaries, and if artists aren't visionaries, then we have no business doing what we do" (56).

As in Anzaldúa's work, her invocation of the *tlamatinime*, glyphs, and codices is not a nostalgic inscription of cultural difference, symbolically meant as a sign of resistance to cultural imperialism. Rather, through these, Moraga attempts to "disenchant" and re-empower artists through the recognition of the political power of their vision as it is externalized in their work. In "Codex Xeri," which closes both the exhibition catalog and her own book, she states:

> The Chicano scribe remembers, not out of nostalgia but out of hope. She remembers in order to envision. She looks backward in order to look forward to a world founded not on greed, but on respect for the sovereignty of nature. . . . As it was for the tlamatinime centuries ago, the scribe's task is to interpret the signs of the time, read the writing on barrio walls, decode the hieroglyphs of street violence, unravel the skewed message of brown-on-brown crime and sister-rape. The Chicano codex is *our* book of revelation. It is the philosopher's stone, serpentine and regenerative. It prescribes our fate and releases us from it. It understands the relationship between darkness and dawn. "*Mira que te has de morir. Mira que no sabes cuándo.*" (1993, 190–91)[24]

"Codex Makers" are therefore also *tlamatinime*, whose tasks are to re-member, envision, and inscribe their readings of the meaning of the cultural signs of their day in illuminating and transformative ways.

In Frances Salomé España's videos *El Espejo/The Mirror* (1987), *Anima* (1989), and *Sacred Confessions and Holy Smoke . . . The Confessions Trilogy* (1997), which includes *Spitfire, Nepantla,* and *Vivir,* the sensa-tion of a space imbued with spirit is carefully created. España's video art might be said to record sightings of spiritual presence.[25] And if the colonial and neocolonial photographic/filmic eye historically "steals" or occludes the spirit or subjectivity of American Indian and third world subjects in visual narratives that render them objects in a Euro-pean discourse of otherness, España's video work operates through the opposite principle. Through an experimental poetics, España's film lan-guage returns spirit to the human tribe, allowing us to perceive spiri-tual presence and power. Within this culturally transformative frame-work, it illuminates Latina womanhood in its complexity, integrity, and beauty.[26]

España does not overtly figure *The Confessions Trilogy* as a glyph or codex at the spiritual and visual cultural intersection of the Native American and the European. It is perhaps better seen as a series of *vis-lumbramientos,* as illuminations, rather than as a set of linear narra-tives about Latina women. Yet images of women, particular gestures, and culturally resonant symbols are slowly, purposefully returned to over and over again, thus constructing meaning in rich, glyph-like fash-ion, as oblique and multiply layered. España's *Trilogy,* like *El Espejo* and *Anima,* produces a different experience of time and consciousness, interrupting linear time and arbitrarily authoritative linear narratives of cause and effect. It allows us to look again, to look more carefully, and perhaps to perceive more intuitively and with a greater range of intelli-gences than do works stimulated by a mass culture predicated on speed, change, and entertainment.

Nepantla, for example, the second of the three pieces in the trilogy, might be more accurately described as a second *acercamiento,* as an-

other and a different approach to the image making of Latinas, in relation to *Spitfire* and *Vivir*, rather than as the second part of a linear argument or narrative. In *Nepantla*, a "live" woman and a historically received, gendered Catholic image, the *alma en pena* (the soul in purgatory), shadow each other, their identity articulated and disarticulated in resonant, flailing gestures. A chain hangs from one of the black-gloved arms of the punkish contemporary woman (figure 1a).

Unlike the soul in flames, the contemporary woman moves with pleasure on her face as she looks into the camera. In a delicate white, fifties-style party dress, black high-heeled platform sandals, dark makeup, leather belts, and chains, she appears a kind of urban angel, at once powerful and vulnerable, sexy and angelic. Another scene shows her moving away from a white wall upon which hangs a black girdle (figure 1b). Through repetition in slow motion and freezing at different moments, that same movement begins to look and read differently. It begins to appear that she is stuck, for every time she steps away, she is sucked back into a space where the black girdle, a symbol of bodily and social constrictions, comes fully into view again. Together, these two paradigmatic images trace the culturally difficult space occupied by those Latina women caught between Christian religious and social discourses of gender that dichotomize women as spiritual or carnal, angels or whores. *Nepantla* suggests that the place where these two poles meet—the negatively racialized and gendered Chicana or Latina body—is indeed a *nepantla*, an embodied purgatory of never-ending social penance.

In all three videos of *Sacred Confessions and Holy Smoke . . . The Confessions Trilogy*, what is ironically suggested in the mock confessions alluded to in the title is the existence of uncolonized spaces of gendered, sexual, and cultural states of in-betweenness. Klor de Alva's study (1988), mentioned earlier in this chapter, productively followed Foucault's examination of the development of new regimes of colonizing social control through practices of self-discipline, in considering the formative role of confession during the Spanish colonial era and the regulatory mechanisms of its attendant practices of self-scrutiny and

guilt. The anecdote that Klor de Alva retells of Father Diego Durán and the "sinful" yet unrepentant Indian, in which the term *nepantla* is first introduced, is a highly ambiguous one. It can be taken to suggest not only the cultural uprootedness of the supposed convert who excuses his Christian failings by explaining that he is still in *nepantla* but also the failures of Christianity to fully reshape indigenous subjectivity into its own image. España makes a similar observation in her video trilogy, focusing it more precisely on racialized and gendered cultural dispossession.

In the third piece of the trilogy, *Vivir*, images of a Christ-like bride of sorrowful countenance alternate with those of a bird cage, eventually shown with its door ajar. In the first piece, *Spitfire*, pre-Columbian and Christian images alternate with those of a young woman. The rosary in her hands seems at odds with her direct gaze into the camera, and a bare shoulder. Like the sorrowful bride in a crown of thorns, and the dark angel of the other two parts of the trilogy, the woman in *Spitfire* is enmeshed within the web of received visual cultural images, and the social and religious values on which they are based, that offer women the impossible, mutually exclusive gender roles of good and bad girl. España's Latinas are spitfires, but not in fulfillment of the racist devaluations of Mexican women in Hollywood stereotypes of the Mexican *cantina* whore. In *Sacred Confessions*, España creates a more complex repertoire of images to represent the specific gender and cultural conditions of Chicana, and other similarly positioned, women. What is ephemeral in U.S. film history, España's trilogy suggests, are remotely accurate representations of "Mexican Spitfires." Such absences and misrepresentations are not merely notes in a feminist revision. They are produced by, and in turn produce, social exclusions and political disempowerment that make Chicana women's experiences all too real purgatories.

Yreina D. Cervántez's *Nepantla* lithograph triptych (figures 2–4), like España's trilogy, aims to undermine racist and sexist histories of representation that inform the fields of visual art in which she works. She too reinscribes alternative and healing visions of reality that can fur-

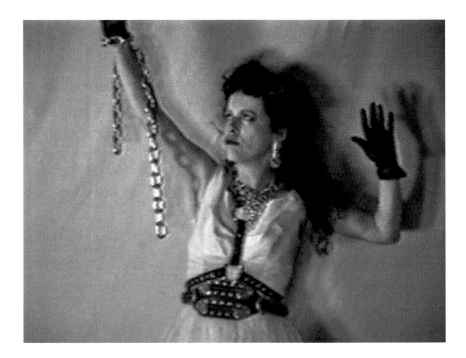

1 a, b. Still images from Frances Salomé España's *Nepantla*, from *Sacred Confessions and Holy Smoke . . . The Confessions Trilogy*, 1998. Color video, 21 min.

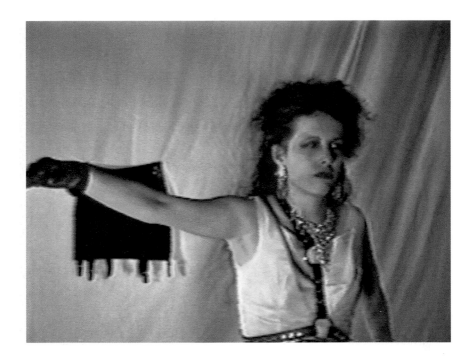

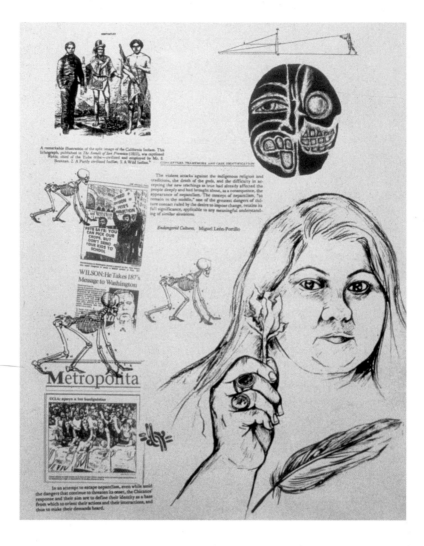

2 Yreina D. Cervántez, *Nepantla*,
1995. Lithograph, 22 × 17 in.

ther the making of face and soul for both "minority" and dominant culture viewers. The first panel introduces nepantlism as the ongoing struggle between two cultural legacies, as revealed in their different ways of seeing: that of an ostensibly universal, European scientific perspective that measures difference against the standard of European man, and that of American Indian worldviews, represented by several objects symbolic of the spiritual and social ideal of harmonious balance between all beings, including the Nahua glyph *ollin*, signifying continuous change and balanced differences. The image of a humanoid skeleton on all fours, repeated throughout the lithograph, makes reference to racialist evolutionary discourses of the unequal development of humans and cultures. A juxtaposed newspaper clipping reports on the anti-immigration politics of Pete Wilson, the former governor of California, accompanied by a photograph of protestors demonstrating against Proposition 187, the ballot initiative that sought to deny education and social services to undocumented immigrants. Floating somewhere between these two images is a passage from León-Portilla's *Endangered Cultures* (1990), which reads:

CONCEPTUAL FRAMEWORK AND CASE IDENTIFICATION
The violent attacks against the indigenous religion and traditions, the death of the gods, and the difficulty in accepting the new teachings as true had already affected the people deeply and had brought about, as a consequence, the appearance of nepantlism. The concept of nepantlism, "to remain in the middle," one of the greatest dangers of culture contact ruled by the desire to impose change, retains its full significance, applicable to any meaningful understanding of similar situations.

Further text, beneath a photograph of student protestors at UCLA, in the lower left of the lithograph, is cited from *Endangered Cultures*: "In an attempt to escape nepantlism, even while amid the dangers that continue to threaten its onset, the Chicanos' response and their aim are to define their identity as a base from which to orient their actions and their interactions, and thus to make their demands heard."

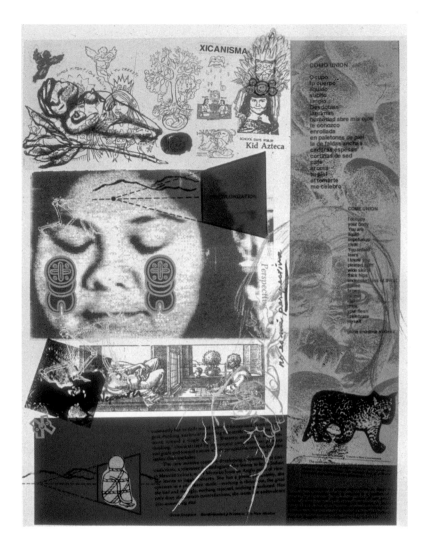

3 Yreina D. Cervántez, *Mi Nepantla*,
1995. Lithograph, 22 × 17 in.

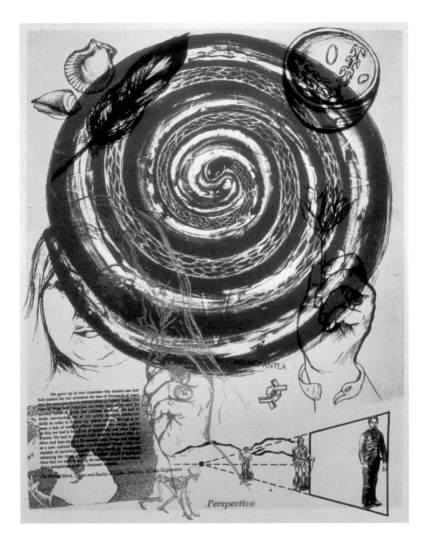

4 Yreina D. Cervántez, *Beyond Nepantla*, 1995. Lithograph, 22 × 17 in.

Cervántez's triptych directly quotes written and visual authoritative texts to suggest the continuity between current and colonial forms of cultural dispossession and fragmentation. Formally, the lithographs enact a visual cultural nepantlism as they hover between the Christian triptych and the pre-Columbian and colonial-era codex, referred to by the parchment-colored paper and the pictographic composition of the prints. The juxtaposition of autobiographical and art historical narratives appears in a collage of a drawing by Albrecht Dürer that includes a grid demonstrating a perspective schema.[27] Pasting an image of her own head onto the female model's, Cervántez illustrates the point written in red ink about evolutionary and masculinist perspectives not being her perspective.

Various images representing the artist appear as a kind of composite self-portrait in the second lithograph, *Mi Nepantla*. The most prominent of these is from a digitized photograph of the artist in which her eyes are closed, as if in meditation. On her cheeks, she bears glyphs associated with Coyolxauqui, the warrior daughter of Coatlicue, dismembered by her brother Huitzlipochtli and contained in the figure of the moon. The artist's visual identification with Coyolxauqui speaks of her own fragmentation as a Chicana artist, through a continuum of gendered and racialized cultural losses that the lithographs pictographically document. The borrowing of the cheek ornaments which give the Nahua moon goddess her name, "She of the Golden Bells," nonetheless marks her as a female warrior.

In the third panel, *Beyond Nepantla*, the image that demands our view is the dark spiral of the feathered serpent, the glyph of Quetzalcoátl, man-God representing both wisdom and the arts, and the unity of the spiritual and the material. The symbol of the circle brings to mind Paula Gunn Allen's observations in *The Sacred Hoop: Recovering the Feminine in American Indian Traditions* regarding the difference between Christian European and traditional American Indian perspectives:

Another difference between these two ways of perceiving reality lies in the tendency of the American Indian to view space as spherical and time as cyclical, whereas the non-Indian tends to view space as linear

and time as sequential. The circular concept requires all "points" that make up the sphere of being to have a significant identity and function, while the linear model assumes that some points are more significant than others. In the one, significance is a necessary factor of being in itself, whereas in the other, significance is a function of placement on an absolute scale that is fixed in time and space. (1986, 59)

Other objects representing various Indian cultures appear in this last panel, including another *ollin* glyph and a reversed, ghostly image of the artist offering a sprig of sage to the viewer. The three "kinds" of Indians referred to in the first panel reappear, ordered by degree of Europeanization but now recontextualized within the Indian cultural perspectives that balance their negativity.

While the effects of colonial histories and continued neocolonial practices are as difficult to erase as the inscriptions upon stone made in the lithographic process, Cervántez's work suggests that perhaps what they represent or narrate may be transformed in viewing them from the nonhierarchical, circular perspective of traditional American Indian, and other, cultures. Indeed, perception and meaning are constructed in the *Nepantla* series in multiple layers and through the signifying systems of different cultures, in a process that, like that of Anzaldúa's *Border-lands*, argues for the value of expanding our perspectives, particularly with respect to cultural difference. Finally, Cervántez's triptych operates as an offering, hybridizing or broadening dominant cultural and visual politics under the glyph of balanced dualities and change.[28]

Más Allá: Cosmic Cruising

The path beyond both nepantlism and Eurocentrism in Cervántez's *Nepantla* series thus appears to be in the re-viewing of humanist cultural awareness from a broader perspective of the interconnectedness of all beings, here embodied in Amerindian cultures, but one that embraces many worldviews, including contemporary nondominant European views and historically earlier ones. Beyond historically specific

cultural differences, Ester Hernandez also works to restore to centrality a perspective of larger consciousness. *Mis Madres* (1986) and *Cosmic Cruise/Paseo Cósmico* (1990) represent American Indian and Latina women at the center of the cosmos. In *Mis Madres* (figure 5), an American Indian or mestiza elder holds up the planet in her left hand. She glows, made up of the very stuff of the stars and the cosmos around her. The size and silhouette of her figure convey a sense of dignity that is reinforced by her celestial pigmentation. Hernandez's silk-screen inscribes into the cultural consciousness of the beholder the existence and, indeed, centrality and sacredness—that is, the inherent value—of the American Indian, the female, and the elderly.

Cosmic Cruise/Paseo Cósmico (figure 6) embeds a personal history (Mesa-Bains 1993a, 58) of the artist's mother as the first woman to drive in her agricultural labor camp and then reinscribes the symbol of this narrative against an image of the cosmos. The juxtaposition brings into view the simultaneity of different experiences and conceptions of time and space, of the modernity represented by the Model-T, and a spiritual, cosmic consciousness that modernist discourses have relegated to the realm of the unreal because it is seemingly unprovable. Hernandez seems to imagine her female ancestors as a planet of their own, or as astronauts of different cultural domains. The memory of the Mexican American female-driven and occupied Model-T in *Cosmic Cruise*, like all the works referred to thus far in this chapter, might perhaps be read simultaneously as a glyph of the greater, spiritual significance of our movements through culturally multiple notions of time and space.

The personally and socially healing work of Chicana *tlamatinime*, such as those discussed here and those that follow, aims to redefine the social role of art and artist in more complex, more ambitious, and more politically and spiritually significant ways than are culturally dominant in the United States and other parts of the world. They create culturally hybrid art practices that I have signified through the glyph and codex, which are neither about nostalgia nor mere resistance to cultural imperialism but rather about transforming a familiar present whose reality is destructive to individual, community, and planet. The visionary yet so-

5 Ester Hernandez,
Mis Madres / My Mothers, 1986.
Silk-screen print, 30 × 22 in.

6 Ester Hernandez,
Cosmic Cruise / Paseo Cósmico, 1990.
Silk-screen print, 37 ½ × 25 in.

cially engaged quality of their work is politically and historically operative, as is their returning to our field of vision a politically engaged spiritual consciousness.

Not all Chicana art at the intersection of the spiritual and the political figures itself as culturally hybrid through reference to the complex and layered semiotics of the Mesoamerican glyph or codex. In other work, the languages of the spiritual figure the ambiguous absence/presence of that which appears culturally and historically disembodied, particularly with respect to Mexican American and *mexicana* women. The dress- and body-based work in the chapter that follows gives shape to "hauntings," in the sociologist Avery Gordon's words (1997), that matter socially and that call for our engagement.

chapter two

Body, Dress

Through body decoration, concepts of social order and disorder are
depicted and legitimized, or specific power and class structures confirmed
or concealed. In all cultures body art also expresses the normal and the
abnormal, stability and crisis, the sacred and the profane.

—Elizabeth Reichel-Dolmatoff, *Body Decoration*

Whether they attempt to appear natural within a given culture or to
create a spectacle of difference within it (Hebdige 1988, 102), clothing
and body decoration signal the nature of membership within a given
culture, be it normal, privileged, marginal, in opposition, or ambiguous.[1] In themselves, dressing and other forms of decorating the body
(cosmetics and other forms of body painting, tattooing, piercing, and
scarification) are cultural practices that produce, reproduce, interrupt,
or hybridize (and thus produce new) cultural values. The use or representation of dress and body ornamentation in visual, installation, or
performative art practices is, similarly, both symbolic and productive.
In contemporary culture in the United States, dresses remain particu-

dresses in U.S. = femininity, identity

larly charged symbols that mark and produce gender identities, whether these be normative or historically newer forms of constructing and representing femaleness, femininity, or the undecidability of gender, and whether these are worn by females or males.

Dresses, like other forms of dress and body ornamentation, are props in racialized constructions of identities, as well.[2] Thus, in the United States, for example, where the majority of domestic workers are Latina or African American, and racist assumptions about the inherent or cultural inequality of people of color continue to circulate, the uniform of the servant or nanny is likely to connote women of color in particular, while the power suit for women is more likely to call up images of Euroamerican or "Westernized" women of particular classes.[3] Indeed, the body itself may be thought of as a social garment.[4] From pigment to physical build to comportment, the presentation and reception of the body is, following the thought of Judith Butler, part of the performance that reinscribes or interrupts social roles attributed as normal to racialized and gendered bodies, whether these be "white" male bodies or those of women of color.[5] Thus, clothing and ornamentation in cross-dressing, passing (i.e., for "white"), voguing, and subcultural styles transgress expectations according to gender, racial, and class roles.[6] Within the double metaphor of the social body as text, dress and body ornamentation are writings on the body, and about it. Body, dress, and body ornamentation speak, in this sense, both of how they are inscribed within the social body and how they in turn, act upon it.[7] Dress and body decoration in the Chicana art of the 1980s and 1990s call attention to both [the body as social and to the social body] that constitutes it as such, specifically through gendered and racialized histories of dress, labor (in domestic service and the garment industry), immigration, urban dwelling, academic discourse, art production, and religious belief. In so doing, the works of Yolanda López, Ester Hernandez, Amalia Mesa-Bains, Diane Gamboa, and Yreina D. Cervántez flesh out the numerous and conflicting ways in which socially and culturally invisible or ghostly bodies mattered in the United States in the 1980s and 1990s — particularly those of women of color.[8]

U.S.: domestic workers = Latina or African American

"power suit" = Euroamerican

body as social & to the social body

"The clothing of humanity is full of profound significance," Carl Kohler wrote more than one hundred years ago in *A History of Costume*, "for the human spirit not only builds its own body but also fashions its own dress, even though for the most part it leaves the actual construction to other hands. Men and women dress themselves in accordance with the dictates of that great unknown, the spirit of the time."[9] In *Margaret F. Stewart: Our Lady of Guadalupe* (1978) (figure 69), San Francisco–based artist Yolanda López focuses precisely on the great unknown of women's socially and economically invisible labor as seamstresses, honorifically framing her mother, seated before a sewing machine, within the Virgin's mandorla.[10] I discuss the rest of the triptych of which this drawing forms part, and other Guadalupe images, in chapter 6.

In her 1994 installation *The Nanny* (figure 7), López endeavors to illuminate the material effects of the spirit of a time. If this spirit is understood to be embodied in the social, cultural, and economic practices of a time, then these can, in turn, be traced in the dictates of dress within a given culture and historical moment. *The Nanny* succeeds in such a project, bringing into view the power differentials among women of different classes and ethnicities through an exploration of dress and media representation of the relationship between women positioned differently by ethnicity and class.[11]

At the heart of the installation, as the title suggests, is the theme of subservience as a constant factor in terms of how relations between Indigenous Latina women and European-identified and Euroamerican women have been, and continue to be, historically constituted. The nanny's uniform hangs between enlarged actual advertisements for airline travel to Mexico (an Eastern Airlines ad from a 1961 issue of *National Geographic* magazine) and for the wool industry (from a 1991 issue of *Vogue* magazine). López chooses to contextualize her study of domestic labor, gender, cultural difference, and ethnicity in the visual language of actual media materials that stage the historical asymmetry

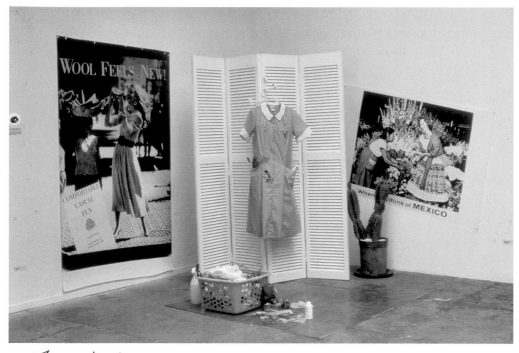

spirit of time = great unknown

7 Yolanda M. López, *The Nanny*, from *Women's Work Is Never Done* series, 1994. Installation. Collection of the artist.

of power relations between so-called first and third worlds. The advertisements mediate this asymmetry through the discourse of tourism. The wool industry advertisement announces that "wool feels new" and implies that the newness of this experience is like exotic travel. The off-the-shoulder, "Latin flavor" clinging wool dress and large hoop earrings worn by a model posed in high heels, with legs wide apart, suggest "Mexican Spitfire" adventures as well. The tourist is clearly meant to appear as free, chic, and desirable, in clear contrast to the Indigenous woman, literally in the other's shadow. Her clothing is both worn and simple, and she does not appear to have been physically groomed for the photograph. She is pictured as static, while the other is dynamic. This same visual strategy of using the woman of color as a foil against which to show a "latinized" European woman as desirable functions in the travel image as well. Cultural appropriation and consumption are also visualized in this blown-up advertisement, through folkloric costume that the blonde tourist affects and the flowers she bends over to receive. Here, the gaze of the woman of color is fixed on the tourist who does not return her gaze but rather focuses on what is presumably her purchase, while the viewer-as-consumer's gaze is drawn to the visually dominating image of the tourist, and then to the other objects symbolizing the sensual allure of travel to Latin America (e.g., watermelon and flowers).

In both corporate advertisements, the women of color are vendors, as the domestic worker is of her labor, and are made to represent racialized relations of subservience, as the nanny uniform does in the United States, where the majority of domestic workers are women of color. The nanny's dress hangs on a white folding screen, over a basket containing laundry, and Indigenous clay figurines, adjacent to toys and a potted cactus. Particularly because of the items that speak of housecleaning and personal service work in addition to child care, López's installation suggests that behind the appearance of the specific job description "nanny" lie troubling relations of exploitation by one woman of another, as the sociologist Mary Romero documented in *Maid in the U.S.A.* (1992). Indeed, the second chapter of Romero's study of U.S.-

born Chicana women engaged in domestic service work is titled, as is López's ongoing series of which *The Nanny* forms part, "Women's Work Is Never Done." "Housework is ascribed on the basis of gender," Romero writes, "and it is further divided along class lines, and, in most cases, by race and ethnicity. Domestic service accentuates the contradiction of race and class in feminism, with privileged women of one class using the labor of another woman to escape aspects of sexism" (15).

The white folding screen in the installation alludes to middle-class conventions of hiding washers and the like behind screens or doors, and thus to a carefully tended culture of appearances, whereby cleansers, laundry, garbage disposal, kitchen, and domestic service itself are veiled to the degree possible, thus erasing all evidence of the labor and "dirty work" behind the seemingly effortless, impeccable wife and home, an illusion that, interestingly, is still at work today. The potted cactus calls to mind two other artworks by López, the installation *Cactus Hearts/Barbed Wire Dreams: Media, Myths and Mexicans* (1988), produced in collaboration with Ricardo Reyes and Larry Herrera, and the video *When You Think of Mexico: Commercial Images of Mexicans* (1986), in which she explored the history of stereotypes about Mexicans and Mexican Americans as represented in films, corporate advertising, souvenirs, clothing, and house and garden ornaments. Thus, along with the uniform of the domestic servant (and this includes the nanny), the potted cactus can be read as a symbol of the Mexican or *cactus = effacement* Chicana nanny's effacement by Euroamerican employers whose sense of superior identity and empowerment derives, in part, from internalizing cultural stereotypes of Mexicans and domestic workers as culturally or socially inferior. "Hiring a woman from a different class and ethnic background to do the household labor," Romero writes, "provides white middle-class women with an escape from both the stigma and the drudgery of the work" and helps to veil the unpaid kinds of psychological and symbolic work that the Chicana domestic is commonly called upon to perform as well (43).

The theme of cultural and ethnic (or "racial") difference staged in the travel and wool industry advertisements is represented differently

in the installation, which focuses instead on the dress of the "invisible" woman of color. The otherwise nondescript blue-gray domestic uniform is adorned, beneath the scalloped white collar, with the gray silk-screened necklace of hands, hearts, and skulls of Coatlicue, a pre-Columbian goddess of balanced dualities that include life and death. This decoration implies the power of the nanny, certainly over the child in her care. A colored image of the plumed serpent Quetzalcoátl, the Toltec man-God of philosophy, technology, and the arts, is drawn above the right pocket of the uniform, and alludes to the nanny's interior being and cultural heritage. In the other pocket is a clear baby bottle in which is inserted a dollar bill. Between the two pockets, in the pelvic area, is stenciled a photograph of a nude *mestizo* baby. On the back of the dress are photos of Latina/o children and a Coatlicue image. The imagery of Native American deities, and the photographic images on the uniform, work to present the subjectivity of the nanny against the objectification of her that is symbolized, and in part produced by, the uniform. Both sets of imagery call attention to a culturally different system of meaning and values that may be operative in an empowering fashion for the installation's imagined Chicana domestic, and to the contrast between how she is seen—and not seen—in her own household and ethnic culture and those of her employer. The pre-Columbian figurines thrown in with the laundry point to what may be the more subversive effect of the nanny's cultural difference, namely, the effect on the children. López's concern with the agency of the nanny brings to mind Laura Alvarez's multimedia *The Double Agent Sirvienta* [Servant] series, discussed in chapter 4, which features the servant as "an undercover agent posing as a maid on both sides of the border" (Alvarez, artist's statement, 1997–1998).

The images of the infant, the basket of laundry, and the toys in *The Nanny* together suggest that the work of women as nannies engaged in other kinds of household service is indeed never done, for their own homes must be cleaned and their children cared for after they have relieved other men and women of these duties. López's *The Nanny* suggests that the beauty, vitality, freedom, and pursuit of adventure

that the travel and wool industry advertisements represent as the desirable cultural difference of European/Euroamerican women are made possible "domestically," as well as abroad, by the economic and gender exploitation of women by women. Thus, in an ironic twist, advertisements exploiting and reinscribing power differentials between first world and third world women are renarrativized in the installation as troubling and apt images of what is happening "back home." By decorating a representation of the middle-class domestic space with marketing advertisements articulated through a discourse of tourism that is rooted in histories of imperialism, López allows us to see that these same intertwined interests are at work in the relations between women in familial and national domestic spaces. The juxtaposition of the two domestic spheres (familial and national), as imbricated in common economic and historical relations, examines unquestioned cultural stereotypes about both dominant and "minority" cultures and thus works toward the denaturalization of racialized relations between women and, between peoples of first world and third world origins.

The Seams of the Ghostly:
Ester Hernandez's *Immigrant Woman's Dress*

"I often wonder what I would take with me if I had to pick up my life and carry it with me — to be scattered like a seed in the wind," Ester Hernandez wrote in an artist's statement accompanying her *Immigrant Woman's Dress* installation (figure 8), originally shown as part of the Oakland Museum's Day of the Dead: Traditions and Transformations 1998 exhibition.[12] The clothing and baggage she created to imagine the geographical, cultural, and psychic journey of her grandmother, who fled from the Mexican Revolution to the United States with her husband and six-year-old child, who would become the artist's mother, includes a transparent, pearl-colored silk organza dress. The fabric is stamped with images of the Virgin of Guadalupe and the dismembered Coyolxauhqui, in white ink that is barely perceptible against the pale

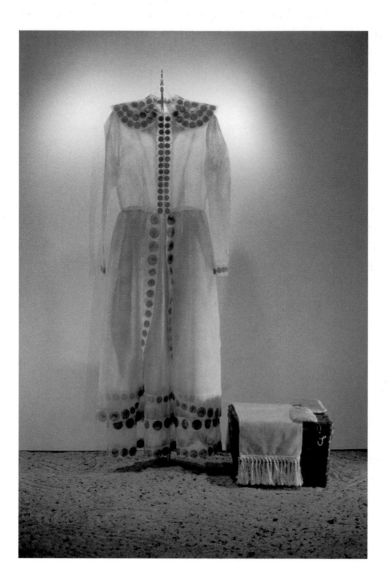

8 Ester Hernandez, *Immigrant Woman's Dress*, 1997. Installation. Collection of the artist.

fabric. The dress is lined with images of Mexican and U.S. coins of that period as well, referring to the habit of safekeeping valuables that her grandmother practiced throughout her life and that must have served her well during the dangerous period of her exodus and immigration. To one side, resting next to the dress in a patch of sand, the artist placed a small, chest-like basket, with a shawl and two small bags of corn and chile lying over it, symbolizing nourishment and protection.

In the installation, the translucency of the immigrant woman's dress, lit from behind, creates a ghostly effect that expresses the idea of the barely visible, gendered history to which the piece's title refers. The dress's styling—high neckline, sober collar, long sleeves, and full-length, layered skirts—and its installation within an island of sand evokes the transitory process of the turn-of-the-century journey. The pale, barely perceptible Coyolxauqhui and Guadalupe stamps function ambiguously, suggesting a cultural legacy in the very fiber of the immigrant's being, yet also a low visibility that can be read as a gradual disappearance.

The tension between the modest tailoring of the dress and the fabric that hides nothing effectively embodies a different tension as well, around the limited movement of women within patriarchal cultures, and their vulnerability. This uncertain place of the Indian and Mexican female lineage in history and religion is told in the fabric of a garment that is barely visible. What it perhaps symbolizes most is the yearning for a time and a place where clothing can be taken to speak, like the gigantic vestments of branches and feathers in Amalia Mesa-Bains's work, of the honor held in the powerful female body it clothes.

Investitures of Power:
Amalia Mesa-Bains's *Venus Envy Chapter III*

From the 1980s to the present, Amalia Mesa-Bains has used dress and "domesticana" to explore the spaces of women's gendered, and transgressive, social and cultural activities in her altar-based installations.[13]

Perhaps the culminations of the altar-installation genre that she has explored in more than thirteen major pieces since 1975, *Venus Envy Chapter One: (or, the First Holy Communion, Moments before the End)* (1993), *Venus Envy Chapter II: The Harem and Other Enclosures* (1994) and *Venus Envy Chapter III: Cihuatlampa, the Place of the Giant Women* (1997),[14] might be read as the carefully researched and meditated study of the social and cultural institutions, and the public and domestic spaces and practices, that have shaped Latina female subjectivity from the present, across ancestral cultural histories, into the ancient past of prepatriarchal myth uncovered by feminist archaeology, and projecting forward through the present to postpatriarchal futures.[15] As their titles indicate, they are also imagining the mythic Cihuatlampa, the place of heroic women, in contemporary terms.

All three "chapters" of the *Venus Envy* installations utilize dresses and gender-specific domestic or public spaces as organizing structures from which to consider the artist's own, and other women's, shaping by, and shaping of, their social and cultural environments. *Chapter One* for example, explores the gendered narratives of religious and social discourses symbolized by the dresses of First Holy Communion, marriage, and religious orders in Roman Catholic Mexican and Mexican American cultures, and the imbrication of domestic and religious spaces, as symbolized, for example, by the juxtaposition of the vanity table and the altar of religious ritual. *Chapter II* continues exploring spaces of feminine enclosure and sociality as the first installation did, but now featuring recreations of a "harem," and Sor Juana Inés de la Cruz's convent study, where laboratory and writing desk once again recall the altar and its invocation of the sacred, power, and *ofrenda* (offering/sacrifice). The desk-as-altar here figures the predicament, sacrifice, and heroic accomplishment of brilliant women like Sor Juana under the patriarchal, religious, and social institutions of seventeenth-century colonial Mexico, while the altar-as-desk speaks to how cultures are "written" or constructed through the gendering of religious practice and experience. As part of the second "chapter" of the trilogy, the desk-altar resemanticizes the vanity table-altar of the first installation, interrogating the

degrees of relation between the vanity table, altar, and desk, particularly [desk & altar] from the point of view of how spatial (e.g., domestic, public) segregation and the social limitations of day-to-day, as well as occupational or vocational practices, produce and enforce gender and other social identities.

On the level of the use of dress, a similar circulation and interrogation of meaning is set in motion. Thus, the First Holy Communion dress, wedding gown, nun's habit, and implied priest's cassock of *Chapter One* are set in dialogue with the dresses of the Goddess/Virgin in one of the pieces in the installation, *Closet of the Goddess*; with the multiple and culturally varied bodies-as-garments of the women connoted by the harem; and finally, with the religious habit donned by the intellectual, creative writer, and feminist Juana Ramírez, who found the most social freedom her time and culture would allow an unmarried woman-loving woman through the convent. The semantic function of dress—and undress—seemingly clear in the case of the wedding gown, cassock, nun's habit, and harem is blurred as these commingle visually and conceptually in the disparate closet of *Venus Envy* as potentially exchangeable costumes that upset the social codes of dress and the social status and identity (i.e., sexual, gender, class, "racial") they are meant to enact when worn according to social propriety. Thus, the dress and undress connoted by the simulation of the harem and nun's habits signify sexualities—enforced sexualities, among other possibilities—and social disempowerment. However, the reference to Sor Juana speaks to the spectacular possibilities heroically achieved by women, in spite of social inequity and enforced subordination.

In this sense, the juxtaposition of various forms of dress, across the gender, historical, and cultural specificities of their normative usage recall Marjorie Garber's insightful discussion of transvestism as practices of dress that signal transgressive crossings, or "category crises" along various social vectors, pointing to the insufficiency of the social sign, including dress, to either define or delimit gender, sexual, class, or racialized identities. "If transvestism offers a critique of binary sex and gender distinctions," she writes, "it is not because it simply makes such distinc-

tions reversible but because it denaturalizes, destabilizes, and defamiliarizes sex and gender signs" (1992, 147).

To the degree that the harem and the convent are gynosocial spaces, *Chapter III: Cihuatlampa, the Place of the Giant Women*, is, like them, situated in an imagined place both within and without patriarchal history. *Cihuatlampa* is the Mexica heaven of heroines who died as a result of their first childbirth, as the artist has explained. *Cihuatlampa* the installation, however, is populated by the memory and projection (into the past and future) of women, including the artist, whose acknowledged creativity is not consigned primarily to biological reproduction, and who otherwise exceed the gendered social roles and expectations of their time.[16] An exhibition statement for the installation's opening in 1997 explains:

> Amalia Mesa-Bains uses *Cihuatlampa* as a metaphor for her own experience of being too large for society. It is a critique of the restriction of those womyn who refuse to keep their proscribed place in the patriarchy. In *Cihuatlampa*, these giant womyn live beyond the roles that men traditionally assign to them. *Cihuatlampa* is a place of counterpoint to a patriarchy that tames womyn, purportedly to ensure social order and to guarantee sexual reproduction on male terms. *Cihuatlampa* is the mythical and spiritual place that enables Amalia Mesa-Bains to cite/site her collective exploration through cultural material, memory, and the interrogation of sexuality and gender. (Steinbaum Krauss Gallery 1997b)

The props in this willful projection of the larger-than-patriarchal-cultures' possibilities for women and society are *The Amazona's Mirror*; the sensually reclining sculpture *Cihuateotl* (*Woman of Cihuatlampa*);[17] numerous hanging iris prints; an *Archaeology Table*; *Der Wunderkammer: The Room of Miracles*;[18] a shelf of feminist and art history books; a miniature perfume garden; and two spectacular pieces of clothing, *Vestiture . . . of Branches*, a copper-mesh dress, nearly ten feet in height, and *Vestiture of . . . Feathers* (figure 9), a nearly ten-foot cape of red, green, and white feathers; and a giant pair of high heels. It is to the

Cihuateotl sculpture (figure 10), the mirror, and the two garments that I would now like to turn.

On one level, the gigantic *Cihuateotl* (*Woman of Cihuatlampa*), covered in green moss, engraved with pre-Columbian figures, and sprinkled with withering Days-of-the-Dead *cempaxochitl* flowers, seems to represent nothing less than "Mother Earth," from indigenous and other pre-Christian "pagan" perspectives wherein both "feminine" and "masculine" energies are considered common to all of nature.[19] Like the Empress in the *Motherpeace* (1981) feminist tarot deck by Karen Vogel and Vicki Noble, Earth is represented as abundant and sensual. She is posed as an odalisque, but she visibly enlarges the Western art historical tradition of the reclining, female nude. Giorgione's *Venus Resting* (c. 1508–10), Velázquez's *The Toilet of Venus* ("The Rokeby Venus," c. 1650), and Ingres's *La Grande Odalisque* (1814), for example, represent women as sexually desirable and available objects, as Roszika Parker and Griselda Pollack have shown (1982). Carol Duncan has pointed to the continuity and preponderance of this representation of women in modernist and modern art. She writes that "the women of modern art," as represented through museum selection and exhibition strategies, "regardless of who their real life models were, have little identity other than their sexuality and availability, and often, their low social status" (1995, 111).[20] In its very mass as a sculpture over eight feet long that at its widest is about three feet and seven inches, Mesa-Bains's *Cihuateotl* is made to literally outweigh masculinist Western painting, displacing its Eurocentric construction of what constitutes the female and the sexually desirable in women.

If what is perceived as feminine—that is, related to women or supposedly woman-like—in patriarchal cultures has been historically divested of social, intellectual, creative, sexual, and spiritual power, as the artist's three-"chapter" installation suggests, then the artist's archaeological sifting of the material culture of the past also reveals what may be the "Venus Envy," or "estrus envy" (Garber 1992, 120) of patriarchal heterosexist cultures.[21] What is instead divested of authority in the Amazonian province of *Cihuatlampa* are patriarchal, Eurocentric dis-

[handwritten margin note: MOTHER EARTH]

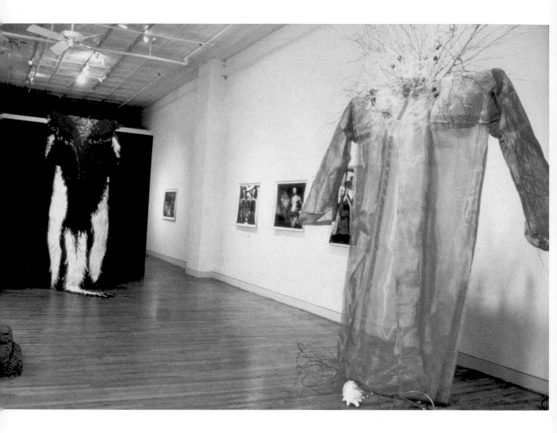

9 Amalia Mesa-Bains, *Vestiture . . . of Branches*
(right), 1997. Mixed media, 117 × 50 × 40; and
Vestiture . . . of Feathers (left), 1997. Mixed media,
117 × 55 × 48 in. From *Venus Envy Chapter III:
Cihuatlampa, the Place of Giant Women*, 1997,
installation. Collection of the artist.

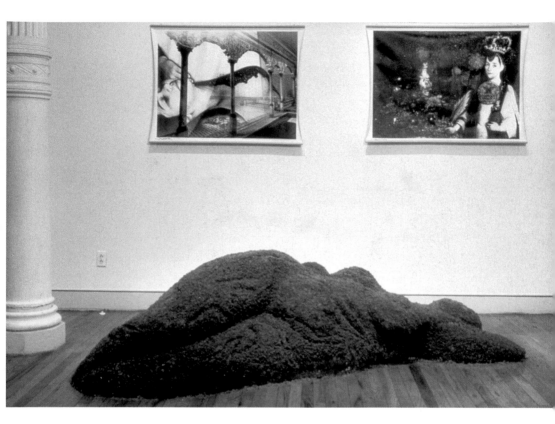

10 Amalia Mesa-Bains, *Cihuateotl (Woman of Cihuatlampa)*, 1997. Sculpture, 24 × 100 × 43 in. In *Venus Envy Chapter III: Cihuatlampa, the Place of the Giant Women*, 1997, installation. Collection of the artist.

courses, and women are (once again) invested with power, as the title of the two regal robes underscore. *Venus Envy III*, like *One* and *II*, is characterized by an aesthetic that reflects the archaeological operation necessary to such investitures and divestitures. Layering, juxtaposition, the impression of images onto mirrors, the use of tables/altars as sites of accumulation, and the repeated use of dress (a layering over the body) all might be read to mimic, and thus signal, this feminist archaeological effort to discover truths beyond those of Western male-centered discourses of knowledge.

In addition to her feminist rereading of art history, history, and anthropology, the artist, a Ph.D. in psychology, appears to be rethinking masculinist psychological discourse, as the title of her trilogy suggests. Mesa-Bains ironically appropriates and undermines Jacques Lacan's theory of the mirror stage in the development of the psyche (i.e., as a sign of the birth of social identity as split and founded on a sense of loss). An immense "hand mirror," over seven feet high, indeed reflects the separation from the mother, but as the historical and cultural loss to patriarchal Eurocentric Christian cultures. The Virgin of Montserrat, one of numerous, enigmatic black Madonnas throughout Europe and Latin America, imprinted upon *The Amazona's Mirror*, reflects a lost wholeness, and the psychic, cultural split from the female, African, and other "dark" peoples that plagued Freud, whom Lacan elaborates, and Jung.[22] The artist would seem to concur that the black Madonnas "are not 'psychological symbols of the dark side of the mother of Christ'— or not solely, or originally. They are solid iconic remains of the ancient time when the religion of the Black Goddess ruled Africa, and from thence, much of the rest of the world" (Sjöö and Mor 1987, 32).[23] But, beyond this idea of Christian Virgins as vestiges of pre-Christian or pagan goddesses, the Virgin-Goddess in *Venus Envy III* leads beyond a debated politics of feminist recovery of what is supposedly distinctively feminine to nondualist notions of gender, sexuality, and spirituality. *The Amazona's Mirror*, like the artist's other scraped and imprinted mirrors in the trilogy, suggests that the surface of cultural beliefs must be worked at in order to uncover what lies beneath biased projections.

Other images function as signs of the layered and masked histori-
cal identities of women and what is perceived as feminine as well, par-
ticularly in the iris prints, produced through digital manipulation, that
hang throughout the installation, and the gigantic robes. Through their
titles and stunning fabrication, these garments most directly confront
the issue of the social empowerment and disempowerment of women.
Mesa-Bains's extravagant use of fantasy reflects a sizable desire to tran-
scend culturally limited notions of identity, truth, and power. The ideo-
logical work of these costumes is perhaps therefore to be found in
the construction of a nonpatriarchal mythos—a modern-day Cihua-
tlampa—from which to redress the split psyche of patriarchal cultures.
Vestiture of . . . Branches, a towering garment with branches spraying
out from the neck and the arms, suggests that the forest itself is the
god/dess-like wearer. A large seashell, and the interlocking circles that
are the symbol of atomic energy, lie dwarfed at the robe's feet, like a
child's ball. Giant, jeweled metal high heels lie nearby. On the other
side of the *Cihuateotl* sculpture hangs the nearly ten-foot red, green,
and white feathered *Plumed Vestiture*. Like the glyphs inscribed in the
moss-covered sculpture, the feathers and their color perhaps refer to
the pre-Columbian Mexica tradition of feather working and to the ex-
quisite postcontact "paintings" made of feathers. Both garments and
the sculpture offer suitable replies to the playful yet socially sugges-
tive question, how does one dress a god/dess? Sensual, beautiful, regal
garments made with abundant use of precious materials, and named
in etymologically rare terms, magnificently bespeak power. Garments
styled like these would indeed create the impressive spectacle the artist
herself made at the opening reception of the installation, in a trans-
lucent black robe with a very high collar framing her head (Steinbaum
Krauss Gallery 1997a).

Within the context of the rest of the installation, the superhuman
dimensions and cosmic allusions of the "vestitures" symbolize transcen-
dence of social gender, and indeed their androgynous styling would
appear to confirm this. Fit for gender-bending Amazons, priest/esses,[24]
or god/desses, *Vestiture of . . . Branches'* wide copper weave of metal and

air, like Hernandez's *Immigrant Woman's Dress*, speaks to the reality and power of that which is partially disembodied, on the level of the social (e.g., female, queer, and "minorities"), the intellectual (e.g., nonpatriarchal histories), and the religious (e.g., non-Christian and nonpatriarchal spiritualities). These garments, as the ellipses in their titles underscore, point to the unarticulated, to that which exceeds what we expect and believe we know. They flash us with social and spiritual beyonds that do indeed seem like the Cihuatlampas of s/heroes.

<div align="center">

Ambivalent Mimicry:
Diane Gamboa's Paper Fashions

</div>

As early as 1972, ASCO, the East Los Angeles art group, was producing performance costumes made partly from paper and cardboard. Patssi Valdez, one of the four founding members, traces the concept of paper fashions to fellow ASCO member Gronk, who organized a fashion show in which he limited the group of Chicana/o artists he invited, including Diane Gamboa, to the use of paper.[25] Diane Gamboa's fascination with the possibilities of paper fashions dates from that show in 1982. Her wearable paper art is characterized by elaborately created, high-fashion clothing and accessory art pieces that are, in terms of design, as wildly imaginative as the most indulgent of haute couture, and that, like it, are largely throwaway, though for clearly different reasons. Unlike high fashion, Gamboa's paper fashions are, first, crafted by the artist herself (rather than assigned to others for assembly), and, second, constructed from inexpensive materials such as butcher paper, tissue, wire, and glitter. "The paper fashions stem," Gamboa was quoted as saying in 1986, "from playing with paper dolls as a little girl and always having the fantasy of being glamorous and wearing an original. But because of my economic bracket, it's very rare for me to even be able to go out and buy a dress. But I figure even if you only have 50 cents in your pocket, you should be able to look great" (Burnham 1986). Gamboa has produced more than seventy-five paper fashions, of which some sixty-five

are dresses, including three cross-gender dresses, and eleven other outfits for males. In addition, she has produced "purse art" and hats, and has painted on preexisting jackets, some of which accessorize her paper fashions. Alongside this art form, she has produced an immense body of paintings and drawings, photography, and other work, such as set designs.

The struggle to survive has remained a constant theme in Gamboa's work, in spite of her establishment as a major Chicana artist in the Chicana/o art community and the sporadic and brief attention that the mainstream media (*Los Angeles Times*) and art publications (*High Performance Journal*) gave her work in the 1980s. This theme generates powerful tensions in her paper fashion work, as well as in her spectacular use of dense, ornate design to decorate bodies and rooms in her drawings and paintings. Rather than the horror of the void that modernist thinkers read into baroque and related aesthetics, Gamboa's characteristic love of ornamentation can be seen as "the incarnation of a seam that never mends," that is, "of the incarnation of desire" (Taylor 1997, 123, 129). The desire her work registers in a gender-, ethnic-, and class-specific way is for that which is inaccessible economically and culturally to her, as a woman of working-class, Mexican American origins, and others like her. Her work registers a politically significant yearning for the material beauty, glamour, and creativity expressed in clothing, domestic spaces, and other parts of the social landscape that the social elite appropriate as innately characteristic to themselves. Gamboa's work makes clear that creativity is restricted only by the tools and the labor that are economically within reach. Her paper fashions cite the function of clothing as a symbol of social status, and in their highly eroticized, glamorous, and ornate construction, they exhibit longing for more fulfilling and creative social intercourse.

As artwork, Gamboa's paper fashions ironically reflect upon the art world (i.e., museums, galleries, publications, academia) as the machinery that produces art as ephemeral fashion and that is ruled by class and economic interests, despite pretenses of economic disinterestedness and innate cultural taste. As art pieces built through dressmaking,

they call attention to the highly gendered and racialized fields of both dressmaking (globally, women of third world origin predominate in the "home work," factory, and sweatshop fabrication of the garment industry) and art (European/Euroamerican men's work continues to constitute the bulk of what is purchased, exhibited, and taught as art).[26] They suggest that the historically constructed class-, gender-, and racially biased divide between craft and art is anything but natural. Particularly from these perspectives, Gamboa's appropriation of glamour and high-fashion design as signifiers of cultural capital, as Bourdieu defined it, display an ambivalent mimicry on her part that records her aesthetic and identity formation through popular cultural media such as film noir, fashion magazines, and celebrity journalism.[27] Lavish detail, mimicry of a high fashion aesthetic, and the fairy-tale wearability of her designs coexist with the irony toward the ideologies embedded in these, and within herself.

The ambivalent mimicry of Gamboa's paper fashions functions with respect to desire for the glamour of the worlds represented through these media, and in particular to how gendered social and erotic desires are constructed.[28] A good number of Gamboa's paper fashions (and their titles) sardonically comment on the constraining and gender-producing absurdity of fashion for women, while inscribing the artist herself and her models (whether female or male) within that problematic economy of desire. At the same time, her paper fashions, as well as her other similarly structured and thematized work, attempt to reclaim the terrains of the erotic and the fantastic as spaces of creativity and freedom. *Cutting Through* (figure 11), for example, was worn by the artist to the release party of *Sí*, the short-lived Los Angeles–based Latino magazine. The outfit included a black, strapless, very short, tight-bodiced, wide-skirted dress, black gloves to the elbow, a fake jewel–encrusted headdress, heavy "diamond" earrings and necklace, makeup that included eyebrows that ended in ornate curls, permanent tattoos on both upper arms, and a huge papier mâché, "jeweled" sword. The fantasy, wit, and sexiness of the piece aptly spoke to the challenging but welcome project of launching a publication dedicated to commentary on Latina/o arts and cultural life.

11 Diane Gamboa, *Cutting Through*, 1995. Mixed media paper fashion, modeled by Linda Gamboa. Destroyed. Photography by Daniel Martinez.

The ludicrous and purely fantastic styling of *Butterscotch Twist* (figure 12) recalls "real" designer evening wear whose symbolic function seems to be the display of nonutilitarian clothing as economic and social capital and the presentation of women as expensive ornaments. *Butterscotch Twist* takes that logic one step further, presenting the female model as nothing more than a superfluous sweet. Gamboa's "rip-off" of high fashion is a politically oppositional reversal of elite designers' 1980s and 1990s ransacking of street, "ethnic," and, in an all-time low, "homeless" fashions. Her show-stopping paper fashions dispel the delusion — (re)produced through fashion, the acquisition of art, and discourse — that "pure" fantasy and creativity are found solely among the "aristocracies" (i.e., historical, economic, and social) of the world. Instead, the high-fashion style of Gamboa's paper fashions, like her "urban royalty" work to be examined in the next section, *show* that "higher rank" is enacted through creativity in thought, art, and social action (D. Gamboa 1999b).

Like high fashion, the design of pieces such as *Mother and Child* and *In the Heat of the Night* far exceeds cultural norms of propriety and utility for clothing. As "garments," they function as ornamental excess, insisting upon the high social value of the wearers. Pieces such as the sadomasochistic-themed *In Charge* and *Don't Touch*, as well as *Cutting Through*, are even more specific in their statement about the paucity of social roles, and thus dress, imagined for women — and men — who exceed sexual, social, artistic, and cultural norms. Painted preexisting jackets such as *Off My Back* and *Falling Angel*, and handbags such as *A Night Out* and *Box Bag* display clothing and dress as social language by making visible, through what is pictured on them, the attitudes, obsessions, and desires with which we dress. When viewed as a reflection of Gamboa's position as a Chicana artist from East Los Angeles — recognized within the Chicana/o art community yet all but invisible in the dominant cultural art world — her paper fashions function like voguing and drag, appropriating and enacting supposedly class-specific and "racial" attributes signified by clothing and demeanor, through cross-class, cross-"racial," and cross-gender dressing (e.g., *She on He*; *He Wares Her Well*; *Boy Blue as Girl*).

12 Diane Gamboa, *Butterscotch Twist*, 1986. Mixed media paper fashion, modeled by Linda Gamboa. Destroyed. Photography by Daniel Martinez.

Gamboa's talents render her appropriation and elaboration of the design language of high fashion a "class act." Her ambitions, however, subvert those of high fashion to decorate the socially and economically powerful in ways that uniquely signal and enact their power. Painted paper, molded papier mâché rhinestone jewelry, and glitter self-consciously mark the illusion of wealth with which the paper fashions play and suggest that the pretensions of the socially and economically powerful to innate cultural, intellectual, and spiritual gifts are also paper-thin. Gamboa's dollar-store originals also mark the contradictions and limits of the fairy-tale lives of glamour, opulence, and power told by the media and signaled by designer originals. From this perspective, Gamboa's complex paper fashions speak to the desire for beauty, creative expression, and empowerment—however these are culturally understood—that such fairy tales also figure.

Inscribing Excessive Social Desires: Diane Gamboa's "Urban Royalty" Drawings and Paintings

Gamboa writes, "I take on the 'urban warrior' mode when I am on the streets of Los Angeles. Conflict is experienced in a blink of an eye in the urban landscape. As I find my way into the studio setting and out of the mass public I go into what I call 'urban royalty' mode. I feel a higher rank on the [level] of the mind. I also use the term urban royalty as a form of expression for creative thinkers, creative art makers, and the powerful creative changers of our time" (1999b). Paintings such as *Tame a Wild Beast*, her numerous India ink drawing series (e.g., *In the Name of Love; Pinch Me; Pin-Up, Pin Down*), and silk-screen prints like *Little Gold Man* and *Altered States* further elaborate the imaginative social setting for such a "futuristic urban royalty."[29]

In these drawings, paintings, and prints, the "flesh" of nearly nude, androgynous bodies is directly ornamented, as are the private interiors in which they are pictured and which function as extensions of the decorated body, in some cases as emotional prosthesis. In *Little*

Gold Man (figure 13), curtains, sofas, rugs, clothing, and bodies are all highly decorated, but it is the decoration of the bodies rather than that of the furnishings that creates a surreal effect. Lavish pink spiral designs adorn several bodies, while another figure wears sutures on her arms, torso, and forehead. Images of human and monstrous (three-eyed, double-headed, zipper-mouthed) free-standing sculptures outstrip in their expressiveness—or compensate for—the coolly composed, images of alienated, hip urbanites. In *Pinch Me* (figure 14) and in *Altered States* (figure 15), the distinction between human and object surfaces is blurred.

From the sofa in *Pinch Me*, for example, hang the kinds of tassels that decorate the nipples and brassieres of androgynous bodies in other pieces. A female or transgender body is decorated like an object, with drawings of jewels on the arms and a floral-and-heart-patterned trellis on one leg.[30] Like Patssi Valdez's psychically intense interiors and palette of the mid-1980s through the mid-1990s, Gamboa's representations of spatial interiors as animated render the energy of human relationships palpable through color, line, texture, and composition. However, in Gamboa's urban royalty world, reversals between the human and the inanimate are part of the dense and obsessive decor. And while paintings by Valdez such as *The Watermelon, Broken*, or *Volcanic Sunday* express anxiety about the repressed violence of domestic or familial space, primarily through cracked and impaled surfaces, skewed perspectives in composition, and the use of bloody reds, Gamboa's urban royalty work expresses anxiety through the *desencuentros* ("disencounters," i.e., bad encounters) between people in emotionally strained or hellish, densely decorated party or sex scenes.

Clothing for both females and males in *Madonna Whore Complex* (figure 16), *Pinch Me*, or *Altered States* is little more than bikini bottoms or breast tassels, and as such it draws attention to body decoration as dress, but also to the body itself as social skin. The bodies represented in pieces like these wear both their scars and their desire, through obsessive decoration as already mentioned but also more explicitly through Sacred Heart and other heart-and-dagger imagery.

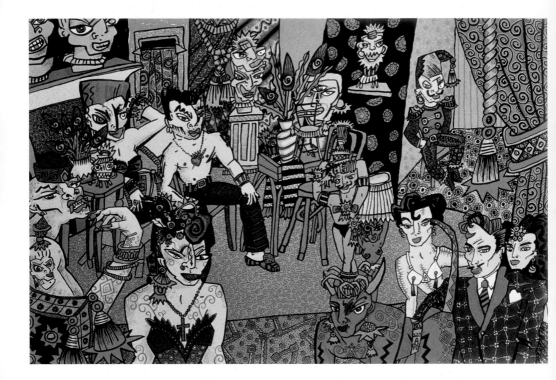

13 Diane Gamboa, *Little Gold Man*, 1990.
Silk-screen print, 26 × 38 in.

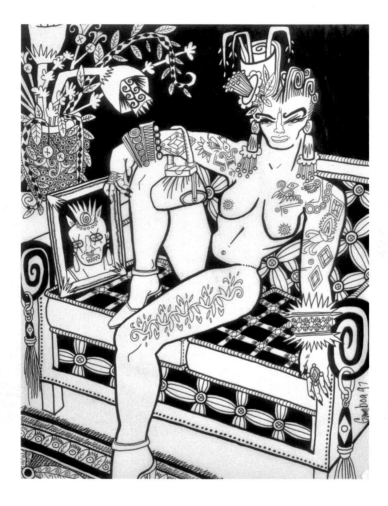

14 Diane Gamboa, *Pinch Me*, 1997. Black and white India ink on 100 percent cotton vellum, 8 ½ × 11 in. Reproduced on Apollo, transparency film. Collection of Esperanza Valverde.

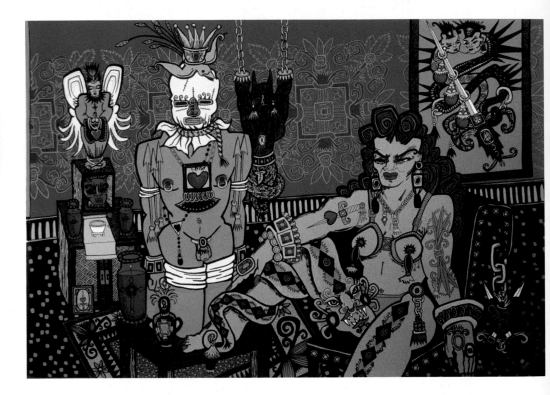

15 Diane Gamboa, *Altered States*, 1999.
Silk-screen print, 22 × 30 in.

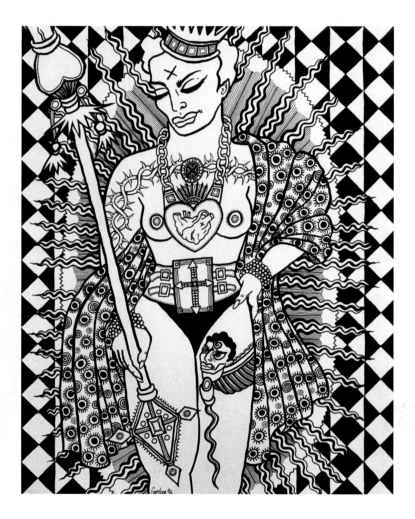

16 Diane Gamboa, *Madonna Whore Complex*, 1992. *In the Name of Love* series. Black and white India ink drawing, 8 ½ × 11 in. Collection of the artist.

Sacred Heart imagery is a culturally specific iconography that is particularly appropriate since its history in the Americas dates back to the Spanish invasion and records the code-switching and hybridity that resulted from the colonial encounter of (at least) two different visual cultures, the Spanish and the Mesoamerican.[31] In *Little Gold Man*, a pierced heart worn as a necklace says more than the closed-face, shirtless pretty boy's expression would allow. In *Madonna Whore Complex*, the sadomasochistic-themed, topless Virgin is tattooed from arm to arm across her/his chest with a double helix of thorns and a chain necklace of a stylized heart, itself decorated with an image of an anatomical heart. The scepter held by the androgynous, downcast-eyed figure is also crowned with a heart. Here, it seems that it is human desire itself which is sacrificed and heroic, but it is an ironic deification, since it is Christian culture that represses the body and prohibits nonreproductive and nonmarital sexual practices.

In *Altered States*, a magenta wall that horizontally occupies half the print is decorated with a pattern elaborated around flaming Sacred Hearts. Heart-like bulbs appear throughout the decoration of the interior space and the bodies within it. Heart imagery derived from both sacred and profane traditions powerfully functions to render the ambiguities of sexual and emotional liaisons. In spite of the dominatrix's harsh expression and the lover's bondage, the abundance of hearts and the overwhelming pink palette speak of the inextricability of love and pain. Perhaps most radically, Gamboa succeeds in picturing a zone where liminal erotic and spiritual experiences cross. On a more general level, it can be said that the figures in these pieces wear their hearts on more than just their sleeves and thus are inscribed visibly at least as much by their desires as they are by their alienation and other wounds.

The visible tensions in the work discussed in this section are generated by the contrast between decorative abundance on highly eroticized bodies and interior spaces, and the closed, distant, pained, or malevolent expressions that the figures wear. In Gamboa's urban royalty work, erotic bodies visibly "wear" emotional and physical scars and desires alongside properly aesthetic ornamentation that nonetheless speaks of

common theme: Fashion is a metaphor for something

countercultural identifications (e.g., punk, sadomasochistic, neotribal).
What Gamboa writes about her *Pin-Up* series may be said of the larger
group of works mentioned: the work "incorporates notions related to
the urban experience as a form of social and personal absurdist com-
mentary" and "focuses on the distortion of ego as a method of surviving
the adverse conditions of the urban environment." Her work "presents
the extreme dramas of the unconscience [*sic*] as a spectacle of the cul-
tural netherworld of 'outsiders' who have chosen to include themselves
into their own world where they can be dominant as well as fashion-
able. Fashion is the metaphor for the temporal nature of what it is to
be 'normal'" (D. Gamboa 1999c).

The decorative excess of Gamboa's highly ornamented bodies, which
has thus far characterized her oeuvre as a whole, figures the extreme of
unrequited social desires of the ambivalent s/heroes of her urban war-
riors/urban royalty.

Defamiliarizing the Racialized Body: Yreina D. Cervántez's *Big Baby Balam*

Tattooing in Western cultures has historically marked social margin-
ality, including criminal status (Mifflin 1997; Chinchilla 1997; Tay-
lor 1997). Since the colonial encounters of the late fifteenth and early
sixteenth centuries, painting of the body (especially parts other than
the face), tattooing (a process of incision and inking), and scarifica-
tion have traditionally been viewed from upper-class Eurocentric per-
spectives as markers of the culturally and historically primitive. Since
the nineteenth-century rise and circulation of modernist aesthetic dis-
courses of Europe and the United States, excess with respect to deco-
ration of the body, the home, and the public sphere has been both
consciously and unconsciously linked to the culturally and historically
primitive, inferior, and vulgar (Taylor 1997, 97–103). Tattooing and the
other forms of body decoration explicitly viewed as transgressive may
continue to function not only to interrupt normative, middle-class dis-

courses, as they have throughout their modern usage in the United States and Europe, but also to disrupt Eurocentric discourses of aesthetic, moral, and cultural superiority. To some extent, these culturally hybrid practices of body decoration reflect the increasingly interracial, multicultural identities and cultural practices of global cities like Los Angeles, San Francisco, Miami, and New York.[32] However, the failure of many viewers to perceive the fictional and performative aspects of Guillermo Gómez-Peña's and Coco Fusco's 1992 performance of "liv[ing] in a golden cage for three days, presenting ourselves as undiscovered Amerindians from an island in the Gulf of Mexico that had somehow been overlooked by Europeans for five centuries" (Fusco 1995, 39) suggests that in spite of the effects of cultural globalization upon both first worlders and third worlders, depending on how "ethnic" (i.e., non-European) they look, Latina/o neotribals might still be mistaken, as Gómez-Peña and Fusco were, for the "authentic," "primitive" Indians.

Particularly in view of the widespread chic of tattoos among celebrities, the rich, and middle-class youth in the United States, it is clear that tattooed, pierced, scarified bodies occupy different social registers and have different cultural meanings, as well as specific iconographic repertoires. That is, not all tattooed, pierced, or scarified bodies read the same way. In Mexican American communities, images of the Virgin of Guadalupe, particular versions of the Sacred Hearts of Jesus, Mary, or Guadalupe, crosses, and tears, for example, have histories that date at least to the pachucos of the 1940s. From the perspective of a mainstream that by definition is normalizing, tattooing on the already devalued bodies of women, people of color, the (presumably) identifiable transgendered persons, gays and lesbians, or members of the working class doubly marks these as culturally and socially marginal, and possibly criminal.

It is within the complex parameters and ambiguities of these considerations that Yreina D. Cervántez's self-portrait, *Big Baby Balam* (figure 17), a work in progress since 1998, needs to be approached. If Frida Kahlo's self-portraits inscribe—with the help of her discovery by U.S. feminists and Chicana/o artists in the 1970s—the female, indige-

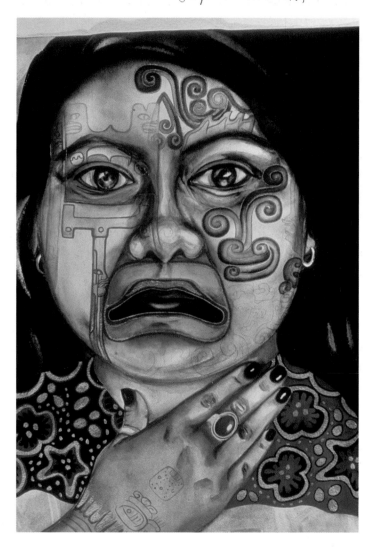

17 Yreina D. Cervántez, *Big Baby Balam*,
2000, work-in-progress. Watercolor, 24 × 18 in.
Collection of the artist.

nous mestiza, and androgynous presence into male, Eurocentric art histories, Cervántez's recent self-portraits deconstruct the visual language of Western portraiture and the racialization of identity (as signified in the body) in which it is embedded. Through it, Cervántez, a student of self-portraiture since the 1960s, has developed visual tactics that defamiliarize an image of the gendered and racialized self. In *Big Baby Balam*, facial tattooing interrupts and recodes what darkly pigmented skin and non-European facial features, particularly in combination, signify in cultures where the particularities of skin and bones have been read through discourses of idealized, Eurocentric national identity (see Fanon 1967).

The repertoire of Cervántez's masks, tattoos, and other facial decorations in her self-portraits in watercolor and prints is drawn, and reworked, from various pre-Columbian genres, pictographic conventions, and images (e.g., glyphs, sculptures, murals, codices), in addition to Western visual culture. For example, in *Danza Ocelotl* (figure 76, "Jaguar Dance"), the artist superimposes a symbolic sun mask, decorated with symbols representing Nahua concepts of duality, over an image of her face. Out of a third eye emerges the *ollin* glyph, representing continuous and harmonious change.[33] A hand that holds up the mirror/mask is sheathed in a transparent glove that recalls Mexica spring rituals. The ritual flaying and wearing of human skins in honor of the god Xipe Totec suggest that the flesh itself is a costume, a mask, and a sacrifice. This serigraph charts Cervántez's early (1983) efforts to develop alternative visual significance for the brown, indigenous body in the genre of self-portraiture and to hybridize contemporary Western visual art languages through the use of Mesoamerican glyphs or glyph-based symbols, spatial conventions, and color palettes. But perhaps most crucially, *Danza Ocelotl*, and *Mi Nepantla* after it, are shaped by indigenous views about the fluidity of human identity, particularly in relation to the natural world. What the artist is perhaps most interested in rendering is the changing and transformative nature of the self, rather than static, limiting, and objectifying notions of the self overly identified with the socially and materially transient worlds.

Big Baby Balam represents the self as a tattooed surface, and as such, it inescapably pictures the fact of the body as a text inscribed with social meaning. But it also represents the self through markings that allude to the animal self—in Cervántez's case, the jaguar. Thus, around her mouth the artist paints the stylized mouth of a jaguar from Mesoamerican art's history, and the spotted pattern of her clothes follows a traditional representation of the jaguar, through its skin. The artist represents herself as both animal and human, that is, the unsocialized, natural self and the socially constructed self. But the portrait has an uncanny effect because the artist captures the twilight between these two selves, in a moment of transformation. The image has the effect of displacing the racializing semiotics of skin color and features. The artist appears as another social self through the unfamiliar signs of the self outside human society, the jaguar. Identity is represented as process, and as a zone between the known and the social unknown. The spiritual self represented by the animal double is one such social unknown, as are a host of other enactments that belie dehumanizing gendered, cultural stereotypes.

In this sense, Cervántez's notion of subjectivity shares a great deal with poststructuralist notions of the uncertainty of identity, but the artist's idea of identity as fluid and changeable is rooted in traditional Indigenous worldviews that understand the human person as a spiritual being, in fundamental relation and identity with a natural environment imbued with spiritual energy and consciousness. Thus, the artist's face is also tattooed with glyphs for water, corn, and other natural elements, making plain the stuff of which she is made. Cervántez's self-portrait is a portrait of our time as well. It speaks of a cultural, as well as an individual, self, balancing very different perspectives about identity, and thus, truth in general. She captures a moment best lived through receptivity to the change that is natural to social identity, culture, and history. Her self-portrait models the struggle for the self-realization that beckons in the face of the demeaning social gaze that may lock us into its perceptions.

What meanings are produced—or silenced—through the kinds of circulation and receptions available—or not—to the artists and their works? What impact does their work have and in what communities? If gender and ethnic identity politics is passé, as some theorists would have it, are we to assume that their work has met with dominant cultural, mainstream, or feminist critical, if not economic, success? How has their work been received in the dominant cultural art world? What does their work finally tell us about the social body upon which it writes? Within the metaphor of the social body, where does Chicana art fit? Is it mere decoration, a (no longer) fashionable but still exoticized "flavor of the month," as the major Latin American and U.S. Latino-themed museum shows of the 1980s and early 1990s now seem to Chicana/o artists, other than the handful who got through the door that cracked open then?[34]

López, Hernandez, Mesa-Bains, Gamboa, and Cervántez are respected, active artists whose reputations were "established" early in their careers within the Chicana/o and, in some cases, U.S. Latina/o art world of galleries, museums, publications, arts education curricula, and to varying degrees, art history. It must be said, however, that though they have all presented their work in Chicana/o studies or ethnic studies departments or programs in universities and community colleges, their art remains marginalized for the most part in these would-be "havens." The art of Chicanas is less visible in mainstream art history departments. López, Hernandez, and Mesa-Bains, like most of the other Chicana artists roughly of their generation to have come of age in the late 1960s and early 1970s, have received some recognition from mainstream, feminist, and multicultural art histories.[35] Lucy R. Lippard's *Mixed Blessings: New Art in a Multicultural America* notably included the work of twelve Chicana artists, including all the artists discussed in this chapter except Cervántez, as well as that of the muralist group Mujeres Muralistas. Some have been included in California art histories.[36] They have

also received some attention in Latin American and/or U.S. Latina/o art histories, exhibition catalogs, and compilations.[37]

A few trailblazing art historians, curators, and critics have helped introduce the work of these Chicana artists to the mainstream art world. Shifra Goldman's curatorial, scholarly, and journalistic writing on Chicana (and Chicano) art, grounded in an equally pioneering (for the United States, that is) expertise in modern Latin American art history, has been both extensive and sustained. Likewise, the work of thematizing Chicana art, and other U.S. Latina/o art, has also been advanced by Tomás Ybarra-Frausto. Encouragingly, the early efforts of Goldman, Ybarra-Frausto, and (in her work as a scholar and curator) Mesa-Bains have more recently been joined by the work of scholars from visual cultural studies and art history.[38] The most exposure these artists have received has been through numerous Chicana/o or U.S. Latina/o group shows, exhibition catalogs, and scholarship.[39] Overall, however, the attention their work has received in art venues, media publications, and scholarship has been scant and, with few exceptions, of limited scholarly or intellectual depth. No doubt this owes to the same reason Goldman (1994a, 318) found the curatorial practices and essays of the Latin American and/or U.S. Latina/o exhibitions of the late 1980s so seriously lacking in rigor and judgment: "Critics—to say nothing of art historians—know very little about Latin American art"—let alone about Chicana/o, or other U.S. Latina/o, art.

Of the artists discussed in this chapter, López's *Virgin of Guadalupe* triptych, Mesa-Bains's altar-installations, and Hernandez's *Sun Mad* and *La Ofrenda* are perhaps best known in mainstream feminist art writing.[40] With the exception of Mesa-Bains, who is represented by the Bernice Steinbaum Gallery in Miami, these artists have shown their work predominantly in venues such as Chicana/o community centers, galleries, museums, international exhibitions of Latin American and/or U.S. Latina/o art, and mainly through group shows. All have had one-woman shows, but none at major mainstream public museums. To date, mainstream and U.S. Latina/o museums and collectors have most often purchased prints of their work rather than larger, more expensive pieces.

Again, Mesa-Bains is the exception.[41] Tellingly, López's groundbreaking Guadalupe triptych, perhaps the best known of all Chicana art images, remains in her private collection, as she has never been approached for its purchase, though as of this writing it had been on extended loan to and exhibition at the Mexican Fine Arts Museum in Chicago. For the most part, their work is sold through Chicana/o or U.S. Latina/o galleries and museums, and acquired by the latter.

All of them, like other Chicana artists, have been asked to curate and/or participate in Days of the Dead exhibitions at mainstream museums. This, however, raises the question of why their work does not appear more regularly in these venues on other occasions. Chicana artists have played a key role in recirculating and redefining indigenous cultural worldviews through Days of the Dead celebrations and creating an art form of the domestic altar tradition. But inviting them to install altars solely on "Hispanic" occasions runs the risk of folklorizing their contemporary art forms and reinscribing them in the margins of an ostensibly multicultural museum in ethnically prescriptive ways. That art by Chicana women in general, and the work of these powerful artists in particular, remains generally unintegrated in art histories of the United States—even in some recent California art histories— owes as much to the ongoing absence of Chicana/o art curricula and artists within departments of art history and university-produced art journals as to a general, ongoing neglect within the mainstream professional art world of museums, galleries, and related publications. As Carol Duncan observed in her feminist study of major public art museums in the United States, Europe, and Australia, "For many, the entire art world— its art schools, critics, dealers, and especially its summit museum spaces—has seemed organized to maintain a universe precisely structured to negate the very existence of all but white males (and a few token 'exceptions')" (1995, 128).

Art by most Chicana artists, like that of most Chicano men, apparently continues to represent cultural, and therefore intellectual, challenges to Eurocentric canons regarding appropriate or interesting formal and thematic concerns. Part of the solution lies in the in-depth

study of Chicana/o art in art history departments and art publications. Another part lies in abandoning facile and unlearned generalizations about Chicana/o art's essentially politically activist nature, such that if you have seen one piece, you have seen them all. Art by Chicana artists, like all vital art meant to do more than decorate the homes or line the vaults of the wealthy, engages issues having to do with our lived reality and the reexamination of our belief systems. The generalization that Chicana/o art is mainly activist or ethnically parochial is as uninformed and dull as saying that German expressionist, French Surrealist, or Mexican Muralist artists were "merely" political or culturally solipsistic.

The National Association of Latino Arts and Culture (NALAC) report on the status of Latino arts and cultural organizations in the United States found that "despite the emergence of several thousand Latino art and culture organizations from 1965 to 1995, most have folded" (1996, xx). It also found that demographics had everything to do with where Latina/o arts and cultural organizations existed—and were funded, such that "sizable populations have made it easier to advocate for Latino art and culture." However, even where "La Raza constitutes a quarter or more of the population . . . there has not been strong support for Chicano/Latino art and culture institutions" (100). Cynthia Orozco, the researcher of the Southwest section of the national report, pointedly observes in an updated version of her portion of the NALAC report that

> Arts and media groups receive public funds to which all taxpayers contribute, among them Chicanos and Latinos, whether immigrants or U.S. citizens. But financial support of art and culture has historically gone to Eurocentric institutions controlled and dominated by European Americans. . . . These larger, white institutions are favored over those controlled by people of color. Latino institutions do not receive equitable funding. (1998, 103)

What indeed does writing on the social body mean if art by most Chicanas, like the artists whose work I study here, is institutionally marginalized at every level of the mainstream art and academic worlds,

effectively barred by racialized and gendered misunderstandings? The gravity of the question is only compounded by the significant funding inequities experienced by local Chicana/o and Latina/o art venues that have almost exclusively supported their work to date. Like Cervántez's self-portrait in facial tattoo, against its general social invisibility, Chicana art like that studied here captures national art histories and identities in a moment of their natural transformations, and in so doing, it contributes to a greater alignment of U.S. culture's "face and soul," a subject to which we will return in the final chapter. But first, let us look closely at altar-based art forms and more deeply at the concept of offering or *ofrenda* in Chicana art.

chapter three

Altar, Alter

The question is whether our eyes can ever be
made to touch the Other again.

—Kevin Robins, *Into the Image:*
Culture and Politics in the Field of Vision

On the Altars of Alterity

Contemporary altar art can be traced back to ancient, cross-cultural
traditions of altar building; even more relevantly here, that of Chi-
canas can be traced to the multiethnic reality and cultural hybridity
of the earliest colonial encounters in the Americas.[1] As a form of do-
mestic religious practice outside the domain of dominant religiosities,
the altar has been a site for the socially and culturally "alter," or other,
to express, preserve, and transmit cultural and gender-based religious
and political differences.[2] It is no wonder then that altar installation
has become a widespread art form in the last three decades (Turner
1999), or that it has been described as a particularly apt late-twentieth-
century art form capturing the "altar-like reality" of the multiethnic,

postmodern, urban cultural world of the United States (Olalquiaga 1992, 42). Altar-installations and altar-inspired art inescapably reference the altar's timeless and cross-cultural spiritual function, whether to sacralize the profane; to interrogate the spiritual claims and political effects of dominant religious beliefs; to figure the imbrication of the artistic, the spiritual, and the political; or, finally, to articulate presently meaningful, hybrid forms of spirituality and spiritually conscious art making. A reading of the function of the altar and religious discourse in Amalia Mesa-Bains's installations, for example, as "replac[ing] the transcendental with the political,"[3] misses the very point of a "politicizing spirituality" that the pioneering altar-installation artist has theorized and enacted through her installations.[4] That altar-installation and related art forms have inspired Chicana artists can be more precisely connected to the search for, and expression of, alternative spiritualities and alternative art practices, particularly those that are visionary with respect to social justice and transformation.

Latina/o theologians, scholars of feminist spiritualities and practices, queer spiritualities writers, and religion journalists have observed the relation between the various civil rights struggles beginning in the 1960s and the changing, and even new, forms of spirituality that have emerged.[5] For Chicana/o and other artists, spirituality, politics, and art have been intertwined in the radical rethinking and cultural restructuring of the past forty years.[6] The concern with the spiritual in Chicana/o and Latina/o art is surely connected to "resistance and affirmation" of Mexican American and indigenous cultural differences, wherever these may be relevant to the artist, but not all forms of spirituality referred to are culturally native to the artists. Thus, cultural difference functions *both* to signal cultural specificity traditionally received *and* to signal the production of culturally relevant visual "thought" about the increasingly globalized, multiethnic, and economically polarized global cities that Sassen (1998) and others have described. The search for, and creation of, more socially relevant spiritual beliefs and practices have characterized the last four decades in the United States and are thus hardly characteristic of U.S. Latina/o artists alone.[7] What *is* different is

the source of spiritualities cited, the politics of such drawing, and the possible effects of such inscriptions, given the historical and ongoing uneven marginalized social, political, economic, and cultural status of Chicana/os as negatively racialized ethnic minorities.

U.S. Latina/os, along with other groups, are at the forefront of newer, socially relevant, and trendsetting forms of both art making and new religiosities. Gruzinski's (1995) model of religious visual cultural warfare and mutual cultural appropriations in colonial Mexico is, in fact, useful for understanding urban postmodernity, particularly in the study of contemporary Chicana/o cultural practices.[8] Altar- and altar-inspired art forms by the artists whose work is studied in this chapter are constructed in varying degrees through the codes of different, competing, and hybridized visual and religious cultures. Western high art conventions, for example, may be seen as the language through which Chicana/o and Mexican American popular cultural beliefs and practices rooted in Amerindian cultures are rephrased. Alternately, the discourse of Western high art conventions might be interrogated through culturally different conventions of "art," beauty, and value that indigenous, Mexican American, and popular urban or rural classes hold. In perhaps all cases, the spiritualities and political stances expressed in the work reflect the post-1965 search for more meaningful spiritual, artistic, and political practices that continues to this day. Feminist neopagan, goddess spiritualities,[9] Native American beliefs and practices, Mexican American "folk Catholicism,"[10] elements from African diaspora *Santería*, Buddhism, decolonizing ethnic minority discourses, and the critique of the Eurocentrism of mainstream and dominant cultural forms, including those of religion and high art—these are all components of the new kinds of cultural hybridity that appear in Chicana art forms that articulate themselves through the spiritual.

Domestic or "folk" artistic and religious cultures have traditionally been a terrain of female agency for indigenous, mestiza women. Thus, the domestic altar has embodied a space of some religious and gender freedom, as well as creativity, for the socially marginal and oppressed. In this sense, the altar has mediated the social and cultural survival, and

to some degree, the personal empowerment, of the *alter*. Kay Turner (1999) has written extensively on the altar as a site for the visual recording of familial histories and has observed the empowerment domestic *altaristas* (altarmakers) derive from control over these histories (40). Among many of the elderly Mexican and Mexican American subjects whose altars she has studied, she has noted the empowering spiritualities that are expressed through their highly personal, religiously unorthodox altars. The preservation of "herstories" appear repeatedly in Chicana art articulated through religious visual culture, as we have already seen. Though partly articulated through Catholic visual culture, altar-installations, like their domestic counterparts, allow for the unorthodox reshaping, appropriation, or rejection, of Christian, patriarchal beliefs.

To some degree, the gender-conscious, politicized spiritualities enacted in Chicana art are part of the "Latino religious resurgence" that Díaz-Stevens and Stevens-Arroyo (1998) have documented as a movement of religious and social reform, rooted in the Latina/o civil rights struggles of the 1960s. Chicana altar-installations and other related art practices that are structured through Christian visual discourses, such as *caja* or *nicho* work, or *retablos*, can indeed be accurately read as third world inflections upon Eurocentric Christianity that do not fully reject Christianity. Amalia Mesa-Bains's early altar to Saint Theresa of Avila, some of Santa Barraza's neo-*retablo* or votive paintings, and some *santos* (saints) or Virgin of Guadalupe–inspired work could be read in this way. However, in the work of many Chicana artists, including other work by Mesa-Bains and Santa Barraza, spiritual beliefs rooted in indigenous, African diaspora, Buddhist, and/or global pagan feminist thought and practice strain the effort to recuperate them into an all-engulfing, "multicultural," but still Euro-dominant, patriarchal Christianity.

Chicana/o and other U.S. Latina/o intellectuals, in the fields of religion and visual arts, along with U.S. Latina/o artists, are radically redefining our understanding of religious and cultural syncretism or American pluralism beyond what is still a Eurocentric idea that ves-

tiges of the precolonial survive as largely incoherent fragments within the engulfing colonial culture.[11] González-Wippler, for example, speaks of syncretism as the logic and power *of* adherents to *Santería*. To her, Yoruba belief systems allowed the diasporic African communities to carefully screen Christian beliefs, adopting those that seemed compatible. In González-Wippler's view, such refitting and adoption operations are part and parcel of a general human search for meaning. Such a view cautions us against the exotifying tendency to ascribe syncretic processes specifically to Creole cultures, as if syncretism, hybridity, and *mestizaje* do not occur whenever and wherever different cultural currents come into significant contact.

Pérez y Mena defines syncretism through cultural differences that cannot be melded into each other, and his emphasis remains, like González-Wippler's on the cultural simultaneity of Puerto Rican Spiritism, for example, with Christianity. Arturo Lindsay and Gerardo Mosquera, from within the intersecting fields of art and religion, in the anthology *Santería Aesthetics*, argue even more forcefully for the predominance of the African diasporic and indigenous over the culturally European in the U.S. Latina/o and Latin American art practices they survey. Similarly, in the work of the visual and performance artist Celia Herrera Rodríguez, the writer Kathleen Alcalá, and Yreina D. Cervántez, for example, unwittingly Eurocentric notions of hybridity, *mestizaje*, or religious syncretism are seen as lacking or one-sided. What these and similar artistic practices suggest instead is the perdurability of Native American and/or African diasporic religious cultural cores that have selectively absorbed bits and pieces of the Euro-Christian, rather than the other way around.

In this regard, Chicana art practices may not reflect broader Mexican American or U.S. Latina/o perspectives on religiosity and spiritual practice. Most of the works considered here, and they constitute a large body, are well beyond arguing from within Christianity, not only because of its patriarchal bent but more importantly because mainstream Christianity in its views, particularly with respect to gender, sexuality and nature, is found lacking when compared with indigenous, African-

diaspora, Eastern, and European pre-Christian folk or neopagan "animistic," nonhuman centered spiritualities. In varying degrees, the works critique the political ideologies manifested in Christian officialdom as the European and American witch hunts, the expulsion of the Jews from Spain, the Inquisition, the invasion of the Americas, and the ongoing social, economic, and political decimation of Native Americans. At the juncture of discourses of globalization, postcolonialism, poststructuralism, and civil rights, the body of Chicana women's work offers sustained reflections on what is in fact a more complex picture of hybridized spiritualities whose compass navigates *through*, rather than *to*, dominant forms of Christianity. If this artwork can be taken, as Cimino and Lattin see it in *Shopping for Faith: American Religion in the New Millennium* (1998), as a present indicator of things to come on a more massive scale, we can expect to move beyond a shallow third worlding of a still Eurocentric Christianity to a fundamental restructuring of views on gender, sexuality, and nature, for example, that might radically shift what we have come to see as traditional Christianity. Cimino and Lattin predict that present trends toward Christian interdenominationalism and cultural pluralism in the United States will continue. But as Chicana and other Latina/o art suggest, the cultural effects of increased globalization and cultural democracy include both the restructuring of religious beliefs and practices and the birth of hybrid forms.

Altars and Related Art Forms

In a culture where "we find it indescribably embarrassing to mention 'art' and 'spirit' in the same sentence" (Krauss, quoted in Grey 1998, 44), altar and related art forms bring into view the important questions of how our religious beliefs shape and impact our social lives, and the role that art plays in the process. Chicana/o artists transferred the popular, domestic altar into the art-installation and related forms at least as early as 1972, when the Galería de la Raza in San Francisco started organizing altars with community participation around the Days of the Dead.[12] Most, if not all, of the visual artists discussed in this book par-

ticipated in early pioneering Days of the Dead altar-installations and related exhibitions.[13] Some have appeared in mainstream galleries or museums only during such guest installations, as noted in chapter 2. Some, like Amalia Mesa-Bains, have achieved a notable degree of success in both mainstream and Latina/o art worlds, through what has thus far been her signature medium, the altar-installation. There are, in fact, numerous other accomplished artists who have productively worked with the altar and its related forms.[14] I will focus here on a detailed examination of the altar art of a few artists working in the media of altar-installations, *retablo* and canvas paintings, reliquary-based found-object boxes, the "altar-book," film and video, photography, and performance.

The Altars of Amalia Mesa-Bains

Amalia Mesa-Bains's altar-installations are among the earliest and the most sustained explorations of the medium, spanning from 1975 through 1997, in more than thirteen major pieces. In terms of women's art in the United States in general, she is considered among "the artists who first brought the women's altar into public settings for consideration of its history, aesthetic attributes, and political force" (Turner 1999, 73). Her altar-installations have been exhibited widely and have received intellectually rich, scholarly consideration. Tomás Ybarra-Frausto and Mesa-Bains herself have been the foremost theorists of Chicana/o and U.S. Latina/o altar-installation, more recently joined by the art historian Jennifer González.

In "Sanctums of the Spirit—The Altars of Amalia Mesa-Bains," for the exhibition catalog *Grotto of the Virgins* (1987), Ybarra-Frausto described the evolution of the artist's altar-installations in three stages. He saw the initial phase of her work, 1975–80, as "revital[izing] an ancient and ongoing devotional expression" within the larger project of cultural reclamation and identity construction of the early Chicana/o movement, and he noted the theme that would become characteristic of her altar-installation work: historical and psychological excavation (1987, 4,

6). Of the altars produced from 1980 through 1985, he noted that "beyond gender affirmation and validation of Mexican models of female experience, the artist begins cross-cultural investigations of arcane spiritual traditions among women in traditional cultures" (9). Regarding what was then her current work, that of 1986–87, he was again particularly perceptive in observing that "narrative history now becomes a symbolic reflection moving beyond Mexican culture to embrace a cross-cultural assemblage of objects and practices from universal sacred traditions like curanderismo, voodoo, santeria, and shamanism" (9). He noted the canonization of figures like the Mexican screen idol Dolores del Río and the artist Frida Kahlo, paid homage as early as 1977 in Mesa-Bains's altars, into a "personal feminist pantheism of goddesses, saints and virgins" (9).

Celeste Olalquiaga interestingly discussed Mesa-Bains's work and that of other contemporary artists using altar and religious forms as "third-degree kitsch" art, a postmodern form of art that reinvests kitschy and traditional religious signs with new meanings, and that, in drawing on Latina/o cultural objects, contributes to the ongoing transformation of an increasingly globalized visual culture that Latin American immigration to the urban centers of the United States has helped to effect (1992, 52–54). Mesa-Bains, however, carefully distinguishes between kitsch and the ethnically different notions and functions of *rasquachismo*, or *domesticana*, its Chicana counterpart, out of which Chicana altar-installations like her own emerge:

> Kitsch as a material expression is recuperated by artists who stand outside the lived reality of its genesis. Conversely, *rasquachismo* for *Chicano* artists is instrumental from within a shared barrio sensibility. One can say that kitsch is appropriated while *rasquachismo* is acclaimed or affirmed. *Rasquachismo* is consequently an integral world view that serves as a basis for cultural identity and a sociopolitical movement. (1995, 157)

Jennifer González has thoroughly studied Mesa-Bains's corpus of altar-installations, through the second part of her *Venus Envy* trilogy (1995).

She has described the artist's practice as a "'memory theater' or *auto-topography* . . . which includes signs of a female Mexican lineage, intimate possessions and family snapshots" (1996, 385). She observes that Mesa-Bains "does not seek to 'salvage' the past or to claim a place of 'authentic' subjectivity, but to use the signs of a material history to illustrate the intricate and overlapping networks of power that produce any given subject. It is in the tension between these two positions—metaphor and evidence—that her work rests, and so forms a new space in which the ephemeral is made concrete" (410).

The politics of Mesa-Bains's altar work are well described by the artist's own theory of *domesticana rasquache*, the sensibility of feminist Chicana art that reclaims cultural practices in the face of their historic social devaluation in Eurocentric culture and that critiques the patriarchal limitations in Mexican and Mexican American cultures. The idea of *domesticana* emphasizes a gendered aesthetic that has developed in the domestic sphere and that "includes home embellishments, home altar maintenance, healing traditions, and personal feminine style or pose" (1995, 159–60). And, rather than situating its aesthetic of fragmentation and recombination in the postmodern experience, she situates it in an aesthetic of the impoverished and socially disenfranchised specific to Mexican and Mexican American cultures, as a "making do with what's at hand," as Ybarra-Frausto and Goldman have both described it (Ybarra-Frausto 1991b; Goldman 1989). Mesa-Bains clarified that though "making do with what's at hand" is, or was, a historic experience for many Mexican Americans, its conscious use as a style—fragmentation, recombination, accumulation, display, and abundance—by Chicana/o artists is a stance of defiant "resistance and affirmation" of not only the popular but more specifically of the "integral world view" of Mexican American urban and working classes "that provides an oppositional identity" (1995, 157).

Mesa-Bains's altar-installations are not, however, solely cultural practices of ideological resistance to the historic discrimination and oppression of Mexican Americans and an affirmation of their rural and urban cultures. As feminist works, they appropriate and transform the

aesthetic of material accumulation of the domestic altar, yard shrines, and the like into "an aesthetic of accumulation of experience, reference, memory, and transfiguration" (Mesa-Bains 1995, 163). The altar-installations of the artist create a space of critical distance through which to simultaneously reexamine the personal as well as the cultural gendered past of Mexican American women and their female fore-bears, symbolized by the domestic altar. Here the ephemerality and changeability of both the home altar and the art-installation genre figure history itself and cultural practices that are not timeless but rather transformed through such histories. However, it is not an altogether nostalgic perspective, for the losses endured may also be emancipatory with respect to the patriarchal cultures from which Chicanas, in part, descend.

It is from this perspective that I would like to more closely examine Mesa-Bains's table-like altars that appear in her gallery-sized trilogy of installations *Venus Envy*. The artist designates each of the parts of the trilogy as a "chapter," in this way suggesting the discursive character of her artwork as a "writing" constituted within the larger "library" of global history, and effective within it. Thus, the altar in her work is also the desk, where what is offered is a response to the past that inevitably must be a rewriting of it (i.e., though history may repeat itself, histories are never identical). What is transfigured in a profane transubstantiation is an old social text, infused with the spirit of new times, as it is embodied in her work. In this sense, the significance of the vanity table in *Venus Envy Chapter One* (figure 18) and the laboratory/ desk of Sor Juana in *Venus Envy Chapter II* (figure 19) partake of this semiotic oscillation between altar and desk, to which are now added vanity table and laboratory. Sor Juana's desk/laboratory, through a make-do-with-what's-at-hand politics of her own, symbolizes the rejection of what was intended for her as a woman in patriarchal, viceregal New Spain: the vanity table and the decorative practices of painting and costuming oneself in the image of male desire. But the vanity table also functions, in a more positive vein, as a theatrical space that allows for potentially expansive refashionings of identity. Like the religious altar, it is a place

for the care of the self, and for the accumulation of objects imbued with personal meaning. In this sense, it is an altar where reverence for the otherwise devalued, racialized, gendered self, and what is important to the self, is cultivated. The richness of possibilities opened up through the exploration and "excavation" of such cultural substitutions and slippages suggests why Mesa-Bains has worked with the altar form so extensively. With *Venus Envy Chapter III: Cihuatlampa, the Place of the Giant Women*, the artist is perhaps beginning to close her thirty-year study of the altar form and social critique through it, as she has suggested.[15] Here, interestingly, the altar does indeed appear to have disappeared. The only table is the archaeology table, figuring the Foucauldian archaeological search for the genealogies that have shaped her, and the condition of women, in general. The concept of the altar and its twin processes of signifying the presence of the sacred and assuring such presence through sacrifice or homage is dispersed beyond the altar as a specific space symbolizing the divine s/Spirit.

In *Venus Envy Chapter III*, the Earth, indeed the cosmos, is the vanity table/altar. Strewn upon the gallery space recreated as the heavenly "Cihuatlampa, the Place of the Giant Women" are high heels, a perfume garden, vestments, and hand mirror. Women's, or "the feminine's" (i.e., in both male and female) body—like the divine—is the seemingly missing but ubiquitous presence. The trilogy structure of Mesa-Bains's installation series rephrases the traditional Christian threefold altar screen that symbolizes the mystery of the tripartite identity of a masculinized image of God as the Father, the Son, and the Holy Spirit. In this way, the *Venus Envy* trilogy calls attention to the three installations as "altars," and to her three "chapters" as a kind of lectionary, or as a holy book, a sacred script. If this is so, then her three-part *Venus Envy* has been an effort to re-enchant the patriarchal world with an awareness of the sanctity, that is, the intrinsic value of women and so-called feminine energy in both men and women.

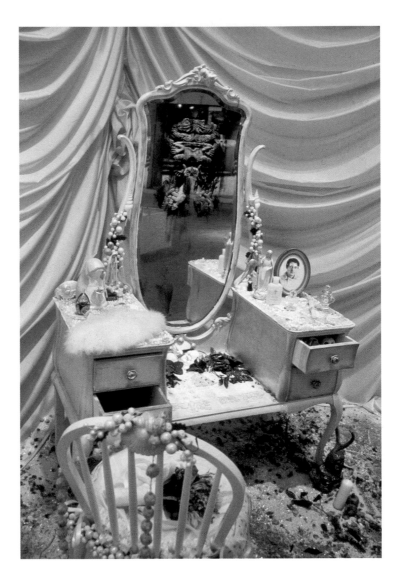

18 Amalia Mesa-Bains, *Venus Envy Chapter One*
(or the First Holy Communion, Moments before
the End), 1993. Installation detail (vanity table).
Collection of the artist.

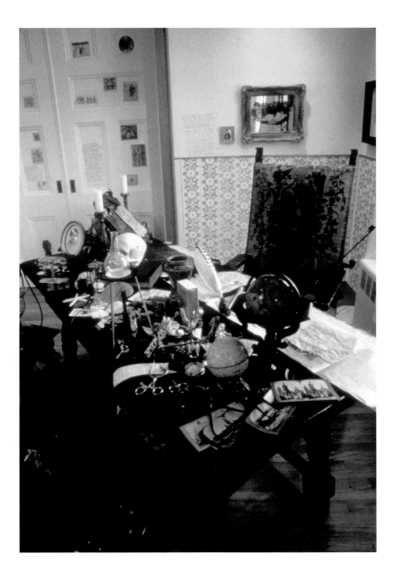

19 Amalia Mesa-Bains, *Venus Envy Chapter II: The Harem and Other Enclosures*, 1994. Installation detail (desk "Sor Juana's Library"). Collection of the Williams College Museum of Art.

What the famed folklore scholar Américo Paredes said of the enabling and community-sustaining psychological and political effects of folklore for stabilizing excluded Mexican American or immigrant communities marginalized and devalorized by Anglo culture, Carmen Lomas Garza has said visually through her early altars, her *monito* paintings, and her *papel picado* (cut paper) work.[16] Her early, highly stylized altar *Don Pedrito Jaramillo* (figure 20) was as much an homage to the Mexican American and the Mexican immigrant communities as it was to the South Texas healer in whom they found solace. This early altar (1976, reconstructed 1991) spoke, as it were, the popular through high art conventions and in so doing suggested the fundamental equivalence of these idioms. The resonance between Ybarra-Frausto's theorization of a Chicana/o art aesthetic of *rasquachismo* and Suzanne Seriff's and José Limón's description of a Mexican American folk aesthetic of "bits and pieces" (1986, 40) bears out a conscious, democratizing cultural politics among Chicana/o artists. In Lomas Garza's case, popular culture-based altars, drawings, and *retablo*-inspired *monito* (i.e., cartoon-like) paintings were neither naïve nor natural choices for a trained artist in the 1970s. They were a conscious political choice for a young artist repeatedly exposed to discrimination against Mexican Americans in South Texas.[17] To combine the visual languages of high and popular arts constituted a de facto critical reappraisal of both, rethinking the former's exclusive claims based on class privilege and reevaluating the aesthetic and historical significance of the so-called folkstyle of self-taught artists.

Some of Lomas Garza's *monito* paintings, of small, doll-like figures, as Ybarra-Frausto has called them, might also be read, like Santa Barraza's work, as growing out of the painted tin tradition of *retablos*, though not only because of their sincere or direct narrative.[18] The ex-voto painting tradition is visually tripartite, containing "a holy image, a graphic rendering of a threatening occurrence or miraculous event, and a text explaining what happened."[19] Pieces like *Curandera* (Faith Healer), *El*

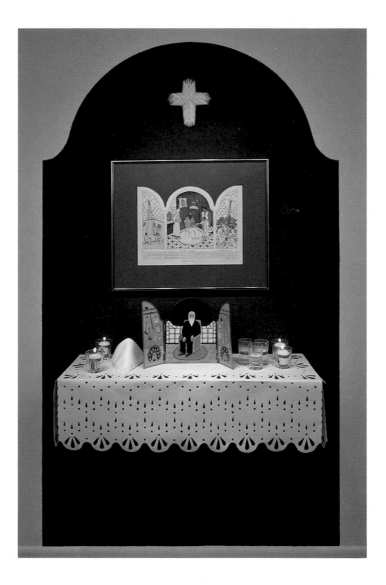

20 Carmen Lomas Garza, *Don Pedrito Jaramillo*, 1976–1991. Oil on copper (triptych) and mixed media. Installation size: 84 h × 42 w × 18 d in. Installation year, 1991. Photography by Wolfgang Dietze. Collection of the artist.

Milagro (The Miracle), and *Barriendo el Susto* (Sweeping Away Fright) (figure 21), with specific themes of healing and miracles, clearly are inspired by the ex-voto painting traditions, as is her oil on copper triptych incorporated into the altar to the South Texas water healer and folk saint Don Pedrito Jaramillo.

Though saints and deities appear, it is the *curandera/o*, the folk healer, and the culture that sustains him or her, that become central in such pieces.[20] In a social sense, the "miracle" attested to is cultural belief and its survival, in the political, rather than anthropological, way that Esperanza Vasquez's 1977 Chicana film *Agueda Martínez: Our People, Our Country* documented the indigenous culture of an elderly, Spanish-speaking healer, weaver, and rancher (Fregoso 1993, 13–14). It is the scene of the familial culture of a Mexican American, rural, Texas childhood appropriately evoked by the faux child-like drawing that is captured in Lomas Garza's *retablo*-style work. This work, as Mesa-Bains has pointed out, is both autobiographical and a chronicle of the Mexican American community of her childhood in Kingsville, Texas (1991a).

In Lomas Garza's paintings, the spiritual is embodied in cultural practice and identity, not, I think, in order to fetishize cultural or ethnic identity as a neoromantic, ultimately separatist impulse but simply to affirm that which is familiar to one, that which already constitutes a particular self, and from whose violent alienation—through racist shaming—pain, loss, and disintegration ensue. In this sense, they are ex-votos testifying to the healing function of art and culture or, in the words of an expression dear to Chicana/o artists, to the truth that *la cultura cura* ("culture cures"). The widespread appeal of Lomas Garza's images among Mexican American and Chicana/o audiences owes to the charm and respect with which she depicts the gentle, supportive, and culturally rich family and community life of traditional, rural Mexican American culture. Idealized and dramatized archetypally as childhood memories can be, her *monito* paintings are nonetheless a balm reminding us of the pleasures of loving familial relations and traditions against the dehumanizing assumptions and projections about Mexican American culture and values.

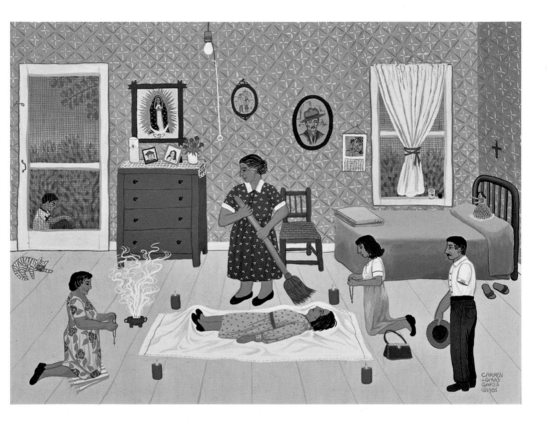

21 Carmen Lomas Garza,
Barriendo el Susto, 1986.
Gouache painting, 14 × 18 in.
Photography by Blair Paltridge.
Collection of the artist.

Santa Contreras Barraza's reworking of the *retablo* throughout the 1990s introduces yet other themes to those discussed, while exploring the meaning of the *retablo* as a *mestiza/o*, or culturally hybrid, art form.[21] As in Lomas Garza's work, religious visual art traditions capture the power of everyday events. In *Untitled*, the safe return of a daughter from a date with a stranger, for example, is implicitly the answered prayer to which the painting bears witness (figure 22). The ex-voto here is powerful, precisely in seeming a hyperbolic medium, for communicating the magnitude of the danger to which girls and young women are vulnerable in sexist culture.

In *Códice II, Homage to My Mother Frances, Códice de Mestizaje, La Cosecha* (The Harvest), *Trinity*, and many other paintings, the artist actively explores the cultural hybridity of the Mexican and Mexican American *retablo* form. She recreates the votive tradition, correctly, as a pre-Columbian legacy as much as a Christian one,[22] by framing her ex-votos through the use of Maya-like glyphs and the Mesoamerican visual conventions of the codex.[23] Her work does not imitate codices but rather explores their logic and contemporary potential.[24] The glyphs she incorporates into her *retablos* and their arrangement would be unfamiliar to most viewers; however, it is clear that the artist has restyled traditional Maya and Aztec glyphs into new glyphs of her own. The *retablo* form, with its convention of image and written text, is reinterpreted as well by Barraza as a contemporary pictographic form where the glyphs function as the writing. Similarly, the pantheon of deities comes to include most frequently the Nahua goddess of the maguey, Mayahuel, representing fertility and regeneration, sometimes in indigenous form and sometimes as a composite with the Virgin of Guadalupe, a figure that for Barraza represents the Native Indigenous as the Náhuatl-speaking Mexican Mary, and thus also represents the earth and its fertility (Barraza 2006).

Works like those listed above express hybrid spiritualities through the culturally hybrid media of the *retablo* as a specifically religious art

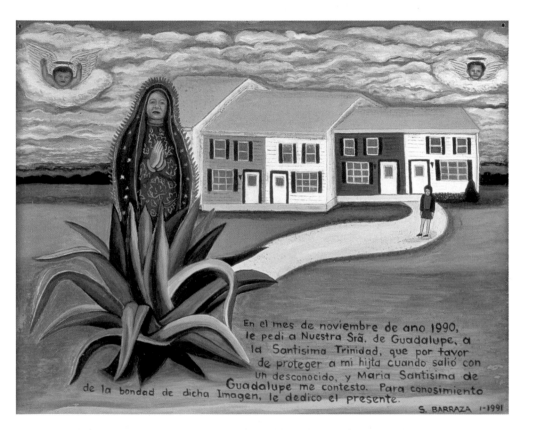

En el mes de noviembre de ano 1990,
le pedi a Nuestra Srã. de Guadalupe, a
la Santisima Trinidad, que por favor
de proteger a mi hijta cuando salió con
un desconocido, y Maria Santisima de
Guadalupe me contesto. Para conosimiento
de la bondad de dicha Imagen, le dedico el presente.

S. BARRAZA 1-1991

22 Santa Contreras Barraza, *Untitled, ex-voto retablo*, 1991. Enamel and oil on metal, 10 × 8 in. Collection of the artist.

form. *Trinity* (1993), for example, refigures the cross, the Virgin, and the Christian trinity in feminist and Indigenous terms, surrounded by symbols of rebirth and fertility in nature (figure 23). Although the *mestiza* women appear in Western guise, as contemporary women, and as the Guadalupe, they are three in one, as the barely visible hands of an outstretched body behind them suggests. God, the Indian mother, dressed as Guadalupe, emerges from a cactus. Juxtaposed on her chest are the symbols of two cultures for the spirit or immortal soul. In Nahua culture, the heart, in particular, is said to be where the soul resides (Furst 1995, 20), and the dove in Christian iconography represents the Holy Ghost, or the Spirit. In *Códice de Mestizaje*, another composite of the Virgin of Guadalupe and the goddess of the maguey is rendered as the Blessed Mother, wrapped in a traditional Indigenous shawl, holding her light-skinned infant. In *La Malinche*, it is the historical Malinalli, Cortés's translator, reviled in Mexican nationalist mythology as a traitor, who emerges, goddess-like, from the cactus.[25] Like the Virgin of Guadalupe, La Llorona (the Weeping Woman), Coatlicue (goddess of life and death), and Coyolxauqui (warrior daughter), the Malinche is a key figure in Chicana feminist literary discourse and visual culture as symbol of cultural hybridity, difference, rebellion, and, ultimately, female empowerment (Rebolledo 1995, 49–76). In *La Malinche*, a Madonna-like, nude Indian woman looks down to the level of her heart where a small embryo grows as she is approached by a European man from behind a cactus. Behind her is a tree from which hangs a lynched body, and a figure at its foot, a Klansman in a hooded robe, carrying a crucifix. History repeats itself, the *retablo* seems to say, and we are left to wonder if the miracle is the birth or the survival of Indigenous and *mestizo* cultures symbolized by that child.

Virgen con Corazón y Maguey (figure 79) features a highly stylized maguey (century plant) in mandorla fashion behind the bust of a Virgin clad in Indigenous garments. Her dress bears a Native American "Eye of God" diamond pattern and its fabric the *ollin* glyph of movement, change, and harmony. Superimposed upon her dress is an anatomical heart, like that of *Trinity*. In *El Milagro de Mi Hermana* the image of

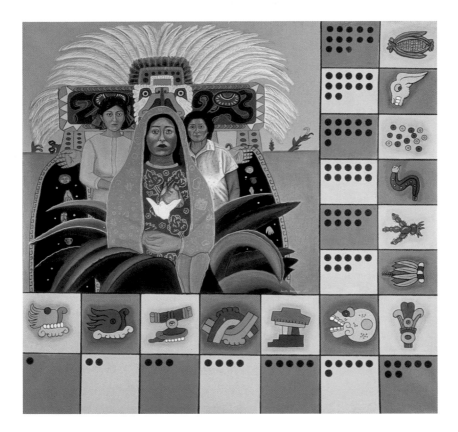

23 Santa Contreras Barraza, *Trinity*, 1993. Acrylic on canvas, 55 × 60 in. Collection of the artist.

a young woman with a scar visible on her chest and a heart emerges from the maguey. In all these votive paintings, the artist bears witness to the historical miracle of the survival of female, Indigenous, and spiritual consciousness, offering, it would seem, her painting as a token of gratitude for those miracles, and as a record of them.

The Found-Object *Cajas* of Patricia Rodríguez

Related to the hybrid material culture of the sacred and altars are *cajas*, box-based assemblages derived from reliquary boxes and altar-like *nichos*, or niches, that Patricia Rodríguez has elaborated since 1980 from found objects whose history she seeks to incorporate. At the time working in very large scale with the Latina muralist collective Mujeres Muralistas (Women Muralists) in San Francisco, Rodríguez was asked to produce some work for a gallery show and cast about collecting items for found-object assemblages.[26] The reliquary has been a theme of these boxes in satiric pieces like *Rock Machismo/Rasquachismo* and *Reliquary*. In *Reliquary*, for example, chicken bones, like the relics of a saint, mark the sacred in the natural world. *The Sewing Box* (figure 24), one of her best-known pieces, brings an altar-like quality to the little everyday things of which many women's experiences are made. The artist described it as a love piece that came into her hands—a man had built the box for his wife—that she in turn made into a love piece about women.[27] Its different drawers contain various objects that figure a range of gendered experiences. Heartbreak is symbolized through a heart-shaped cushion and pins; maternity through a baby doll hand. A wishbone, the broken stem of a wine glass, knives, and razor blades suggest desire and violence. Two surprise drawers, as Rodríguez described them, function as a "reality check." One features soldiers, suggesting cultures of war, and the other frogs that stand in for fantasies of being rescued by a prince. *Rosita*, built from a medicine chest from a Victorian-style house in San Francisco, was carved in prison for a sweetheart, with her name engraved in the box. It was purchased by the artist

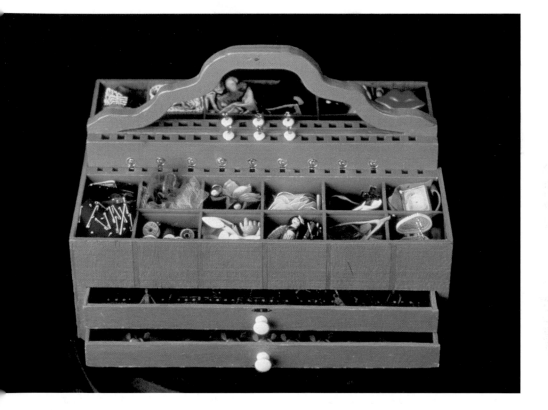

24 Patricia Rodríguez, *The Sewing Box*, 1996.
Mixed media, 24 × 18 × 16 in. Collection of
the artist.

from the man's brother at a flea market and turned into a meditation on impossible love.

Though many of Patricia Rodríguez's *cajas* explicitly engage religious or spiritual themes, the reliquary-like construction of some of her boxes functions at times ironically, as in *Rock Machismo/Rasquachismo*. The triptych structure of the open box reveals a symmetrical, altar-like structure upon whose base are glued bullet casings, while porcelain doll body parts hanging from the top of the box suggest that it is the machismo or patriarchal culture of the Catholic Church that is in poor taste, or *rasquache*. Betty LaDuke quotes the artist as saying that her works are "a vehicle where spiritual messages are expressed. Each construction has its own self-consciousness that is both a personal, spiritual, and a socio-political statement" (1992, 102). In my interview with the artist, she observed of her *cajas* that "all of them have an altar effect." The artist has created an ongoing (since 1980) self-portrait in *caja* form.[28] In the next chapter I will examine more closely some of Rodríguez's recent *cajas* that function as metaphors of the self and the land, particularly through the intersections of the sacred and the political.

The Altar as Sacrificial Slab
in the Paintings of Patssi Valdez

Along with performance art, paper fashions, photography, photo-collage, and actual altar-installations, Patssi Valdez has produced a number of paintings of altars that, in bringing the viewer directly into the representational space of the altar, seem to function as altars themselves (e.g., *The Dressing Table*, *Forbidden Fruit*, *The Altar*, and *Homage to the Dead*).[29] *The Dressing Table*, *The Daisy Queen*, and *Virgin on Orange Table*, like Mesa-Bains's altars, show the ordinary side- or vanity-table doubling as domestic altars through the juxtaposition of recognizable holy objects, votive candles, and personal items such as jewelry, perfume, photographs, or party mementos. Valdez has also painted a number of Christian Virgins and imaginary goddesses in the tradition

of religious paintings, though like most of her work, they are hardly conventional Christian images. It is Valdez's images of kitchen and living room tables, however, that most powerfully bring to my mind the darker aspect of the altar as a site of sacrifice, and of the self as such sacrifice.[30] *The Watermelon*, for example, represents the fruit as a wounded body, its streaming juice slowly staining the tablecloth upon which it sits.[31] A curtain on the left, the skewed perspective of the room, and the skirt-like movement of the tablecloth create the unsettling effect that one has peeked in on a domestic scene of repressed sexual violence. Pieces like *Café, The Crying Table*, and *Volcanic Sunday* reinforce the association of psychological and physical violence, sexuality, and anger associated with the table in Valdez's paintings of the mid-1980s through the mid-1990s.

In painting after painting in the mid-1990s, a sense of pain in the domestic space irrepressibly bleeds out through rooms awash in a blood-red or orange-red palette, unexpectedly covering walls, floors, tablecloths, dishes, and utensils. The sensation of danger and anger is explicit, in the recurrence of impossibly pointed forks and knives, and sharply cracked surfaces.[32] These enigmatic scenarios of domestic order and safety gone awry seem to function as a metaphor of the violenced female body and psyche.

In several paintings, the simultaneous absence and presence of the unacknowledged is rendered through the uncanny. Chairs and brooms fly, umbrellas walk, sheets escape from drawers, and the energy of unseen forces within the domestic space pictured are given shape through swirling brushstrokes evoking sweeping movement and carefully delineated, luminous lines of color. In *House of Spirits*, haunting is directly the subject. A ghostly shadow is perceived at the foot of the stairs where no visible body reflects it. In *Room with Walking Umbrellas*, the inert figure of a small girl is only half drawn. As such, she captures the telltale paradox of simultaneous obliteration and the haunting trace that violence leaves in its wake. And while human figures in any form rarely populate Valdez's paintings, there are visible traces of their recent or nearby presence, suggested by tables set for meals that appear to have

been interrupted. What is captured instead in these scenarios is the palpable existence of an upsetting or menacing unseen presence. Thus, in several of these paintings, the contents of the set table are shown moving, shaking, or spilling, and anthropomorphic objects are pictured as they mutely speak of what they alone witness.

Most of the work of the second half of the 1990s, like *Tulips* and *Saturday*, however, can no longer be characterized in this way, in terms of their palette, perspective, or stylization. Nor can the tables function as metaphors of the sacrificial altar. *Virgin on Orange Table* seems to capture the grounding of the earlier, teetering tables suggesting violence and sacrifice. Out from an image of a statue of a Virgin spin roots that eventually cover the whole room in a pattern that echoes that of the deities' dress. In *Tulips/Tulipánes*, a vase of beautiful flowers has replaced the statue, and instead of loose, climbing roots, a mosaic pattern reinforced by white tiles covers the table surface. The floor, too, displays an orderly tile pattern. A yellow ribbon unwinds itself from the glass vase but now recalls the mysterious benevolent supernatural energies pictured by Remedios Varo, the Spanish expatriate who lived in Mexico during the era of Frida Kahlo and the Mexican Muralists. Valdez brings the trajectory of the domestic altar through art full circle, uncovering the domestic space as the site of violence and unwitting sacrifice, and, eventually, of the recovery of integrity, well-being, protection, and control.

Modern-Day *Calaveras* and Saints in Barbara Carrasco's Work

Robert Farris Thompson has written of tombs and of charms made from graveyard soil as altar forms among the Kongo and other related African and African diaspora communities because they "occur . . . where worlds end and start" (1993, 22, 48). Barbara Carrasco's sixteen-drawing series *Here Lies/Hear Lies*, shown in a solo exhibition in Los Angeles in April 1988, might be read in a related way, but more hu-

morously, given its inspiration in the *calaveras* cartoons of the Mexican printer José Guadalupe Posada (1852–1913) lambasting political and social folly through animated skeleton figures. In wooden, coffin-shaped frames, Carrasco's portraits of the living as the future dead are meditations, as well as spoofs, as the title of the series suggests, on that which is lasting and that which is ephemeral or only apparent. The drawings are based on questionnaires regarding the objects they would like to be buried with that the artist distributed to the subjects (H. Gamboa 1989). Shifra M. Goldman has written of this series, "We might think that Hieronymous Bosch had returned in modern dress. The same didactic and moralizing sense is at work in Carrasco's miniature figure drawings that represent ethical or unethical types" (1988a). Made during Carrasco's bout with cancer, the series includes images of several Chicana/o artists.[33]

In *Here Lies/Hear Lies Diane Gamboa*, for example, Gamboa is pictured in one of her own exquisitely crafted and perforce disposable paper fashions, the *Snow Queen*, exhibited in 1990 as part of the Chicano Art: Resistance and Affirmation, 1965–1985 exhibition. Gamboa's paper fashions are apt symbols of the ephemeral nature of life, particularly with respect to fashion, glamour, and appearance. *Here Lies/Hear Lies Harry Gamboa, Jr.* pictures the photographer, writer, and multimedia artist more humorously, in straitjacket, as a cool *loco* mindful of his own mortality, with his own shovel, M & M's, paper and pencil, a steaming cup of coffee, and voter's card. Carrasco's own self-portrait, under a placard reading "R.I.P.," features her skeletal face on a heart-shaped pillow, a red-tainted United Farm Workers flag in one hand, and paintbrush in the other, standing in a bucket of red paint. This image recalls her earlier ballpoint drawing, *Self-Portrait in Coffin Form*, reproduced in the Chicano Art: Resistance and Affirmation exhibition catalog, where she drew herself in miniature, within an open coffin.

In her triptych *Modern Day Altar* series (figures 25–27), the coffin as framing device has been replaced by the gray television box. Painting here seems to want to absorb television's power to widely broadcast the social work of three modern-day *Pietá* figures of compassion: César

Chávez, nonviolent organizer of the exploited farmworkers and president of the United Farm Workers Union; Princess Diana, a fundraiser for the poor children of Africa; and Mother Teresa, for her charitable work with the poor in India. Part of the *Imágenes e historias*/Images and Histories: Chicana Altar-Inspired Art (1999–2000) exhibition, curated by Constance Cortez, the three paintings were displayed at the DeSaisset Museum at Santa Clara University as a triptych. Three accompanying text boards were aligned on a perpendicular wall with definitions of "icon" and "archetype." The artist juxtaposed the idea of the icon, "a representation or picture of a sacred Christian personage, itself regarded as sacred," to that of archetype, "an original model or type after which other similar things are patterned; a prototype," to pay tribute to the three advocates of the poor as social work "saints."

Carrasco's lifelong commitment to social justice, particularly through her artistic work in support of the UFW, is in the tradition of spiritual "good works" and brings to the religious tradition of the icon a notion of a lived, politically significant spirituality that explains her pantheon of social activist saints. Carrasco's triptych of modern-day saints acknowledges the everyday lived spirituality of the *pueblo*, the Mexican American/Chicana/o people, and its unofficial saintmaking of beloved and revered advocates, such as Don Pedrito Jaramillo and Juan Soldado, who even in death continue to aid the poor and victims of injustice through their miracles. Carrasco thus not only acknowledges social activists dear to the poor of the world; she also reminds us of the embodied and social nature of spirituality and sanctity. In their work on behalf of the needy, Chávez, Mother Teresa, and Princess Diana lived an exemplary spirituality and politics of care for the defenseless — a tradition to which Chicana/o art in general has continued to adhere, given the ongoing plight of the poorest Mexican American and Mexican immigrant rural and urban laborers, educational inequity, and the criminalization of youth.

Carrasco's representation of the paintings as televisions also acknowledges another of the practices of lived spirituality, the constant recreation of "altars" on everyday surfaces like TV sets and dresser tops with

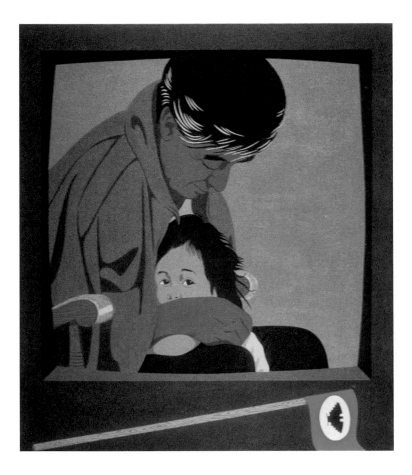

25 Barbara Carrasco, *Modern Day Altar*
series: *César*, 1999. Acrylic on canvas,
24 × 24 in. Collection of the artist.

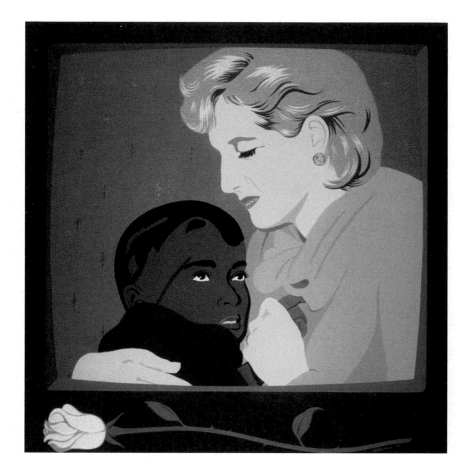

26 Barbara Carrasco, *Modern Day Altar*
series: *Diana*, 1997. Acrylic on canvas,
24 × 24 in. Collection of Rosenda Moore,
California.

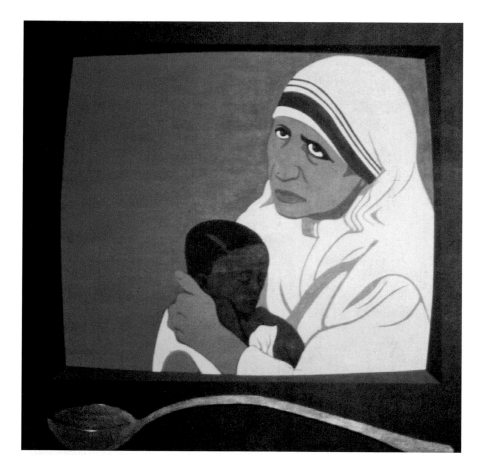

27 Barbara Carrasco, *Modern Day Altar*
series: *Mother Teresa*, 1999. Acrylic
on canvas, 24 × 24 in. Collection of the
artist.

objects like family photos, party mementos, prizes, jewelry, and other objects that are sacred to the family. As in the work of Santa Barraza and Lomas Garza, Carrasco works to popularize and to culturally hybridize art historical and official religious visual languages, thus, like her heroines, offering the fruits of her artistic labors toward the care of the socially belittled and disenfranchised. She and other artists whose work is studied here are a positive response to Alex Grey's critique of the shallowness of fame-driven, short-lived, commodified "hot" new art: "Is art merely the fashionable expression of artist's egos and a reflection of the world they live in, or can art become a healing path that reveals the beauty and holiness of ourselves and our world, projecting an ideal of what we and our wounded world may become? This is not a dogma for new art, merely a call for art to manifest its power to uplift, inspire, and become a flame of spiritual vision" (1998, 67).

The Filmic Altars of Lourdes Portillo, Francés Salomé España, and Rita González

Lourdes Portillo's *La Ofrenda: The Days of the Dead*, a documentary film co-produced with Susana Múñoz and written and directed by Portillo, functions as a cultural *ofrenda*, or offering, much like the temporary altars for the dead on the first and second of November. The filmmaker portrays the belief in, but also a sense of the presence of, the spirits of deceased family and friends for builders of domestic and cemetery altars on both sides of the U.S.-Mexico border. As importantly, she represents altarbuilding, ceremonies, and feasting as an *ofrenda*, to both the living and the dead, a point captured poignantly by a male actor in drag slowly removing his/her merry widow costume and speaking to the camera as s/he proffers a piece of fruit to the filmmaker and viewer. The still image of this moment is reproduced in *The Bronze Screen: Chicana and Chicano Film Culture*, in which Rosa Linda Fregoso discusses the film. She notes how "*La Ofrenda* is a documentary about more than the Day of the Dead," that it is "a film that complicates the production

of fixed meaning, opting instead for contingencies, for the process of making sense . . . not features commonly attributed to documentaries" (1993, 112). Alongside the use of traditional documentary discourse, she writes, "long, lyrical shots of the distinct tempo of the film evoke a non-Western sense of time and space, suggesting that something else is at stake in this film. *La Ofrenda* spatially and temporally re-configures oppositional identities of origin, authenticity, and collectivity" (113–14). Fregoso is insightful as well about the film's evocation of the unsanctioned indeterminacy of gender and sexual identities. In relation to this, she observes, "*La Ofrenda* proposes a 'spiritual' encounter rather than a political engagement with the AIDS problem, in the face of the state's [California's] indifference around the issue. For U.S. Latinos, *La Ofrenda* opens up a space for talking about AIDS and for confronting death through the language of ritual" (118).

The film features, for example, the altar of a gay Latino man, with an image of his deceased lover and other friends who have died of AIDS and AIDS-related complications. What we see in scenes like this, however, is also political, in that domestic altars such as this one function as sites for the reappropriation of religiosity. The altar here is the material effect of the reappropriation of spirituality from heterosexist, patriarchal institutionalized forms of Roman Catholicism and other forms of Christianity that have, with few exceptions, abandoned to the closet homosexuals and queers and women who do not accept that their sexual practices make them sinners. *La Ofrenda* brings depth to understanding the rebirth among Chicana/o artists of the Days of the Dead celebrations and altar-building or *ofrenda* traditions.

Once again, Américo Paredes's lasting observation that the retention of Mexican "folk" practices among Mexican Americans functions to heal social and political ills is relevant. The altar tradition as a site of the memory, invocation, and coexistence with the spirits of our dead becomes particularly meaningful within the context of AIDS, its racialization, and the historic and ongoing, sometimes fatal, discrimination against queers and Latina/os. Altar building and tending allow for a cultivation of memory that in itself is political and that in turn can

generate wider social and political effects.[34] As discussed earlier in this chapter, domestic or altar art is also a social space in which to affirm self-fashioned and culturally received aspects of identity. In figuring the altar in its aspect of offering and as the site of mediation between the material and the spiritual, *La Ofrenda* is an altar-like cultural space where exchange between the socially disembodied—that which is not fully within social discourse, that is, the ethnic "minority" Latina/o, the sexually "queer"—and the larger community occurs. Because Latina/os and the queer, particularly those with little economic, social, or cultural capital, are living specters within the heterosexist social imagination, they end up disproportionately dead as a group, and certainly disproportionately wounded.[35] Under the guise of a documentary merely about a cultural celebration, *La Ofrenda* invokes cultural and sexual alterities as necessary to the maintenance of personal and collective well-being. Such spiritual and healing work is crucial to the political work of social transformation.

More recently, Portillo has produced a prize-winning documentary, *Señorita Extraviada*, honoring the memory of the hundreds of young women of Ciudad Juárez, Mexico, who have been "disappeared" and sexually tortured in murders that continue to the time of this writing.[36] As a work of social justice and human rights advocacy that honors its subjects, the video works against police apathy and complicity that has justified itself in revealing sexist remarks that suggest that the young women, many of them night-shift workers, may have brought their deaths upon themselves by being out late at night to begin with. As a piece of investigative journalism, the video works against the misogynistic pseudo-religious culture that has attempted to shame the poor families into silence by questioning the disappeared daughters' decency. What is instead seen as shameful is the misogyny, cowardice, and corruption of the police and government, and the unspeakable evil against the young, working women of a free international-trade-zone city that preys upon poor working women not only economically but now even sexually unto their death.

In Portillo's earlier *Las madres de la Plaza de Mayo* (The Mothers of

the Plaza de Mayo), the altar as homage is a defiant act of remembrance against the disappearance of suspected leftists and the denial of such by the authorities. Against such feigned historical and cultural amnesia on the part of the military dictatorships that clandestinely snatched and murdered thousands of youths and intellectuals during the 1970s and 1980s in the Southern Cone, Portillo, in a filmic act of solidarity with the protesting mothers of some of these *desaparecidos*, "disappeared," made her investigative film honoring both the murdered youth but also the women turned activists precisely in the name of a protective and defensive, rather than acquiescent, notion of motherhood. In this earlier film and in Portillo's more recent exposé and call for justice, *Señorita Extraviada*, the altar-like function of art becomes salient precisely in its affirmation of the reality of the disembodied and its invocation of their haunting presence to demand social justice for their unholy deaths. The films attempt to rebalance a culture of distorted, violent masculinity gone awry by calling it to accountability before justice and exposing the falsity of its patriarchal claims to protecting the family, the homeland, and females in particular.[37]

Rita González's *St. Francis of Aztlán*, with text by Ramón García (figure 28), appropriates institutional Roman Catholic discourse ironically, both to playfully queer and claim one of its most beloved saints and to interrogate it by its own standards of "brotherly love."[38] In the video, contemporary gay brotherly love is rendered through a play on the life of St. Francis, once a rich and charming hedonist who gave it all up to follow his calling as a servant of divine love, today remembered as a fervent mystic, Church revolutionary, and lover of the poor and animals. González's and García's St. Francis of Aztlán "was a beautiful cha cha boy. He was handsome and superficial. He was an Echo Park party boy" who, called by God to "go find the city of angels/the necropolis in your flesh," is spiritually and politically transformed. He walks the solitary and devastated landscape of urban East Los Angeles and Latino gay culture, in this era of ongoing AIDS and related illness and health service inequities, in the garb of a monk, at the end of the video continuing his ambulations in high heels and blood-smudged lips. In all

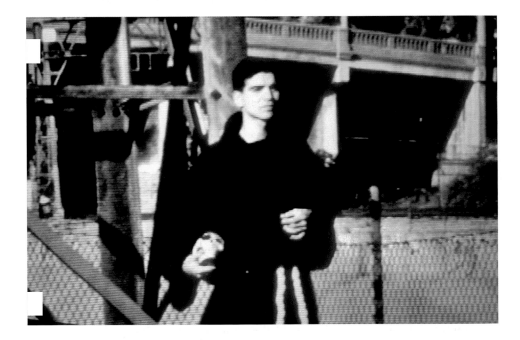

28 Rita González, still image
from *St. Francis of Aztlán*, 1997.
Color video, 18 min. Text by
Ramón García.

of this, "he prayed as he walked. / It had been forgotten that walking is the same thing as praying / when one walks in the midst of death" (González and García 1999).

Through self-consciously kitschy details like blaring the early sixties hit "Angel Baby" while Francis receives the stigmata from very cheesy, visible strings of light, the video makes a show of its poor taste and wickedly ironic religiosity. Yet it nonetheless succeeds in appropriating the language of divine love, service, ecstasy, and marked suffering as elements in an allegory of Latino gay love. To the degree that the video takes the spiritual seriously, it does so, much as Carrasco's and Portillo's work suggests, by seeing it as the interpenetration of earthly and divine love, borne in the flesh of individuals and in society.

Francis of Aztlán's change of spirit from social frivolity to social conscience and social service is visually illustrated by the move from interior space to graffiti-covered, chain-linked, urban public space. It is precisely at a corner with a street sign named after one of the last Mexica-Aztec emperors, murdered by the Spanish colonizers, Montezuma Place, that Francis reverently dons high heels. Like other Chicana/os, the now sanctified Francis wanders as a cultural transvestite—ironically so, because he walks within the racialized wastelands of the ancestral "northern" homelands of the Mexica ("Aztec") ancestors of some Chicana/os, the Aztlán referred to in the title of the piece. Thus, this scene of multiple transvestisms makes explicit the ambiguous zone between sanctity and racialized queerness within the social landscapes in which they are embedded: without tyrants and social intolerance, there would be no martyrs. Only because the former exist is sanctity played out and earned on the earthly plane.[39]

Frances Salomé España's experimental video *Anima* (Soul) is a filmic altar as well.[40] It is a five-minute video, produced by España during 1989 and 1990. Through sound, the flash-like return to a set number of images, and a focused filming of movement, *Anima* conveys a sense of the animation of the natural world and the reality of the presence of the spiritual and of disembodied souls. The video opens with the sound of Native American chanting and the scene of a cemetery. Images of the

swaying grass around tombstones come into view and are enhanced by the swaying motions of the camera. This scene is followed visually by women in half-skeletal Days of the Dead skull face paint who slowly dissolve in ghost-like fashion. The continual use of slow motion dilates time, allowing us to remain with these shimmering images for what seem to be long periods of time, though in reality we see them quickly and repeatedly. Tombstone-like skyscrapers, solid, motionless, and in the distance, come into view, from the level of the swaying grass, as if seen by the spirit of the interred. Images of animated dancing skeletons and shots of blue sky also appear and reappear. The short video ends with the following poem, in hot pink lettering against a black background:

> Anima.
> El Sueño.
> La Danza.
> Shaking hips with
> the inspired Spirits.
> Breathless moods,
> and I surrender
> my face and heart
> to life.
> My redemption,
> in orange
> and blue moves.
> Día de los Muertos 1989

In *Anima*, España successfully visualizes the communion with the spirits of the ancestors and the dead that the Days of the Dead invoke. The video becomes a space for entertaining spiritual consciousness, intuition, dream, and vision. It haunts the viewer with a sensation and, to some degree, an experience of the reality of these states of being. España's sightings of the spiritual in this way are ideologically subversive to the extent that they seem to "document" that presence against

its negation in dominant, materialist intellectual discourses. Her work challenges standard ideologies that reproduce perceived splits between things of the mind, spirit, and body. The consequences of these rationalized and supposedly factual or natural dichotomies are not trivial. The historical idealization by many within dominant forms of Christian discourse of the spiritual and the intellectual against the material world has been gendered and racialized as well, rendering women, people of color, and the natural environment as the bodily other of a spirit- and intellect-identified ideal male. As the political, economic, and cultural colonization of the Americas shows, this kind of discourse has rationalized the exploitation and mistreatment of humans and the natural world as less worthy of the regard, consideration, and political and social "rights of man."

"Altar-Photography": The Work of Christina Fernandez, Kathy Vargas, and Delilah Montoya

The work of contemporary Chicana photographers such as Christina Fernandez, Kathy Vargas, and Delilah Montoya explores the "ghostly aura" that Gilberto Perez, following Barthes, has spoken of as "a quality innate to all photographic images . . . of appearances become apparitions, phantoms of themselves, a sense that these luminous moments rendered on film are in reality soon to evanesce" (G. Perez 1998, 128). If Perez is correct that "the images of still photography . . . don't convey the feeling of hallucinations," that "the film image is the hallucination, the material ghost" (28), then perhaps we should call the chemical and digital photo-based work of these artists filmic. The fact is that even without the advantage of moving images in producing such hallucinogenic effects, such distinctions do not hold for a host of photographic projects. Given the socially acute observation that "with its singular commitment to the rationalization of vision, digital culture has tended to deny or to devalue other uses of the image" and to "facilitat[e] greater detachment and disengagement from the world" (Robins

1996, 162; 13), it is particularly relevant to understand the ways in which Chicana photographers manipulate contemporary technologies to represent that which functions as the ghostly and hallucinogenic in society.

The early work of Christina Fernandez, the youngest of these three photographers, particularly her *Oppression* series and *Sin Cool* series of reverse negative photographs, perhaps most clearly explores the idea of presence as an accumulation of losses, a brilliant project, given the description of film culture as an "index" or sign of the absence of the photographed (Barthes 1981). The untitled piece featuring the back of a woman repeatedly incised (figure 29), as well as the ghostly and bound forms of other untitled pieces in the *Oppression* series, evokes the idea of sacrifice through social violence or disappearance. The idea of the photographic altar is more explicitly explored in her *Sin Cool* series, however.[41] *Christina: Self-Portrait*, for example, is a photograph of the artist sitting on the floor with her nude back, bearing the names of female ancestors, facing the camera. Her face is visible only as a reflection, through a mirror she holds up, and she is surrounded by lit votive candles. In *Enchanted*, a circle of lit votive candles rests before two glowing feet. In *Fiery Path* and *Bleed I*, a female body assumes Christ-like poses.

This work seeks to perceive the ghostly as social and historical aura but also as the life of the mind, emotional being, and spiritual consciousness. Like the French artist Christian Boltanski, Fernandez is concerned to evoke a portrait of being in history that commemorates the losses and references the absences that also constitute us as individuals and societies. To do this, she makes use of a visual religious discourse, as Boltanski does, but also that of irreality, particularly through the use of negative images that are color-reversed and that represent embodiment negatively, as disembodiment, as an absence signified by darkness, and, conversely, the surrounding space of emptiness as light and presence.

The socially invisible that is thus made to appear in her suggestive work is primarily the body of a woman of color. Sometimes it is her own body that models this social being, not as an illustration of the West's intellectual adventures (in publications such as *National Geographic*),

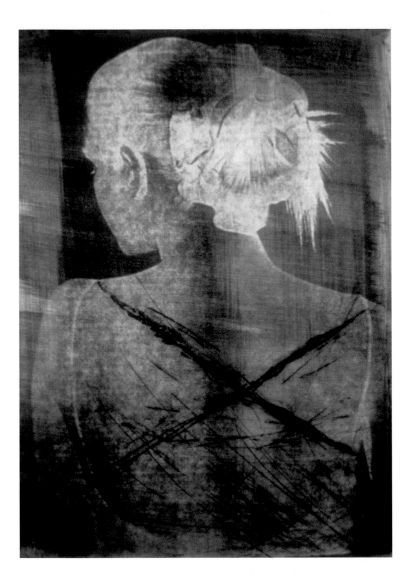

29 Christina Fernandez, *Untitled* (Woman's Back), from *Oppression* series, 1989. Intaglio, gelatin silver print on rag paper, 11 × 9 in. Private collection.

nor as the empathetic but misguided picturing of the ethnic "minority" subject as abject, which so characterizes the dehumanizing effects of politically progressive photography from its inception to the present. Fernandez, like España, concerns herself with the creation of a photographic language that captures the complexity, humanity, and cultural difference of the bodies—and most of these are female—she represents. The experience of oppression, in her *Oppression* series, is effectively rendered through the reverse negative process and its erasure of fine details such as facial features. Subjectivity is inevitably blurred through the process, and the experience of selfhood is marked by violent inscription, which the artist communicates literally (i.e., intaglio), or, in one image, as the gagged, blinded, and bound figure is approached by a menacing, cloaked figure (figure 30).

In *Cuidado Amada*, the haunting text of gendered violence is written through strong contrasts of light and color, as in the reverse negative, to convey the drama and danger of the sexualized and headless female form in motion. Framed in broken shards of glass, the life-size figure holds in her outstretched hands liquid that spills out, and down, against her form. *Fiery Path*, in the *Sin Cool* series, crops the now nude, moving female body even more, picturing it from below the breasts. There is something iconic, religious about these images that is more explicit in *Bleed I, Enchanted*, and *Christina: Self-Portrait*.

Fernandez's late-1990s series, *Bend* and *Ruin*, explore the historical and the art historical. Images of well-known archaeological ruins in Oaxaca, Mexico, predominate in these series and contextualize the "portrait/self-portrait" images that appear. In *Ruin*, the image-as-information (rather than representation) that characterizes digitized media, and the beautiful and contrived aging effect of the sepia coloration of the prints, figure the ambiguity of presence (as absence and presence) but, alongside this, the uncertainty and contrivance of Eurocentric anthropological and art historical discourses. Photography and digitalization are carefully exploited to produce the effect of haunting, of suggesting that not all is as it appears, that what is not yet visible calls for our reckoning, as Avery Gordon (1997) has observed, before it will be laid to rest.[42]

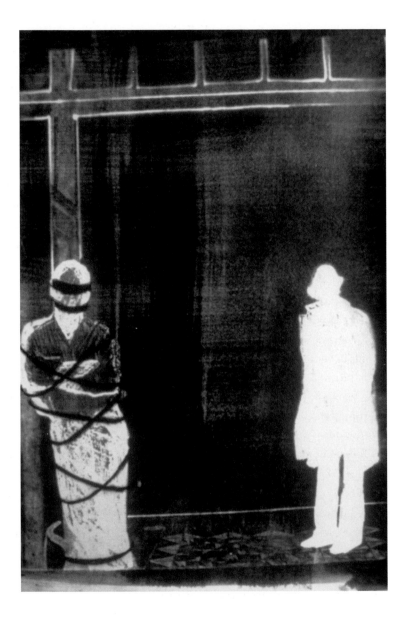

30 Christina Fernandez, *Untitled* (Man
Tied Up), from *Oppression* series, 1989.
Intaglio, gelatin silver print on rag paper,
11 × 9 in. Private collection.

Kathy Vargas's and Delilah Montoya's work in the 1990s, like Fernandez's, expands culturally overdetermined vision to include seeing, and thereby dwelling, with the visually and culturally absent, that is, with the socially invisible, as well as with the physically deceased. Delilah Montoya's photography-based work has long been concerned with the exploration and depiction of Chicana/o or New Mexican *Hispano* spiritualities in photographic portraiture that involves installation, in the codex/art book, in what she has termed the "photo-mural/altar," and in serigraphs that involve digitized imagery. Montoya's *El Sagrado Corazón* series (1994) of collotype portraits of Albuquerque's Chicana/o community brings to visibility the marginalized in society in art, as a collaboration with the portrait sitters and graffiti artists. By organizing the series around the contemporary meaning of the symbol of the Sacred Heart, Montoya suggests that the diverse community members she photographs constitute the heart of the Chicana/o community, and also that they produce new meanings in Sacred Heart imagery that historically draws on both pre-Columbian notions of the heart as an important dwelling place of spirit and the post-fifteenth-century hybridization of indigenous meanings with the Christian European cult of the Sacred Heart.[43] The Sacred Heart in this work becomes a symbol of a culturally hybrid form of spirituality that is characteristic of the Chicana/o community of Albuquerque and that functions as a symbol of that community's unique and complex cultural and religious history (figure 31).

Se Abre el Mundo/The World Opens Up #2, an ektacolor photocollage that appeared in the Chicano Art: Resistance and Affirmation exhibition, captured the experience of visually and spiritually heightened awareness that characterizes one aspect of communion with nature. In *Saints & Sinners*, a mixed-media, photography-based installation, Montoya explored the juxtapositions between sacrificial offerings of the ongoing all-male Christian tradition of the religious *penitente* brotherhoods that, in New Mexico, trace back to the sixteenth century, and which are, in some ways, tragically echoed in the brotherhoods of today's poor, sacrificed by barrio drug use.[44] The artist's late-1990s

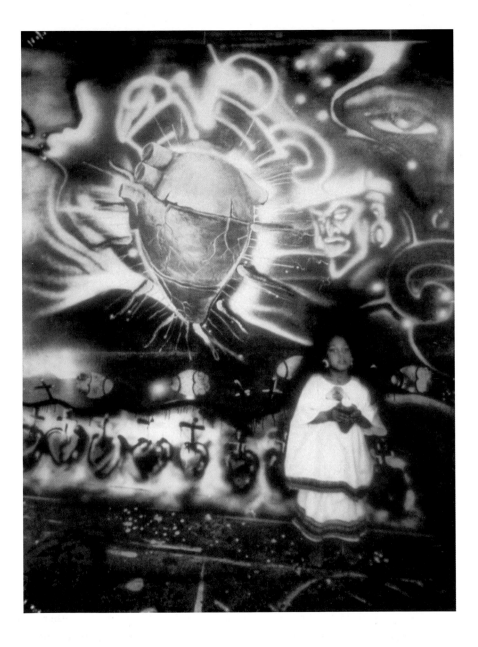

31 Delilah Montoya, *Teyolia*, 1993.
Collotype photography, 8 × 10 in.
Collection of the artist.

photography-based altar work around Chicano *pintos*, or prison inmates, has continued to investigate the relationship between social invisibility and social sacrifice. Montoya has worked with variations of the photo-based image of a handcuffed and tattooed inmate's back in altar-installations and prints. In *La Guadalupana* (figure 32), for example, the artist created a giant (14 × 10 foot) photomural that places the viewer at the level of the inmate's shackled hands. Invited to create an installation involving the Guadalupe at the Musée Puech Denys at Rodez, France, the artist decided "to present them with the Chicano vernacular of the Virgin. . . . The intention was to bring back an image of colonialism's dark side to Europe, but ultimately the piece engulfed the sacred and profane" (Montoya 2000). The clear visibility of the texture of the photographed man's skin, and the tattoo of the Virgin of Guadalupe on his back, powerfully convey the presence, humanity, vulnerability—and spiritual consciousness—of the prisoner. As an altar, and titled in the feminine (i.e., not *El Guadalupano*), it suggests that the prisoner has become a living altar, because he bears a sacred image on his flesh, and because his life is sacrificed for social redemption. Such thoughts work to move us beyond both liberal idealizations and an unrelenting punitive will to greater compassion and identification with the ultimate humanity and inherent sacred worth of the incarcerated *pinto*, otherwise seen as refuse.

Kathy Vargas's photography-based art work dates to the 1970s. Like Montoya and, more recently, Fernandez, Vargas, who lives in San Antonio, is highly regarded as an artist. Like Fernandez especially, she has concerned herself with capturing interior states of being and spiritual presences that are unseen but felt. What is most striking and characteristic about Vargas's work, however, is its lyrical power. She has thus been successful in producing various photographic series on hearts that convey their spiritual and emotional fullness through multiple layered double exposures, and, in some cases, multi-media installations. In *My Alamo* (1995), Vargas created dream-like collages of text and images to illustrate, in a diary-like narrative, childhood memories of the cultural conflicts symbolized by the Alamo in San Antonio, particularly from

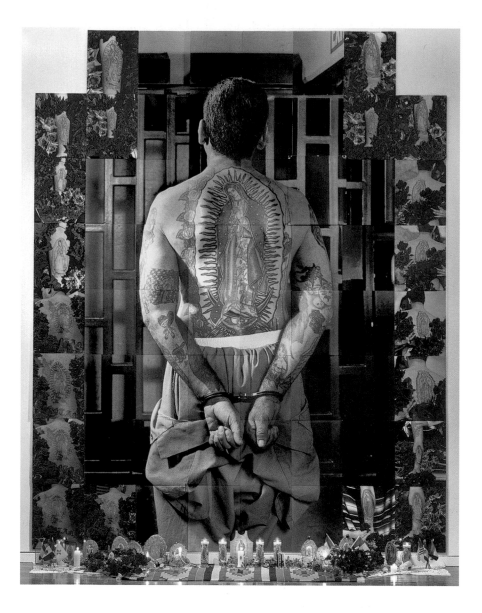

32 Delilah Montoya, *La Guadalupana*, 1998, Photo mural, 14 × 10 ft. Collection of the artist.

her perspective as a Mexican American. In *I Was Little, They Were Big* (1998), she created a series of layered photographic images evoking both her childhood and her deceased parents, in effect giving material form to the memories and feelings about these which continue within the living. It is in the context of this show, and as she herself was emerging from mourning the loss of her mother, that Vargas wrote, "Sometimes it is possible to photograph the missing being."[45]

State of Grace: Angels for the Living / Prayers for the Dead (figure 33) also meditated upon loss and death and the paradoxical life of the past in us through love and memory. A central crucifix-shaped arrangement of separately framed photos on a wall, titled *Broken Column: Mother*, images of a bedridden woman, and x-ray-like photos of her spinal column, were part of the installation. Flanking these, and hung from the ceiling some eight feet from the earth-colored wall, were two huge hand-colored photos, *Angel Denny* and *Angel Oscar*, commemorating two friends who, like her mother, had also recently passed away. The images were visibly created through the layering of butterfly wings and feathers, juxtaposed onto the images of the two deceased friends. Perhaps Vargas was expressing the concept of the undying spiritual force, according to Mexica ("Aztec") thought, lodged in the divinized heart (*yolteotl*) and symbolized by winged creatures, or making reference to that symbolized in Catholic Sacred Heart imagery, or both.

Juanita's Heart (figure 34), from the *Miracle Lives* installation, also of 1997, conveys feelings of love, grief, and yearning, symbolized by the layered heart. Lucy Lippard has written, "Friendship is one of this series's core themes, as it is in her life, and the 'message' might be read as the assurance that everyone has a miracle in their lives of one kind or another, whether it is a relationship, a place, a child, work, art, or even death" (2000a, 25).

In any case, Vargas's work in both installations exquisitely conveys the simultaneity of loss and presence, whether emotional, cultural, or historical. But perhaps as much as this, Vargas's aesthetic materializes the simultaneously intelligent and poetic quality of contemplative consciousness as a vital, if unseen, part of the experience of being.[46]

33 Kathy Vargas, *State of Grace: Angels for the Living / Prayers for the Dead*, 1997. Mixed media installation with photographs.

34 Kathy Vargas, *Miracle Lives:
Juanita's Heart*, 1997. Hand-colored
photograph, 24 × 20 in. Collection of
Juanita Luna Lawhn.

The Altar-Based Installations and
Performance Work of Celia Herrera Rodríguez

Celia Herrera Rodríguez's work, like that of Mesa-Bains and other installation artists, makes use of the gallery or exhibition space itself as an altar, a place of *ofrenda*, or offering, and a meeting place of the seen and unseen, of past and present, spirit and flesh. Rodríguez's performance and installation work calls attention to the sacrificial in the cultural politics of the past and present. In her mixed-media installation *Red Roots/Black Roots/Earth (Tree of Life)* (1999), for example, Rodríguez, who is part Tepehuan Indian, staged the drama of cultural and personal loss behind the forced baptism of Indigenous children akin to that of every Chicana/o disconnected from direct, conscious Native American tradition (figure 35).[47] A willow tree–like structure, resembling an open hand reaching up out of the ground toward the sky, holds an infant-sized black and red bundle. The structure rests on a linoleum floor, in the colors of the Mexican flag. On the floor tiles are written various Christian names. A wooden cross, covered with nails, rests on the floor. It is wrapped in a red cord that leads up and hangs off the willow tree structure. An enclosed space around all these things is created by an open-air, mesh screen pen, silk-screened with the ghostly images of children on all four sides. The pen-like structure recalls the experience of many Native American peoples of being herded into and imprisoned in camps. It is a powerful visual metaphor of the cultural and spiritual experience of Christian Hispanic and Anglo indoctrination.

The pen is, in effect, a graveyard. The bundle, for many Native peoples, a container of sacred objects to be cared for and only reverently exposed, here might recall the image of stillborn death upon a funeral pyre. But for the artist, the bundle is also a marker of "all that is remembered, all that is possible. *Lo que nos ha dejado nuestra madre* [what our Mother has left us]" (C. H. Rodríguez 1999). A braided, blood-red rope like a root connects the nail-covered wooden crucifix to the willow-and-bundle structure. In an artist's statement, Rodríguez expressed these themes in verse:

35 Celia Herrera Rodríguez, *Red Roots / Black Roots /
Earth (Tree of Life)*, 1999. Mixed media installation,
8 × 6 × 6 ft. Collection of the artist.

> Tree of life:
>
> Red Roots / Black roots / earth
>
> What is drawn up from earth
>
> What is brought down from heaven (C. H. Rodríguez 1999:2).

Black rope hangs about the bundle and willow tree, recalling the path of the red and the black inks of the *tlamatinime*, the artists, or sage glyph-makers of Mesoamerica that Anzaldúa, for example, discusses in *Borderlands* (1987). It is the Indigenous children and traditional knowledges that have been partly effaced behind new Christian identities from which they now step. As the ghostly images caught upon the mesh wire screen walls suggest, something is present, though not fully visible. Rodríguez's altar is a memorial altar to the Indigenous on both sides of the American continent. It is also an alter of invocation, of summoning and activating memory of the seemingly disappeared Indigenous within us, beyond the nostalgic U.S. nationalist identity and Mexican *mestizaje* discourses bemoaning or celebrating the Indigenous as dead or past. Instead, Rodríguez helps us to perceive the Indigenous within the everyday as still present.

The *Alter*

In Latin, the *alter* is literally "the other." Otherness has been historically contemplated in words referring to the unfamiliar as the strange(r), the barbarian. In Socratic Greek, as in ancient Nahua, thought and, more recently, the poststructuralist thought of Jacques Derrida and Julia Kristeva, radical otherness was astutely and modestly referred to in concepts such as *khora*.[48] For Plato, it was the unknowable substance and energy from which knowable being emerges by will of the Creator. Post-Enlightenment philosophy, enmeshed as it was within the spoils and labors of imperialist colonial expansion and the rise to global power of particular European nations, conceptualized the non-European other as the irrecuperably different, as the hardly human

and clearly unequal, culturally and ostensibly intellectually inferior to Western European upper-class, educated, and socially powerful males in particular. In European poststructuralist thought from the 1960s to the present, notably that of Derrida, Gilles Deleuze and Felix Guattari, Michel Foucault, Kristeva, and Luce Irigaray, otherness, difference, and alterity have been explored as the salvific with respect to the West's narcissistic and distorting false universalizations, falsely authoritative scientism, and intolerance for difference. Prior to this, the critique of the culturally ethnocentric and empire-building nature of post-Enlightenment Western thought had been the subject of many prominent Latin American intellectuals and artists in the late nineteenth century and the early twentieth, such as José Martí, José Vasconcelos, and the Mexican muralists. An unbroken lineage of such thought continues through the present in the work of Enrique Dussel and Aníbal Quijano. Elsewhere in the world, anti- or post-colonial thinkers rejecting Eurocentric solipsism and Darwinian notions of "race" include Frantz Fanon, Edward Said, V. Y. Mudimbe, Stuart Hall, and Gayatri Spivak. In the United States, W. E. B. Du Bois critiqued the negatively racialized differences of African Americans, while Américo Paredes did the same with respect to Mexican Americans, spear-heading the civil rights movements.[49] Thus the question of who or what the "other" and alterity are depends on who is asking.

Meditation on the ongoing vexing question of what is ultimately a matter of cultural differences of interpretation and tradition is particularly fruitfully approached through altar-based art forms, in their conceptual language of *ofrenda*, memory, invocation, and the idea of sacrifice as developed within Mexican American culture. At the altar, conditions that appear in mutual opposition are mediated. Through altars and related forms, Chicana artists bring to visibility that which is disembodied for reasons of its alterity with respect to dominant cultural norms. They call upon an ancient domestic art to bring to light the enduring and alternative beliefs and practices of those who have historically and unofficially worshipped and communed at altars other than those of the official and the institutionalized. In the Americas of

the last five centuries, those celebrants of other ways of being continue to be marked by gender, sexuality, ethnicity, culture, and other socially weighted differences. Through altar-based art, Chicana artists succeed in reminding us of a different approach to alterity, one that is in fact a perennial and cross-cultural concept, expressed in the Mayan as "You are my other self," *In'Laketch*. The following chapter explores this concern with alterity and the embodiment of spiritual and political effects through the recurring preoccupation in Chicana (and Chicano) art with *tierra*—land and earth.

❦

Tierra, Land

We must name ourselves as liberated free zones.

—Patrisia Gonzales, *The Mud People*

What could seem more solid than the earth and the land we live on, the neighborhoods, the houses we inhabit, our bodies even? And yet our relationship to these does not always give us a sense of being *arraigados*, rooted, that is, of belonging, being at home. The ideas of knowing your place and having a place are tied together and suggest that the personal sense of being at home, whether in society or in your body, whether it is a female, a queer, an immigrant, or a negatively racialized minority body, or a combination of these, is shaped by our sense of belonging socially. This sense of belonging is not untied from our historical relationship to the places in which we dwell. Here too, Chicana/o cultural *mestizaje* is reflected in a split sense of belonging and not, tied to the original formation of Mexican Americans in the mid-nineteenth century, as a result of Mexico's loss of territories to the United States and the attendant increasing and systematic racialized social marginaliza-

[handwritten margin note: sense of belonging socially]

tion, particularly of unmoneyed Mexican nationals who suddenly became U.S. citizens. The militarized and cultivated virulence of Anglo-centric anti-Mexican sentiment served to rationalize both the United States' "Manifest Destiny," at the cost of Mexico's, and the further dispossession of the newly formed, land-owning, Spanish-speaking U.S. citizens through vigilante terror and legal and tax manipulations. Thus, Chicano scholars since the late 1960s have helped elaborate the theory of internal colonialism that the sociologist Robert Blauner and African American intellectuals theorized regarding the subjection of third world and Native populations following an imperialist colonial logic of conquer, subjugate, and segregate. Territorial dispossession and dislocation have been part of the historic Mexican American experience and the different Native American communities of the continent from which the former variously descend. The experience of those whose families have immigrated from Mexico in the last two generations repeats this sense of cultural displacement, sharpened and conditioned by this historic anti-Mexicanism, still rooted for many in the assumption of the inferiority of both the Indians and the Spanish from whom Mexicans originally descended.7[1] But whether descendants of the original Spanish, then Mexican land-owning families in what later became the United States, or the children of immigrants from the first decade of the twentieth century, the twenties, or the fifties, Chicana/o artists and intellectuals lay claim to the American continent alongside full-blooded Native Americans as descendants too of its original inhabitants.[2] This twilight sense of belonging to the Americas as ancestral homelands yet today being socially marginalized, systematically disempowered, and the objects of devaluation within it as Indigenous, negatively racialized people is expressed in the concept of "Aztlán," as is the resistance to racist and undemocratic notions of nationhood, and the dream of respectful and egalitarian coexistence among different peoples, including queer men and women and those who resist patriarchy.[3]

North America was traversed in both directions, north and south, by ancient trade and the inevitable migrations and cultural exchange that such contact created, as in our own time. Mexican migration today is

a continuation of these ancient and humanly natural activities. Viewed through this lens, as some artists enable us to do, racist or cultural intolerance toward poor Mexican Americans and recent Mexican immigrants in particular, expressed in the xenophobic, "Go back where you came from," is particularly ironic, as Yolanda López expressed in a 1978 poster featuring a Mexica ("Aztec") warrior pointedly asking, "Who's the illegal alien, Pilgrim?" But further, in traditional Indigenous worldviews of the American continent, as for many peoples elsewhere, the land of our forebears is literally and symbolically charged with spiritual and cultural significance. As we are learning today the hard way, through the cancerous effects of industrial chemical pollution of land, water, and air, we are made of the very stuff of the natural world around us. Our care of the natural world is eventually reflected back to us within our own flesh. Our historical relationship to certain places is reflected in specific natural landmarks charged with memory as markers of our identity and that of our ancestors and cared for and respected in part as such. Methodical displacement from the lands inhabited by our kin through wars of conquest and relocation to non-ancestral "reservations" has gone hand in hand with economic, social, political, and cultural disenfranchisement. The loss of a physical sense of belonging within a landscape witnessing our families' and peoples' histories, coupled with cultural imperialism that replaces the now-devalued customs and worldviews of a population subjugated by material and ideological weapons, has produced, over time, people torn between the once respected ways of our elders and those of the hostile, dominating culture imposing its claims to superiority. It has produced among some, perhaps many, the fear and discomfort within one's own skin that are the hallmark of the trauma of colonization, reinforced even today in the related aftereffects of everyday racist experiences.

Theories of the "politics of place," that is, the idea of place as an effect of social and political power and as a site of struggle,[4] of "the power of place" in terms of the vitality and spiritual presence of the natural world, and of the historically inscribed built environment,[5] and of social space, particularly urban space, as a reflection of racialized so-

cial, political, and economic orders (Villa 2000), are particularly appropriate for thinking about Indigenous, Mexican American, Chicana/o, and recent Mexican immigrant experiences of geographical and cultural displacement or deterritorialization,[6] and the related issue of "cultural citizenship" (Rosaldo 1994). Thus, for Mexican Americans, the politics of place has been tied historically, first, to the idea that "the border crossed us" literally, in the case of the borderlands-dwelling families divided by the newly imposed border after the U.S.-Mexico War. And second, it is tied to the subordinated, racialized segregation of Mexican Americans into "Mexican towns," neighborhoods, or ghettoes. For most Mexican Americans, the politics of place has translated into historically being "kept in their place," that is, in circumscribed social and geographical locations by vigilante, gang, and police violence, as well as by the ongoing psychological violence of rendering one invisible by lack of social acknowledgment or starkly out of place by cold and disdainful looks. It involves the inadequate and unequal investment of tax dollars made available for public space maintenance and recreational and educational services, yielding unsightly highways, ugly industrial buildings, hidden illegal sweatshops, and toxic waste sites. Without democratic access to quality schools, parks, and after-school programs that provide creative and stimulating alternatives to the scourge of drug cultures preying upon our communities, our poorest youth are patrolled by police and helicopters and negatively racialized as potentially criminal, by virtue of their class and appearance in assumptions rooted in the bankrupt theories of the late-eighteenth- and early-nineteenth-century pseudoscience of phrenology. The politics of place therefore involves for Chicana/o artists and intellectuals exposing and challenging the assumptions associated with the places and social spaces we have dwelt in, sometimes through little choice, in segregated housing and neighborhoods. With respect to women, it involves challenging the racialized assumptions that we belong in border town bordellos, in service as cleaning women, childcare workers, waitresses, hotel chambermaids, farmworkers, factory workers, or exploited sweatshop laborers.

The "power of place" in Dolores Hayden's (1995) and Celia Alvarez Muñoz's (1991) work on the Embassy Project in Los Angeles celebrates the now abandoned labor union building as a site of historical memory of Latina/o presence and leadership decades ago. The power of place also involves telling alternative stories about what our communities were and are like, countering stereotypes and showing what are important, life-sustaining (and thus, "sacred") community centers to us today, as Yreina D. Cervántez has observed, of the *altepetl* (Nahuatl, "water" and "hill," i.e., the social and spiritual heart of the community) of our day and place. She and other Chicana/o artists have endeavored to honor the lifegiving spirit of our culture, for example, in their mural work on the walls of community centers, schools, hospitals, and central thoroughfares in Latina/o neighborhoods.

And, finally, Chicana/os engage the idea of "social space" as the terrain of struggle over culturally different values. The idea of Aztlán here signals the shared landscape of a social imaginary, the shared cultural values of post-sixties Mexican Americans newly and collectively identifying as "Chicana/os," and more broadly, of an alternative way for us all to imagine living together across cultural and ethnic differences. Aztlán is thus the symbol of an imagined, ideal, more democratic nation, which, if once a separatist impetus by which some early Chicana/o activists countered their exclusion by racists with the idea of secession, today marks a grounding politics of geographical, social, and ideological space of inclusion for Mexican Americans and other minoritized population groups, including women and the queer (L. Pérez 1999a).

It was largely the late Gloria Anzaldúa, in *Borderlands/La Frontera: The New Mestiza* (1987), who furthered the idea of Aztlán through her description of the borderlands as psychological, sexual, and spiritual, as well as geopolitical and cultural.[7] She suggested that while rooted in the historical experiences and actual condition of social and economic marginalization of Mexican Americans, the borderlands could also be used as a metaphor to understand the equally real experience of outsiderness and of being pulled in different directions of other socially

or culturally marginalized groups, including, for example, women and sexual minorities within the Chicano "nation" of Aztlán itself, the queer worldwide within dominant heteronormative cultures, and the spiritually minded amid growingly skeptical cultures. Yet even as she discussed the painfulness of the in-betweenness—the "nepantilism"—of the literal and metaphoric borderlands experiences, she also claimed these experiences as rich sources of much-needed democratizing cultural transformation and as part of a healthy process of continual growth and change of the individual and society.

Some of the artists examined in this chapter take up the concepts of homeland and social and cultural belonging by structuring their work through reference to land and territory. Some Chicana feminist art further relates the significance of space and land or *tierra* to the sexed, racialized, and gendered human body as the particular site where exclusions or conditional, normativizing inclusions and, conversely, practices of "disidentification" (J. E. Muñoz 1999) with social orders are played out. Queer Chicana feminist artists in particular have asked what people, land, and ideology we can call home amid the persistence of heteronormative male-centered visions of the nation, the family, and even of the female body and its desires.

Beyond Euro-*mestizajes*: (Re)claiming the Indigenous in Celia Herrera Rodríguez's *What Part Indian Am I?*

In May 1998, Celia Herrera Rodríguez presented an installation and performance at Stanford University before a largely Latino audience. Its title was *La ve p'atras (She Who Looks Back) as Visionary*, the epithet in the first half of the title making reference to colonial Mexico's caste paintings recording the "racial" mixtures of the time. The piece incorporated an installation, *Altar a las Tres Hermanas: Antes de Colón, Colonialism, Después de Colón*, and the performance *What Part Indian Am I?* This two-part work was originally developed for the Institute of American Indian Art Museum in Santa Fe in 1994 and was performed and

altered numerous times. Rodríguez, who is also known for her painting, in particular her watercolor work, as well as her 1970s collaborative work with the San Jose–based artists collective RCAF (Royal Chicano Air Force), describes this work as an evolving investigation that yields different insights into the relations it explores. My observations draw on the performance at Stanford University and on an earlier performance at "Oppositional Wetness," a conference held at the University of California, Berkeley, in the fall of 1997 that explored the relations between sexuality, spirituality, alternative knowledges, and Latina identities.

What Part Indian Am I? engages the interrelated questions of history, the sacred, the politics of space, and discourses of identity. In this performance piece, alterity itself is rethought and explored in both dominant culture stereotypes and associations and those of Chicana/os themselves. The piece, significantly, is portable: performed on a small weaving, it is symbolic of the loss of ancestral homelands and social space and of the consequent loss of uninterrupted Indigenous knowledges. The body itself and its everyday habits, such as eating beans and *chile*, therefore become the mobile country and the embodied memory bank that is, in traditional cultures, accessed through the natural landscape. In the performance and the accompanying installation, the artist pushed boundaries, beyond politics of identities received within both mainstream and progressive minority ideologies, beyond stereotype and romantic idealization, into a space where, instead, we are left reflecting on the historical continuities and changes of the Indigenous in our own time and circumstances—on what "the Indigenous" looks like today.

Altar a las Tres Hermanas (Altar to the Three Sisters), which consisted of a photographic triptych and stacks of canned beans, hominy, and peppers (i.e., the "three sisters") topped with votive candles, functioned partly to establish the sacred space in which the artist chose to contextualize the audience-interactive performance of *What Part Indian Am I?* The three large photographic images of the artist invoked, in attire and action, three different historical and cultural moments, yet still bore

relations of identity to each other: *Before Columbus, Colonialism*, and *After Columbus* (figures 36 a–c).

Carefully sweeping the space, the artist lit the candles and welcomed the audience, laying down the weaving and another cloth on which she sat.

In the performance, the opening invocation to the ancestors was expressed as historical consciousness: the remembering of the history of Indian and *mexicano* peoples in the place where the performance itself was taking place, Stanford University. The artist spoke of a distant past as if it were her own as a laborer on the campus, blurring the line between past and present, self and ancestors, and between art and ritual.

Members of the audience were invited to sit with Rodríguez on what she described as the only space left to claim as her own: the blanket and shawl upon which she now sat. The audience participant was asked to leave something to the ancestors in exchange for a tarot-like personal or historical reading that the artist would make based on the participant's selection of four cards from a deck of photographed body parts, each card corresponding to one or all of the three photographs of before, during, and after Columbus. Though the audience members had been told their offering would not be returned, this announcement and the artist's natural manner seemed to confuse audience members about whether the performance was an actual spiritual ritual. Each of the three audience volunteers deposited something valuable, including a ring and a necklace. No one offered money. The selection of four cards, made after viewing all the cards in the deck, elicited an improvised "reading" which drew on stories of what the Indian elders "used to say," Rodríguez's historical research, and commonsense deductions and intuition about the particular audience member.

The photographic deck of body-part images provided tongue-in-cheek direct responses to the question "What part Indian am I?" The leg, back, arm? But the deck also worked another way, through layered, and sometimes conflicting, associations. The raised arm held in an L-shape (figure 36d), for example, is Indian, the artist explained, if one associates it with the Mexican-Aztec codex illustrations of sacrificial

(a)

(b)

(c)

36 a, b, c, d.

Celia Herrera Rodríguez,

Before Columbus, Colonialism,

After Columbus, 1994–1999.

Three photograph details of

Altar a las Tres Hermanas.

"Arm" detail of photographic deck

of images. *What Part Indian Am*

I? Performance and installation.

Photography by Hulleah J.

Tsinhnahjinnie. Collection of

the artist.

(d)

body parts, or with the Lone Ranger's dumb "Indian" sidekick Tonto's greeting "How?" The deck and its reading ironically literalized the concept of *mestizaje*, or "racial" mixing, to the point of the ludicrous, by raising the question of how exactly the theory is embodied. At the same time, it suggested, as elements of the installation did, that the body carries memory of the ancestral in very specific ways.

Though memory of the ancestors is perhaps carried in the bones and spirit as diverse traditional cultures hold, what Rodríguez traced was far less esoteric: on the one hand, that the Indian body has been coded culturally as a result of the colonial encounter, and on the other, that received traditions, such as continuing to prepare and eat the same staples eaten by our forebears, represent the continuity of that tradition, albeit in different packaging, and albeit without the full stories of what those things represented in all their richness to our forebears—both exemplified by the now-canned vegetables and by the artist herself.

Throughout most of the performance, the artist adopts the same relaxed kneeling position as in her images before, during, and after European contact, literalizing the continuity of appearance and activities, while pointing to the change of meaning within the cultural transformations of different historical epochs. One troubling continuity is suggested in the activities represented: sacrificial purging, participating in Christian prayer, the gendered grinding of corn, and the general posture of subordination. Using her autobiographical self and body as part of her media, the performance artist insistently inserts herself in this lineup, probing the relationship between reality and artistic fiction; past and present; ancestors and self; performance art and religious ritual; the sacred and the mundane. Less pliable to romanticized and sexist nationalist appropriations, the performance and installation of the mixed-race "she who looks back" further suggests that one thing that remains across time and cultures is the flotsam of gendered subordinations. The familiar narrative of gendered colonization that the photographic altar refers to on the most literal level also gives way visually, however, to an affirmation of continuity and survival of the Native American, as figured by the bodily presence of the artist herself, featured in the photo-

graphs as ancestor, anchored in some of the same cultural habits, such as eating the same basic staples, the "three sisters" (corn, beans, and *chiles*).

Rodríguez's powerful insight, which she has spoken of in different venues, and which is also visible in her watercolor explorations of pre-Columbian symbols, is that the sacred and the Indigenous have survived by exploiting the colonialist blindness to the non-Eurocentric, by being hidden, ironically, in the daily activities seemingly dissociated from the Indigenous in Mexican national discourses of *mestizo* identity received by Chicana/os. For the artist, whose performance and installation are based on years of historical research into the history of the native peoples of Northern Mexico and the U.S. Southwest from which her Tepehuan ancestors came, the discourses of *mestizaje* and hybridity are one more effect of ongoing internalized colonialism in Chicana/o and Mexican peoples if they serve to erase our Indigenous identities. If in the United States the domination and displacement of Indians is aided by the myth of total decimation that whitewashes actual widespread "miscegenation" in Mexico and other parts of Latin America, mixture and assimilation have been idealized in Hispano-centric discourses of *mestizaje* and *mulataje* that have failed to account for racialized segregation and marginalization of Indigenous, African-diasporic, and even Asian populations.[8]

Rodríguez's simple yet stunning observation—that there is coherent continuity of the indigenous in mundane practices inherited from ancestors—and her historical search for the traces of her own particular Native American ancestors lead her, for example, to place a nail surrounded by four grains of corn upon her altar during the performance. The nail, she explains, is sacred to her because it may have been made by one of her ancestors, relations, or neighbors in the mines of Durango, Mexico, where native peoples were virtually enslaved, forced to extract ore and other minerals in order to provide the raw material for the fabrication of such things as nails, which in turn helped make possible the material foundations of modernity and the present. Rodríguez's practice of cultivating consciousness of our personal interrelat-

edness to other human beings through even the most quotidian objects around us, and their embeddedness in history, strikingly evokes the similarly profound Buddhist practice of mindfulness. In both cases, what is sought is a sense of interrelatedness of self and others that heals either psychic and cultural fragmentation or the related problem of seeing the world in terms of essential and irreconcilable differences, as "us and them" or "I and it," that are unrelated and thus, supposedly, less worthy and less sensitive to depredation and abuse.

Celia Herrera Rodríguez's performance is in fact a performance of an Indigenous consciousness, both in that she is conscious of her own Indigenousness and in that she represents the present as one of co-existing Indigenous alterities (i.e., with respect to dominant and mainstream cultures), even if these have been rendered unrecognizable as such through the discourses of *mestizaje* or hybridity. In her work, discourses of *mestizaje* are reread as the coexistence of cultural differences; these differences are revealed to be as, or more, significant than their synthesis or notion of syncretism, in which the Indigenous, for example, is supposedly fragmented beyond meaningfulness.

Like the tarot deck, the artist's deck speaks of the participant both because of what s/he is drawn to select—what images most attract that individual—and through the artist's commonsense deductions and intuition with respect to that person's choices. The performance artist now is an interpreter of signs, a *tlamatini* ultimately facilitating self-knowledge and the integration of self. In this way, like the tarot's art of interpretation, the performance stages itself as a healing ritual, a cultural hybrid of traditional Indigenous ritual and a present-day art form, with specific attention to the wounds of colonization, neocolonization, and racism for both native and dominant culture participants.

This performance of Indianness brings to mind two other well-known Native American artists, Jimmie Durham and James Luna. Durham's work has ironically enacted or illustrated dominant culture stereotypes about Indians, while subverting, in its mundaneness, the performance of these Euroamerican projections. His work frustrates expectations of the Indian as inherently in tune with nature and the

supernatural. It optimally confronts the art world spectator with the absurdity of projected stereotypes about the Indian and destabilizes a more general, underlying passivity and consumer mentality in the public. James Luna has debunked commonplaces about the Indian through a deadpan exploration of what their literal enactment yields. Thus, Luna has played the dead Indian, displaying himself in a glass case, as animals are displayed in natural history museums. His work may trouble some in the dominant culture art world because he draws a parallel between the natural history museum's treatment of animals and the art museum's treatment of the body of Native Americans, or the "body" of their artwork. The only Indian around here, his work suggests, always seems to be a dead one. Celia Herrera Rodríguez shares some of these strategies of destabilizing present cultural platitudes and certainties, particularly as these relate to the myth of the disappearing Indian and lost Indian ways. But her work is perhaps less about dispelling romantic and otherwise unreal cultural and visual images of Indianness than it is about countering the myth, widespread among Chicana/os, other U.S. Latina/os, and Latin Americans, that the native self has disappeared within the *mestizo*, and about claiming for Chicana/o culture a literal, not just ideological, identification with the Native American.

Rodríguez, it seems, is after the decolonizing effects of a shift in the discourse from nostalgia for lost national origins to the recognition of the persistence of the Indigenous in everyday being, habits, and material culture. In her performance, one's relations, and thus one's history and identity, achieve some sense of balance amid the recognition of the ubiquity of native cultural and ancestral presence within the mundane routines, foods, and beliefs of the post-Columbus present. Rather than unwittingly reinscribing an essentialist identity politics, Rodríguez's practical and healing project illuminates the Indigenous, not so much as alterity but as the familiar, rooted in continued historical and cultural presence.

Legacies of Im/migration:
Yreina D. Cervántez's *Tierra Firme* and *La Ruta Turquesa*

Yreina D. Cervántez described these two pieces, commissioned for the Spics and Beaners exhibition on immigration, curated by Reina Prado at the Social and Public Art Resource Center (SPARC) in Los Angeles in 1997, during the era of Propositions 187 and 209, in an artist's statement:

> "Tierra Firme" [from the Latin *terra firma*, "firm" or dry land] and "La Ruta Turquesa" [The Turquoise Route] are my response to the myth-fallacy of the Mexicano/Latino/Indígena as "illegal alien," and my effort to create new metaphors for migration and homeland from the old. In these works are the poetic and traditional symbols of mountain and *corazón* as sacred space: *cuezalin*, the macaw feather and *xihuitl*, the turquoise stone, were both associated with elemental fire by the Mexica. Also included is the *ollín*, meaning constant, dynamic movement both spiritual and physical. I've combined these symbols to represent our migration in the Americas, past and present. . . . Over centuries throughout this continent there has been communication back and forth, a sharing of culture and influences between peoples, movement that has never ceased. A *timelessness of movement*.

Cervántez printed and then painted these pieces on amatl paper, a painting-writing (glyph-making) surface made of fig tree bark used in Mesoamerica before European colonization. In these pieces, Cervántez endeavors to broaden the ideological palette beyond European philosophical, religious, and artistic traditions to include Mesoamerican and other Indigenous cultural legacies through incorporation and reinterpretation of the visual culture conventions of the latter. *Tierra Firme* is spatially dominated by the glyph-based stylization of a heart, a cuplike shape, with thick drops falling from it, and the glyph for mountain, which symbolizes the dwelling place of the spirit or heart of the community.[9] Cervántez visually reduces to the margins of her piece "highlights" in the genealogy of racism in the United States. A rack

of *calaveras* (skulls) in the tradition of Mexican artist and printer José Guadalupe Posada satirizes hostile events, people, and policies in the ongoing history of Mexican and Mexican American deterritorialization (e.g., Manifest Destiny; the Treaty of Guadalupe Hidalgo; Repatriation; English Only; Pete Wilson, Petty Tyrant; and California's Propositions 187, 209, and 227).

The idea of solidity or constancy that Cervántez invokes in her title and the idea of the heart of the community are set against the recurrent anti-Mexican sentiment that has justified the systematic disempowerment of Mexicans in the United States after the imperialist war against Mexico of 1846–48 and the ongoing racism that justified unequal access to quality education, jobs, living conditions, and even justice. In response to the historically ignorant injunction of Euroamerican xenophobes to "go back where you came from," *Tierra Firme* suggests that Chicana/os are in their ancestral homelands. Opposing and outweighing the materialist, individualist, and colonizing impulse of such a legacy, Cervántez invokes a more profound understanding of the land as a living and ancestral homeland, in symbiotic relationship with humans and other life forms. Her lithographs act as memory chips, recording past and present histories from a spiritual vantage point that renders the ethnically hostile claims of ownership of newer inhabitants of Indigenous ancestral lands as what they are: colonizing, partial, and absurd from a historical perspective documenting and predicting the ubiquity among most peoples of some form of migration, or as the artist put it, "the timelessness of movement." Chicana/os, like other Latina/os, whether recent immigrants or descendants of previous generations of U.S. citizens, descend from Native Americans and, in the West Coast and Southwest, the Spanish, the first European colonizers. The American continent and islands are the homelands of Latina/os, alongside full-blooded Native peoples.

In *La Ruta Turquesa* (figure 37), the artist calls attention to the history of travel and cultural exchange in the Casas Grandes area of the Southwest, which extends to both sides of the border, as a response to anti-immigrant rhetoric. The piece also provokes a comparison be-

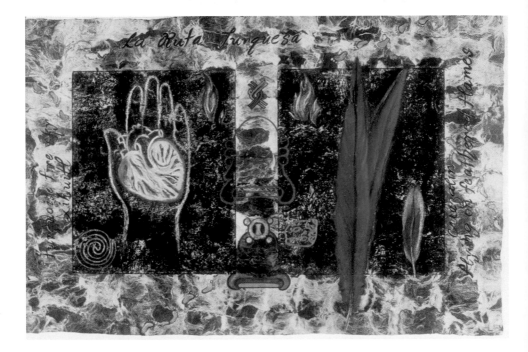

37 Yreina D. Cervántez, *La Ruta Turquesa*, 1997.
Part II *Sacred Space* series. Mixed media monoprint
on amatl (tree bark, amate) paper, 15 ½ × 23 ½ in.
Collection of Ramon Cervántez.

tween what was traded historically in the Americas and what is traded now. Turquoise and feathers, "both associated with elemental fire by the Mexica," were, by extension, also associated with s/Spirit, and as such were considered sacred. In the traditions of capitalist accumulation of land and wealth, what has become sacred is that which has high monetary exchange value and the social and political power that it can provide. In contrast to this idolatrous notion of power, Cervántez insistently invokes the power of things held sacred for their role in the expansion of spiritual consciousness (i.e., the feather and turquoise). As she suggests in *Tierra Firma*, it is profoundly ironic that the expression of hospitality "My house is yours" (*Mi casa es su casa*) seems to have been useful mainly during imperialist claims to Indigenous and Mexican homelands, or when subminimum wages for noncitizens have been sought to maximize economic profit (e.g., the 1940s Bracero Program and today's U.S.-owned assembly plants staffed by Mexican nationals). *Tierra Firme* suggests it is a false belief that Chicana/os, Mexican immigrants, and other Latina/os do not belong in the United States: they are in their ancestral homelands.

Consuelo Jiménez Underwood: Reweaving the Fabric of the Nation(s)

The question of return to the ancestral is broached by Consuelo Jiménez Underwood through weaving, painting, and other mixed media and installation. Weaving was the high art of the Huichol (from whom the artist descends on her father's side), equivalent to painting, as she has pointed out, much as tapestry was in pre-industrialized Europe.[10] Underwood was trained as a painter; her multimedia, loom-based artwork powerfully undermines contemporary gendered and racialized distinctions between art and craft that demote weaving to a "feminine" or "third-world" artistically undeveloped "craft." Her striking multimedia weavings include the life-size *Heroes Burial Shroud* series honoring Joan of Arc, John Chapman (a.k.a. Johnny Appleseed), Emiliano

Zapata, Martin Luther King, Jr., Woodie Guthrie, and César Chávez. The dimensions, type of thread, weaving pattern, and stenciled images reflect the distinctive life of each of these individuals. Joan of Arc's shroud, for example, is white, "the hottest part of the flame," the artist has explained, and is woven as a "kind of beautiful and strong, feminist armor," while Zapata's shroud has angular weaves that suggest the bullets shot into his body. Dr. King's shroud is in a sheer black checkerboard pattern that recalls a weaving pattern of his ancestral African homelands. It is silk-screened with the words "Sister Rosa" and "I have a dream," which can be read from behind, and at a distance, since "his words are his power."[11]

But perhaps Underwood's most unforgettable signature has been the visually stunning and poignant weaving of barbed and other wire into her meditations upon the U.S.-Mexico border and its dangers for those crossing from Mexico into a militarized, vigilante-attracting, racially polarized U.S. "frontier" culture. The artist first wove with barbed wire in *Virgen de la frontera*. One reviewer wrote of the piece:

> A number of her works touch upon contemporary Chicano dilemmas, such as the Mexico/California border. Take the seven-by-five foot *Frontera Virgen*, woven of multi-hued threads of linen and barbed wire, covered by a second layer of gauzy, woven veil silk-screened with Virgen de Guadalupe images and painted with a big "V." She said the veil represents the difficulty of seeing the things clearly, while the Virgen is used because she is a guardian spirit of the poor who make the dangerous crossing. The barbed wire stands for the border, she explains, but also for pain and suffering. (Alba 1993, 40)

The Sacred Jump (figure 38) features a number of silk-screened images in red upon a woven background, including the image, taken from actual road signs near the border, cautioning motorists that migrant families are crossing the roads. The bloody, and sometimes fatal, outcome of the border patrol's and citizen vigilante groups' "hunting" of undocumented immigrants[12] is suggested by the clever image of other "wetbacks," salmon, similarly involved in a dangerous crossing as they head

38 Consuelo Jiménez Underwood, *The Sacred Jump*, 1994. Woven, mixed media, 83 × 38 × 1 in. Collection of the artist.

homeward, and by the image of Mictlantecuhtli, the Nahua guardian of Mictlán, the underworld.[13] *Virgen de los caminos*, an embroidered quilt which honors the Indian and *mestiza/o* embroidered tradition of *colcha* (blanket) work in the Southwest, places at its center an image of a skull-faced Virgin of Guadalupe whose mandorla is crossed by stitched barbed wire (figure 39).

Consuelo Jiménez Underwood's use of weaving as a medium to render images of the dangerous (because unfavorably racialized) contemporary immigration of Mexicans into the United States resonates with ancient, cross-cultural metaphors about the fabric of being, life, and society, and contemporary critical discourse about cultural practices as threads in the social text(ile). The metaphor (shown through the barbed wire) of geopolitical boundaries as a weaving wryly comments upon those boundaries as fabrication, as human artifice. At the same time, but from Western and Indigenous spiritual perspectives, what is recalled is that the disrespected and sometimes despised lives of Mexican immigrant laborers are part of the sacred weaving of creation. Underwood's weaving-based multimedia work thus comments darkly upon the dehumanizing hostility toward Mexican immigrants that ruptures a harmonious sense of balanced relations between all beings and things. Through her use of the loom and needlework (quilting and embroidery), Underwood boldly makes reference to the occluded creative legacies of women's "domestic arts" and Native American "folk arts" within patriarchal Eurocentric cultures. But, further, she uses the "genteel" needle arts to picture precisely what feminized domestic art, following the legacy of nineteenth-century Victorian ideologies, is supposed to keep out: the hard, ugly realities of the public world. But again, the arts of the needle and loom have indeed been considered arts and not dismissed as mere craft among the Huichol, as among the Indigenous and before the peculiar aesthetization of masculine dominated modern(ist) art forms.

As a quilt, *Virgen de los caminos* further suggests that the troubled immigration of Mexicans is a thorny bed in which we must all lie, and from which none of us may derive much comfort or warmth. The racial-

39 Consuelo Jiménez Underwood, *Virgen de los caminos*, 1994. Embroidered quilt, 60 × 36 in. Collection of the Smithsonian National Museum of American Art.

ized hostilities invoked by politically reactionary individuals toward working-class immigrants of color, much like the hostilities toward the Irish, Italians, Germans, and Asians during the nineteenth century and the early twentieth, contribute to the social marginalization of laborers needed within the U.S. economy and therefore only render them more vulnerable to the extreme economic exploitation from which the nation as a whole benefits enormously. As numerous commentators and scholars have pointed out, behind the seeming paradox of the ongoing and massive undocumented labor in the United States is the hidden fact that, for the corporations involved in manufacturing and agribusiness, this labor is a necessary, desired, and solicited element, since it enables the extraction of superprofits through subminimum wages. Moreover, well-heeled two-income families benefit from undocumented labor because it allows them to outsource child-care labor to low-paid workers, freeing both adult members of the family to engage in paid labor outside the home. Given that it is the flourishing and massive global "informal economy" of exploited female, child, and undocumented labor that holds patriarchal national and transnational economic structures afloat, it is quite fitting that Underwood pointedly employs historically recent women's creative genres to portray the predicaments of the politically, socially, and economically vulnerable in the present Westernized world.

Underwood's *Land Grabs — 500 Years* appeared as part of the *Imágenes e Historias*/Images and Histories: Chicana Altar-Inspired Art (2000) exhibition (figures 40 a, b). Five small weavings, framed in their looms (essentially, nail-studded frames) and made from an array of materials including plastic strips and paint, depict territorial maps recording colonial and imperialist histories: *1493: The Line of Demarcation; 1600s: Illegal-Alien* [i.e., Pilgrim] *Settlements; 1700s: The Louisiana Purchase; 1800s: The Treaty of Guadalupe Hidalgo*; and *Present: Hispanics Below*. Again using historically and culturally appropriate threads and weaves, such as a lace pattern for the Louisiana Purchase piece, the artist works against culturally narrow assumptions about the meaning and function of different genres. Weaving regains the narrative quality that it

has held among Native Americans throughout the Americas, particularly as a mnemonic device. What Underwood remembers in her *Land Grabs* series is not only the modern history of colonization that created the United States but the more basic, if naturalized, fact that territories have been historically constituted. *1493: The Line of Demarcation*, for example, "depicts the line imposed by the Roman Catholic Pope, dividing the land between France and Spain," while "*1600s: Illegal-Alien Settlements* illustrates the boundaries between English and French territories in North and South America" (Wylie 2000). The impermanence and unnaturalness of political boundaries is further underscored by the unfinished appearance of the weavings, which are seen suspended from their warps and woofs, in a way that visualizes them as unfinished processes.

Fashioning Exploitation and the Garment Industries: Alma Lopez's *California Fashions Slaves* and Celia Alvarez Muñoz's *Fibra y Furia*

Los Angeles–based artist Alma Lopez's *California Fashions Slaves* (figure 41) takes up themes similar to those seen in Rodríguez's and Underwood's work.[14] Lopez digitally layers a map of present-day northern Mexico that reaches the Los Angeles skyline and an image of a contemporary seamstress, behind whom stand rows of ghostly seamstresses from the past. Running south on the map is a man pursued by a patrol car. The south and the west are the targets of a large red arrow, appropriately labeled "Manifest Destiny." Directly in the path of that trajectory of imperialist expansion is an image of the Virgin of Guadalupe standing over the date of annexation of the Mexican territories, 1848. The Virgin may be appearing to the pursued undocumented laborer because, like the recently canonized Juan Diego to whom she originally appeared, he is *un inocente*, innocent, though he is pursued like a criminal for not having proper immigration papers. The man, like the seamstresses, symbolizes the oppressive conditions of many undocumented

40 a, b. Consuelo Jiménez Underwood, *Land Grabs—500 Years*
series, 2000. Wood, fiber, gold, corn, mixed media installation.
5 × 15 × 15 feet. Detail: "Louisiana Purchase," 1996, 36 × 12
× 5 inches. Collection of the artist.

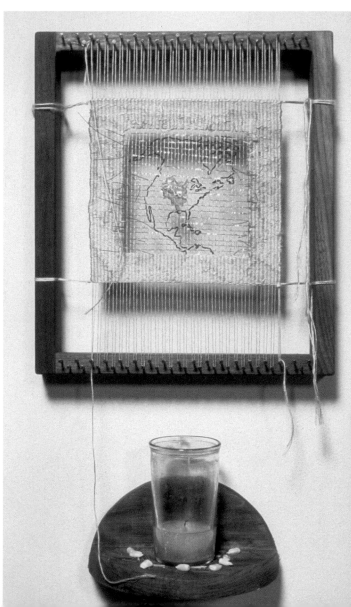

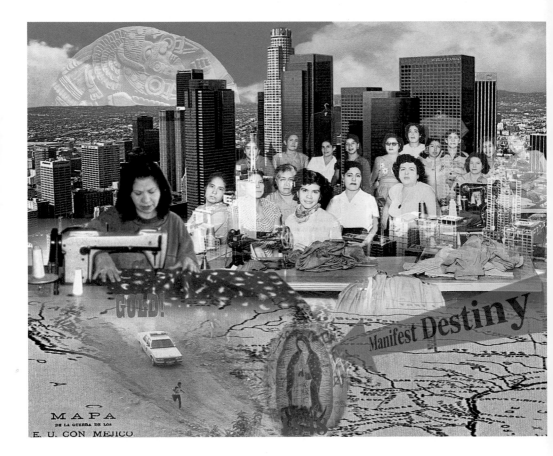

41 Alma Lopez, *California Fashions Slaves*,
1997. Digital print on canvas, created in Photoshop,
20 × 24 in. *1848: Latinos and the U.S. Landscape
after the Treaty of Guadalupe Hidalgo* series.

workers in the United States, publicly reviled yet desired by agribusiness, factories, sweatshops, restaurants, hotels, and homes needing gardeners, servants, and nannies, though their "illegal" status makes them more exploitable, that is, "affordable."

An homage to her mother, who is a seamstress, and to other garment workers (Prado 2000, 8), Lopez's work juxtaposes the spectral seamstresses against the mute Los Angeles skyline, which hides garment industry sweatshops. This imagery effectively conveys the hidden presence of female garment workers in Los Angeles, one of the garment-production capitals of the world, whose superprofits are built upon unseen superexploitation.[15] Cynthia Enloe has written about the illegal domestic and transnational garment trade built on the labor of women of third-world origin. She observes that "the international politics of garments stretches from the women at their sewing machines stitching polyester sleeves to the men in board rooms and ministerial offices drafting memos on investments. . . . The risk-taking banker needs the conscientious seamstress to hold his world together" (1990,158, 160). Jo-Ann Mort, in turn, notes that the highly feminized and racialized garment industry thrives because of its own illegal work practices and conditions in Los Angeles, one of the garment production centers of the globe.

> The Los Angeles garment industry is largely nonunion. It is like a sponge that soaks up available labor and thrives especially on illegal immigrants who—in this anti-immigrant climate—are more dependent on their bosses. They produce the goods in what has become a $13.3 billion-plus industry in Southern California. Virtually none of the legislation either to tighten or to discourage illegal immigration will do anything for the tens of thousands of illegal immigrants who already work in the Los Angeles area garment shops. About two-thirds of the sewing shops in LA are sweatshops, many operating in full view of anyone who cares to look, especially in the downtown garment district in the shadow of the Convention Center. (1999, 197)

The layering of images of Los Angeles high-rises, the map of Mexico, and Mexicans and Mexican Americans in each part of Lopez's five-

piece *1848: Chicanos and the U.S. Landscape after the Treaty of Guadalupe Hidalgo* series makes clear that the conditions of life for Mexican Americans and *mexicana/os* today are overdetermined by a history of racialized, class-based exploitation. Another work in the series, *Juan Soldado*, focuses even more directly on the injustices resulting from social inequalities and on the formation of an unofficial, popular religious cult around the victim-intercessor, or social martyr, unjustly accused by his superior officer (figure 42). The artist's Web site included the following explanatory text about the piece:

> Juan Castillo Morales, most commonly known as Juan Soldado, is the unofficial patron saint and protector of undocumented immigrants. Morales was a soldier in Tijuana accused of the rape and murder of an 8-year-old girl and executed in 1938. He claimed that he was framed by a superior officer who actually committed the crime. According to the legend, he swore that he was innocent and his innocence would be proven when miracles were asked and granted in his name.
>
> Today, most people travel to Panteon 2 in Tijuana to ask for miracles relating to issues of immigration: crossing the border safely, dealing with the border patrol and negotiating permanent residency and citizenship. Those same people are the ones who have converted his plain tombstone into a one room altar space filled with photographs, letters, gifts, constantly lit candles, fresh flowers, and xerox copies of micas (green cards). He is not recognized by the church and is therefore an illegal saint of "illegal" immigrants.
>
> Juan Soldado is about the creation of myth, spirituality, and cultural history as a survival mechanism during transnational migrations and survival in hostile environments.[16]

In addition to framing Juan Soldado against a mandorla-style aura composed of Coyolxauhqui's lunar image, Lopez's digital print incorporates texts attesting to Juan Soldado's miraculous intervention with respect to the dangerous border crossings of undocumented, or illegal, laborers and their families.[17] In this sense, the print functions like a *retablo*, incorporating an image of sanctity and showing the peril averted by the intercession of the holy dead.

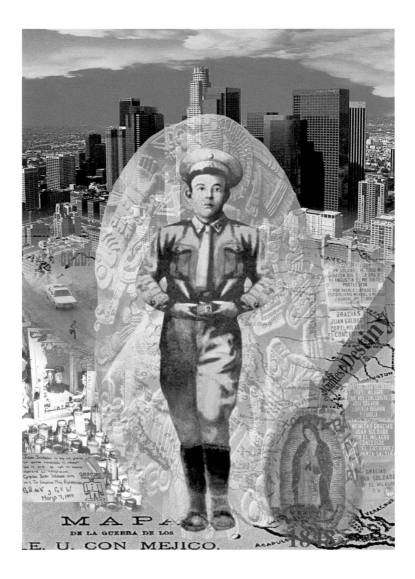

42 Alma Lopez, *Juan Soldado*, 1997.
Digital print on vinyl, created in Photoshop,
6 × 4 ft. *1848: Chicanos and the U.S. Landscape
after the Treaty of Guadalupe Hidalgo* series.

The cityscape and map remain the backdrop in Lopez's more recent *Our Lady, Ixta*, and *Lupe & Sirena in Love,* which place sexuality at the forefront of histories of presence rendered spectral through discrimination. Same-sex desire is superimposed onto the ever-present calendar renditions of the pre-Columbian myth of Popocatepetl grieving over the dead Ixtacihuatl. This myth, said to be configured by the shape of the volcanic landscape of the valley of Mexico City, is recast as one young Latina grieving over the body of another lying over an inner-city, graffiti-covered wall at the U.S.-Mexico border. Following Anzaldúa (1987), the print suggests that because lesbian desire is culturally, socially, and politically "illicit" and illegal, there is no homeland for women who desire women, on either side of the border.

Lupe & Sirena in Love (figure 43) raises further questions about how we inhabit the spaces we dwell in, including our bodies, in gendered and sexualized ways. Thus, two Mexican national icons, one religious (the Virgin of Guadalupe), and one from popular culture (the *lotería*/lottery game's *sirena*/mermaid) are rendered embracing each other, symbolically claiming visibility for lesbian desire within national popular culture and religious cultures. The backdrop already described in other works by Alma Lopez (e.g., maps, squad car, graffiti-covered border wall, L.A. skyline) here suggests that a history of intolerance of queer presence is also our legacy, interrogating the gender and sexual politics of Mexican and Chicana/o anti-imperialist discourses. The gendered exploitation of women's labor alluded to in *California Fashions Slaves* is indeed continuous with the heterosexist construction of gender and sexuality that transnational capitalism directly profits from, and with male-centered, homophobic oppositional movements that recenter their own gender and sexuality privilege.[18]

The fact that the brutal and often tragic contradictions of gender and class workplace exploitation are reinforced and compounded by the fashion industry was the subject of a 1999 installation by Celia Alvarez Muñoz at the Irving Arts Center in Irving, Texas. Muñoz has worked with photography since 1988 and became well known for her meticulous and conceptual photography-based book art. Her work in this area

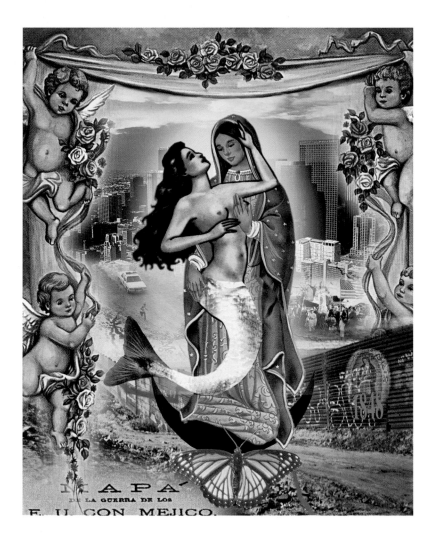

43 Alma Lopez, *Lupe & Sirena in Love*, 1999. Iris print on canvas, 17.5 × 14 in. *Lupe & Sirena* series.

has gradually moved from portable art books to wall-size installation "books" and on to explorations of space, place, and the histories and politics of what Bourdieu called "habitus," or the social spaces and ideologies we inhabit and that inhabit us. *Fibra y Furia: Exploitation Is in Vogue* is one such project that closely explores the relations between the gendered and racialized garment industry, the fashion industry that ideologically sustains it, and women's, particularly poor and racialized women's, lack of safety or "homeland" within a so-called benevolent paternalistic, male-centered culture that, in the case of the young disappeared women of Juárez, shows itself capable of preying upon its "daughters" precisely because of its own empowerment at the expense of the female citizenry it genders as vulnerable to male violence.

The artist dramatically hung over twenty streaming bolts of fabric from a height of thirty feet (figure 44). Between or from these, she suspended seventeen ironically styled garments that spoke alternatively of the absurd and perilous sexualization of women through fashion, and the uncritical, transnational culture of their consumption. On the walls she hung two digitized photo collages that incorporated images of the dresses hanging nearby. In one section of the room, the artist created a memorial shrine made of shoes, as a reminder of the then more than two hundred young *maquiladora* female workers brutally murdered, and in some cases raped, from 1993 to 1998, in the Ciudad Juárez area, across the border from El Paso.[19] One glamorous, short red party frock, *Prom Queen (La Sirena/Siren)*, featured large red roses at the level of the breasts and crotch (figure 45). Another, more conservative dress, *Lorena*, in memory of Lorena Bobbitt, a Latina who severed her Euroamerican husband's penis, also marked the genitals, but with nonfunctional buttons. On the lambda print Muñoz created from this piece, she superimposed the image of a single-edged razor blade in the pelvic area. *Niña traviesa/Naughty Girl* rendered the grotesque character of the sexualization of female children, and the infantilization of women, through a baby doll–styled dress with a conventional bib at odds with the garish black and gold fabric employed in making women's evening wear. The journalist Paula Felps reported on the exhibition, noting, "Ms. Muñoz

44 Celia Alvarez Muñoz,
Fibra y Furia: Exploitation Is in Vogue,
1999. Installation view. Collection
of the artist.

45 Celia Alvarez Muñoz, *Prom Queen
(La Sirena / Siren)*, 1999. Lambda digital
photograph, 40 × 60 in. Collection
of the artist.

added her perspective of the deaths into her exhibit, which originally appeared at the Center for the Arts in San Francisco under the title 'Fibra.' The original exhibit focused on the fashion industry and its exploitation of women, both as workers and as those trying to fulfill the industry's image of women. . . . Ms. Muñoz added the 'Furia' as she watched the border town tragedy evolve" (1999, 4c). In another newspaper review of her installation, the artist herself remarked: "The fashion industry exploits us. . . . They have us dress whichever way they want. They have us follow. . . . The bait is fashion. And we switch to girls that are killed. Their aspiration was to make enough money to buy clothes like this, and instead they found danger—abuse and death" (Goodrich 1999, 6b).

The anthropologist Norma Iglesias Prieto's study (1997) of *maquiladora* workers along the U.S.-Mexico border found that female workers were rewarded for physical attractiveness and sexual responsiveness to their male bosses, even as they had originally been screened in the job application process precisely to ensure their status as sexually "good girls." *Fibra y furia* exposes the links between the gendered exploitation of young women workers in the garment industry, their manipulation and exploitation by the fashion industry, and the violence against them, so repugnantly evident in the Juárez murders.

Laura Alvarez's *Double Agent Sirvienta* Series

Laura Alvarez's *Double Agent Sirvienta (D.A.S.)* series is a multimedia, ongoing project built as a kind of soap-opera series of its fictive protagonist's adventures. While creating an imaginary landscape that in its improbability is often humorous, Alvarez's *D.A.S.* project nonetheless brings attention to the ways in which the social space of the home is inhabited, gendered, and racialized, from the perspective of the domestic servant. Fashioned around the central figure of a double agent posing as a domestic servant, it is at once a fantasy about social empowerment and an allegory of the artist as provocateur within hegemonic culture's own "home." Alvarez published the scenario of the soap opera–style rock

opera, lyrics, and digitized images in Adobe L.A.'s second volume, *La Vida Latina en L.A: Urban Latino Cultures*, and described the general project:

> The Double Agent Sirvienta Rock Opera (1996–1998) explores the adventures of the Double Agent Sirvienta—an undercover agent posing as a maid on both sides of the border. The D.A.S. series includes a video, digital images, paintings, and other works on domestic surfaces. The intent is not only to elevate the position of the ethnic domestic worker with irony and humor but also to discuss technology as a symbol or tool of wealth, knowledge, and power. The narrative of the rock opera follows a young woman as she becomes a telenovela (soap opera) actress/pop star (every girl's dream) who always has to play maids, who, through disillusionment, and addiction to aspirin, and a vision, becomes an undercover spy for secret forces posing as a maid. (Leclerc, Villa, and Dear 1999, 108)

Alvarez's fictional heroine travels from a "small colonial town [in Mexico] where she cares for goats and fixes hair" to the mixed success of "everyone want[ing] her to play maids" in the soap operas, then to Los Angeles, where she dedicates herself to undercover assignments from "a secret society infiltrating into forbidden zones of corporations and oppressive zip codes, stealing secrets and blackmailing authorities for the demands of the less fortunate."[20] Alvarez's multimedia series captures the adventures of the D.A.S. as narrative fragments of soap opera–style installments of a spy-thriller.

Part of the series' irony rests on transformations of everyday cleaning supplies into the secret weapons of a counterintelligence spy as she does a "clean-up" ("Gun Boat") of enemy territory. Just as humorous and ingenious, the D.A.S.'s gadgetry is masked behind the apparent humbleness of her everyday cleaning supplies: "a micro brush that slits" and "spray/. . . tuned to kill someone" ("Gun Boat").

The D.A.S.'s intelligence work is featured in *Undercover Letter* (figure 46). The cartoon-style figure of the agent disguised in domestic servant uniform "maxifaxes" information in and out of the place she's "clean-

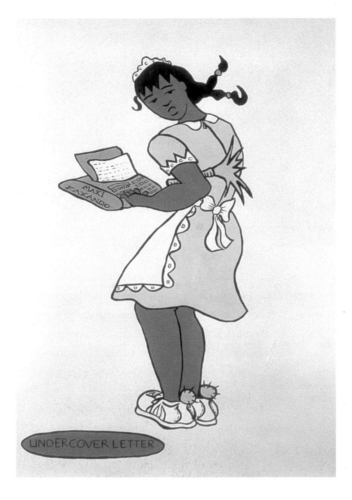

46　Laura Alvarez, *Undercover Letter*, 1996. Acrylic on paper, 44 in. × 5 ft. Collection of Heidi Brant.

ing up." "Headcuarras" shows the spy/servant speaking into a device with headphones and antenna. *The Double Agent Sirvienta: Blow Up the Hard Drive*, the serigraph created for the first all-women's silk-screen atelier at Self-Help Graphics in Los Angeles, featured the D. A. S. on a laptop, against a backdrop of flames and a file folder covered in typographic code. The complete commitment of the spy/servant to getting her "work" done, whatever the cost, is explicitly suggested in *D.A.S. Movie Poster*. In a scenario that recalls the film *Casablanca*'s bar scenes, a sultry D. A. S. is pictured with a far-away expression, revolver in hand. In a digital image from the rock opera as simulated art performance (published in Leclerc, Villa, and Dear 1999), the D.A.S. is pasted directly over a *rica*, a stock character "rich woman" who has asked God for help with her "digital dilemma."[21] But the technology-stealing secret agent maid declares "En tus sueños, Patrona! [In your dreams, boss!] It's too late now." *Prime Time Sirvienta* mixes the photonovel and soap opera with the comic book adventure more strongly (figure 47).

The doubleness of the D. A. S. as both spy and servant suggests that the two are interchangeable. The servant as servant is a spy-like creature able to penetrate class and cultural barriers and retrieve otherwise inaccessible information. And spy and servant are both phantas(ma)tic, only partly visible social figures; both are marked by confusion between who they are perceived to be and the role they are assigned to play, as the D. A. S.'s narrative shows.

Because she is (type)cast by her spymasters as well, the dimension of her doubleness as an agent for two organizations against each other is also suggested. The lyrics of "Masterscript," for example, where "she" sings (literally or figuratively): "I don't wanna say/Those words you wrote for me /. . . ./I don't wanna wear/Those clothes you picked for me" or, "Secretos/Tan Negros /. . . ./Me tienen wachada," from "Vamonos," leave open the possibility that she is railing against both sets of employers: those of the house she works in, and those of "headcuarras." When she gets the message from headquarters to "Get with the program/Get with the program/On track," her response that closes the song, "Reprimand," is "It's not so easy." In "Gun Boat," where the

47 Laura Alvarez, *Prime Time Sirvienta*, 1999. Acrylic on panel, 11 ½ × 12 in. Collection of the artist.

D. A. S. is cut off from headquarters and any news of her mission, fulfilling only her domestic service orders, the lyrics are:

And I begin to pensar [think]
Am I trapped in a mundo [world] of
Real household duties?
Donde están [Where are] all my contacts—
The signs—the lie detectors?
 Aquí estoy [Here I am]
Con ilusiones [With illusions]
De no nacer [Of not being born]
To stay inside her
Corriendo [Running] down
The hallways of my
The hallways of
Domesticity.[22]

The dehumanizing and deadening work of a domestic servant, ignored or condescended to by her employers, can apparently depress even a double agent posing as a servant. When the D. A. S. loses contact with headquarters, she seems to lose her professional calm ("Sin instrucciones/Porque me han/Abandonada [*sic*]," in "Gun Boat": Without instructions/Because they have/Abandoned Me). The D. A. S.'s "mission" as a servant is dangerous and her doubleness strains and is painful to her, as symbolized by her addiction to aspirin. We may surmise that the spy/servant's difficult location is constituted by the harmful nature of the psychological and physical work demanded of her as a household domestic worker,[23] and because undercover work as a servant is rather too close to home to be ethnographically interesting to the spy, given her social and economic origins.

In that the D. A. S.'s work opens the social wounds of her previous social identities and locations, Alvarez perhaps suggests the psychological space of the ideologically oppositional artist working from and against the experience of "minoritization." Like a spy in an art world built on

ethnic- and class-specific values, the negatively racialized ethnic minority artist engages in the intelligence work of collecting information and technologies in order to redeploy these in a discursive war over empowerment. As de Certeau has pointed out with respect to the capillary social power dynamics of everyday practices for the relatively disempowered, "warfare" for social space becomes a question of time-based tactics (1988). The advantage of the disadvantaged opponent lies in her mobility, flexibility, and speed against the interests of the socially authorized, and through a parasitical kind of squatting on the institutionalized social space that is denied her.

Through its staging in and around the "master's house," Laura Alvarez's *D.A.S.* series exposes the inequities in social, economic, and cultural access for different social actors. In characterizing the servant as double agent spy, and in making her the star, Alvarez challenges hegemonic discourses that would interpellate (i.e., re/produce) the economically unprivileged as the socially and culturally subservient. To this, Alvarez's series seems to say, "Think again."

Patricia Rodríguez's Archaeological *Cajas*

Amalia Mesa-Bains has correctly observed of Patricia Rodríguez's four-part *Tierra* series of *cajas*, or reliquary-inspired, box-based installations, that it "enact[s] the theme of land as homeplace and burial ground" (1993a, 62).[24] Executed as part of the protest exhibitions during the quincentenary of the Spanish invasion, these box-constructions are conceptually built around the tension between Western scientific discourses and the truths, emotions, and beliefs that exceed these. Thus, *When I Am No Longer on Earth/Cuando Ya No Esté en la Tierra* suggests that what remains after death cannot be measured or quantified through mechanisms such as those suggested by the clocks and dial that it features (figure 48). In the context of the quincentenary, the sharp, sword-like spikes radiating from the crucifix recall the bloodiness of the military and religious Spanish invasion. The piece is constructed as

48 Patricia Rodríguez, *When I Am No Longer on Earth / Cuando Ya No Esté en la Tierra*, 1992. Mixed media, 16 × 10 ⅝ × 8 ½ in. Collection of the artist.

a tripartite structure, through the use of two nail-studded, red, vertical pieces of wood, and an arch between these, over the crucifix. The clocks and dial constitute the only visible trinity, and the structure spatially reiterates the sense of hollowness that this mechanistic deity inspires. Thus, the "reliquary" box seems to mourn the chilling spirituality of colonial Catholicism and its absence of heart signaled by the ghostly metallic silhouette made by the heart-shaped cut-out of the red timer dial.

Our Land/Nuestra Tierra, Ashes to Ashes/Cenizas Somos, and My Land Forever/Mi Tierra Siempre similarly suggest the insufficiency of archaeological and scientific discourses to give an account of a sense of origin, cultural identity, and the meaning of place. In Ashes to Ashes, the small glass enclosure of ashes stands in stark relief to the warmness of the carved wooden box in which these are framed as a specimen. The tin collar, which surrounds the glass, functions ambivalently here, as it did in the previously discussed piece. It brings to mind traditional New Mexican tinwork, but through the atypical austerity of its design, coldness, and barrenness, it suggests the tradition of the sword and the cross of Hispanic Catholic imperialism.

In Our Land, the tension is expressed spatially, and again through the materials used. A glass partition allows for a view of what could be a sample of a segment of layers. In the upper half of the construction, a tiered, crown-like metal sheet appears poised to slide over the exposed contents of the box. Behind the glass, mostly bone-shaped, pale wood fragments, little plastic skeletons, soil, and other remains recall displays in natural history museums. The piece creates the unsettling feeling of the cemetery in the museum or laboratory and recalls Gómez-Peña's and Fusco's anti-quincentenary installation, Year of the Great White Bear.

The theme of such scientifically classified displays for the relics of Indigenous and third world peoples is more directly confronted, and visually settled, in My Home Land Forever (figure 49). Here, the reliquary is a blood-red box with a draw-bridge-style top that opens to disclose, on one side, a tombstone arrangement of red angular shapes

49 Patricia Rodríguez, *My Home Land
Forever / Mi Tierra Para Siempre*, 1992.
Mixed media, 26 ½ × 15 ⅞ × 25 ¼ in.
Collection of the artist.

jutting out of the earth-like plane, becoming larger and more irregular, and as they do so, the small shapes of hearts, a wishbone, a ram skull, and a winged figure are visible beneath layers of paint. Standing above this vertically is another plane of the box, set back into it, out of which emerge figures like cacti and a yellow star, from beneath layers of color, as well. Here, it becomes evident that a white layer, a yellow star, and green cacti are beneath the red one we see. A small strip of green rests off the floor between the two open panels of the box. The proportion in relation to each other of the four principal colors in the box—red, green, white (the Mexican flag) and yellow (the star of Texas)—neatly symbolize the violence of the appropriation of Mexican territory and its painful effects to the Texas-born artist whose homeland it will be "forever." The box hints at this indestructible ancestral and telluric link through the bones and objects and symbolizes the natural world that rises out of the blood-tinted historical loam described earlier. These objects are an inseparable part of the earth, and, like them, memory returns to it too, as will one's own bones. If home is where the heart is, home is the indestructible spirit of the place that lies beneath the flow of history, with its new cultural and national identities, but alive within the memory of the natural world of which we ourselves are part.

Claiming Space and Place with Spirit: Juana Alicia's Murals and Other Painting

Like the work of all the artists discussed here, Juana Alicia has worked in a variety of media and from a broad range of thematic concerns. The Detroit-bred, Berkeley-based artist has produced murals since 1982 and has collaborated in, or solely executed, more than twenty-six of these projects, for which she is well-known. In Chicana/o art, murals continue to be a meaningful art form precisely because they lay claim to public space and art for the communities in which they are located. A theme that appears in many of Juana Alicia's murals is, in fact, the politics of location and, as with other Chicana/o and feminist

murals, community empowerment and environmental enhancement.[25] The concern with how we occupy public space and the social location of gendered and racialized bodies appears in a number of her most striking paintings, drawings, and prints, as well. Her concern with reflecting the emotional and spiritual as part of the public landscape is conveyed through a distinctive technique and yellow-dominant palette that colors the visualized flow of energy and identity between people and objects.

Pieces like *Earth Book*, executed on the exterior wall of Skyline College library, picture the natural landscape as an energy-imbued field that transmutes, at one end, into an open book (figure 50). In *Yo Naturaleza* (I, Nature), a nude woman stands tranquilly in a marshy body of water, amphibious, like the half-submerged reeds surrounding her. *Auto-Vision/Self-Portrait* shows the sensual, knowing journey of hands making their way across a parched, rocky wall (figure 51). From the hands stream ribbons of color and energy from within which sprout succulent dahlias. And from the wrist of one of the jewelry-clad arms a bracelet with an eye looks out and communicates the intelligent seeing imbedded in the hands' sensual knowledge. The power of the natural world, represented through the natural landscape and through the human body as a part of it, is often visible in Juana Alicia's work through streams of light color, often white or yellow, that emanate in wave-like patterns off bodies and forms (e.g., *Santuario/Sanctuary; Mission Street Manifesto*) or that criss-cross a space (e.g., *Las Lechugueras; La mujer del río Sumpul; Regeneración/Regeneration; Sobreviviente*) and constitutes one of its inimitable qualities. In pieces like *Alto al fuego/Ceasefire*, geometric energy, criss-crossing the landscape, emanates from the sun. Painted upon the artist's return from a trip to Nicaragua in 1987, the mural depicts the Chicana/o communities' efforts to stop U.S. military intervention in Central America, through the hands of a man holding back weapons.[26]

In *Sanctuary*, as in many other pieces, yellow waves of color exude from the foregrounded figures in particular, visually enhancing their presence and suggesting the vitality in them of unseen emotional, spiri-

tual, and intellectual dimensions. This technique successfully conveys the complexity of people who historically have been objectified because of their appearance as "minorities," immigrants, or impoverished. The warmth and, more than humanization, vitality that Juana Alicia brings to the human, natural, and built landscapes conveys space and place as inhabited, rather than as mere transit points. In *Mission Street Manifesto*, inspired by the Chicana/o poet, performance artist, and musician Juan Felipe Herrera's poem of the same title, the mural celebrates San Francisco's pan-Latina/o community, showing it as a place bustling with life and creativity, and conveys the sense of a lived-in, familiar neighborhood, not merely a busy street in the anonymous, and to outsiders, scary "urban jungle." It pays homage to the Latina/o Mission District neighborhood and the people who inhabit it as a vital part of San Francisco in general.

Juana Alicia's and Emmanuel Montoya's mural at the San Francisco International Airport, *Santuario/Sanctuary*, creates a visual and conceptual sanctuary for the diverse users of this airport in one of the most culturally mixed cities of the country. It thus welcomes, with images of familiar faces, visitors, immigrants, and returning dwellers to the city that people of color have inhabited since ancestral times. The giant fresco (19′ × 23′) freezes and enlarges, like a memory, the vision of affectionate encounters, play, and even introspection of the city's ethnically varied population. Likewise, San Francisco's natural environs are also made present through the aquatic bird bas-relief sculptures carved by Montoya. Juana Alicia's and Emmanuel Montoya's sculptural mural, in essence, makes a claim on the global city to remain present to the local human and natural histories of the San Francisco area, acknowledging these as a vital part of the great Bay Area. The artists create a sense of accountability in the city's public thoroughfares, not only to the local community but to the natural world, and in this way they help to counteract the drive toward the disembodied consciousness, the sense of cold anonymity and disinterest, that airport experiences can sometimes entail.

50 Juana Alicia, *Earth Book*, 1998.
Mural, 10 ½ × 16 ft. Skyline College
Library, San Bruno, California.
Assisted by students Barry McGee
and Sia Yang.

51 Juana Alicia, *Auto-Vision / Self-Portrait*, 1987. Pastel on rag paper, 22 × 26 in. Collection of Rudy, Axelrod, Zeif and True.

Kathleen Alcalá's *The Flower in the Skull* is the second novel in her trilogy on the invisible histories of Indigenous, Jewish, Mexican, Mexican American, and Chicana/o peoples. Her previous novel, *Spirits of the Ordinary: A Tale of Casas Grandes* (1997), was remarkable not only for its lyrical, prize-winning writing but also for its telling of the story of a Jewish-*mexicano* family on the northern Mexican frontier in the 1870s.[27] This is a history that scholarship has only begun to plumb, and one that until Alcalá had not, to my knowledge, been registered in Chicana/o literature. Equally powerful are the links that she makes between the hidden and exilic cultures of Jewish *marranos*, or secret Jews, and the recently dispossessed Indigenous peoples. The histories and the religious beliefs of both Jews and Native Americans, like those of their descendants, the Jewish *mexicanos* and Mexican Americans of the novel's plot, reflect the author's belief that literature tells the same archetypal stories, cross culturally and ceaselessly, though it does so in specific ways: here, it is the age-old heroic struggle to reintegrate the psyche after the individual's confrontation with evil and to return to her lost community as a home.[28]

The Flower in the Skull is also the story of how peoples and their culture—the Opata Indians of the Sonora Desert, specifically—disappear. What Alcalá uncovers through her novel, and the historical research it is based on, is that disappearance is both elimination and, more simply, being out of view. The most contemporary of the novel's three protagonists, Shelly, stands inside the church in Magdalena, Arizona, visiting the reclining statue of Saint Francis and looking around her at the Mexican and/or Indian people:

> It was then I realized who I was seeing—the Opata. . . . I had received my unspoken, unknown wish: I had found the Opata, alive and well in the place they had always lived, since the time of their ancestors—the Sonoran Desert. Only, I thought, standing in a slight daze outside in the bright sun, they did not know who they were. Or if they did,

they would not tell me, as their ancestors and relatives had refused to tell others. The ancient rituals were there, perhaps even remnants of the old language, but overlain with new pickup trucks, makeup, Country Western music, and television. This was survival, I realized. This was how you stayed alive in a world that did not want you, or at least wanted your land without you on it. You kept your head low and prayed to Saint Francis. (1998, 153–54)

There is a very personal reason, it will turn out, that Shelly "wanted to follow these people home, be invited for dinner, look at their family albums" (154). Researching the Opata, as part of a project she is assigned by the large publishing company she works for in Los Angeles, allows her to recognize, as one of her own ancestors, a woman in one of the photographs she is collecting as a remnant of a supposedly extinct tribe from the Sonoran Desert. Like so many Chicana/os, Shelly knows very little of her extensive familial past, especially of Indigenous ancestors. The first two (of three) sections of the novel, the stories of Shelly's great-grandmother and grandmother, narrate how such a process of silencing, forgetting, and not wanting to know might have occurred as daily practices on the individual and social levels. Shelly's discovery that the Opata are not extinct and that she is descended from them matrilineally speaks to the discontinuous Indigenous histories of Mexicans, Mexican Americans, and Chicana/os discussed earlier (chapter 1), as well as to the way Eurocentric cultural practices (in clothing, behavior, and language) functioned in nineteenth-century Mexico, as elsewhere, to deracinate the Indigenous.[29]

The trauma of surviving the colonizing genocides of Indigenous peoples explains the desire on the part of survivors like Shelly's great-grandmother, Concha, to erase, at least from public view, signs of Indigenousness which continue to endanger this victim of two rapes and her village's pillaging and destruction. Anti-Indigenous discourse belittles the Native American, thus communicating that it continues to be dangerous to identify as Indigenous. It is not that no one remembers, Alcalá reminds us; it is that some do not dare remember in public by enacting their identities and do not fully pass their own cultural

traditions down not only because they have been damaged but also to protect their offspring from being viewed as prey.

Shark's Tooth from the Sea, renamed Concha (seashell) to make her more attractive to the Mexican family who will employ her as a domestic, loses not only her name but a safe social or domestic space. She is first raped as the *hu'uki*, the women's space, is desecrated and destroyed along with her Opata village by Mexican soldiers. She is raped again by the Anglo son of an honored guest in her Mexican employer's home, when he, like the Mexican soldiers, trespasses with impunity her own small living quarters within it. The public loss of collective memory that the people from the destroyed Opata villages experience is facilitated through their deterritorialization. Their displacement from their own lands in turn facilitates their cultural deterritorialization, interrupting, if not breaking, the elemental ties between self, ancestors, and the natural landscape and crucially disempowering the survivors, who feel, like Concha's legless brother Beto, that what they must never forget is to keep on running.

It is perhaps because of these kinds of considerations that *mestiza-*, Mexican-identified Rosa, who distinguishes herself from her mother Concha for having received and achieved love throughout her life, nonetheless describes herself as having grown up "having nothing that was really my own. Everything I wore, everything I ate, was borrowed" (84). While she is referring to having grown up in her mother's employers' household, this Mexican household could just as well be the Mexican national "family" that *mestizo* identity discourse would attempt to secure from the nineteenth century on, and that the rebirth of *indigenista* movements like the visible emergence of the Zapatista National Liberation Front (EZLN) in Chiapas contest and undermine. In spite of her feeling of unrequited love, Rosa, the Opata–Irish American *mestiza* resulting from the rape of her mother, does not feel safe either: "Early on, I saw what the world had done to my mother and what could happen to me if I was not careful. So I covered my teeth when I laughed and stood up straight when I carried water. I was always polite and obedient and tried not to complain if things were not right. But I hid my mother's language" (84).

Under colonization and the anti-Indigenous ideologies that continue to secure the political and economic hegemony of the colonizers, whether Hispanic or Anglo, the Opata cultural legacy becomes, like that of the secret Jews of the Southwest, one of profound fear and, in who can know how many cases, one of social acquiescence that is reviled as cultural apostasy, much as the Jews who converted to Christianity under the duress of the Inquisition were reviled as *marranos* (swine). With tragic irony, it is this legacy of fear and uprootedness, and the vulnerability these create psychologically, spiritually, and thereby socially, that are evident in Shelly, the contemporary Chicana employed in the publishing world, whom we first encounter hiding in the closet of her own apartment. She is avoiding the boss who stalks her and will eventually force himself into her apartment and rape her. She is, horribly enough, reliving history in the terms of more contemporary gendered and racialized depredations that are nonetheless the offspring of the public, armed rapes on the frontier.

What indeed would happen if we went back to our ancestral, Indigenous homelands? This is the question that *The Flower in the Skull* poses as a form of closure. Having completed her professional assignment and incidentally discovered threads to the mystery of her own family's story, Shelly realizes that nothing of worth compels her to return to Los Angeles and that the most valuable thing she owns is a picture of her great-grandmother, Concha. Shelly returns to Magdalena, to begin the process of finding out who her people were and are, and thus, who she might be.

Through a dream that places Shelly in a scene of her great-grandmother's life that we have read in the early chapters of the novel, Alcalá suggests that there is a crucial relationship of identity, and not simply heredity, between these characters of the same family lineage. Such relations of identity are also suggested through the tripartite structure of the novel, each section featuring a different though related protagonist, all of whom narrate autobiographically. The novel suggests through these devices and its narrative repetitions that we literally are our past, and that our past lives in us, triggered and reawakened in ways that appear coincidental, and that are, in any case, certainly fortuitous.

"Could anyone be more troubled than I am?" Shelly asks herself after she realizes that the Opata surround her and have been returning to Magdalena continuously, if not officially as such. "Could anyone's life be harder? Of course it could, I thought, suddenly bitter. But who could stand it?" (154).

It is finally this question that motivates Shelly, and artists like Cervántez, Celia Herrera Rodríguez, Patricia Rodríguez, and many, many others, to explore the cultural terrain of the Indigenous, in spite of Eurocentric discourses of *mestizaje* and even of the hostilities of some "northern"-identified Native Americans who are also "mixed-race," yet question the authenticity of such searches in Chicana/os and Mexicans. Does the United States, or Mexico, for that matter, offer Chicana/os descended from different Native communities of the south and north, and identifying as Indigenous, a place that is safe, a place that can be called home? The revival in the late 1960s and the widespread and ongoing appeal among Chicana/os of the Mexica-Aztec myth (i.e., the oral and pictographically transmitted story) of Aztlán, the originary homeland somewhere in the Southwest or West of what is today the United States, and the dream of our "returning" to it, was a rather clear, and moving answer that Chicana/os understandably could not feel at home in Eurocentric, racist cultures on either side of the border. That Chicana/os dared name their ancestral rights to be in the present-day United States through their construction of the refurbished idea of Aztlán was among their first audacious and decolonizing ideological acts (L. Pérez 1999a).

Queering Aztlán:
Cherríe Moraga's *The Hungry Woman: A Mexican Medea*

If the myth of Aztlán itself as a compelling critique of the ongoing cultural disenfranchisement of Chicana/os and other Indigenous people in the Americas is understood, then one can perhaps begin to grasp the degree of tragedy, pain, and the sense of betrayal that Cherríe Moraga's

play *The Hungry Woman: A Mexican Medea* expresses. Set in the "*muy* [very] 'bladerunner-esque'" "near-future of a fictional past," Medea, discovered making love to a woman and refusing to renounce herself as a lesbian, is exiled from a reoccupied Aztlán, with the other *jotería* (queers), to Phoenix, named by them "'Tamoanchan,' which means . . . 'We seek our home.'" Medea is in a psychiatric prison ward, incarcerated for having poisoned her twelve-year-old son rather than see him gendered in heterosexist, patriarchal Aztlán. Such gendering would spiritually distort him ("I cannot relinquish my son to them,/to walk ese camino triste/where they will call him/by his manly name and he goes deaf/to hear it" (2000, 353) and his view of women ("Betrayal occurs when a boy grows into a man and sees his mother as a woman for the first time. A woman. A thing. A creature to be controlled" (69–70).

The exilic Phoenix/Tamoanchan is neither a desirable place nor is it the homeland. The homeland *is* Aztlán, but not the cultural and social world appropriated by the heterosexist Chicana/o revolutionaries. In this Aztlán, it is Medea and the *jotería* who are now considered the counterrevolutionaries as they were considered at the beginning of the Chicana/o movement and continue to be considered by Chicano "narrow nationalists" who idealize Mexican culture over others and whose model of the private and the political family is Hispanic (Spanish), patriarchal, and heterosexist. When Jasón, nearing sixty, admits he will wed a young wife, Medea says to him:

> Send me your wife. I will teach her of her own embattled and embittered history. I will teach her, as I have learned, to defend women and children against enemies from within. Against fathers and brothers and sons who grow up to be rapists of women, traídores de una cultura mas anciana que [traitors of a more ancient culture than] your pitiful ego'd life can remember. (340)

Medea is referring to the prepatriarchal cultures of ancient Mexico of which Anzaldúa (1987) and others have written, that is, the cultures that were appropriated by apparently imperialist patriarchal cultures such as that of the Mexica ("Aztecs"). Thus, in a later moment, Medea will rage

against Huitzlipochtli, who dismembers his warrior sister, Coyolxauh-qui, relegating her to the moon, and against their mother, Coatlicue, for allowing the destruction of the sister. Moraga reads this myth as an allegory of the rise of patriarchy in Indigenous Mexico, the ancestral legacy of Chicano sexists: "Coyolxauhqui, diosa de la luna [goddess of the moon]./[*Her arms stretch out to the full moon*]/Ahora, [Now] she is my god./La luna, la hija rebelde [The moon, the rebel daughter]" (356–57).

It is significant that Jasón, Medea's husband, has appropriated her land during her exile since he cannot call upon any Indian blood of his own by which to make a descendant's claim. He has suddenly called for his son in order to secure his hold over Medea's land. This is horribly ironic, since the search for homeland is exactly what the revolutionary struggle for Aztlán was about. That there is no safe place for women — and not just queer-identified women — is what *The Hungry Woman* exposes. Women will forever be hungry for this safe place, a fully egalitarian social space, in patriarchal, heterosexist cultures, whether they be Mexican, Chicano, Indian, or Euroamerican. Moraga's *Mexican Medea* ends with a Pietá-like image of the dead Chac-Mool (Medea's son) now holding his own mother, just as she had held him shortly before. She too is the sacrifice, and she is, it is hoped in this translation of myths, also the daughter to be reborn free after her sacrifice and underworld experiences. Shortly before her death, Luna (Moon), her lover, gives Medea a bundle. It is a figure of a Cihuatateo, one of the "warrior" women honored as heroines among the Mexica for dying in their first childbirth.[30] "(*Suddenly urgent, she grabs Luna*) 'Is that how I died,' she asks Luna, '[g]iving birth to myself?'" (359).

The significance of land is not only literal in *The Hungry Woman*. It is also about the consequences of having, or rather not having, a social space or place, as I have already suggested. Medea can return to Aztlán but will not do so because to renounce her lesbian desires would be to renounce her right to live as a human being free to choose something as basic and invaluable as whom she chooses to love. The homeland that the warrior daughters of Coyolxauhqui struggle for are the time-space

beyond the patriarchies, the future, suggested by the past chronicled in myths. In one scene, Medea explains to her son that he is her land, a materialization and a claim to social and geographical space (339). Her life as a giving birth to herself is also this "land." Her life, through the practices of her body, such as making love to a woman, but not only this, charts social and cultural territories that are rendered invisible.

The body is the site "of embodied geographies," the feminist geographer Linda McDowell observes, and drawing on Judith Butler, "the body and sexual practices are socially constructed and variable, involving changing assumptions about what is or is not 'natural' or 'normal.' They have, in other words, a history and a geography" (1999, 34, 36). And later, "Social, economic and political structures are crucial in defining and maintaining not only a particular urban form but also particular versions of acceptable bodies" (66–67). Such observations about how the physically and culturally built environments shape and produce identity and behavior help us to understand Medea's ultimate reluctance to allow her son to go with his father to a male-centric "occupied Aztlán." "The man I wish my son to be does not exist, must be invented," she says to his father, Jasón. "He will invent himself if he must, but he will not grow up to learn betrayal [of women] from your example."

Following and developing Moraga's earlier observations about the relationship between speech as an embodied practice and sexuality in *Loving in the War Years* (1983), in *The Mexican Medea*, political ideologies cannot be dissociated from their effects in the bedroom. Luna thus states, "My private parts are a battleground. I see struggle there before I see beauty" (334). Women, Moraga's play suggests, have been robbed of our land, that is, the geographical, social, cultural and political spaces/places in which to freely give body to our human desires for principled self-realization. The self-interested demands of male-centered cultures, inculcated continuously since childhood, create an even more basic theft and exile in us all: that of more authentic and vital ways of inhabiting the land of our own flesh more comfortably and with greater integrity. We are unwittingly dehumanized in the processes of

consciously or unconsciously reproducing sexual, gender, ethnic, and class privileges. In Moraga's important play, Aztlán, mythical homeland of the Mexica and symbol of Chicana/o nationalism, is remapped beyond the territories of a patriarchal and homophobic imagination in a war of visions that goes to the heart of the vital political and spiritual function of what we are capable of imagining.[31]

chapter five

❦

Book, Art

When the historian of religion Mircea Eliade complained that "we are condemned to learn about the life of the spirit and be awakened to it through books," he didn't acknowledge that this living spirit is in many ways the spirit *of* books.

—Eric Davis, *Techgnosis*

Art relating to the book or book-like forms ranges from the more familiar forms of literature and book art to gallery-sized "book" installations, comic-book art, photo- and graphic novels, and zines, but also sound recordings of the spoken word, as oral "books," and the digital interactive medium of CD-ROM.[1] Literature, book art, and hybrids of the "writing machine" (E. Davis 1998, 31) can be viewed as paradoxical "storage devices" of the ephemeral or the spirit-like. In the range of works studied in this chapter, the language of the ephemeral expresses the disembodied, whether this be an ideal or a thematic focus on the unrecorded and the barely visible, socially or conceptually, or, finally, the intangible realms of myth and spiritual consciousness.

Contemporary visual art created through reference to the post-Gutenberg book form may figure art making as a subjective or fictive narrative, as one of many possible "stories" that cultures tell themselves. Artwork represented as a form of writing upon the larger text of society may thus question the authority, objectivity, and values reigning within different realms of society, including art historical discourse.[2] The written word and the book form may also be called upon to ironically "report on" the gendered and racialized cultural politics of scholarship, the art world, or society in general. Culturally distinct writing and picture forms, such as the Mesoamerican accordion "book," might be used to record cultural and gender differences, as well as to reflect upon modern-day pictographs, such as the photonovel and comic book novels. Comic books and animation-style drawing by the Chicana artists in this chapter self-consciously, and ambivalently, enter the theater of traditionally heterosexual, male projections, bringing largely unwritten images and stories into the popular cultural history of those mass media genres.[3] And in CD-ROM forays, as a new book format, the medium is indeed the message, and knowledge seen to be the product of multiple media and multiple sources.[4] Other pictographic formats involve combining traditional narrative with images, creating "altar books." And last but not least, "straight" narrative and sound recording nonetheless serve as alternative historiographical archives of the little-seen, little-considered worlds of the Latina/o communities in mainstream cultures of the United States.

The Book Art of Muñoz, Cervántez, and Montoya

Celia Alvarez Muñoz is well known for her photography, book art of the 1980s, installations, and public art projects. The Chicana/o Art: Resistance and Affirmation (1990) traveling exhibition featured the fourth book of her ten-part "Enlightenment Series," *Which Came First.*[5] From 1981 through 1985, Muñoz created ten books as part of this series.[6] Two were in the form of "match-books" (*Chispas Quemen*, #1 and *Double*

Bubble & WWII, #2). The fourth through ninth books of the series consisted of loose-leaf pages contained in boxes (see figures 52 a and b for book #9). *La Yodo* makes reference to Muñoz's childhood "imaginary friend [who was] fair and light-complected" (qtd. in Kutner 1984, E2). The third piece, *El Tuetano*, placed the sheets in a brown paper bag. In the eighth and ninth of the series, each page was framed. *El Espiritu Malo*, #6, took the form of a green accordion book. The tenth piece of the series, *La Tempestad*, is a mixed-media triptych that was wall-mounted.[7] Muñoz has stated, "My works are a narrative of visual and verbal expression. A love of story-telling, toys and books brought me to bookworks as an art form. Through them I reveal my bilingual and bicultural heritage; a schizoid type of existence from growing up in the border town of El Paso. I gently poke fun at myself and my culture. I call the works enlightenment stories, because they help me synthesize my own history" (quoted in *New Talent in Texas* 1986). Muñoz's trajectory, as the last piece of her "Enlightenment Series" suggested, has continued as an exploration of the exhibition wall and gallery space as surfaces upon which to inscribe images and written text and to further her concern with "two languages, two thought processes" and "visual lies, verbal truths or vice versa."[8]

Incorporating earlier pieces, *El Límite* (1991) was an installation that continued the exploration of the relationship between visual and written languages, as well as "the notion of assimilation and the difficulties of translating meaning from one culture to another."[9] The artist described her mixed-media installation *Postales*, dealing with the culturally specific ways in which Mexican migrants recreate a sense of home in the north, "as a giant book."[10] *Rompiendo la Liga/Breaking the Binding*, as the title indicates, was a piece that marked the breaking away from different sorts of strictures, including, one might assume, those limiting fine art book consumption (figure 53).[11] Originally made in collaboration with students throughout its process of conception and production, the installation reflected on the concepts and practices of religious and art patronage, and on the patronage of the larger community. Describing the effect of the stark black and gray figures and "a

"LA YODO," OR IODINE, WAS THE NAME I GAVE MY IMAGINARY FRIEND.
SHE WAS FAIR AND LIGHT COMPLECTED.

52 a, b. Celia Alvarez Muñoz, *La Honey*, and detail of *La Yodo*.
Enlightenment series #9, 1983. Mixed media, rock honey
maple box, seven framed pages, 9 ¾ × 12 ½ × 12 ½ in. each.
Collection of the artist.

53 Celia Alvarez Muñoz,
Breaking the Binding / Rompiendo la Liga,
1989–90. Installation. Collection of the artist.

line of text that runs along the wall at the eye level of a small child," one journalist wrote it was "like walking into the pages of a children's book populated with memory's ghosts" (Ennis 1990, 30; 32). Another described it as a "black-on-white-mural" (Tyson 1990, 7).

In *Abriendo Tierra/Breaking New Ground*, the artist's attention moved more fully to the question of the politics of space and the representation of what is seen as lost or dying. Extending the interior installation of wall painting into the courtyard of the Dallas Museum of Art, she built a dwelling based on those made by the traditional inhabitants of the El Paso area, the Hohokam (or Mogollan) and incorporated a pre-existing pool into her indoor and outdoor installation. She explained her " 'deconstructive' " approach to the space of the installation at the time, noting: " 'Just as a writer may break the form of a book, I broke the site of the installation, outside and in, and used the [museum's] glass wall as a transition."[12] In this same year, as part of her collaboration with UCLA's The Power of Place project, she self-published *If Walls Could Speak/Si Las Paredes Hablaran*, a thirty-two-page paperback book (figure 54). It was given away in the thousands and was described by Dolores Hayden as one of the most successful pieces in the The Power of Place's "The Embassy Project." The UCLA-based organization's project aimed to unearth the contribution of Latinas in the garment labor union movement of the first half of the century and their leadership in it, tracing this history through the recorded and remembered usage of the Embassy Hotel and Auditorium in Los Angeles.[13]

Muñoz's *Herencia: Now What?* was a commission created in response to a desire on the part of the curator at New Mexico's Roswell Museum and Art Center, Wesley Rusnell, to better reflect and integrate the local Hispanic community, as it calls itself, into the museum. In the early stages of the project, Rusnell mailed the artist clippings about the Roswell community. Muñoz then followed up with over fifty interviews of local Hispano leaders, some of whose words were inscribed on the museum walls. Playing off Roswell's UFO fame, Muñoz humorously explored the intertwining themes of invisible aliens and social alienation.[14] The curator, local community leaders, and art critics responded

54 Celia Alvarez Muñoz, *If Walls Could Speak*,
1991. Front cover, paperback, published 32-page book,
8 ½ × 7 × ½ in.

enthusiastically to the exhibition. Lucy R. Lippard wrote the text for the exhibition publication, concluding, "*Herencia* is a milestone in the long slow journey of artists toward exchange with people about their places" (1996, 4).[15]

Muñoz's engagement with public art continued in her collaboration in the five-year (1997–2003) expansion of the Henry B. Gonzalez Convention Center in San Antonio. Two of her designs, for example, were an accordion-shaped pedestrian bridge, making reference to northern Mexican and Southwestern musical traditions, and carpets featuring the history of San Antonio and Mexican folkloric dancers. *Fibra y furia: Exploitation Is in Vogue*, discussed in the previous chapter, continued this trajectory of engagement with issues that concern the communities where her work is exhibited, in its focus on the murders of more than two hundred young women *maquiladora* workers, beginning in the 1990s and continuing to this time, in Ciudad Juárez, across the border from El Paso.

If Walls Could Speak, a book project that the artist described as her "first step into public art" (C. A. Muñoz 1991, iii), ambitiously attempted to plumb the depths of the unseen, marking the traces of the socially and culturally ghostly, the historically ephemeral, and even something of what the inner lives of the users of a long-abandoned seamstress union building had been like in its heyday. "If walls could speak," the book begins, "these walls would tell in sounds of human voices, music and machines of the early tremors of the City of Angels. You would hear grand melodies ranging in style, beginning with the classics and ending with jazz. Also you'd hear the chatter of conventional camaraderie and the roar of the proletariat in progressive protest snapping the spine of the nation in place" (1–8). The book's three-part narrative and visual structure mirrors a three-part representation strategy and the three-pronged approach to the lives of the workers who congregated at the Embassy Hotel in Los Angeles through their labor, recreational, and political activities. The uppermost level draws on the research of fellow team members of The Power of Place, George Sánchez, and Al Camarillo, as well as that of historians such

as Vicki Ruiz, and records the early leadership and presence of Latinas as members of labor unions from the 1920s through the 1940s. A middle level consists of photographic, archival images and/or more text, culled from historical sources. These include photographs of the Embassy Hotel's façade and the interior auditorium that hosted concerts and dances along with labor meetings. Photographs of union activities and of the important and historically obscured labor organizers Rose Pesotta, Luisa Moreno, and Josefina Fierro bring to life both the historical and the familial narrative. The abundance of pretty, decorative elements surrounding historical images or embedded between narrative strips further conveys the cultural, intellectual, and ideological richness that can be erased in scholarly accounts through omission of the history of laborers or, conversely, through representing laborers as little more than mute, one-dimensional victims of greed and power. The third, bottom level of the book fondly recalls the artist's memories of her mother's experiences as a factory garment laborer and her revelation to the artist that she also worked at "The Union." Personal memory, interwoven with historic record, works powerfully in this book to demonstrate the meaningful presence and contributions of everyday Latina/o female and male workers.

The front and back covers of the book, like the walls that Muñoz had already dedicated herself to making speak in earlier works, reproduce a photograph of an auditorium filled to capacity with smiling, well-groomed Latina women. The book honors such women, whose participation in labor history, as in so many other facets of cultural life in the United States, has been rendered ghostly. As the artist hopes, her art book contributes to the effort "to evaluate our history more realistically with more than the usual stars shining" (C. A. Muñoz 1991, iii). It also successfully tackles the concern of visual artists in the 1960s and 1970s who turned to book art to create "democratic multiples," hoping that an inexpensive book format would allow greater circulation. That effort has been assessed as mostly unsuccessful, either as a tactic for unmooring art from the gallery system and delivering it more directly into the hands of broader audiences or as a medium receiving sufficient

art-world attention and support (Drucker 1995, 69–91; Zweig 1998). Muñoz's art-book and book-based installations of the 1990s, however, are instructive as examples of artwork that succeeds in democratizing the circulation of art, and in freeing it from the elitist aura of rarefied object most meaningful to connoisseurs and investors.

Codex Delilah: From Mexica to Chicana (1992), a mixed-media, experimental book, translates the Mesoamerican codex and the type of knowledge it recorded into culturally relevant terms today (figures 55a and b). The book form is particularly appropriate for the visual artist Delilah Montoya, given her concern during the 1992 quincentenary with the colonial encounters and their aftermath in Latin America on Indigenous and *mestiza* Latina women in the United States. "The historical contributions of women have been undermined or completely ignored," the artist writes.[16]

> This project attempts to correct that injustice by rethinking the traditional interpretation of the European/Native Encounter. The narrative of this artist book is viewed from the perspective of Six Deer, a fictional Mayatec young girl from the Tutuepec region near present day Mexico City. From her home to the nuclear weapons laboratories in New Mexico, the codex details Six Deer's journey of enlightenment. . . . As she journeys "pal norte" [*sic*], [to the north] towards Aztlan (spiritual home of her ancestors) Six Deer also travels forward in time meeting well-known women of the Chicano folklore tradition. Each of these characters informs her of the long and negative historical processes that were initiated by the European encounter. For example, Six Deer meets La Llorona, a manifestation of Cortez' mistress, Malinche, who describes the effect of the conquest on her people. As Six Deer travels through time and space she learns and simultaneously reveals to us our historical identity and how for our people, survival has meant learning to live within a multicultural heritage and ambiance.[17]

The exploration of the possibilities for meaningful translation of the pre-Columbian pictographic tradition of glyphs for our time leads the

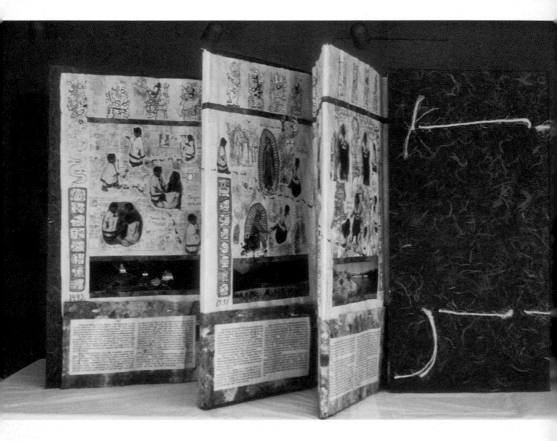

55 a, b. Delilah Montoya, *Codex Delilah: 6 Deer.
From Mexica [or Mexicatl] to Chicana*, 1992. Artist
book, mixed media, 18 in. × 5 ft. Detail: Panel 5.
Special Collections, Green Library, Stanford University.
Text by Cecilio García-Camarillo.

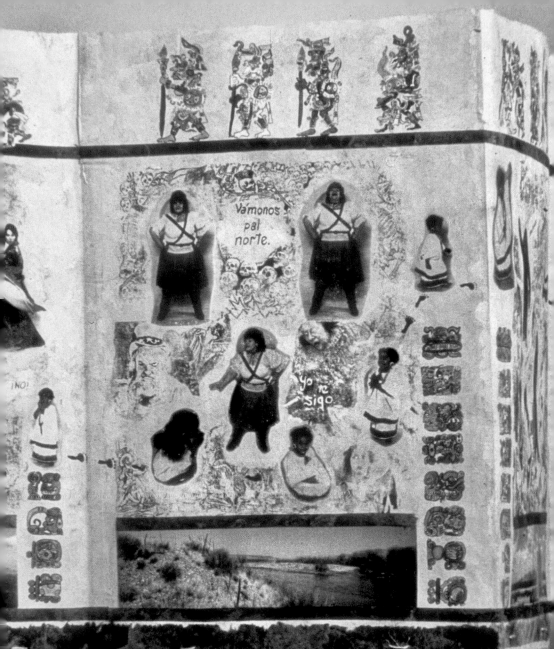

6-Deer kneels and stares at her face on the muddy waters of the Río Bravo. It's the same and yet different from the face she remembers when she left her village. Gone is the baby fat on her cheeks, and her skin looks tougher and darker. "But," she wonders, "I think it's my eyes that seem so different. Could it be that I'm learning to see truth?"

6-Deer washes her face and dampens her hair. She drinks a little of the dark water then looks towards Ciudad Juárez. People are awakening and turning on their lights. "Juárez, where are you?" she whispers.

Suddenly she feels a hand on her shoulder and a raspy voice asks, "So you're going to the other side too, eh? No problem, now is the best time to do it. I'll help you. I know where the river is real shallow. Come on." "Wait, what's on the other side?" 6-Deer asks facing the husky woman. "El Norte, of course," the woman replies. "You mean Aztlán," 6-Deer adds. "I don't know about that. It's just El Norte." "What are those things you have on your chest in the form of a cross?" 6-Deer inquires. "My, my, you're full of questions aren't you, girl?" the manly woman teases. "I'm Lucha Adelucha, a revolutionary, and these are the bullets I use to fight for liberty and justice. I may wear a skirt, but when it comes to fighting or running from la migra, police or most capitalist dogs, I'm as good as any man." "Who is the real enemy you're fighting," asks 6-Deer." "The oppressor. They're here in Mexico, the United States, everywhere. First they were called invaders, but now everyone knows them as oppressors. They've stolen the land, destroyed our traditions and hired the masses as slaves in their fields and factories."

"My heart tells me I must cross the river so that I can understand the truth. Will you help me?" 6-Deer asks. "Of course, come on. We'll walk together for a while. Hell, maybe you'll even join our struggle for freedom and equality," Lucha Adelucha expounds. "I like what you're saying, it makes sense," 6-Deer agrees. "Go ahead, I'll follow you." 6-Deer and Lucha Adelucha hold hands and slowly cross the Río Bravo as the first rays of the sun strike their bodies.

artist to cross the Mesoamerican codex with photonovels, landscape photography, and literary narrative. Montoya's undergraduate studies in Mesoamerican art led her to pattern her book after the narrative and reading conventions of the codex. "The composition of each panel expresses the Meso-American cosmic order."[18] With the exception of the cover material, each page is in four layers: a top, deities zone; a middle, earthly level; a third level, indicating specific spatial location; and, at the level of the Underworld, the written narrative, by the poet Cecilio García Camarillo.[19] Like the Mesoamerican codices, the text(s) can be read from various directions (top to bottom, or the reverse). It can also be read in four different languages: the Mexica- and Mayan-based pictographic (top, sides, and backdrop); the purely visual (landscape photography, second to the bottom layer); the literary (lowermost strip); and the photonovelistic (photographic images and written text in the middle and major portion of the codex). The visual continuity of the book is created by its accordion structure; its unifying construction with amatl and other papers; the use of a backdrop of glyphs; and the narrative of the young Six Deer, who travels five hundred years from Yucatan to New Mexico.

The idea of the northern and southern parts of the continent as one "book" is suggested through the narrative and visual continuity in the earthly section of the codex and is reinforced through the landscape photography, functioning as the "place glyph." While the photographs of distinguishable terrain are carefully matched to visually complement the different locations referred to in the three other levels of the codex, one is nonetheless struck by the similarity of these dry and mountainous landscapes. The book also creates a mythical space of temporal fluidity, since Six Deer, in panel number one, set in 1492, travels forward into the future of 2012 in search of Crow Woman, in the northern province of the historical homeland of Mexica ("Aztec") myth, Aztlán. The pages in between register her encounters with key female figures of Mexican and Chicana/o popular culture in a format that borrows from the photonovel, one of the most popular media of the Spanish-speaking world, and the comic book. Llora-Llora-Malinche (Cry-Cry-

Malinche) bewails the loss of Indigenous lives and culture destroyed by the Spanish invaders. Lupe-Lupita, the Indigenous Virgin of Guadalupe, however, assures her that "La tradición vive" (Tradition lives). But in 1687, Adora-la-Conquista, (Adore-the-Conquest, in reference to La Conquistadora, the patron saint of Christian New Mexico), advises her that "lo viejo debe morir" (the old should die) and to change her name to the more Christian "Reza-Rosario" (Pray–Rosary).

In 1910, Lucha-Adelucha (Struggle Adela–Struggle), a Mexican revolutionary *soldadera*, or soldier woman, tells her that she doesn't know anything about Aztlán but invites her in very colloquial Spanish, "vamonos pal norte" (let's go north) (figure 55b). In 1968, Six Deer meets La-Velia, a Chicana activist, who tells her that Chicanos "are mestizos proud of their Indigenous heritage," engaged in the "non-violent struggle for justice and equality." In the final panel, Six Deer reaches Crow Woman, an embodiment of the Sandia Mountains of New Mexico, dying from the toxic nuclear waste buried within her. Six Deer, messenger of Ix Chel, a Mayan goddess of healing, begins the slow cure of her new teacher, Crow Woman, promising to return to her homeland when the earth is restored to balance. Montoya's book mixes different "instruments. . . . of storage" (E. Davis 1998, 31), beyond those of the book or codex proper, to create a female-inclusive oral folklore tradition as one other such historical "text" and to recapture the oral component of decipherment that accompanied Mesoamerican codices. As Montoya has explained in an interview, the folkloric tradition records how Chicana women and our female ancestors experienced the last five hundred years. Their history, like the history of the pre-Columbian book, haunts present-day histories of the "book" and is a valuable resource in the face of noninclusion in official historiographies.[20]

The exclusion within male-centered Eurocentric curricula of the non-Western and female from which Chicana artists may draw both inspiration and artistic techniques is the subtext of Yreina D. Cervántez's charming and moving artist's book *Black Legs: An Education* (figure 56a). Cervántez produced the book as a response to her experience in the master of fine arts program at UCLA, where she was told directly by

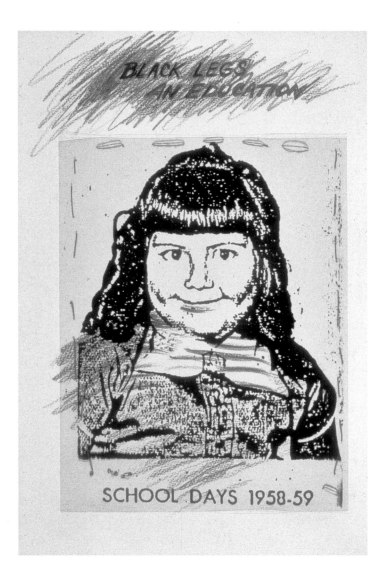

56 a, b. Yreina D. Cervántez, *Black Legs: An Education*, 1989.
Front cover, "School Days 1958–59," color pencil, 16 × 12 inches.
Page 5, "I See the Writing on the Wall. I Don't Like School,"
color pencil, 16 × 12 inches. Artist book, mixed media.
Collection of the artist.

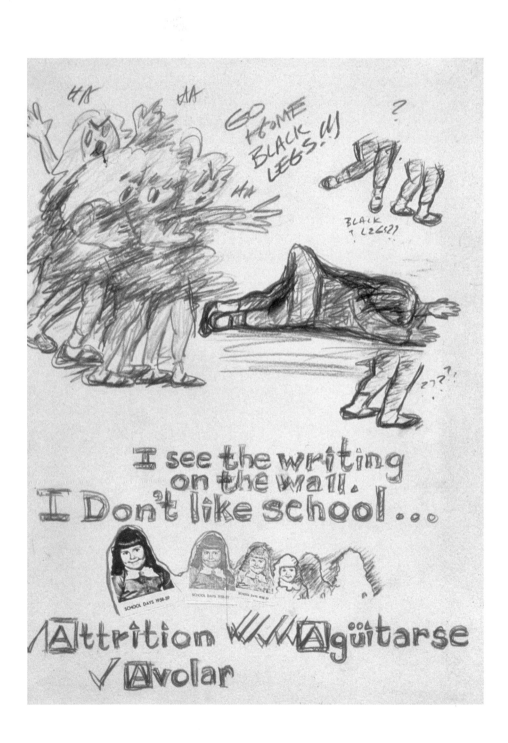

one faculty member that figural representations of women and people of color were not done at UCLA.[21] She found little support for her interest in spirituality, gender, or racialization or for the medium of her forte, watercolor. The message, she felt, was that her interests were naïve and not sufficiently "universal." This depressing experience reminded her of an earlier, equally painful period in her life when she experienced racist exclusion as a new student in a predominantly white grammar school. She tells of having been called "Black Legs" by a "Blondie" and pictures a moment when she was knocked down by a group of girls. "I see the writing on the wall," the text continues on the following page. "I don't like school . . . Attrition, Agüitarse, A volar" (Attrition, Demoralization, Flight) (figure 56b).

The book form is an ironic medium here, given the context of its production in 1989, while the artist was in graduate school. If page 3 of *Black Legs* records that for the child artist "drawing and coloring. . . . makes me feel better, purrr . . . ," the adult artist's alienation from art school is now figured through her "flight" from visual language as anything other than illustration to words and their medium, the book. Cervántez's "School Days"–style book is also a self-fashioned report card whereby she evaluates herself with "A's" throughout, though what these signify varies from "attrition" to "artistic." But her use of figural illustration and writing indirectly "speak" for the unarticulated subtext of the piece, her art school experience, only vaguely alluded to on page 6 of *Black Legs*. There, she draws herself as an adult and surrounds herself with the words of the African American writer Zora Neale Hurston: "Like the dead-seeming cold rocks I have memories within that came out of the material that went to make me. Time and place have had their say. So you will have to know something about the time and place I came from in order that you may interpret the incidents and the directions of my life" (*Dust Tracks on a Road* [New York: Arno Press, 1942]).

What Cervántez says through Hurston's self-affirming words about her unseen strength and worth in the face of disregard authorizes her own response, her book, to the sometimes unwitting and even well-meaning yet still ethnocentric and gender biases of art instructors, crit-

ics, and curators, knowledgeable only about their parochial cultural milieu, which they have been taught to believe is universal. *Black Legs: An Education* echoes in so many ways the art school stories of so many of the artists studied here, as well as many others who do not appear in this book. Because of this hostile pedagogic climate, *Black Legs* is also a coming-of-age story, symbolic perhaps of any artist, indeed any individual in search of authentic being, given that the final test, so to speak, is whether we have the vision and a sufficient sense of self to break beyond the vogues and cultural norms to which even those who profess knowledge, in teaching and artistic vocations, cling.

The Altar Books of Amalia Mesa-Bains and the Ortiz Taylor Sisters

I have discussed particular elements of Mesa-Bains's *Venus Envy Chapters I–III* in chapters 2 and 3 in some detail. Here I would like to return to the artist's conceptualization of her three-part installation as a collection of book chapters in an ongoing investigation. If this installation triad is indeed a trilogy, it is a heavy-duty tome, both in its spatial and temporal extension and in its ambition. Like smaller-format, more traditional artists' books, or installation book art, in which the viewer interacts with room-size visual and linguistic texts, Mesa-Bains's *Venus Envy* trilogy figures visual culture as discursive, that is, as engaged with the production of meaning in a community of individuals sharing or negotiating a common cultural language. The title of the work suggests that her artwork specifically engages psychoanalytic discourse, through the reversal of one of its key concepts, "penis envy." The patriarchal idea of women as lacking with respect to males, symbolized by a figurative or literal penis envy, is regarded as a culturally specific manmade theory rather than the natural law Freud hoped he was describing. Humorously, in Mesa-Bains's *Venus Envy III*, in particular, it is females and the so-called feminine who are "big" and who symbolize power as judged by their goddess-sized garments and accoutrements.

The literary critic Marjorie Garber has ironically pointed out the greater logic in the possibility of male "estrus envy" (Garber 1992), and Mesa-Bains would seem to be in agreement. The artist explores the possibilities of an "*écriture féminine*," not as a male-opposed essentialist notion of a biologically determined female way of writing, seeing, or feeling but rather the opposite, through props that speak of gender-defying performances that show the "crises" or inadequacies of the binary logic and biases, as Garber put it regarding different forms of transvestism, of current forms of patriarchal culture.[22] From this perspective, Mesa-Bains's ambitious "chapters" perhaps allude not merely to missing volumes but whole libraries absent within patriarchal and racialist discourses of knowledge.

Though *Venus Envy* extends beyond this field of discursive practices, and beyond the historical itself—if the historical is arguably understood as that recorded through alphabetically written record—its references are to a world history beyond the modern European, to the ancient Mesoamerican, the Muslim, and the prepatriarchal European. The size of Mesa-Bains's ambitions is indeed huge. And size is one way by which she figures her rejection of the intellectual paltriness of patriarchal claims and, simultaneously, pokes fun at contemporary Western male obsessions with penis and breastsize. In chapter 2, I discussed the gigantic, regal robes and the massive, reclining sculpture that literally outweighs and visually displaces the masculine objectifications of women inscribed in painting and other visual forms from at least the Renaissance through the present. Mesa-Bains's work belittles—in order to make room for other ways of imagining gender, and ultimately power—the limiting assumptions of still-dominant ideas about the supposed nature of women and femininity.

Venus Envy makes room for that larger investigation by using the installation space as a measure of the immensity of the tasks of inscribing women's missing presence in patriarchal discourse, and of correcting the distorted representations that do exist. The minutiae of the objects in Mesa-Bains's installations function as so many authorizing citations of the presence of women who speak through them, in some sense—not

only literally, through quotations from feminist writings emblazoned on the walls and through piles of pertinent books as part of the installation, but also through the objects speaking of historical and mythological female lives from different epochs. These quotations and the incorporation of a feminist "body" of texts occur on the level of visual art as well. In *Venus Envy I,* for example, images of artwork by other Chicana artists are mounted against a wall, a kind of mini art history and Chicana art exhibition. In this installation, as well as in the second, some of these images, in postcard form, are scattered as well in display boxes, in drawers, or among piles of cultural and/or autobiographical debris. This scattered quality connects the archaeological and Walter Benjamin–like impulse, quoted in Mesa-Bains's writings, for the location of socially relevant illuminations in precisely the rubbish-like heaps of "historical ruins." [23] Lived and barely recorded histories, as glimpsed in the traces of alternative belief systems visible in myth, the material culture of the past, and contemporary cultural practice, are the library from which Mesa-Bains visually and discursively claims space within the powerful imagination of patriarchal discourse.

Imaginary Parents: A Family Autobiography by sisters Sheila Ortiz Taylor and Sandra Ortiz Taylor rethinks the patriarchal family romance through the visual and the literary. The pictographic altar book is structured through an aesthetic of the seemingly random juxtaposition of found objects and a mining of the sometimes ambivalent memories triggered by these. Like Montoya's *Codex Delilah,* or Laura Molina's Jaguar Woman comic, *Cihualyaomiquiz,* which is discussed below, the Ortiz Taylor sisters' pictographic text self-consciously recalls autobiographical lineage through reference to pre-Columbian history. Sheila Ortiz Taylor muses in her foreword:

> Call this book autobiography. Or memoir. Call it poetry. Call it nonfiction. Or creative nonfiction. Call it the purest fiction. Call it a codex. Give it a call number. . . . I say it is an altar, an *ofrenda.* Small objects with big meaning set out in order. Food, photographs, flowers, toys, *recuerdos,* candles. *Pocadillas,* my grandmother would say. Scissors and paste, my father would say. *Bricolage,* my sister says. A miniaturist to

the bone, Bone Woman insists on all the parts. . . . *La Huesera*. Who else am I, in this making?. . . . A lawyer, like my father. I question, I return to the scene of the crime, search for weapons, motives, opportunities. I assemble the witnesses in the drawing room. And yet I cannot interrogate them; I can only heap up evidence. (1996, xiii)

For her part, Sandra Ortiz Taylor says of her visual strand of the book, described as a "double helix" by her sister's partner, "When I work with boxes as 'found objects' they may be containers for pieces. As such I frequently regard them as books; that is, the outside is the cover that sets the mood for the interior action. . . . In particularly successful pieces there are layers of meaning, like letters from the unconscious waiting to be opened" (xvi). Both writing and found-object boxes build themselves through material or remembered objects, indeed like an altar commemorating the family. As a dual autobiographical family memoir, the book is a shrine to the disembodied and the ephemeral: an invocation of an admittedly irrecoverable past and of deceased parents who may be only partially recuperable through a mixture of fact and fantasy. But the memories and indeed lives that it revivifies, like Pandora's opened box, are no longer neatly contained through the parents' at times narcissistic and socially ambitious idealizations of themselves and their family. Sheila's memory of being ill and alone and feeling "this terrible Tin Man has somehow taken away my real mother, leaving me with beautiful strangers who can dance and eat lobsters while orphans or the rightful children of royalty are devoured in the dark" (42) suggests that the sisters' childhood and the family past are sometimes also an emotional underworld. In another memory, the sisters are "in the Maid's Room now, moved the farthest distance from their parents' room. . . . Banished" (196). And elsewhere, recording feelings of adolescence, Sheila thinks: "There are no decent mirrors in our part of the house; my parents have them all" (204).

In passages like these, and in visual pieces like *Family Room*, where a Raggedy Ann doll sits in a corner of the room with a large gun on her lap (figure 57),[24] the reexamination of memory or dreamt experiences exposes the pain, damage, and anger beneath the idealization of

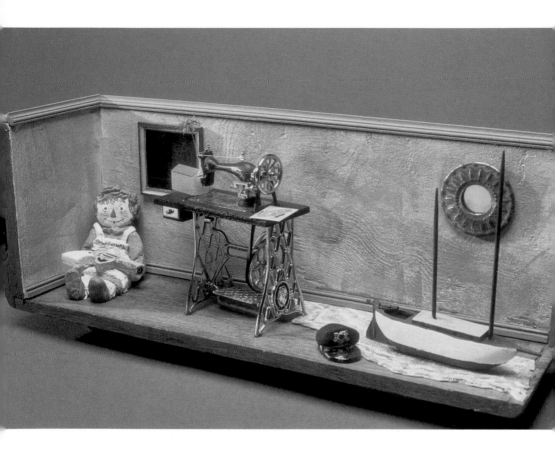

57 Sandra Ortiz Taylor, *Family Room*, 1992.
Mixed media, 5 ½ × 13 ½ × 4 in. Collection of
Joan Schulze. Photography by Phil Cohen.

the Hollywood-inspired family myth that sometimes marginalized the girls. The book testifies to a coming of age in the crafting of a different, independent version of the family narrative than the romance starring glamorous and successful parents, hindered by children who sometimes feel they are less than ideal props. The sisters' altar is thus perhaps ultimately an *ofrenda* for themselves. They have jointly created a space where their own subjectivities can play more freely, as happened in the old "electricity tree" they turned into their treehouse when they were children. In this sense, the altar symbolizes the need of those who are living to remember, as much as the "need" of our dead for us to remember them. The adult sisters' own narrative of the past is finally the means through which the irreality and dissimulations that beset their memory—and their identities—are released and mastered, thus opening up the possibilities for their own more authentic, less parent-haunted being in the present. It is not, however, that what they ultimately uncover is the lie of their parents' and their own childhood lives but rather the complexity of their different perspectives, generational and cultural, and of their sexual desires.

Stray lines here and there, like snags in an otherwise smooth fabric, hint at the unequal gender dynamics within the family (59; 155), at the tensions in the parents' relationship, at the mother's inculcation of racialized social climbing and gendering in her girls (80) but also at her preference for girls, even if idealized, and the legacy of female agency in her own mother's family (92).[25] The father's successful and relentless striving to improve himself is remembered alongside the "cheap[ness]. Or frugal[ity] which is the word he prefers" (205) and the fact that it, and his drive to be in control, unfortunately mark even his death. Even more delicately broached are the complexities of the interracial dynamics of the family, given the parents' love for each other, and the Anglo father's desire for his wife and the girls to not lose the Spanish language or their Mexican heritage. The maternal Ortiz family's desire to lose this heritage, however, and the girls' mother's angry correction, "We're not Mexicans, we're Early Californians" (11), hint at the powerful, repressed effects of the highly racialized Southern California culture of the first

half of the twentieth century and of the mother's internalized racism in her acceptance of the idea of the inferiority of Mexicans, and thus her identification instead with an idealized "Spanish" identity.[26] For all the parents' and their extended families' efforts to smooth over cultural difference and racial tensions, Sheila's adolescent obsessions (e.g., "My nose is the unhappy issue of two antithetical cultures," 204) obliquely reveal a different perception. The impulse of the Euroamerican father to enclose his Mexican American wife in a perfect Spanish colonial-style home and to urge her to cultivate her Hispanic ethnic roots suggests the effort to transcend cultural difference through the idealization of its seemingly more desirable aspects (Pisarz 1998).

Narrative fissures in the text, like those of the memories it records, eventually lead to the productive shattering of the illusions of glamorous perfection cultivated by the parents—and their Southern California culture of the 1940s. And it is this cracked reflection of the heterosexual, patriarchal, and racialized ideal of the gendered selves and the family that her parents toiled to reproduce that allows Sheila to come out of that boxed-in notion of the permissible and the desirable, to her own bisexuality, as explored in several parts of the book. It is significant that it is after her father's death, and away from the home he had built, on the way to their aunt's home in the town of Tepoztlán, that Sheila wakes from a nap feeling "tired of carrying around the little glass cage of a heart split in two and divided between her loves: the English teacher and the French teacher; Mary and Christ; the female and the male; the forbidden and the conventional. So much drama and dichotomy. When would she have either succor or solitude?" (254). It is in the house of this aunt, who pronounces the big straw Pancho Villa that they have purchased "simply magnificent," that they promise themselves to return, "my sister to paint, I to write" (257). As in Carmen Lomas Garza's visually female-inhabited house in her print *Camas Para Sueños* (Beds for Dreams, 1989), they "will fall asleep, dreaming the past into tropes and signs and symbols, beginning the dangerous art of fitting it all back inside the heart of a child" (257).

It is really no surprise that lines from Gaston Bachelard's *The Poetics*

of Space stand at the entryway of this altar book. But what is striking is the attention given to the ambivalence of the parental home. "A nest— and this we understand right away—" the epigraph reads, "is a precarious thing, and yet it sets us to daydreaming of security." In the Ortiz Taylors' work, the parental home is where the girl children, coming of age, do not feel themselves so fully reflected, contrary to the French philosopher's gender- and class-inflected musings.

The conception of artwork, home, and the self as altar-like underscores the desire for interior and exterior sacred dwelling spaces in *Imaginary Parents*. Perhaps it is not so much that different parents are desired, for theirs is the typical generational inability to escape the culture of their time, as the book repeatedly suggests. But it seems the unrealized selves of the parents haunt this book, alongside their children's sense of marginalization. Those spectral selves all speak of the yearning for a home within the self and the social world.

On the Interface of the Pictographic: The Comic Book-Style Art of Isis Rodriguez and Laura Molina

Trina Robbins, pioneering feminist artist and historian in the realm of comic books,[27] has observed in her histories of women's comics in the United States (1999) and great women superheroes (1996) that there have been several moments when comic books were consumed by and aimed largely at female readers,[28] in spite of the fact that "by the nineties, comic books had become not merely a boy's club, but a Playboy Club . . . produc[ing] sex object heroines which appeal to a male audience" (1996, 166). In contrast, Robbins notes a wealth of "wonderful girl comics" (139) by women self-publishing their own comics and zines during the 1990s. She does observe of these, however, that "so many women's autobiographical comics are depressing, and so many are about dysfunctional families" (127). Robbins also favorably reviewed the Los Cartoonists (September 11–October 10, 1999) exhibition at Self-Help Graphics/Galería Otra Vez in Los Angeles that included the work

of Isis Rodriguez and Laura Molina.[29] "Today's comic book world is a White Boy's Club," Robbins wrote, "in which men of color are a rarity, and women cartoonists rarer still. Thus, it was nothing short of revolutionary when . . . Los Cartoonists . . . included in its lineup five women of color, four of them Latinas. All five women come from different artistic backgrounds, and reflect fine art, traditional kid's cartoons and even superhero comics in their disparate styles" (2002).

Neither Molina's nor Rodriguez's comic book–style work of the 1990s could be described as depressing, although "the overt anger" in one of Rodriguez's images, *No More*, did cause discomfort, perhaps because that anger was expressed by an image of a brown Eve, handgun in one hand and a snarling tiger leaping out from her crotch (see Chicago and Lucie-Smith 1999, 110–11). The work of Molina, who describes herself as "The Angriest Woman In The World" on her Web site and in her self-published comic book *Cihualyaomiquiz: The Jaguar*, is likely to upset others as well, given Jaguar Woman's trouncing of Nazi skinheads and her snarling last words: "My ancestors used to eat their enemies. Viva la Raza! punks, see ya later." Rodriguez's and Molina's superheroines do not cater to the unproblematized fantasies of the typical Euroamerican, adolescent-identified male comic book and cartoon audience.[30] Molina's Jaguar Woman and Rodriguez's varied Superhero Virgins are particularly witty because they are superheroines with brains as well as the hypersexy bodies of the comic book world, engaged in battle against the seemingly superhuman forces of sexism and racism.[31]

Isis Rodriguez's superhero Virgin of Guadalupe pieces innovate in what is by now a large and fascinating body of appropriated and reinterpreted, Virgin Mary-Guadalupe imagery, more fully explored in chapter 6. As early as 1972, and continuing through the present, Chicana art has reassessed Western and non-Western visual historical legacies, especially the culturally ubiquitious, through a feminist and queer lens. Patssi Valdez, Yolanda López, Ester Hernandez, and Yreina D. Cervántez were among the earliest to seize a visually familiar icon, the Indigenous Virgin of Guadalupe who appeared in Mexico in 1531, and insert within her sacralizing mandorla modern-day *mestiza* women, as unex-

pected today as the brown, Indigenous Guadalupe was to the Spanish conquistador religious hierarchies. Rodriguez's Virgin superheroines in *Virgin Biker, Virgin I, Virgin II*, and *Virgin III* were originally drawn as towering, fleshy, and maternal figures, somewhat in the funky, lumpy style associated with Robert Crumb. In *Virgin III*, the deity looks like somebody's mother laying down the law for the last time. But in *Virgin Superhero*, Rodriguez drew her heroine in a 1940s style that is a cross between a cheerful, brown Betty Boop and Supergirl. Wide-eyed, cute, and girly now in traditional male-style representation, she lands with a wave of her hand and a cheery "¡Buenos dias Juanito!" but her crossed Superwoman-Virgin of Guadalupe costume makes clear she is a lot more than meets the eye. The T-shirt image, *Lupita Tee*, also pictured the Guadalupe as spunky, but this time as a little girl in a baby mandorla and a Band-Aid, playing with a yo-yo (figure 58).

Rodriguez's more recent work develops a comic book-style language that is a mixture of Japanese anime and U.S. superheroine, comic, and animated cartoon traditions. The *Little Miss Attitude* (LMA) series, ongoing since 1996, and especially the work of 1998–1999, has particularly succeeded in creating images of adventurous, self-possessed young women who can hold their own, providing empowering visual models for young women who feel the lack of options offered them in patriarchal culture where only guys seem to have the adventures (Gutiérrez n.d., 18).[32]

One of Rodriguez's LMA images (figure 59) appears as a mischievous-looking, spunky cross between Supergirl and a 'tween Virgin of Guadalupe. The one-time sale of T-shirts, underpants, and stickers bearing Rodriguez's Super Guadalupe images made these affordable to the young, female audiences she most would like to reach.[33]

In *Freedom* (figure 60), the Virgin biker superheroine appears as the imagined double of a stripper. The drawing was part of the *My Life as a Comic Stripper* series for Rodriguez's solo exhibition, at the Galería de la Raza, in San Francisco in 1997.[34] The opening was surprisingly large and coverage of the show ample in the smaller and independent press, but in a subsequent interview, the artist observed that the whole point

of the show—the tension between sexual freedom and sexual exploi-
tation—was overlooked by many who instead focused on the seeming
"glamour of being a lap dancer, an exotic dancer" (M. S. Lee 2000).
At least one critic got it right. Deirdre Visser reviewed the show in *Art-
week*, noting its reflection of the artist's own experiences as a stripper,
seduced into the business by "the promise of financial independence
and sexual freedom," and her reexamination of those assumptions.[35] Vi-
sser wrote, "The new stereotype-shattering female icons she's creating
in her art embody her struggle to understand the unresolved relation-
ship between sexual liberation and exploitation in both a personal and
a social context. In bringing her process into the public forum and in
using an accessible medium, she's extending the dialogue to the next
generation of 'bad girls'" (1997, 23).

That some other viewers and press missed the more serious implica-
tions of Rodriguez's *Comic Stripper* no doubt derives from the ambigui-
ties that structure her work. One of the major difficulties of the visually
uncharted terrain she is working on is that we are saturated with hyper-
sexualized images of women like those she employs in the *Comic Strip-
per* series, from Barbie dolls to TV shows, cartoons, comics, and men's
pornographic culture.[36] It is this familiarity which makes it difficult to
see that Rodriguez is visually referring to the ubiquity of a patriarchal
erotics in the seemingly innocent and harmlessly childish ideological
landscape of the worlds of animation and cartoons. The work is sexy and
titillating to the degree that our own desires have already been shaped
by such images. But even when these things come into view, another
difficulty lies in escaping the idealizations that such images produce,
precisely through their construction around the whore/virgin binary.
Rodriguez's refusal to idealize her stripper and related images through
celebration "of the whore as the symbol [of] sexual empowerment"
(M. S. Lee 2000) or as a flat victim, focusing instead on the politics
of sex-industry work as labor, configures a still unfamiliar feminist dis-
course.[37]

The smaller of the two rooms in the gallery where *Freedom* was seen
as part of the larger *Comic Stripper* show was set up as a peep show

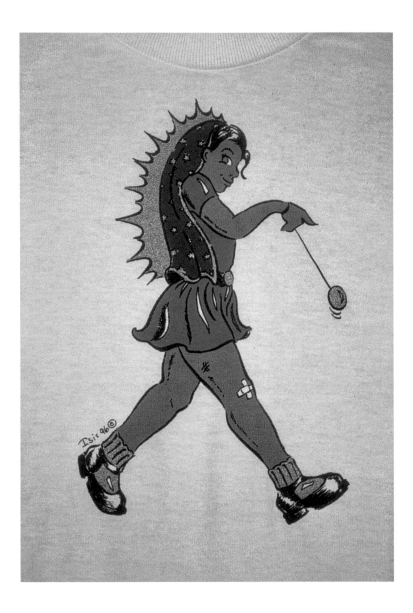

58 Isis Rodriguez, *Lupita Tee*, 1996.
T-shirt image. Photography by
Rubén Guzman.

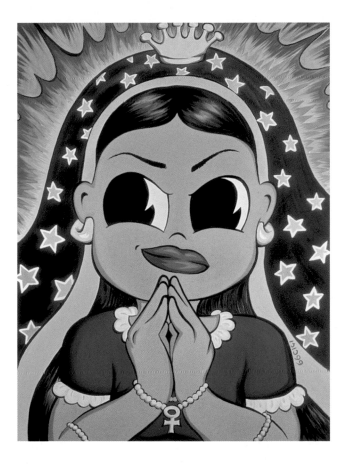

59 Isis Rodriguez, *Virgin LMA*, 1999.
Acrylic, pen, and ink on Bristol, 19 × 16 in.
Collection of the artist. Photography by
Judy Reed.

60 Isis Rodriguez, *Freedom*, 1996. Gouache
on Bristol, 13 × 20 in. Collection of the artist.
Photography by Rubén Guzman.

booth, linking art and sex show viewers, raising the issue of the seemingly passive voyeur's complicity in the larger systems that have created the sex and art industries as they function today. The pornography-style images, particularly *No More* and *She's Got Legs*, put the exhibition viewer explicitly into a position analogous to the sex show client in *Creep Show*, where a boss figure with a pig's head grunts, "It's still not enough!" as he looks down at the stripper, legs spread atop a slice of cheesecake. Read alongside *I Want You*, the promotional poster of a fictional "United Pimp Lobby for a Free Amerikkka," it becomes clear that the smiling stripper's seeming pleasure in *Freedom* is partly paid performance, and partly the effect of her own fantasies, since she is imagining herself riding off and leaving behind an absent-looking Virgin of Guadalupe image. It is significant that it is the stripper persona who drives off to a superheroine life of adventure, rather than the Virgin superhero of Rodriguez's earlier work. The performing stripper, with a Carmen Miranda–style Virgin of Guadalupe headdress, would seem, interestingly, to be in effect patriarchy's good girl as well, as she performs in the largely male space of the club according to their expectations rather than in defiance of these.

The cartoon stripper can also be read as thoroughly enjoying the mesmerizing effect the sight of her body has on the roster of familiar, stupefied U.S. cartoon characters in the audience, from Felix the Cat and Popeye to Bugs Bunny and the Road Runner, Fred and Barney, Scooby Doo, and even Homer Simpson. Such a convocation spotlights the hypersexualization of women in the cultural unconscious produced through the deceptively harmless childhood and adolescent world of animated cartoons, reinforced through the kinds of toys that the exhibition displayed on a table in the center of the gallery. *Freedom* suggests that the world of cartoons and the sex club have until now been one and the same, in that they are both dominated by the projections of male fantasies of sexually objectified, subservient females.

Rodriguez's seizing of the virgin/whore dichotomy to craft her stripper/superhero(ine)'s dual identity boldly confronts the cultural hypocrisy of Euroamerican and Latina/o cultures that "pimp" sexist and distorted views of women and men, through the mass media forms of

comics and animated cartoons. The enormity of the social and spiritual evils against which women struggle is symbolized by the superheroine persona of her Virgins and stripper. *In Mexico You Don't Fuck with the Guadalupe* features a gun-toting, girlish, brown Virgin and pointedly brings to mind the violence against women implied in many of the *Comic Stripper* pieces where women wear shackles, and which has been evident in real-life responses to other Chicana artists' feminist transformations of the Virgin.[38] It also makes reference to the patriarchal, humorless protests against feminist artistic revisions of the Virgin of Guadalupe, which I will return to in the next chapter. Within this historical context, Rodriguez's cartoons go to the very heart of patriarchal culture's virgin/whore dichotomy and its dissimulation, which produces and reproduces the sex-work industry and its generally sexist politics.

Laura Molina's Jaguar Woman is also partly modeled on the hypersexualized superhero(ine) comic book and animation traditions. In regular life, she is a "scholar of the law" who slips into her animal double persona in order to obtain papers important in her fight against the contemporary California backlash against civil rights and people of color. Racist police and neo-Nazi skinheads are the villains in this comic-book world. Jaguar Woman's Nahuatl name, "Cihualyaomiquiz," the reader is told, means "woman ready to die in battle." Linda Rivera prepares to transform into her animal spirit guide, the Jaguar, through ritual and prayer. From the cover of the comic book, she warns, "Right-wing fundamentalists — racist bigots and white supremacists!! Watchate! I resist!" (figure 61). On the back cover of the original version she is shown in fighting action, exhorting the reader to "Fight racism NOW!"

In a survey of the European and Euroamerican history of the comics and their century-plus imbrication with high art forms, Adam Gopnik observed that the advent of the comic book in the 1930s, particularly through the foundational genre of the superhero comic, "pointed the way toward the emancipation of comic-strip style from humor, or to put it another way, its degradation into illustration" (Gopnik 1990, 181). But Molina's *Cihualyaomiquiz: The Jaguar* is perhaps closer in its

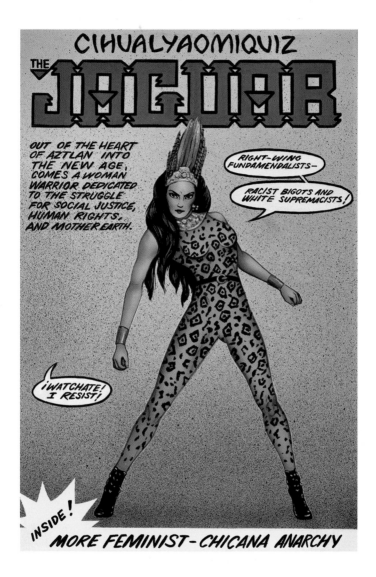

61 Laura Molina, *Cihualyaomiquiz: The Jaguar*.
Original comic book front cover, 1996.

aesthetics and politics to the graphic novels of Art Spiegelman, given the seriousness of the social issues that the format of fantasy allows them both to broach. The repugnant reality of the contemporary rise of neo-Nazi and Eurocentric racist sentiments in contemporary California is another commonality between Molina's art and Spiegelman's *Maus* books chronicling his Jewish parents' experiences of anti-Semitism in Nazi Germany and his upbringing in the United States in his parents' home, in the aftermath of those experiences.

Molina's folded 8 ½″ × 11″, self-published, slim comic, now in its second edition with a new cover image, is more or less indistinguishable from the do-it-yourself zine, especially in its politics of uncensored expression. The flourishing of the self-published zine among young women is an exciting development that reflects women's exclusion from the current boy's club of comics but also their refusal to compromise what they want to say and draw (see Robbins 1999; Zweig 1998; Vale 1996, 1997) and, finally, their criticism of mainstream cultures (Duncombe 1997).

The setting of Molina's comic book is, like Moraga's in *The Hungry Woman*, "the near future" of ongoing social injustice. In this case, "regressive legislation against immigrants turns California into a police state." A Newt Gingrich look-alike "illustrates" the explanatory text that occupies five subsequent panels.

> The newly elected right-wing, their very souls bought and paid for by greedy corporate monkeys and the super rich — rail against the immigrant and single parent as the cause of middle class ills like crime and high taxes. Racist hate groups fester, proliferate and grow more vocal and violent. The dignity of people of color is assaulted on a daily basis. Violence against La Raza[39] and others increases — racism reaches intolerable levels. But despite the rising oppression of people of color, the poor, the unempowered, from the ancient spirit of struggle and resistance emerges a new consciousness at the dawn of a new millennium. (1996, 2–3)

Law scholar Rivera "does what is necessary to see that justice is done." She transforms into her animal spirit double, the Jaguar, in order to

break into a law firm and examine some files for information that is being withheld from her. On her way home, two skinheads menacingly corner her in an alley and taunt her, asking if she believes in white power. Saying no, she swiftly kicks one of the two in the jaw. "It's over quickly," though. Cihualyaomiquiz—"woman ready to die in battle"—says to the felled pair, "you forced me to use violence to defend myself. But you guys are pretty lucky tonight anyway. After all. . . . My ancestors used to eat their enemies. Viva La Raza!, Nazi punks, see ya later." Molina battles neo-Nazi racism with Chicana/o nationalist pride, ironically embracing the frightening image of the "bloody Aztecs" in the Western imagination.[40]

Like Rodriguez's *Little Miss Attitude* and *My Life as a Comic Stripper* series, Molina's comic featuring Rivera/the Jaguar models the agency and vital impulse to fight back, rather than acquiesce to injustice. That this is done through physical violence is not precisely the point, given that the violence of racism today is widely effected linguistically, symbolically, and through exclusionary and exploitative practices. The Jaguar, like feminist Virgin of Guadalupe imagery, overturns stereotypes of the Latina as passive, subservient, and, for that matter, less intellectually and culturally sophisticated with respect to idealized middle-class Euroamerican norms. Like much of the Chicana art work we've seen, Molina too draws from a Mesoamerican cultural past and a present identification with the Indigenous in constructing her fearsome heroine, and this in itself is a tactic in the larger ongoing struggle against a racism that, like an evil comic book nemesis, keeps rearing its ugly head in ever-new twists of the same old plot.

Bending Narrative Boundaries:
Lucha Corpi's Psychic Sleuth Trilogy and
Rosa Martha Villarreal's *Doctor Magdalena*

Lucha Corpi's sleuth series, like Rodriguez's and Molina's drawings, is a gender- and genre-bender. Her sleuth uses psychic as well as intellectual gifts for rational deduction. At the start of the first book, the

protagonist is a young wife and mother, a Chicana, helped by family and friends on her cases. But in an ironic reversal of nineteenth-century European, U.S., and Latin American literary conventions that is now familiar to us, particularly in the widespread female-authored mystery and detective genres of the present, Gloria Damasco survives rather than dying. It is her husband, concerned about the time spent away and the danger to her family, who is made to unexpectedly perish for the narrative to go forward. His death and her daughter going off to college free Damasco from familial obligations to take up her calling as a private eye, eighteen years after she first receives the dark gift of her psychic vision. Throughout her career in the first three novels, *Eulogy for a Brown Angel* (1992), *Cactus Blood* (1997), and *Black Widow's Wardrobe* (1999), she is, therefore, like other gumshoes, single. But again, nodding to the expectations of the genre, she has a growing love interest in the wings: another private investigator, a Chicano who has left the Oakland police force because racism has prevented his professional ascent.

Corpi, the first Chicana mystery novelist, places Chicana/o culture at the center of her narratives. One interesting effect of such a decision is that it brings to the fore the crucial role that cultural knowledge plays in the ability to use one's powers of deduction. The fact that the highly rational and intelligent Damasco eventually learns to accept, trust, and use her psychic gifts, and those of others, also introduces an unlikely element into a genre generally defined by the undisputed powers of rational deduction. In Corpi's 1990s trilogy, a more complex model of intelligence and knowledge displaces, or, rather, outstrips the exclusive claims of post-Enlightenment scientific discourse to privileged knowledge. The rational and scientific are, of course, important components in Damasco's powers of detection, but they are not her only, or most crucial, tools. Nor is it left to chance or luck to explain the happy coincidences that help unravel her cases. The cases are always unraveled with the help of Damasco's and other characters' psychic abilities. In this sense, it is mystery itself that returns through Corpi's brand of psychic mystery novels.

Having traditionally defined herself through her intellect, the college-educated Damasco is at first distrustful of, and uneasy with, her visions and powerful intuitions. Eventually, however, she will accept the challenge from her best friend, the poet Luisa Cortez, to trust her intuition and psychic gifts because "there are things that can't be grasped intellectually" (1992, 48). It is in *Eulogy* that Damasco first receives psychic visions of terrifying things to come. These visions haunt her, until she finds the courage to acknowledge and entertain, rather than repress, them. In some cases, she is then able to glean information from them that is useful in preventing their materialization or some other harm from occurring. With increasing openness, Damasco uses the cultural "folk" wisdom of her family and Chicana/o culture as a source of knowledge and personal support.

Corpi's whodunits are set in the San Francisco Bay Area, with occasional forays to Los Angeles, or Mexico, and rooted in Chicana/o and Mexican American local histories. The mysteries these novels uncover "incidentally" are facts of these histories, given their widespread omission from official or popular accounts. *Eulogy for a Brown Angel*, for example, opens in Los Angeles, at the scene of the Chicano Moratorium, August 29, 1970, the largest gathering of Mexican Americans in the history of the United States. As is the case in García Márquez's *One Hundred Years of Solitude*, through the ruse of fiction, we are able to witness what official history represses. In this case, the historical if little-known fact is that the Los Angeles Police Department attacked a peaceful gathering of Vietnam War demonstrators that included families, children, and the elderly who were protesting the disproportionate number of Latinos drafted (C. Muñoz 1989, 86; Acuña 1981, 366–71). Many were killed, and many more injured. At the opening of the novel, it is therefore unclear if the murder of the "brown angel" has occurred at the hands of the Los Angeles Police Department or of some other culprit. *Cactus Blood* involves the fictionalized, illegitimate descendants of the old northern California, Mexican land grant Vallejo family, as well as the story of an undocumented Mexican woman, raped in her youth by her U.S. employer, who eventually dies from earlier exposure

to pesticides as a farm worker. *Black Widow's Wardrobe* opens during the San Francisco Mission District's Days of the Dead (November 1 and 2) procession and frames the issue of domestic violence as a recurring history through a character who believes she is the reincarnation of "the great maligned one" (1999, 119), the historical Malintzen or Doña Marina, who was given as a gift to Hernán Cortés and became his translator, the mother of his child, and was eventually passed on to one of his men.

In *Cactus Blood*, Damasco is gripped by the recurring vision of a woman bound, Christ-like, to a thorny cactus. As it turns out, she is also pregnant, and the image creates a visual counterpart to an observation that holds throughout the three novels, made in *Eulogy for a Brown Angel*:

> Her thoughts drifted over the many mothers who had been involved in this case. Lillian Cisneros and Mando's mother, Flora Cadena, had certainly suffered the greatest losses. Then, there were Cecilia Castro-Biddle and Karen Bjorgun-Cisneros, who had unwittingly unleashed furies and fools on the rest of them. They seemed to be caught in a game where all the main players were men, and the losers were all women and their children. When this was over—as in time of war and subsequent peace—the women would have to swallow their grief and their shame. They would have to comfort and support each other, then begin the long and painful task of rebuilding their lives. (1992, 170–71)

Indeed, like Laura Molina and Isis Rodriguez, Corpi poaches on what was long a traditionally male genre, ironically appropriating powers passed off as male-specific, those of detection, to fight the violence that male and racial chauvinisms unleash against women, particularly those of color.

Doctor Magdalena (1995) is a short novel by Rosa Martha Villarreal built around the concept of simultaneous space, time, and identities. Its protagonist is a woman struggling against the "prison of reason" (9) and

the patriarchal biases transmitted through the Spanish colonial legacy (9). More than experimental, its fluid spatial, temporal, and character structure seek to give form to related traditional Native American concepts of reality and spirituality. The novel begins in the present-day Houston reality of a medical doctor, Magdalena Ibarra, dutiful Mexican American daughter of socially ambitious parents. She too, like Corpi's Gloria Damasco, prides herself on her intellectual prowess, and like Damasco, initially resists all that seems irrational and might jeopardize her being respected in a male-dominated and racialized profession. However, "sleeping and waking dreams" (24) eventually draw Magdalena into the past so that she might remember who she is. Eventually she will bring forward into the future the knowledge and ideals she held as a "Dreamer" of ancient lineage who fled into the "tunnels of time" with such knowledge during the time of the Spanish conquest. To fulfill her mission and her self-willed destiny, she must recover the fluidity of her identity, and in order to do this, she must overcome her father's "train[ing of her] to be ashamed of what he called woman's witchery and superstition" (43). The paradox is that she must "remember whose daughter you are" (12) but forget the "false order" (11) her patriarchal, culturally Westernized parents upheld.

Dreams, voices, memories, intuitions, and desires all interrupt Magdalena's control of her thoughts, behavior, environment, and the narrative, estranging the reader, like the protagonist, from the language of time-space realities we take for granted, assuming that only they are real. It is precisely these cracks in knowledge and experience that allow other realities to surface, through which Magdalena will travel in both temporal and spatial directions to recover the "Ritual of Restoration" in ancient Mexico, which must be performed in Los Angeles. Her retrieval of the Ritual of Restoration will "restore us [Magdalena and her cousin, Consuelo]—the keepers of the old medicine—to visibility" (41), but just as importantly, it will restore a different and necessary cultural sensibility to a patriarchal, materialist modernity. As Magdalena rides in an ambulance with the cousin whose life and child she has saved with the Ritual and her surgical interventions, she reflects:

I watch this vision of the city world unfold before me, a city created by the dreams of men who would conquer not only a land, but an imagination, the desires of the most secret dreams of women and Indians. I imagine what my Spanish forefathers must have thought and wondered as they first looked upon the city of gold, Tenochtitlan. I, too, am a conqueror. I am their child. I have conquered the rivers of time with my desires. I can return to their conquered land and right the masculine wrongs: the rejection of the father of his children, and the sacrifice of the young woman, the virgin-whore, the mother of a new race. I have conquered my ancient fathers who denied to their bastard offspring their memory of the Indians. I have reclaimed the ancient dream, the invisible world of our Indian blood and its secrets about death and time. (71–72).

In the end, even Magdalena's father has his ancient purpose and identity as a keeper of time and reason restored. He too has a productive and crucial role to play, in patriarchal guise, in Magdalena's recovering and enacting the Ritual of Restoration. She concludes that she "defeated death with my father's dream, his desire to make me into a great doctor," the ambition he instilled in her, a gendering in which he too "defied his culture" (73), and that she "inherited the secret knowledge of the Indians" from him as well (77). Villarreal's novel is complex and challenging, and at first disconcerting, not only because of its fluid conceptions and enactments of time, space, and identity but also because, in seeming contradiction to these, it initially stages essentialist oppositions between male and female, Indian and European that it later undoes. It is eventually seen, for example, that the laws of the fathers refer to patriarchal culture in general, rather than to all men by nature. In the end, it is not one supposedly timeless culture or one essential gender over another that is espoused but rather their melding. "I dream," the penultimate chapter ends, "of the conquistadores and they worship a native god of feathers" (85).

Digital media seem to herald the disappearance of the paper-format book and the appearance of a new kind of text. Digital is the medium of choice for more richly conveying pictographic information in *Coyolxauhqui: An Ancient Myth, Chicanas Today* (2000), an innovative and prize-winning research tool and artwork created by Ana Garcia, Elba Rios, and Alma Cervantes (figure 62). The CD-ROM updates users on ongoing scholarly research and debates and the artistic elaboration of the iconography of the sculpture and the myths surrounding the Mexica warrior goddess. The use of this research tool cleverly mimics the underground investigations that led to the Coyolxauhqui sculpture's rediscovery on February 23, 1978, in Mexico City.

For Alma Cervantes, the CD-ROM medium helped her "learn to tell a story in a different way" and is comparable to the oral tradition, but now combining sound, still images, written text, and film.[41] The CD-ROM, developed as a prize-winning multimedia arts master's thesis at the University of California at Hayward, does reinscribe the oral tradition into new technologies by including film segments of scholars and artists telling the user about their work on Coyolxauhqui. One cannot help but see Coyolxauhqui scholars and artists as the *tlamatinime*, as described in chapter 1, of our times, orally deciphering their own or others' scholarly writings and artwork, the myths about Coyolxauhqui, and the iconography of the stone sculpture of Coatlicue's warrior daughter. Learning is presented as an underground search, as Latina animated characters travel through dark tunnels in search of knowledge. There is a visual and textual menu of six main areas, each containing further subdivisions. At the center of the Lazy Susan–shaped menu is "The Body of Coyolxauhqui" option, opening onto filmed interviews with the scholars Doris Heyden and Carmen Aguilera on the significance of the iconography and related concepts in the sculpture. The oral content is transcribed in both Spanish and English. Visual options include magnifying particular portions of the sculpture and accessing accom-

62 Ana Uranga-Gomez, *Cosmic Dancer*.
Interface detail from Ana Garcia, Elba Rios,
and Alma Cervantes, *Coyolxauhqui: An Ancient
Myth, Chicanas Today*, 2000. CD-ROM.

panying explanations of the imagery, in Spanish or English, orally or textually. The five other main sections of the CD-ROM are "Sacrifice as Ritual," "The Storytellers," "Re-Membering Coyolxauhqui," "Reflections of the Goddess," and "The Library," containing bibliographic information.

"Reflections of the Goddess" includes a gallery with images by the late Gloria Osuña Pérez, Yreina D. Cervántez, and Alma Lopez. The artists explain the significance of Coyolxauhqui in their work. Cervántez's remarks are especially interesting here. She explains that rather than nostalgia, what is behind the use of Indian concepts in Chicana artists' work is the attempt to deal with timeless concepts. Remembering figures such as Coyolxauhqui and issues embedded in her story such as the power struggle between matriarchy and patriarchy, and the political power of spirituality, she states, makes us whole. "We're speaking, of course, but at heart, Coyolxauhqui is speaking through us," she muses.

The two major versions of the Coyolxauhqui myth are recounted in "The Storytellers," that of the priestly perspective of the compilers of codices, and that of an accented Latina woman. The male gives voice to images of a monk and of codices that clergy compiled of Indian beliefs and customs. The woman's voice corresponds to that of a young girl reading a book. The monk recounts a version of the myth where Coyolxauhqui and her four hundred warrior brothers turn against their mother Coatlicue, intending to kill her because her impregnation by a feather, while she slept, dishonors them. Huitzilopochtli emerges from the womb and dismembers his sister, protecting his mother. In the woman's version, Coyolxauhqui awaits Huitzilopochtli's birth in order to kill him and preclude his legacy as god of war, but she is instead killed by him and his four hundred brothers. In both cases, Coyolxauhqui's dismembered body is exiled into the sky, as the moon. Scholars, in the "Re-Membering Coyolxauhqui" section, however, are debating this and other elements of the myths surrounding the goddess and her mother, Coatlicue. They are, in effect, like the artists, recreating the myths surrounding these figures.[42]

At the end of the CD-ROM, the stone image of Coyolxauhqui is re-

painted comic book–style by Ana Garcia, according to the original colors described earlier by the art historian and iconographer Carmen Aguilera, and the animated, re-membered goddess runs off, recalling the striking work of the Oakland-based artist and original member of Mujeres Muralistas, Irene Perez. Perez's *Coyolxauhqui Last Seen in East Oakland* is a groundbreaking and contestatory imagining of the goddess's body whole, rather than dismembered (figure 63). An immense version of this piece is incorporated, with various modifications, into one wall of the *Maestrapeace* mural on the San Francisco Women's Building. Here, Perez depicts the warrior daughter as artist, breaking out of the full moon–shaped sculpture with one hand, while holding paint brushes in the other.[43] CD-ROM allows Garcia, Rios, and Cervantes not only to re-member the figure and myth of the warrior daughter but also to animate her and, like Moraga in *The Hungry Woman*, to translate the "timeless concepts" of the myth into the cultural present of Coyolxauhqui's spiritual daughters: the artists, scholars, and activists engaged in battle against the myths of patriarchy and racism, and the social, economic, and cultural effects these spawn.

Marisela Norte is well known in Los Angeles for her "spoken word" readings of both poetry and prose. Her public performances date from 1980–81.[44] Like ASCO, the Chicana/o conceptual artists' collective and performance group,[45] she is an original rebel within Chicana/o culture, indeed the "Bad Girl Poet," as she was called by Linda Burnham in *High Performance* magazine in 1986. Though audiocassette and compact disc recordings of her readings, *Norte/Word*, were published in 1991, her work is surprisingly little known and unremarked even in Chicana literary circles outside Los Angeles.[46] Norte's meticulous craft and evident pleasure in the word is matched by few and her narrative voice is unmistakable. In *Norte/Word*, Norte's reading voice is generally a monotone, inflected with the longing and fatigue of a narrator who has been around the block a time or two and seen just about everything. Whether speaking for herself or collectively (as in "Salmo Para Ella," Psalm for Her), the narrator's persona, dipping in and out of the different pieces,

63 Irene Perez, *Coyolxauhqui
Last Seen in East Oakland*, 1993.
Acrylic on canvas, 96 × 58 in.
Collection of the artist. Photography
by Catalina Govea.

gives voice to the embarrassing, painful, and contradictory things she sees and feels.[47]

In "Peeping Tom Tom Girl," the speaker is an urban bard, telling, and in so doing, recording, the lives of the Latina women she observes as she crosses the city by bus. She is "driven to," "invaded by" the lives she observes, and "like a lost tourist," she says, "I can't help wondering why so many of us are being lied to, cheated, getting pregnant." Of these Los Angeles Latina lives, including her own, so unlike the gendered fantasies that have ill-prepared them for the burden of responsibilities they must juggle in reality, she concludes "somos actores sin papeles" (actors without roles; undocumented). Because they are neither scripted, nor documented, nor within the mainstream, even the telling of these lives is like the illicit act of a voyeur, for no one who matters is supposed to be looking at those marginalized lives.

In "Se Habla Ingles" (English Spoken), the black-lidded Chicana narrator, thought to be a "bad" girl by her Mexican female cousins, responds to their questions about love, boyfriends, and sex in the north with "El romance es un mito" (romance is a myth). The cousins' fascination with Euroamerican mainstream 1980s U.S. culture (e.g., *E.T.*, the natural look in makeup, *Dynasty*) is also poorly matched by the narrator's experiences. "And I am making faces at them," she says, "for those faces are making no mention of the social world back home: the other side . . . the urban circus where I perform. My emotional sword swallowing three shows nightly . . . and there is no mention of *imperialistas* who wear *zapatos exorcistas* [imperialists who wear exorcist shoes]." In "Baby Sitter Girl," the narrator is the world-weary social critic who could be any woman reading the newspaper. In noting that the raped and murdered baby sitter's story is buried on page nine, she makes one wonder at the numerous ways the girl was "bleeding before her time."

How do we trace the effects of the work of individuals who produce significant social and cultural effects through words and performances scattered in print, film, digital, or other media, and who are otherwise barely visible? Gloria Enedina Alvárez is a Los Angeles–based artist well known in the Chicana/o and avant-garde arts community there for her

poetry, performed throughout the city since 1982, and more recently for her highly praised translations and Chicana/o cultural adaptations of Jean Genet's *The Screens* and C. F. Ramuz's original text to Igor Stravinsky's *A Soldier's Tale*, in collaboration with Peter Sellars.[48] She has worked in numerous artistic and community venues. Her poetry has been incorporated into murals, paintings, prints, and experimental videos, and her influence has been felt through the numerous writing workshops that she has conducted, one of which led to the formation of the Chicana artists' collective, "L.A. Coyotas."[49] Her poetry has been self-published in chapbooks, collected in anthologies, published in newspapers, and published as a compact disc, *Centerground* (2004/2005). But more than anything, Alvárez's work, like Norte's, has been heard in numerous group readings, performances, art exhibitions, and local college campuses.[50] Her medium, the spoken word, is by definition ephemeral, but her published bilingual poetry is also marked by her concern for what escapes translation as excess or the culturally unfamiliar or unspeakable.[51]

Translation is, in fact, Alvárez's abiding concern. Her poetry is written in bilingual versions, or in a combination of both Spanish and English, which effectively gives voice to the biculturalism of Chicana/o bilingualism.[52] "Como unión," and "Come Union," for example, disarticulate the word "communion," in both Spanish and English, into two root words, but in the process uncover different meanings. "Como unión" can be read to mean "like union" as well as "I eat union." Similarly, the English version, "Come Union," is read in Spanish as "S/he eats union." In this poem where hunger for the beloved is precisely the point, the ambiguities of the title reflect the doubleness of this lover's discourse where the poetic I is, finally, revealed to be the object of her own desire.[53] In "Cuando Entras" (When You Enter, 1997) the translation is dispersed within a single poem, marking continuity but also manifesting the difference in the bilingual repetition:

Siento el vacio

The vacuous silence

fills

my arms fall

my eyes yield

and you are there

una corona de ausencia

te rodea

Estas sin el presente

Estas atras

El futuro te suspende

When you enter

I feel the void

Llena

el necio silencio

mis brazos caen

mis ojos ceden

y estas allí

a crown of absence

surrounds you

There without the present

Back there

The future suspends you

Bilingualism and translation add to the multiplicity and accumulation of possible meanings in the poem on yet another set of registers. "Llena" exceeds its immediate task of translating the word "fills," and stands alone as "I am/She is full" of the void and/or the silence mentioned in the preceding and following verses. The poetic I, a spectator, is filled with the presence of the desired other, and now silence is not simply vacuous, it is "necio," stubborn and ill-behaved. And whereas arms and eyes fell and yielded in receptivity in the second strophe, in the fifth, arms and eyes are unable to reach the desired other in his or her regal remove. The entering indicated in the title becomes rather the poetic voice's perception of the remote other, while the object of the poet's concerns is, in fact, unable to access the present, split as s/he is between

the past and the future. The poet seems to trace the spectral, attracting presence of one whose confused or unresolved subjectivity freezes or "suspends" him or her. The poem could thus be read as willful words to disenchant the other from the grip of a past excluding the poetic speaker, or conversely, as the very spell that wills the other's enchanted and paralyzing remoteness.

One of Alvárez's earlier poems, "TOTEM/La siempre firme" (Totem/ The Always Solid), of sixty verses, uses bilingualism to record the "crazy solitary multiple search" of Latina women, *mal correspondidas* or poorly requited by male mates and society. "Overdosing on Super Macho vitamins, unassimilable," they are described as powerful, beautiful, and full of life, yet "always under heavy criticism," "un mapa [a map] bordering locura,/roto y encendido/broken, in flames." Spanish-English bilingualism here marks with precision the inequalities that these two languages carry in the United States, and female, native Spanish speakers as the persons who most bear this maddening burden. The history of the Spanish language as a marker of the unequal cultural, political, economic, and social status of its native speakers dates to 1848, a legacy that is revived in the current English Only sentiment and in the anti-immigration and anti-affirmative action measures taken in California in the 1990s and elsewhere in the United States.

Tantas como yo
hirviendo, hinchadas
So many like me,
brown faced women
boiling, swollen
bodies/lives
a map bordering madness
vidas/cuerpos
un mapa frontera con locura
super señora,
chingate-loca,
daselo, hacelo,
super e-x-p-l-o-t-a-b-l-e mujer

The *locura* (madness) of what is experienced by "so many . . . brown faced women" is expressed in the reversals and riffs that succeed the translations, as well as the untranslated Spanish expressions (e.g., "super señora,/chingate-loca,/daselo, hacelo," and "chingándose como toda La Chingada" in verses 29 and 30). The lack of translation in these cases recreates the sensation of the impossibility of respite in the gendered *fregadera* (pummelling) that "tantas como yo . . . so many like me" Latina women endure, psychologically and economically, in Spanish- and English-language cultures. The impossibility of this bicultural, racialized location can neither be translated nor rendered into one single language. As with the other artists discussed here, as well as so many others, Alvárez brings into view the historically constituted violence of social, economic, cultural, visual, and discursive erasure whose effects are felt in the bodies and spirits of these women, but she also illuminates their resilient survival and creativity. Seen or unseen in literary, artistic, popular, or mass media, the Chicana artist's word is heard, her performance felt, her actions witnessed, and her transformative effect felt.

chapter six

Face, Heart

You had to align heart, spirit, & body. In order to be a man of worth all of the things had to be aligned. In their culture they believed that everything was connected

In ixtli in yollotl is a trope, a *difrasismo*, that yokes together the Nahua concept of "face" to that of "divinized heart," to express personhood as the attunement between inner and outer being, the person and the community, the earthly and the divine.[1] Life is the process of aligning these and properly making for one's self the face and heart of a harmonious, spiritually guided person of higher purpose. In Nahua thought, this work of alignment is particularly the work of artists. For negatively racialized women, for women further shamed because of their sexuality and sexual preferences, for those made lowly by unjust inequities, "making face, making heart" involves a labor of deconstruction and reconstruction, of tracing the histories of meaning attached to the verbal and visual images in which we daily traffic, of questioning the provenance of habits that push us back into place whenever we trespass social expectation. It means tailoring the fit of our thought, visuality (what and how we are able to perceive visually), and daily social performances of being to our particular bodies, as Gloria Anzaldúa so vividly suggested in the preface to her anthology *Making Face, Making Soul*:

Women of color strip off the *máscaras* [masks] others have imposed on us, see through the disguises we hide behind and drop our *personas* so that we may become subjects in our own discourses. We rip out the stitches, expose the multi-layered "inner faces," attempting to confront and oust the internalized oppression embedded in them, and remake anew both inner and outer faces. . . . You are the shaper of your flesh as well as your soul. According to the ancient *nahuas*, one was put on earth to create one's "face" (body) and "heart" (soul). . . . In our self-reflexivity and in our active participation with the issues that confront us, whether it be through writing, front-line activism, or individual self-development, we are also uncovering our inter-faces, the very spaces and places where our multiple-surfaced, colored, racially gendered bodies intersect and interconnect. (1990, xvi)

In the language of other contemporary, culturally democratizing thought, it means disidentifying (J. E. Muñoz 1999) or cross-dressing with respect to unjust social conformities (Garber 1992), and otherwise performing with a critical difference the normalizing roles we have been taught to merely repeat (Butler 1993). In other words, blowing the stereotypes of expected behaviors we *know* don't fit us.

Christian Virgins, Goddesses, and Superheroines

The courage to fashion the faces of, and the work of denaturalizing gendered and sexed expectations of, negatively racialized women is at the heart of the enormous body of Virgin of Guadalupe art by Chicana feminist artists.[2] This art disputes the disempowering patriarchal interpretations of the Mother of God that have turned her into a model of female acquiescence to male-centered society. In her study of twenty San Francisco Bay Area, second-generation, young married Catholic mothers, *Our Lady of Guadalupe: Faith and Empowerment among Mexican-American Women*, the Latina Catholic theologian Jeannette Rodriguez observed of her sample and the larger community they might represent:

Traditionally, they have been encouraged to emulate Our Lady of Guadalupe's qualities of humility, obedience, and ability to endure. If religious leaders stop at this limited view of Our Lady of Guadalupe, then the women will not have access to her other qualities: being faithful, tenacious, strong, a defender of the poor, and many more. . . . If these latter values/qualities were emphasized . . . then these women would have that much more to gain from this image of Our Lady of Guadalupe and she might remain a significant aspect of their world view. (1994, 131–32)

Chicana artists have been at work since the early 1970s reinterpreting this image in the Mexican American community and in the larger, feminist art-making community. Through hybridization with goddesses and popular culture superheroines, they have provided a different interpretation of not only the Mexican Mary but more generally of the Christian Mother of God archetype used so unremittingly as a screen of projections for the human patriarchal imagination for more than two thousand years (Warner 1983; Cunneen 1996; Johnson 2003). In Chicana visual art, creative writing, and theater, the Virgin becomes an archetype of the powerful and empowering in everyday women, who embrace the negatively racialized female body in ways that claim it too as a temple of the sacred. These images consciously overturn patriarchal projections re-rooted in colonial sexual violence against Indigenous women and women of African origin and the characterization of the dark female body of the poor as the site of evil (NietoGomez 1976, 1995, reprinted in A. García 1997).

Chicana scholars and artists have dared to go beyond the merely mortal, male-centered religious interpretations of gender, sexuality, and the demonization of paganism of the non-Western "dark races," refashioning for themselves interpretations of Guadalupe, the goddesses of Nahua, and other non-Christian pantheons that no longer cost them, or other women, a pound of flesh. Whether as culturally familiar symbol or spiritual force, they see her—or want to see her, as Sandra Cisneros has written—as a figure of empowerment for women, a champion of the poor and of social justice, their champion, instead of patriarchy's

yes man. "My *Virgen de Guadalupe* is not the mother of God," Cisneros has written.

> She is God. She is a face for a god without a face, an *indígena* for a god without ethnicity, a female deity for a god who is genderless, but I also understand that for her to approach me, for me to finally open the door and accept her, she had to be a woman like me. . . . When I see *la Virgen de Guadalupe* I want to lift her dress as I did my dolls' and look to see if she comes with *chones*, and does her *panocha* look like mine, and does she have dark nipples too? Yes, I am certain she does. She is not neuter like Barbie. She gave birth. She has a womb. *Blessed art thou and blessed is the fruit of thy womb* . . . Blessed art thou, Lupe, and, therefore, blessed am I. (1996, 50–51)

Chicana artists have called upon the Christian Mother of God's Mexican—that is, culturally and religiously hybrid—apparition image and activated it, so to speak, as the protector of those disenfranchised by virtue of their gender, sexual orientation, stigmatizing racialization, and poverty. For in this human war of images of the divine and religious systems, and of the ideologies that make these intelligible, they recognized that women have been made lowly by the stories, visual and otherwise, that have rationalized the physical, psychological, social, economic, legal, and spiritual violence against them in male-centered cultures, beginning in the home and religious institutions.[3] *La Llorona*, the weeping woman; Malintzen Tenepal, Cortés's translator given to him as "gift"; the *curandera* figure, a physical and spiritual healer; the pre-Columbian goddesses Coatlicue, Tonantzin, Coyolxauhqui, Mayahuel, Cihuacoatl —these and other symbols, alongside the Virgin of Guadalupe, have been reimagined by Chicanas in crucial post-1965 struggles over the social, ideological imaginary that shapes, and sometimes distorts, our realities.

The Spanish mystic nun Mary of Agreda (1602–65) shared in her detailed and extensive revelations, *The Mystical City of God*, that it was granted her to witness Mary's creation as, in effect, God's superhuman, spiritually and physically more perfect than Adam and Eve before the

loss of their powers in the Garden of Eden. Thus, in her revelations, after Jesus and beyond the legendary Old Testament prophets, Mary is the most sublime and powerful of humans (Agreda 1978, 42–43; 139; 569). In Agreda's visions, Jesus' mother, Mary, is a force of love and care for others, a superpower, in fact, of goodness enacted through the enormous power of her mind and will as directed through the active intercession of her prayers. Mary had a room of her own, Agreda tells us, in which she spent much of her time, undisturbed, and constantly at prayer in an effective, spiritual battle against evil. In the visions granted Agreda, Mary is not subservient, though there are touching contests between Mary and Joseph as they kindly attempt to outdo each other in service toward the other and in the care of their home. Joseph feels himself honored beyond merit in being espoused to the Blessed Virgin and is eager to serve his spiritually superior spouse, aware of the incredible blessing he has been granted by being chosen her earthly partner (Agreda 1978, 276–78).

Whether we read this as a seventeenth-century nun's protofeminist undoing of male-dominated religious discourses through the loophole of mystic revelation, or as another chapter in the historically evolving revelation of the Gospel's truth, or even as just another good story, it is, in fact, a counternarrative certainly more charitable and inspired on the question of women and gender than the intellectual disquisitions of early Church patriarchs (e.g., Origen, Saint Augustine) and medieval Church theologians (e.g., Saint Thomas Aquinas) that shaped sexist Christian thought. In Agreda's divinely inspired interpretive bid, known to Marian devotees who have included the Popes, she, among all, is the most powerful human, the fortressed "mystical city" through whom one reaches God and defeats evil, second only to her half-divine son. And whether viewed as holy writ or viewed as human fiction, the stories of the gender-bending Jesus and Mary resolutely illustrate a politics and a spirituality of egalitarian human relations and of nonviolent but active resistance, in clear opposition to the predatory logic of hierarchical power subjugating others. In congruence with Agreda's revelations of Mary as a human powerhouse poorly grasped in patriarchal

follies, Chicana artists and scholars, among many others, have sought to discover, uncover, and recover the power of the Mother of God—or her image—from self-serving literalist translations of her spiritual humility before the will of God as a prescriptive sign authorizing male privilege and female abnegation and submission before it. Furthermore, the image of her apparitions is characterized unmistakably by their ethnic and cultural diversity (Varghese 2000), significantly revealing herself in the recognizable flesh and tongue of the socially powerless of first and third worlds alike, challenging in this way the claims of those who put religion to use to authorize ethnocentric discourses of political extremists claiming to be religious.

In Mexico, the Mother of God appeared as the Virgin of Guadalupe. Dark-fleshed, she spoke in Nahuatl to the Mexica man Juan Diego in 1531, only ten years after the Spanish seized power. Likewise, she "appears" to Chicana feminist artists who work with her image and that of negatively racialized women, most significantly, even through their sexualities. The nonjudgmental aspect of the Holy Mother they have invoked through their artwork accepts women whole and unconditionally, lovingly sheltering under her mantle their hard-won and decolonizing love of their own bodies and those of other women. If our sexuality, and our genitalia specifically, have been eroticized through the projection of titillating evil upon them by Western patriarchal culture as the gateways to a deadly carnality and sin (Warner 1983, 53–59), then by necessity the uncovering of the dignity of each and every body that Mother Mary's and Jesus's incarnations symbolize must contest rather the "sin" in demeaning representations of these, and perhaps even the idealist belittlement of and violence against a body that is unavoidably the temple of embodied being.

Feminist Chicana artists have shown Mary-Guadalupe as an ordinary woman, with a sometimes very visible body, and in contemporary clothing. They have also seen in her overall silhouette the elongated, flower-like shape of the vagina (Trujillo 1998). In the novel *Santora: The Good Daughter* by Resurrección Cruz (2001), it is the image of a vagina that appears in the sky one day to an awe-struck Santora (139).

And in *The Virgin Vagina: The Transmogrification of Women*, a 1997 installation and performance, Patricia Valencia lay like a trauma victim on a wooden platform with an image of Guadalupe on her crotch. In one hand, she held a Barbie doll and in the other, a Mexican Zapatista National Liberation Army Commander Ramona doll. Her legs were tied apart and between them she propped a sign reading "$5 a pop or should I say $5 a prayer." The young artist's accompanying written text discussed the politics of conquest of the Indigenous and the Barbie doll-like roles offered to women today, as well as the example of the Indigenous female rebels of Chiapas who rose up against ongoing racist exploitation by Mexican landowners. She concluded, "The more that I looked at the image of the 'Virgín de Guadalupé' [*sic*] the more I realized that it is more about sexual revolution than the condemnation of sex. In the image of the virgin one can see all of these roles that have been placed on women, [b]ut there is hope with a new perspective of what the image of the virgin resembles, a vagina, a reclaiming of our sexual and social identity."

In poetry collections like *Women Are Not Roses* (Ana Castillo) and *Loose Woman* (Sandra Cisneros), Chicana writers express a sexuality that is not submissive to male-centered desire or silenced by the prohibition, again buttressed in patriarchal religious interpretation, against female sexual pleasure. In Cherríe Moraga's play *Giving Up the Ghost*, Marisa, raped as a child and haunted by the sexism and homophobia of culture and her own internalization of these, remembers her female lover saying to her, "You make love to me like worship." She thinks of how she would have like to have responded " 'Sí, la mujer es mi religion'" (Yes, woman is my religion), musing sadly in this closing monologue, "If only sex coulda saved us" (1994, 34). Moraga is perhaps suggesting that the healing power of lovemaking that places female pleasure and fulfillment at its center is like religion in that it aspires to be an embodiment of the spiritual ideal of love.[4]

In a later Moraga play, *Heroes and Saints*, Cerezita, a young woman who is born with only a head as a result of pesticide spraying of crops, stages a public protest "draped in the blue-starred veil of the Vir-

gen de Guadalupe" (1994, 144) and accompanied by the small corpse of another victim of agricultural chemicals that she has arranged to have symbolically hung upon a cross. Minutes before being peppered with bullets from an overhead helicopter, awakening from a meditative trance in which she has assumed the Virgin's characteristic downward gaze and facial expression, Cerezita addresses the gathered crowd, saying, "Put your hand inside my wound. Inside the valley of my wound there is people. In this pueblito where the valley people live, the valley runs red with blood; they are not afraid. . . . you will be free. Free to name this land Madre. Madre Tierra. Madre Sagrada. Madre. . . . Libertad. The radiant red mother . . . rising" (1994, 148). Cerezita, already mutilated by pesticides from birth, is finally martyred with the rest in a hail of bullets because of her redemptive message demanding justice and is spurned, like Jesus, by the socially and economically powerful.

Chicana artists and the institutions that support them have repeatedly been reminded that reinterpreting the meaning and image of the Virgin as ordinary woman or goddess is dangerous work. Hernandez's 1975 *The Virgin of Guadalupe Defending the Rights of Xicanos* was received negatively by some (Quirarte 1992, 21). In 1978, as a result of featuring Yolanda López's *The Virgin of Guadalupe Goes for a Walk* on its cover, in heels and a dress that exposed the Virgin's calves, the office of the feminist magazine *fem* was bombed in Mexico City. In the late 1980s, Ester Hernandez received a death threat by phone in response to her silk-screen image *La Ofrenda*, which had appeared on the cover of the first edition of the anthology *Chicana Lesbians: The Girls Our Mothers Warned Us About* (Trujillo 1991). More recently, Chicano nationalist activists and Roman Catholic clergy demanded the removal of Alma Lopez's *Our Lady* (1999), a digital print exhibited in 2000, from the Cyber Arte show at the New Mexico International Museum of Folk Art in Santa Fe, because the artist had placed a defiant-looking woman clad in flowers within a mandorla and had bared the breasts of an equally unamused female cherub (figure 64).

In the artist's written response to the letters and demands she and the museum received, Lopez astutely wondered what it is about women's

64 Alma Lopez, *Our Lady*, 1999. Digital print.

nude bodies that seems inappropriate and sacrilegious to the men leading the protest to censor her image (2001, 255). Conversely, we should ask what it is about a painting of a man bearing a tattoo triptych of a naked pin-up, the Virgin of Guadalupe, and a "good girl" in braids, exhibited during the same time period but circulating widely to several museums and through its exhibition catalog, that seems inoffensive, drawing instead only the wink-wink approval of its content and technique by its famous owner, the owner of most of the pieces in the show. I am referring to Cesar Martinez's image of a neighborhood type, *Hombre que le gustan las mujeres* (Man Who Likes Women) in Cheech Marin's otherwise important Chicano Visions: American Painters on the Verge, an exhibition launched in 2002 and scheduled for exhibition through 2006, which contains other stereotypical and offensive images of women as sexual objects and objects of sexual violence that are so familiar that they appear natural and thus unworthy of comment, though clearly not of notice.

By contrast, Alma Lopez's *Our Lady* is clad in the Virgin's favorite flower, the rose (Calvo 2004, 2000). Though the artist does not eroticize the female bodies in this print, she did so explicitly, however, in *Lupe & Sirena* (figure 43), in which the two traditional images are drawn from both religious iconography and the popular Mexican bingo game *Lotería.* "And, what of it?" Lopez's *Lady* seems to ask. Perhaps the focus in male-dominant culture has remained on which bodies we are ostensibly permitted to love—or degrade—rather than how we should love them, because its institutionalized inequities against women, and the unrelenting statistics of rape and other forms of violence against women, demonstrate that you don't have to love them to *chingar,* or screw them over. Eroticized images that are dehumanizing and violent to women are not only openly tolerated; they are ubiquitous visual reminders of what some men have done, and others will continue to do, to hold power over women.

The historical and present-day hypervisibility of images of women in positions of subservience and as objects of male power, sexual desire, and violence, cyclically reinforce, and are reinforced by, the use of the

Virgin of Guadalupe as a model of abnegation and passivity with respect to patriarchy. Thus, Chicana feminist artists struggle over the representation of the everyday negatively racialized female body through her. Her mandorla, her gown, and other signs of her sanctity are borrowed visually to conceptually "protect" or dignify and sacralize the otherwise trampled bodies of real women. As patroness of the Chicana/o movement, and the symbol of the righteousness of other radical struggles for social justice, the Virgin has been promoted to goddess, queen, and super-heroine by the Chicana feminist movement.

In 1972, even ASCO, the Los Angeles–based conceptual and performance art collective that prided itself on resistance to the Chicana/o movement's own new stereotypes, laid claim to her in *Walking Mural*. In their march down one of the busiest streets of East Los Angeles on Christmas Eve in 1972, a punky Patssi Valdez wore a black glittery gown, white and black makeup, and a black and silver mandorla around her head (figure 65).

She was accompanied by a three-headed crucified Christ also in black and white, and a Christmas-tree-in-drag character (Romo 1999, 13–14; H. Gamboa 1991). Writing about Valdez's work for the San Francisco Mexican Museum's retrospective survey of her painting, and citing Valdez's statement in 1989 that her interest was in the aesthetics rather than religiosity of Virgin imagery, Amalia Mesa-Bains observed of the 1972 performance that "the Dark Madonna is the first of Valdez's ongoing representations of racialized beauty, and one of the first Chicana reconstructions of the *Virgen de Guadalupe*" (1999, 37). Valdez would go on to explore punkish black Virgin-like figures in her photography and altar-installations, and in her dark goddess paintings of the late 1980s through at least 1996, when she painted a visually dominating (48 × 24 inches) *Virgen of Guadalupe* compassionately cradling the city of Los Angeles in her arms.

Another early image combining the popular cultural with the Mesoamerican was produced by the San Francisco-based artist Ester Hernandez, *Libertad* or "Liberty," a 1975 etching. It depicted a female artist chiseling away at the Statue of Liberty, freeing from within it a regal

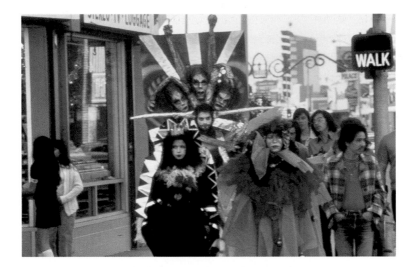

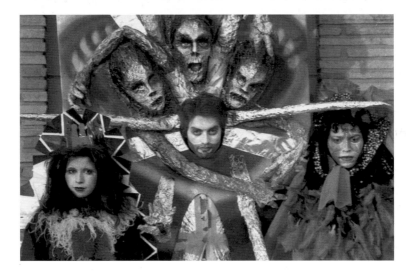

65 Patssi Valdez as Madonna, detail of
Walking Mural, December 25, 1972, ASCO
performance, Whittier Blvd., Los Angeles,
California. Photography by Harry Gamboa Jr.
Collection of Harry Gamboa Jr.

Mayan female figure and, in the process, creating a culturally composite image of Lady Liberty that encompassed women of color, descending from Indigenous and mixed bloodlines, alongside those of European descent (figure 66). One year later, Hernandez created *The Virgin of Guadalupe Defending the Rights of Xicanos*, using the familiar iconography of the Virgin's mandorla, or full body halo, to suggest an idea of feminine power and sanctity that differs from the one received through male-centered interpretations of a Bible-mandated female subservience to men (figure 67).

Early Chicana feminist scholars such as Adelaida Del Castillo, in her 1974 analysis (reprinted in Del Castillo 1990) of the misogynistic demonization in Mexican nationalist thought of the Indigenous Malintzen ("La Malinche") as the traitor of *mestizo* Mexico, and the historian Anna NietoGomez, in her essays of 1976 and 1977, showed the links between imperialism, racism, patriarchy, and *marianismo*, or male-serving Marianism. NietoGomez argued that the ideology of *marianismo* rationalized the Christian European colonizer's patriarchal, racialized gendering of women, such that after the Spanish invasion and colonization, more socially mobile and empowered Native American women inevitably played the fallen Eve to the more socially controlled, American-born *criollas* (Spanish) and white-identified *mestiza* women (NietoGomez 1976, 1995, reprinted in A. García 1997).[5] Del Castillo and NietoGomez wrote in response to male-centered Chicano nationalist criticism of Chicana feminism as disloyal, "white," "lesbian," and altogether unnatural to Chicano culture.

These early Chicana feminists, together with Martha Cotera, Elizabeth "Betita" Martinez, and Ada Sosa Riddell, most cogently argued instead that anti-racist, decolonizing struggle had to be more than a struggle for Chicano men's rights "first" or for a patriarchal, colonizing conception of personal and communal "family." They asserted that the history of feminist and female struggles on behalf of justice were as old as female resistance to colonization, from the seventeenth-century intellectual Sor Juana Ines de la Cruz, to women's participation in the Mexican independence struggle of 1821, to women's resistance to the annexation of Mexican territories in 1848, to their intellectual and po-

66 Ester Hernandez, *Libertad /
Liberty*, 1976. Etching, 12 × 9 in.
Collection of the artist.

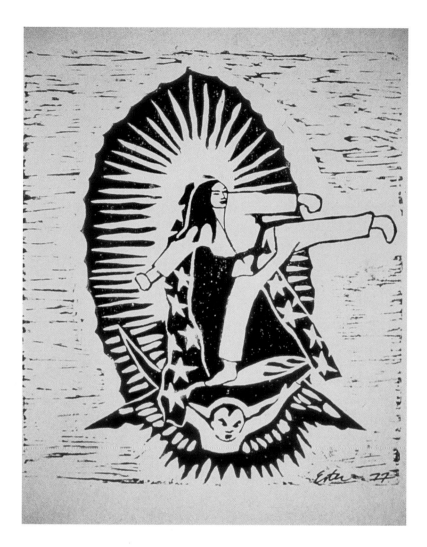

67 Ester Hernandez, *La Virgen de Guadalupe Defendiendo los Derechos de los Xicanos / The Virgin of Guadalupe Defending the Rights of the Xicanos*, 1975. Etching, 9 × 12 in. Collection of the artist.

litical leadership within the Chicana/o movement of their own day (A. García 1997).[6] The historian Antonia Castañeda has shown that the roots of this present-day racializing, male-centered logic existed on the Mexican frontier and in California in the nineteenth century (1990, 1993).

The excavation among Chicana artists in search of knowledge of ancestral female pre-Columbian cultures, particularly when juxtaposed to their Guadalupe-themed work, was far from being a naive idealization of the good old days before colonization. Feminists did not picture themselves as the swooning Ixtacihuatl princess in the arms of Popocatepetl, according to the legend immortalized in calendars distributed each new year by butchers, grocers, and barbers in Spanish-speaking neighborhoods in the United States. If, as I have said, much Chicana feminist art using the Virgin's image shows her as an everyday female—countercultural urban punk, working-class middle-aged laborer, physically disabled, spunky, spirited, defiant girl, agent of sexual desire both straight and queer—another body of Chicana art represents her as a goddess. And how could it not be so, when research revealed the presence of gender-bending creator gods, expressed simultaneously as female and male (such as Ometeotl), and pantheons of similarly twinned gods representing the cosmos and nature? Feminist scholarship disseminated by Gloria Anzaldúa and others also revealed that the Mexica ("Aztec"), though less thoroughly than Western culture, had displaced female power in their elevation of the male god of war Huitzilopochtli over and above his sister Coyolxauhqui. The Virgin of Guadalupe and pre-Columbian goddess myths and images thus served to inspire Chicana feminist scholars and artists to investigate, and then visualize, nonpatriarchal notions of womanhood as modeled by deity figures. The juxtaposition of the visual traditions of both popular Mexican and Indigenous cultures present in the dark Virgin, "La Morenita," has long been observed, but it was further explored in experiments combining visual elements from various European and pre-Columbian traditions.

Yolanda López experimented with these and other cultural collages extensively in her Guadalupe work from 1978 through 1988. Her well-

known oil pastel Guadalupe triptych of 1978 (figures 68–70), has been reproduced numerous times, mainly in feminist and Chicana/o art publications.[7] These drawings were part of a larger, groundbreaking *Guadalupe* series exploring the possibilities of mixing European and Mexican-Indigenous art histories and visual art languages. At the time López was an atheist; her concern with Virgin of Guadalupe iconography was more an experiment of speaking through the familiar to a population visually and not simply religiously shaped through culturally omnipresent images (López 1996). López made collages of Indigenous breast-feeding women, such as *Madre Mestiza* (1978) and *Eclipse* (1981), the latter of which showed an image of the artist herself jogging away from the frame. She created composite images of the Virgin and an earlier Nahua female goddess, a version of the creator-destroyer goddess Coatlicue, in *Nuestra Madre* (1981–88) (figure 71). And in *Love Goddess* (1978), she overlaid Botticelli's *Birth of Venus* carefully within the Virgin's mandorla, suggesting that despite different traditions, these two images represent continuity in the discourses of gender and sexual desire within male-centered cultures, even as these were signified by the clothing of one and the lack of it in the other (figure 72).

This melding of the visual languages of sanctity in the Western religious imagination, the popular, and the Native American continued in the work of many Chicana artists in various media, including the later work of Ester Hernandez. In *Full Moon/Luna Llena* (1990), created during a period of active, if covert, U.S. intervention in the civil wars of Central America, Hernandez protectively enveloped a Central American Indigenous *campesina* revolutionary within the shadow of the moon goddess Coyolxauhqui (figure 73). Alongside other Chicana feminist reinterpretations of the Mexica myth, Coyolxauhqui, the daughter of creator-destroyer goddess Coatlicue, is no longer characterized as evil. Rather than being the vengeful daughter wishing to destroy her mother because she was mysteriously impregnated by downy feathers while sweeping, she instead attempts to destroy her brother, the god of war who would become the Mexica's supreme deity, Huitzilopochtli, throwing off balance the earlier, broader Nahua culture's

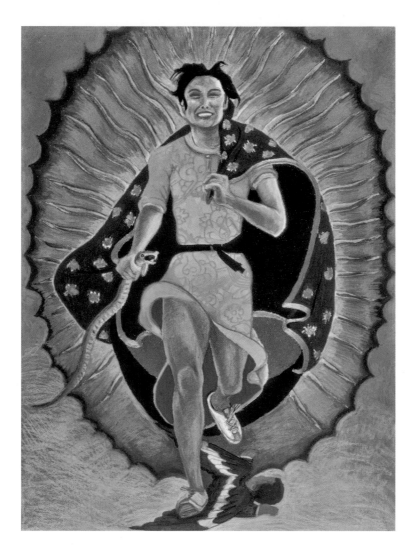

68 Yolanda M. López,
*Portrait of the Artist as the
Virgin of Guadalupe*, 1978. Oil
pastel on paper, 32 × 34 in.
Collection of the artist.

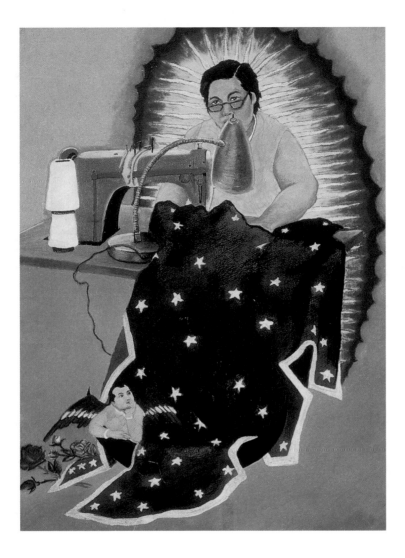

69 Yolanda M. López, *Margaret F. Stewart: Our Lady of Guadalupe*, 1978. Oil pastel on paper, 32 × 24 in. Collection of the artist.

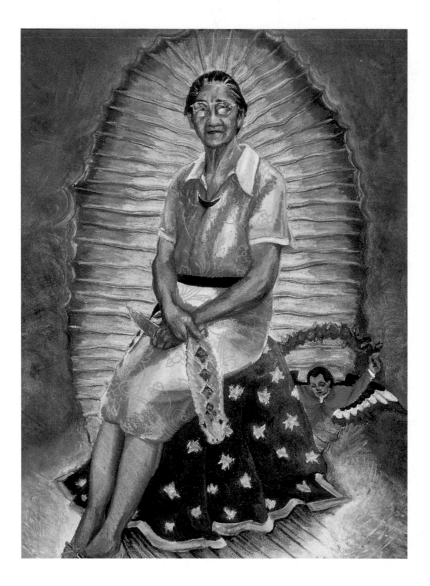

70 Yolanda M. López, *Victoria F. Franco:
Our Lady of Guadalupe*, 1978. Oil pastel
on paper, 32 × 34 in. Collection of
the artist.

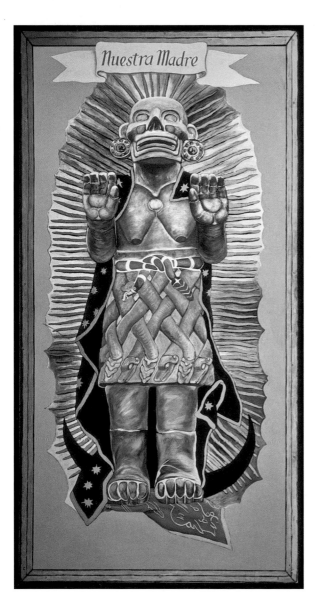

71 Yolanda M. López, *Nuestra Madre*, 1981–88. *Guadalupe* series. Acrylic on masonite, 4 × 8 ft. Collection of the artist.

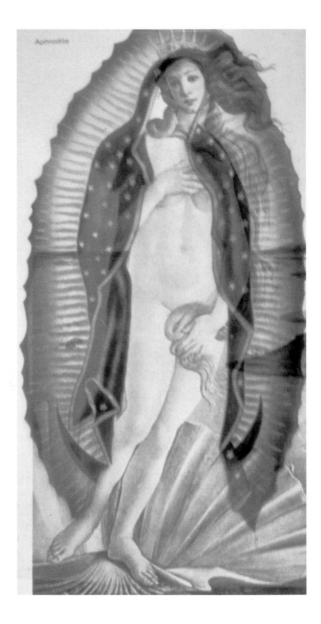

72 Yolanda M. López, *Love Goddess*, 1978. *Guadalupe* series. Assemblage, 4 × 8 in. Collection of the artist.

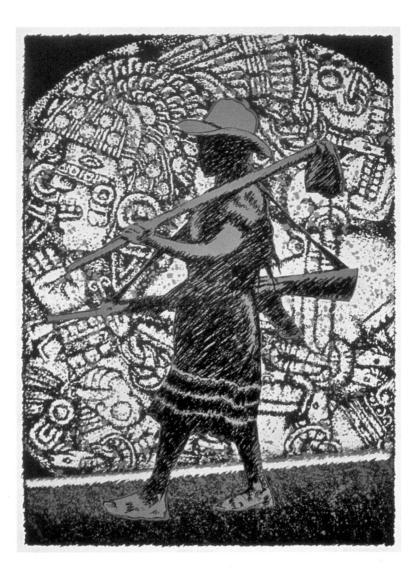

73 Ester Hernandez, *Full Moon / Luna Llena*,
1990. Screenprint, 30 × 22 in. Collection of
the artist.

notion of male-female balanced deities (León-Portilla 1963, 30). Here, it is the aspect of the righteous warrior woman that we saw in Hernandez's early karate-kicking Virgin that is invoked through Coyolxauhqui's image, reminding us of a lineage of female warriors that is interestingly not incompatible with the tradition of Mary as the quintessential warrior against evil, whether in the spiritual realms or as it manifests on earth through human acquiescence.

Hernandez also juxtaposed Virgin Mary/Guadalupe and Coyolxauhqui imagery in her 1997 installation *Immigrant Woman's Dress*, as we saw in chapter 2. Likewise, Yolanda López's own dress-based installation, *The Nanny* (1994), discussed in that same chapter, used Coatlicue's necklace of hearts and hands on the seemingly identity-obliterating uniform to suggest the Nanny's hidden power and full humanity.

In *Juan Soldado*, Alma Lopez replaced both mandorla and Virgin with the popular saint and patron of the wrongfully accused, Juan Soldado ("Soldier John"), one of many "victim-intercessors" or popular saints wrongfully accused to whom Mexican American populations, immigrant border-crossers in particular, appeal.

Isis Rodriguez, a Chicana Puerto Rican artist originally from Kansas and now based in San Francisco, cast the Virgin of Guadalupe in a Virgin series that includes girl bikers, a stripper, a brown Superwoman and Little Miss Attitude (figure 59), in numerous cartoon superheroine images. In this tradition of fictional visual superheroines crossed with the Virgin, she followed the pioneering Yolanda López in her 1978 *Tableau Vivant*. Rodriguez, like Alma Lopez and Yolanda López, emphasized the Virgin's superhuman ability to crush evil, as does Laura Molina's superheroine, Cihualyaomiquiz, the Jaguar woman (figure 61), helping us to identify evil in everyday yet powerful ills.

The rediscovery, reclamation, and reimagining of the Nahua goddesses among Chicana feminist artists has been simultaneous and often syncretized in Guadalupe work. Gloria Anzaldúa's contribution in this regard, in *Borderlands*, was probably the most influential. Irene Perez gave visual form to this feminist effort to revive the goddesses from patriarchal demotions in her 1993 rendition of the once-dismembered

warrior daughter, Coyolxauhqui (figure 63). Like Santa Barraza, Perez painted her emerging from the maguey plant, symbol of life and regeneration, whole, open-eyed, and in motion.

In her later rendition of Coyolxauhqui on one of the two walls of the Women's Building in San Francisco as a part of the *Maestrapeace* mural, co-created with a team of six other women and many volunteers, Perez painted the goddess two stories high and breaking out of the moon disc to which she had been confined in myth and in pre-Columbian sculpture (figure 74). In both versions of the image, the artist drew her with an exposed Sacred Heart, encircled with thorns and crowned with flames, an image to which I will return in the final section of this chapter. The visually and spiritually hybrid Marian imagery that we have seen—a mere fraction of what exists—is a decolonizing visual gallery of the socially wronged who are pure of heart.

Self-Portraits and Representations of the Body

By necessity, self-portraits are another terrain of contestation for women of color who, like those working with Guadalupe imagery, must peel away racialized and gendered associations in both art history and mass culture that their bodily appearance triggers in Eurocentric ways of seeing. As we have seen in previous chapters, a number of Yreina D. Cervántez's self-portraits undertake this complex work. One of Cervántez's earliest self-portraits, *Homage to Frida Kahlo* (1978), is, along with the work of Valdez, Hernandez, and Yolanda López, one of the earliest feminist transmutations of the Virgin (figure 75). The artist's own image looks out at the viewer from a small round mirror held up by the pseudo self-portrait of Kahlo. Employing a kind of visual pun on *The Two Fridas* (1939), Cervántez slyly honors herself, as Yolanda López had in her own 1978 *Portrait of the Artist as the Virgin of Guadalupe*. In picturing herself as the brilliant Kahlo's double, she symbolically cross-dresses a third time in this homage of the artist as Christian, pre-Columbian, and art world goddesses all at once. No wonder Cer-

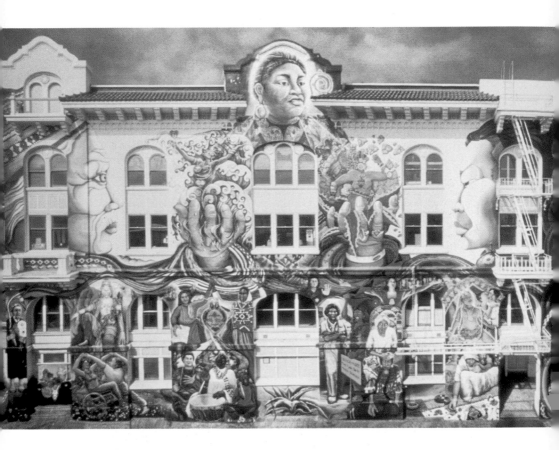

74 *Maestrapeace*. 1994. Two-wall collaborative mural on The Women's Building, corner of 18th Street and Lapidge, San Francisco. Juana Alicia, Miranda Bergman, Edythe Boone, Susan Kelk Cervantes, Meera Desai, Yvonne Littleton, and Irene Perez.

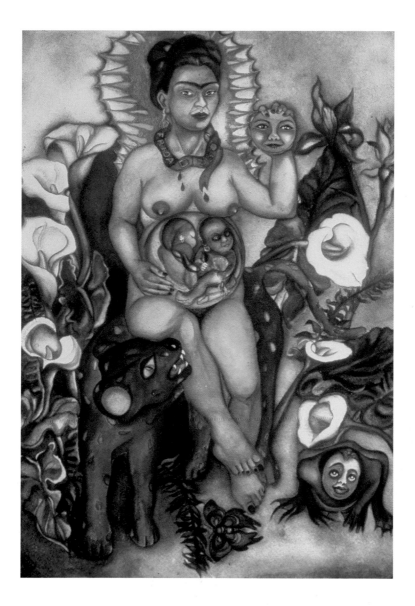

75 Yreina D. Cervántez, *Homenaje a Frida Kahlo*, 1978. Watercolor, 20 × 14 in. Collection of the artist.

vántez pictures herself smiling impishly, while her patroness looks on pointedly.

In Cervántez's *Danza Ocelotl* (1983), the masking is literal, and the Aztec spring renewal ritual of sacrificial flaying and layering of another's skin are central metaphors through which the piece is structured (figure 76). The strategy here of a self-portrait that is defamiliarizing, as in her later *Big Baby Balam* (figure 17), brings to mind Salomon Huerta's portrait-like paintings of the backs of bald cholos seen against equally bare, seemingly anonymous streetscapes. Cervántez layers symbols and colors that interrupt negatively racialized visual readings of facial features, instead revealing features of an inner landscape. Thus, she uses jaguar imagery, representative of transformation and spiritual being (such as were-jaguars); the *ollin* glyph representing the constant and interconnected transformative energy in all life forms; the sun mask of Quetzalcoatl, the pre-Columbian avatar and patron of the arts and wisdom; the skin glove of flayed flesh that honors the god of regeneration, Xipe Totec; the rubber bracelets of East Los Angeles cholas with whom she had recently worked; and the blouse (borrowed from a Kahlo self-portrait) worn by the socially empowered Indigenous women of the isthmus of Tehuantepec, with which Kahlo identified (Herrera 1983, 109).

Cervántez's self-reflection through the image of Coyolxauhqui also appears to be at work here, as in other of her self-portraits, in the closed eyes and cheek bell-ornaments of the warrior daughter's jade and stone head sculptures. Coyolxauhqui is used explicitly, however, as we have seen, in the artist's *Nepantla* of 1995 (figures 2–4). The theme of the visual as key terrain of ideological decolonization becomes paramount in that triptych, in which her image as a ghostly silhouette, a kind of canvas for other images layered over it, reappears insistently.

Laura Aguilar's laconic black and white photographs in her *Stillness* and *Motion* series seem to represent the unseen through defamiliarization of what we have been taught to read through normative body type associations. In these 1999 series, the artist poses, sometimes with two other

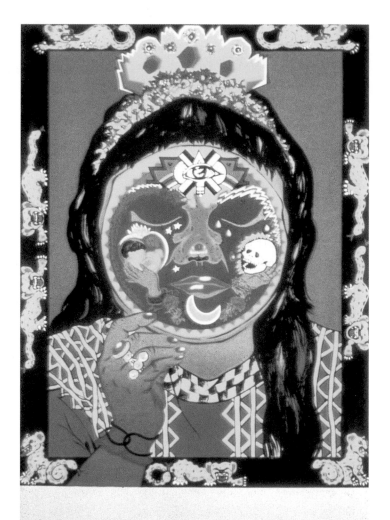

EXPERIMENTAL SCREENPRINT ATELIER
SELF HELP GRAPHICS AND ART, INC. MARCH 1983

76 Yreina D. Cervántez,
Danza Ocelotl, 1983. Serigraph,
24 × 18 in.

women, against the backdrop of desert and boulder-strewn landscapes, or among twisting tree branches, photographing bodies in formations complementary to those of the surrounding natural landscape. Their bodies are both strange and beautiful in these highly poetic images (figures 77 and 78). These series seem to be studies in perspective and proportion, and thus in vision, as culturally shaped and unshaped possibilities. Few of the photographs allow for identification of the subjects, most of whose faces are obscured by hair, distance, or posture.[8] The effect is a totemic anonymity, as if these women are simply anonymous natural forces. The paradoxical self-portrait through anonymity and natural setting that disables the assumptions these clothed or nude bodies would unchain in domestic or streetscape settings, or even here, if the camera focused on faces, for example, is pictured instead as liberating, conducive to reflection and perhaps to new configurations of self.

Aguilar, a Los Angeles-based photographer whose earlier work has been written about from the perspective of the identities she stages and disrupts within her portraits and self-portraits (Jones 1998), breaks new ground in these pieces. Though she had worked with the nude body, contrasting it to the clothed in her *Painted Pony* series, for example, in *Stillness* and *Motion*, Aguilar moves away from socially identifiable and readable bodies, seemingly seeking more environments or settings in which to play with and explore the body's capacities. The two series chronicle her rediscovery of nature and of her and other women's bodies within that order as natural too, inversely revealing the unnaturalness of the social order where larger female bodies, for example, are devalued and marginalized.[9]

Sacred and Divinized Heart (Yolteotl) Imagery

Images of the Catholic Sacred Hearts and of the Nahua concept of the divinized heart, *yolteotl*, in Chicana art, particularly when crossed with each other, make reference to the alignment between the cosmic and the human. Artwork structured around such heart imagery

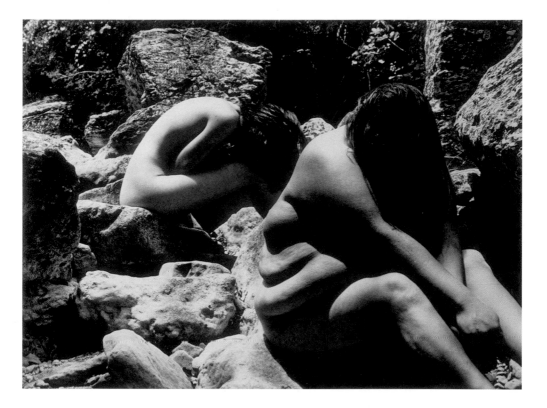

77 Laura Aguilar, *Stillness #15*, 1999. Gelatin silver print, 16 × 20 in. Courtesy of the artist and Susanne Vielmetter, Los Angeles Projects.

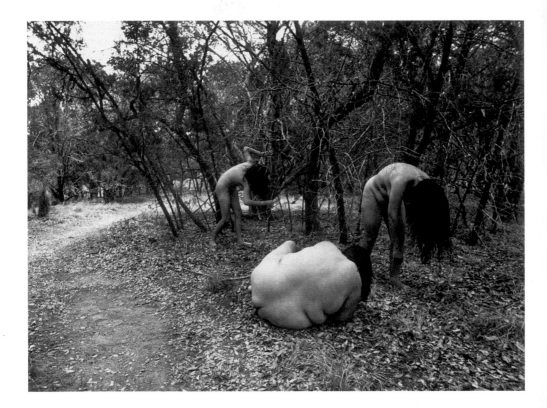

78 Laura Aguilar, *Motion #57*, 1999.
Gelatin silver print, 9 × 12 in. Courtesy
of the artist and Susanne Vielmetter,
Los Angeles Projects.

also concerns itself with that which is not easily visible beyond surface appearances, whether the emotions or memories stored away within the heart, or the related contents of our soul, our spiritual x-ray, as it were. Irene Perez's *Coyolxauhqui* (figure 63) combines pre-Columbian mythology with the Christian Sacred Heart, expressing perhaps more easily the Nahua idea of the divinized heart of the artist, given that Perez makes Coyolxauhqui a *tlacuilo* and *tlamatini*, placing brushes in one hand and the moon in the other. Yreina D. Cervántez's *La Ruta Turquesa* (figure 37) translates the idea of the spiritual heart of the community, the *altepetl*, through the anatomical and pre-Columbian glyphs of the heart. Likewise, Delilah Montoya's *Teyolia* (figure 31), a collotype photograph from her *Sagrado Corazón/Sacred Heart* series (1993–94), used the more familiar anatomical and Christian heart-related imagery to convey some of the richness of the idea of *yolteotl* in connection with the abiding spiritual sensibility, diverse as it is, in a New Mexican Chicana/o community.

Santa Barraza's hybridizations of the divinized heart, *yolteotl*, and the Sacred Heart are evident in numerous paintings, including her *Virgen con Corazón y Maguey* (1991) (figure 79) and *Corazón Sagrado I* (1992) (figure 80), and in numerous other paintings that show female figures emerging from the heart of the maguey (century) plant. Drawing on both the Christian and pre-Columbian conventions expressing the spirit lodged in the heart through wings or winged creatures, her paintings feature exposed anatomical hearts and doves. The artist has written that the history of heart disease in her family first led her to explore this symbol, an interest that was deepened by her discovery of Indigenous forebears and by trips to Mexico that allowed her to further study Mayan and Mexica iconography and philosophical concepts such as the divinized heart and the making of face, heart, that is, of the struggles for personal integrity and alignment between self and society, self and cosmos (Barraza 2001, 40)

In *Virgen con Corazón y Maguey* (figure 79), the Sacred Heart of Mary is expressed through Native American symbols. Thus, her veil is covered with glyphs representing roses, and her gown with those representing

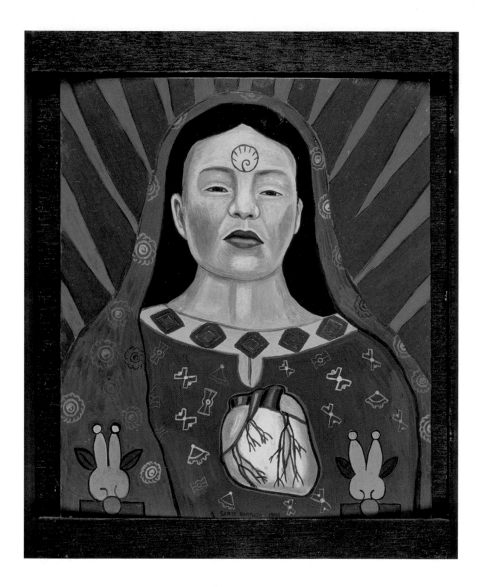

79 Santa Contreras Barraza, *Virgen con Corazón y Maguey*, 1991. Oils on metal, 8 × 9 in. Collection of the artist.

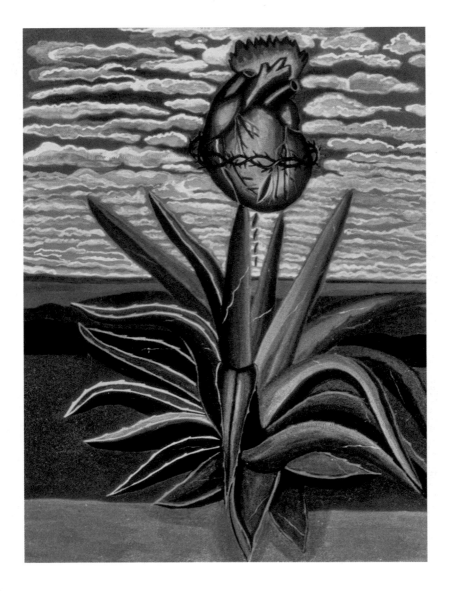

80 Santa Contreras Barraza, *Corazón Sagrado I*, 1992. Oils on metal, 8 × 9 in. Private collection.

the dynamic life force, *ollin*; diamond-shaped "Eye of God" patterns adorn the neck of her dress, and her mandorla is the spiky leaves of the goddess Mayahuel's life-giving, regenerative maguey.

Maya González's *The Love that Stains* (2000) likewise makes reference to *yolteotl*, symbolized through the hummingbird (figure 81), which in other artists' work is expressed through the butterfly. Like Cervántez in *Homage to Frida Kahlo*, González invokes the spirit of Kahlo's *The Two Fridas*. But in González, rather than conveying *The Two Fridas*'s painful sense of being torn psychologically, the duality of the physical and spiritual sense is conveyed as a resource of strength, as the ghostly spirit embraces and comforts the living self. The bleeding, exposed heart of the one does not affect the spirit self, though it communicates precisely through the heart as the hummingbird which represents it, because it itself is the spiritual lifeblood of the heart.

Celia Herrera Rodríguez uses pre-Columbian symbolism, the Valentine's Day heart stylized silhouette, and the Christian Sacred Heart in *My Little Wound* (figure 82). In this four-foot-high watercolor, the heart is depicted as a suffering female torso caught in a moment of death-like escape of the spirit and consciousness; a bird-like head labors upward and away as a swollen, blood-red vagina weighs down the other end of the body. *My Little Wound* delicately conveys the evil that has reduced the lovely figure to an eroticized trunk of genitalia, rendered limbless, immobile, and faceless by sexual violation.

Women's gendered suffering in the context of war was the theme of Patricia Valencia's and Aida Salazar's installation performance *Ramona* (1996), dedicated to the Zapatista National Liberation Army commander of the same name in Los Angeles, as part of a fundraising event. Upon a stage hung a heart in a metal ribbed cage to which was attached a uterus-like object, with two embryonic forms popping out from it through tubes. Behind this hanging skeletal figure was written the name "Ramona," and elsewhere the words "destruction" and "creation" had been spray painted. In the video-recorded event, barefoot and clad in a slip, Salazar, wearing an image of a heart, reads a text throughout the performance that begins in Spanish, "The revolution

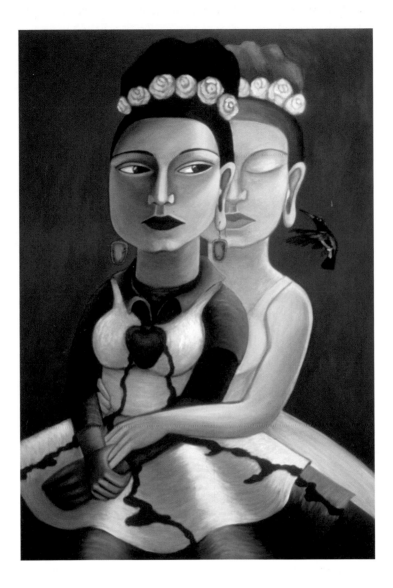

81 Maya González, *The Love that Stains*, 2000. Acrylic on masonite, 36 × 24 in. Collection of Gary Keller.

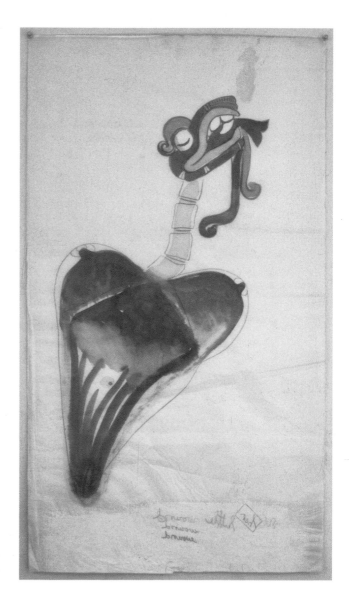

82 Celia Herrera
Rodríguez, *My
Little Wound*, 1991.
Watercolor, graphite
on Kozo paper, 25 ½
× 43 in. Collection of
Laura E. Pérez.

begins at my breasts," while Valencia pours a bucket of guts onto the floor, then frantically cleans it up. Eventually Valencia beats at the heart within the metal rib cage, offers the guts on a platter to the audience, and, frustrated, throws them against the wall. The piece concludes with the exhausted Valencia taking Salazar's "heart" and putting it within the ribcage, and repeating, "Asi es la vida, asi es la muerte," this is life, this is death. Valencia wrote of the piece,

> What really happens to women in war? Women are raped, mutilated, their pregnant bellies are sliced and their babies choked with their umbilical cords. That's what happens to women in war. We are already so disconnected from our daily emotions and when it comes to war, the whole family can sit around the TV set and watch the bombing of Iran [*sic*]. Our memories have been erased. We do not remember our history, or even our own genocide. We emerge from this society, desensitized and apathetic.[10]

Through defamiliarization of images, both the sacred and those of everyday women, including their own, and through the telling of new and different stories about the meaning of these, Chicana artists struggle to change our ways of thinking about and seeing the world. They expose the violence of the predominant view that racializes and genders us as less fully human, and therefore less worthy of egalitarian and respectful treatment. While reclaiming the right to their sexuality, Chicana feminist artists negotiate or expose the violent effects of male-centered erotification of female bodies as sexual objects. They expose the myths idealizing women behind which lurks the violence against women. Images are a terrain of struggle through which women—and men—have been taught to behave according to patriarchal ideals and warned should they fail to do so. By redeploying the images and performances of their female, negatively racialized bodies in ways that respond to a different logic, or expose its bloody logic, Chicana feminist artists attempt to interrupt the evil of genderings that do violence to us.

Whether the language of the spiritual is used to make literal references to specific belief systems, or whether it is used metaphorically

to express specter-like socially marginal presence, it is recognized as powerful in the social, political, economic, and cultural worlds. Religiously derived symbols and concepts are a central machine in the reproduction of unequal, racialized gender relations and sexual orientations, felt bluntly by women of color in the United States and other parts of the world. Who if not women have the right to the iconography and to the narratives around power and gender that concern them? Nothing less than brave superheroines clearly sighting targets on the field of the ideological, through word and image, Chicana feminist artists reconnect spirituality and social justice, spreading the message of hope for human dignity and integrity—for "face, heart"—wherever their work appears.

And where, finally, does their work appear? Do we buy it, do we exhibit it, do we attend and support it if it is performative? Do we review it? Cite it? Allow it to transform us? Do we support its presence and dissemination in our schools, professional journals, mainstream art magazines, established museums, cutting-edge galleries, bank vaults, and living room walls? Do we study it in its differences and allow it to create a difference, an altar-like offering toward the greater good? Let us turn to these questions and other final thoughts in the conclusion.

conclusion

Self, Other

All the work addressed in this book calls attention to the politics of the spiritual, that is, to the fact that spiritual beliefs and practices—however varied these may be—generate social and political effects that matter. And indeed the spiritual and the material are imbricated. In academic and art world spheres, particularly in the studied nihilism of much post-modern art and poststructuralist thought, the spiritual and the political largely remain separated, following assumptions dating to the Enlightenment in the modern Western world—a binary that is clearly one of the last "frontiers" to be deconstructed.[1] For most of the Chicana artists whose work is included in this study, the spiritual is invoked in their art for political effects that are very different from those sought by racist, sexist, homophobic, fundamentalist politicians and religious leaders. A particular kind of spirituality, a culturally hybrid spirituality is what most often is cited or articulated in the work presented here by women who have identified as professional artists. This hybrid spirituality is indeed a "politicizing spirituality," as one artist phrased it,[2] and it emphasizes embodiment—that is, manifestation on the earthly

plane in acts of goodness with respect to real bodies and in human societies, in nature, and on the globe, rather than in vague, abstract, and binary notions of goodness, God/gods, s/Spirit(s), and spirituality. In the Chicana art studied here, what is explored, articulated, or deployed is a notion of spirituality whose effects matter socially and politically. In the work of these women, it is the day-to-day practices of spiritual consciousness and its material effects, rather than identification with the dogma and ritual practices of religious organizations, that are brought to our attention as mattering individually, socially, and globally.

Because spirituality is understood as having political effects and as historically construed, Christianity is criticized in some artwork for its role in the Inquisition; the genocide of Native Americans throughout the continent; the persecution of folk or Indigenous healers as satanic; and the extension and reproduction of Eurocentrism, patriarchy, and compulsory heterosexuality. At the same time, what appear to have been historically patriarchal and imperialist cultures such as those of the Mexica ("Aztec") people are also viewed critically, in contrast to the uncritical idealization or purposeful invocation of those legacies by male-centered, heterosexist Chicano nationalist thinkers. It should not, therefore, be surprising that what emerges most often as a hybrid notion of the spiritual in the work of some of the Chicana artists studied here claims continuities with cultural traditions alongside, or other than, the dominating European and Euroamerican Judeo-Christian. In many cases, references to the Christian express post-Christian or Christian-bending beliefs, in a process that is inadequately described as syncretism.

In part, this is a consequence of the present and hereditary biculturalism of Chicanas. While it may not be the case for all Chicana/os or U.S. Latina/os, the artists whose work has been studied here descend from, and claim in varying degrees, Indigenous and other third-world, as well as European roots. This received polyculturalism of many Mexicans and other Latin Americans is multiplied in the United States, where a secondary *mestizaje* (hybridization) with Euroamerican and other cultures further defines the uniqueness of Mexican American

and Chicana/o experiences, distinguishing these, for example, from the experiences of Mexicans and other Latin Americans not residing in the United States and, more importantly, not having been formatively shaped here.

The multiethnic and multicultural realities of Los Angeles, San Francisco, Chicago, Detroit, San Antonio, Houston, and parts of the U.S.-Mexico borderlands, where Chicana artists have historically been raised and to which they have gravitated and or now reside, have allowed for the circulation of a multiplicity of religious worldviews from which to compare received spiritual practices and to fashion personally and historically meaningful new ones. The receptivity to the unorthodox in the aftermath of the socially revolutionary 1960s and that decade's criticism of received state, family, and religious institutions has also played its part. And finally, Chicanas have shaped, and been shaped by, criticism of patriarchal and heterosexist family structures and ethnic and gendered hierarchical orderings within the United States, Mexico, and the Chicana/o "nation" (A. García 1997; Ruíz 1998; E. Pérez 1999).

In addition to fomenting criticism of the received, the legacy of countercultural and civil rights struggles has led to the search for more useful social, political, and spiritual models. Chicana artists have looked to the distant past, to Mesoamerican and North American Indigenous female deities, to those of African diasporic and Buddhist pantheons, and to the goddesses of ancient Europe and the Mediterranean, in part, in order to imagine a future beyond patriarchal cultures. They have variously assimilated goddess-spiritualities (whether of bona fide or recent vintage) from around the globe. Some have embraced Eastern spiritualities; others have studied and incorporated aspects of African-diaspora *santería* in their lives and/or their art practices. And many have engaged Native American spiritualities of Mesoamerica and North America, whether to scrutinize, nurture, or affirm these. In the work of many, Christianity and other systems of religious belief have been subjected to a feminist critique of Eurocentric, patriarchal, and heterosexist underpinnings and to their embodiment as social practices.[3]

As could be expected, the intersection of the spiritual, the political,

and the artistic looks very different, and sometimes means very different things, to the artists whose work has been examined here. Sometimes it is the gender politics of religion or spiritual beliefs, that is, their social effects that are in question. In other work, reference to nonhegemonic spiritualities serves to reference different cultural worldviews and suggests politically oppositional ways of thinking, understanding community, and practicing art. The use of Mexica and Mayan glyphs, codex formats, and other pre-Columbian "art" conventions and spiritual concepts can be characterized in this way. From the earliest work to the most recent, the relations between gender and spirituality and sexuality and spirituality are investigated. In some work, the inquiry is centered on how religious beliefs about sexuality and gender buttress male privilege in society and church. In more recent work, this concern is extended into the sex-work industry through both religious and popular cultural visual languages. Other work traces heterosexist privilege in nationalist discourses and the religious ideologies used to sustain these. Still other pieces are concerned with the ambiguous zone between sexually and spiritually liminal beliefs and behavior.

In artwork specifically inspired by and structured through ancient and cross-cultural religious forms, such as the altar, reliquary boxes, and votive offerings, artists have been interested in reexamining the contemporary dissociation of ritual and artistic practice, reenchanting what is perceived as profane, but perhaps they have also been interested in piercing romanticized cultural identities and spiritualities, challenging the meaning of the sacred for us, particularly as it undergirds our valorizations of certain kinds of men and the devalorizations of particular women. The personally and socially empowering effects of scrutinizing traditional religious beliefs and crafting one's own are the subjects of recent writings by established and newer creative writers, alongside visual and performance artists. In the photography-based, video, and film work discussed here, the spiritual describes the disembodied—death, the seeming absence or irreality of particular histories, cultural realities, and states of being—and is expressed through an aesthetic of the ghostly.

In all this work, the social, economic, political, and cultural realities of Chicanas, and of the larger Mexican American communities, are visible, if in varying degrees, and affect both the subject matter and the formal strategies of the work, in much the same way as the local, national, and global realities of the avant-garde movements before and between the world wars conditioned the politics and aesthetics of their artistic interventions. Because most of the work presented here was produced from the mid-1980s through 2000, references to the spiritual are historically grounded even more precisely. This was the historical moment of the spread of multiculturalist awareness in education, museums, and society in general, and the backlash against it. Gains resulting from civil rights-era struggles, and losses to anti-affirmative action policies and sentiments arguing reverse discrimination, were all felt. Real, if brief and numerically inadequate, apertures in academia, the art world, and the mainstream media went hand-in-glove with ongoing discriminatory experiences symbolized by the televised videos of policy brutality against African Americans and Mexican undocumented workers.

In spite of highly visible successful athletes, mass media entertainers, politicians, and business people, and the gains of the numerically small, highly educated middle class, the majority of Mexican Americans, the largest group among U.S. Latina/os and the second largest "minority" in the United States, continued to experience marked inequity in the quality and degree of education, jobs, and income.[4]

Alongside the historical facts of the colonization of Native American territories and the slavery of Africans, the appropriation through war of one-third of Mexican territory in 1848 helped to create the vast wealth of the United States that catapulted it to superpower status in the nineteenth and twentieth centuries. Today, the prosperity and globalization heralded by the digital superhighway culture are built, in part, on the wealth produced by the superexploited undocumented labor of Mexican agricultural workers and the manual labor of Mexican American and *mexicana/o* factory, *maquiladora*, domestic, and other low-end ser-

vice workers, many of whom are unable to access the prosperity of that culture.

The danger of crossing borders into territories that were once Mexican and, before that, ancestral Native homelands, and whose loss to the imperialist greed of Manifest Destiny policies greatly affected the impoverishment and indebtedness of Mexico, is well established, if unpleasant and painful to contemplate. It may be illegal to cross borders without proper permission, but it is not a criminal activity. What is criminal is the vigilante borderland sport of hunting "Meskins" that dates to the Annexation, lynching and raping to swindle Mexicans out of their landholdings and to intimidate and finally marginalize them socially, politically, and economically. Anti-Mexican sentiment is rooted in the spurious writings of the nineteenth century on which later film images and media campaigns drew and which has been used to generate and promote negative racial and gendered stereotypes that seemed to rationalize the Anglo right to seize Indian, then Mexican territories, and either hold slaves or treat culturally different peoples as inferiors to be ill-used. That many Chicana artists keep within view the tensions generated by these repressed histories reminds us that we are all still subject to their effects. Chicana artists and scholars, however, have led the way in exposing negatively racialized stereotypes as false projections, instead showing us more humane, rich, and complex images and circulating alternative, more socially democratic visions of respectful coexistence in the United States.

In their concern with the inequities and contradictions of the world we live in, and their desire to contribute to a more just world, the women whose work is studied here join the classic writers of the Greco-Roman tradition, the glyph-makers of the Mesoamerican world, the artists of colonial and neocolonial worlds, and the artists, intellectuals, and social visionaries within the Western hegemonic centers in Europe and the United States.

In the art world of public museums, private and community galleries, cultural organizations, nonprofit foundations, government agencies, corporate funding, and scholarship, the 1980s saw the re-aperture toward Latin American art, and an opening toward U.S. Latina/o, including Chicana/o, art. The excitement generated by successful auction house sales in the new and relatively more affordable investment area of Latin American art in the early and mid-1980s (Stellweg 1989; Seggerman 1990; Sullivan 1990) was reflected by a spate of Latin American and U.S. Latina/o nationally touring exhibitions, the rise of multicultural-themed exhibitions, and the inclusion of U.S. Latina/os, including Chicana/os, in nationally and internationally prominent exhibitions. Scholars, art critics, curators, and funding agencies debated the claim that Eurocentric values constituted natural and universal standards of aesthetic quality and the characteristics of the most "advanced" artwork. Latin American art specialists criticized the representation of U.S. Latina/o and Latin American art as characteristically exotic, fantastic, spiritual, folkloric, raw, or peculiarly authentic (Goldman 1994a, 1988c, 1987; Mosquera 1996a; Lindsay 1996). They pointed out the impossible bind created by Eurocentric standards that demeaned non-European standards of quality, technique, and thematics and yet dismissed Latin American art working with these same standards as mimetic and therefore second-rate.

It seems that, in spite of all the intellectual excitement and goodwill toward multicultural inclusion, Euroamerican culture and power brokers remained at the center, and "ethnic" others were reinscribed yet again at the margins (Richard 1996; Yúdice 1996; Chávez 1993; Gómez-Peña 1986, 1993). While it would be difficult to imagine, thinking of Euroamerican art as a whole, that once you had seen a few pieces, you had seen them all, the limited inclusion of a few prominent Latin Americans, U.S. Latina/os, and particularly Chicana/os in museums, mainstream galleries, art histories, and art publications suggests that an ongoing Eurocentric bias remains at work. Alicia Gaspar de Alba's

study (1998) of the first major touring show of Chicana/o art documents the achievements, tensions, limits, and contradictions of the mid-1980s and early 1990s, during which time the Chicano Art: Resistance and Affirmation, 1965–1985 (CARA) exhibition was organized and toured the country. As she argues, the CARA show was clearly a major experiment in further democratizing the public museums.

The intersecting fields of museum studies, cultural policy, and art-world economics make clear that, in spite of their mandate to serve and educate the citizenry and their use of taxpayers' money, large public art museums are being reshaped today, by all accounts, by securing the on-going traditional patronage of wealthy individuals; currying the sizable but consequential monetary gifts of new corporate patrons; securing government and nonprofit foundational monies; and their own fund-raising efforts (e.g., membership, gift shop and restaurant sales, and sales of artwork holdings).[5] As might be guessed, corporate gifts, like those of individual wealthy patrons and grants by government agencies, influence exhibition policies in the pursuit of their promotional and market interests (Alexander 1996; Kurin 1997a, 1997b). U.S. corporations, interested in promoting their image to the growing U.S. Latina/o and Latin American markets, seem more interested than the gatekeepers of Eurocentrism in promoting multiculturalist exhibition agendas.

But whether cultivating a greater Latina/o presence in the nonprofit public museum through acquisition and public outreach should be paid for by serving corporate interests is another matter. This is a particularly sobering question if viewed from the perspective that the proportionately modest advertising investment made by corporations is multiplied for them through taxpayer money, government grants to nonprofit organizations, and the funds public museums raise. In effect, art as corporate advertising may end up as publicly funded corporate assistance, rather than the other way around, if corporate logos and information, for example, end up competing with those of the museums or with artwork, as has been the case with the Target logo's omnipresence in the Cheech Marin collection exhibition. It has been stated outright by one global corporation representative (Laurie 1994) and con-

firmed in a number of studies that major corporations fund innovative artwork in some cases only if it serves their own desire to represent themselves as technological innovators, for example, but then only in support of already established "avant-garde" artists, and only in larger, well-established venues.

Though many writers are optimistic that collaboration with corporations can be mutually enriching, there is no reason that public museum exhibitions should be increasingly shouldered by corporations. Studies show that people in the United States value the arts and appreciate the opportunities to experience them in their community and that "majorities frequently support raising taxes to pay for the arts."[6] Because public museums, like public universities, are intended to serve the public good, they are funded by taxpayer dollars. And scholars have weighed in very positively on the short- and long-term benefits of a citizenry exposed to the arts throughout the country, and not just in major cities. Still other researchers have documented the significant revenues generated by the arts, nationally and internationally (Riley 1994, xiii–xxii; Heilbrun and Gray 1993).

Heilbrun and Gray point out that " 'democratizing the arts' in the sense of increasing the participation of ethnic minorities and those having lower income and occupational status and less education than the traditional arts audience has been a U.S. public policy objective since the 1960s" (50). Furthermore, local and national public museums have an obligation to represent the artistic production of the multiethnic communities that have constituted U.S. national identity since its foundation and whose taxpayer money they receive. But this is not the sole issue. Without the funding to create the infrastructure (e.g., research and production grants; artists' colonies; community arts programs, etc.) that gives artists the basic ingredient of time, there may be less and less Chicana/o art to acquire.

The art of Chicana women is among the most vibrant today, and the most threatened by lack of funding, minimal acquisition, and limited exhibition and publication. Few of the more than forty women whose work is presented here are able to fully support themselves through the

sales of their artwork or writing alone, or by supplementing these sales with grants and artist's residencies. In spite of the overwhelming number of M.F.A.'s among their ranks and some tenured positions in art, Chicana/o studies, and ethnic studies departments, the sobering fact is that very few of the artists studied here are employed in steady or even temporary higher educational settings because of corporate-modeled university downsizing and its unwitting collusion with the cultural conservatism and neglect of many art history and art practice departments. Failure to prioritize the arts in Chicana/o studies and ethnic studies programs and departments, where most of those who have worked in colleges and universities have found sometime employment, has not served Chicana—or Chicano—art well, either.

The arts have the potential, in the Nahuatl expression, to create integrity between "the face and soul" of their beholders, as well as in their makers. Likewise, they do indeed mirror the superficial, visionary, or conflicted soul of the societies we live in. As we understand them, and as they largely still function today, the arts optimally embody and facilitate the critical, truth-seeking, and daring consciousness that is necessary to both social and spiritual well-being.

In'Laketch: Tú Eres Mi Otro Yo: You Are My Other Me

The Chicana artists whose "spirit work" I have studied here display the courage to attempt to inspire or provoke greater balance between who we appear to be ("face") and who we long to be ("heart"). They teach us to perceive and imagine differently, and that seeing is a learned, revealed, ever-changing, and transformative process, whether we do so through the mind, the eyes, the heart, or the spirit. If we are receptive, their work contributes toward leading us to beliefs and practices of greater personal and social integrity and therefore harmony.

These works ultimately remind us that we are inescapably, in visible and invisible ways, each other's other selves, an idea expressed in the Mayan In'Laketch. It is my hope that *Chicana Art*, and the dissemina-

tion of the artwork I have focused upon, may contribute to a greater and more healing understanding of ourselves and each other, and that we may be spurred along on the great spiritual, social, political, and artistic adventure of more fully realizing our best selves, societies, and globe as a part of the interconnected web of life into a future that will succeed us, and for which we too are responsible.

notes

Introduction: Invocation, *Ofrenda*

1 Spirituality and religion, and their related adjective and noun forms, are often used interchangeably, and their dictionary definitions overlap in important ways. However, I choose the former over the latter to describe the loose, unorthodox, or self-created forms of belief and practice that characterize the work under study. Under "religion," the *Oxford English Dictionary* (OED) emphasizes membership in religious orders and "action or conduct indicating a belief in, reverence for, and desire to please, a divine ruling power; the exercise or practice of rites or observances implying this"; "a religious duty or obligation," and "a particular system of faith and worship" (1979 [1971]: 410). "Spirituality" is defined by the OED as "the quality or state of being spiritual; spiritual character" and "the body of spiritual or ecclesiastic persons; the spiritual estate of the realm; the clergy" (625). It is the former, broad definition of spirituality that I use throughout this study, to refer to a range of beliefs culled from different established faiths, as well as new, self-fashioned forms of belief, worship, and social practice. As I discuss in chapter 1, spiritual and/or religious beliefs are not transparent, timeless universal categories, in spite of the transcendent subject matter to which they refer. The acts of articulating our beliefs and formulating spiritual and/or religious practices, however, are not socially or historically transcendent, and they reflect our social positionings and interests. The marginalized and demeaned place of Indigenous and African-diaspora beliefs and practices within the Christian churches, for example, speaks of the earthly interests at play in what gets to count as spiritual. See Díaz-Stevens and Stevens-Arroyo (1998) and essays in Lindsay (1996) for

detailed discussion of the Eurocentrism of Christianity in the United States, and chapter 3 for my own extended discussion of these and related issues. I should also say that while Marx's observation that religion is political is clearly at work in my study, his theory of religion as false ideology and the "opiate of the masses" is not taken by me, or other Latina/o scholars, as a universal truth, applicable to all spiritual belief and religious systems, across time (qtd. and discussed in Bürger 1984, 6–8). I do not, therefore, automatically regard all art that engages with spiritual issues, whether ironically or seriously, as socially and politically escapist. It is not my interest in this book to study citations of the spiritual in Chicana art as manifestations of such flights where, at best, the measurement of those "escapes" speaks indirectly to how very bad social reality really is. Marx's materialist critique of religion is itself a reflection of his own cultural and historical specificity. To view his historically and culturally specific observations as analytic gospel might itself be read as a flight from the present realities of cultural differences that seek democratic inclusion on their own terms, not as reflections of dominant intellectual or religious discourses. The kinds of arguments that Chakrabarty (1997) makes about the contradictions of Western social sciences imposing their culturally specific notion of history and time onto other cultures are revelant here as well.

2 See page 345, n. 1 for a discussion of Derrida's later views on religions and scientific thought and more details regarding Chakrabarty's views, as well as other sources in poststructuralist religious studies.

3 I later discovered that many parallels exist between this study and a chapter on "orthodox and non-orthodox religious culture" in U.S. Latina writing in McCracken (1999). In describing the work of the Chicana writers Lucha Corpi and Demetria Martinez, for example, McCracken speaks of the "deploy[ment of] politically imbricated religious practices" (105), and in describing the work of Denise Chavez, she writes that "it recuperates the denied or repressed body of official religious culture" (127). Another essay, while acknowledging that "Chicana visual language, like Chicano Spanish, is multidialectical," focuses on the uses, including subversions, of "the language of Catholicism in Chicana art" (Black 1999, 135, 136).

4 "Race, as a meaningful criterion within the biological sciences, has long been recognized to be a fiction. When we speak of 'the white race' or 'the black race,' 'the Jewish race' or 'the Aryan race,' we speak in biological misnomers and, more generally, in metaphors. Nevertheless, our conversations are replete with usages of race which have their sources in the dubious pseudoscience of the eighteenth and nineteenth centuries. . . . The sense of difference defined in

popular usages of the term 'race' has both described and inscribed differences of language, belief system, artistic tradition, and gene pool, as well as all sorts of supposedly natural attributes such as rhythm, athletic ability, cerebration, usury, fidelity, and so forth. The relation between 'racial character' and these sorts of characteristics has been *inscribed* through tropes of race, lending the sanction of God, biology, or the natural order to even presumably unbiased descriptions of cultural tendencies and differences" (Gates 1986, 4–5).

5 See Said (1994), Mudimbe (1988), Dussel (1998, 2000), Quijano (2000), and McClintock (1995).

6 For early critiques of Christianity as colonizing and patriarchal, see the essays of Anna NietoGomez and Elizabeth Martinez in A. García (1997).

7 On the history of Mexican Americans in the United States, and the political and economic structure of that incorporation, see Acuña (1981) and Montejano (1987). On the Chicana/o movement, see C. Muñoz (1989) and Acuña (1981). On Chicana/o art and the Chicana/o civil rights movement politics, see Goldman and Ybarra-Frausto (1985, 1991), Ybarra-Frausto (1991a), and Griswold del Castillo, McKenna, and Yarbro-Bejarano (1991). On global economics and the restructuring of corporations and labor, see Sassen (1998). On the accelerated flows of information, money, and production, see Harvey (1990). On the history of Chicana feminism, see Gaspar de Alba (1998), A. García (1997), and Ruiz (1998). On the politics and aesthetics of Chicana art, see Goldman (1988a, 1994d) and Mesa-Bains (1991b).

8 For Chicana and Chicano cinema arts, see Fregoso (1993) and Noriega (1992, 1996, 2000). For U.S. Latina, including Chicana, performance, see Arrizón (1999). For book-length studies of Chicana literature, see Sánchez (1985), Rebolledo (1995), Quintana (1996), and Saldívar-Hull (2000). For Chicana and Chicano art, see Gaspar de Alba (1998), Griswold del Castillo, McKenna, and Yarbro-Bejarano (1991), Keller et al. (2002), Keller, Erickson, and Villeneuve (2004), and Ochoa (2003).

9 On *difrasismo*, see León-Portilla (1963), Carrasco (1990), and Arteaga (1997).

Chapter One: Spirit, Glyphs

The first epigraph to this chapter translates as, "Fruit of the dialogue sustained with his own heart, that has ruminated, so to speak, the spiritual legacy of the Nahuatl world, the artist will begin to transform himself into a yoltéotl, "a

deified heart," or better, human mobility and dynamism oriented by a kind of a divine inspiration." (My translation.)

1 For the communications theorist H. L. Goodall Jr., "Spirit, it seems, is best read as a sign that means to be taken as deeper clue. . . . To move toward the unifying awareness of Spirit in our ordinary, everyday texts; social texts; and communal texts is to grant voice to the creative powers of imagination and interpretation, from which emerges a fuller body for experiential knowing capable of sustaining not only a rhetoric for the ordinary, the ritualized, and the rational, but one ready to embrace a *poetics* of the extraordinary, the intuited, the felt, and the lived. From this unifying awareness comes the possibility for genuine holistic dialogue, a dialogue capable of learning from the body of experience without denying to Others what has not been bodily experienced for oneself, a dialogue in which the full measure of truth is found only in the quality of our lives" (1996, 213).

2 As Janice Hocker Rushing puts it: "Spirit was thus revealed by Nietzsche to have died, by Marx as a pretense to maintain political domination by the ruling classes, by Freud as an illusory and neurotic hedge against the finality of death, by feminists as an excuse for male domination, and by poststructuralists as the illusory transcendental signifier" (Rushing 1993, quoted in Goodall 1996, 212).

3 In Paula Gunn Allen's view, "We as feminists must be aware of our history on this continent. We need to recognize that the same forces that devastated the gynarchies of Britain and the Continent also devastated the ancient African civilizations, and we must know that those same materialistic, antispiritual forces are presently engaged in wiping out the same gynarchical values, along with the peoples who adhere to them, in Latin America. I am convinced that those wars were and continue to be about the imposition of patriarchal civilization over the holistic, pacifist, and spirit-based gynarchies they supplant. To that end the wars of imperial conquest have not been solely or even mostly waged over the land and its resources, but they have been fought within the bodies, minds, and hearts of the people of the earth for dominion over them. I think this is the reason traditionals say we must remember our origins, our cultures, our histories, our mothers and grandmothers, for without that memory, which implies continuance rather than nostalgia, we are doomed to engulfment by a paradigm that is fundamentally inimical to the vitality, autonomy, and self-empowerment essential for satisfying, high-quality life" (1986, 214).

4 "The words of a Náhuatl Indian from the middle of the sixteenth cen-

tury refer to the risks, so closely related to cultural identity, that can present themselves in attempts at inducing acculturation. A Dominican friar, Diego Durán, had reprimanded a native for his behavior, pointing out that it was also in discord with the ancient indigenous customs and morals. The wise old native responded: 'Father, don't be afraid, for we are still '*nepantla*' — in other words, 'in the middle,' or as he later added, 'we are neutral'" (León-Portilla 1990, 10).

5 "Perhaps the most prominent contemporary archetypal heroine in Chicana literature is the curandera/partera (healer/midwife) who is also the bruja (witch). As do most complex symbols, the curandera/bruja encodes both positive and negative attributes . . . The curandera possesses intuitive and cognitive skills, and her connection to and interrelation with the natural world is particularly relevant. She emerges as a powerful figure throughout Chicano writing" (Rebolledo 1995, 83). Also interesting to bear in mind with respect to *curanderismo* are the conclusions of a classic study of Mexican American "folk" healing practices: "Indeed, the study of curanderismo questions specific techniques, philosophies, and goals of contemporary dynamic psychotherapy, which may have developed more for their compatibility with the ethos and value system of our own culture than for any well-founded scientific reason . . . Finally, there is no evidence that dynamic psychotherapy is of more value than such forms of treatment as curanderismo" (Kiev 1968, 179, 183).

6 Grey (1998), Haynes (1997), and Gablik (1991) are examples of contemporary Euroamerican artists and art writers arguing for the return of more socially meaningful and visionary art practices.

7 "Like the ancients, I worship the rain god and the maize goddess, but unlike my father I have recovered their names" (Anzaldúa 1987, 90).

8 With respect to the discursive power of what she calls third-degree kitsch in postmodern art that incorporates religious imagery, Celeste Olalquiaga writes, "Besides imploding the boundaries of art and reality, the third degree carries out an active transformation of kitsch. Taking religious imagery both for its kitsch value and its signifying and iconic strength, it absorbs the icon in full and recycles it into new meanings. These meanings are related to personal spiritual experiences, recalling users' relationships to first-degree [kitsch] imagery, except that the first-degree images are part of a given cultural heritage and as such they are readily available and their usage is automatic. Third-degree kitsch, on the other hand, appropriates this tradition from 'outside,' searching for an imagery that will be adequate to its expressive needs . . . Instead of appropriation annihilating what it absorbs, the absorbed invades the

appropriating system and begins to constitute and transform it . . . Rather than of active or passive cultures, one can now speak of mutual appropriation" (1992, 52–54).

9 I use scare quotes around "third" world to indicate a questioning of the nomenclature of rank and difference (first, then second, then third world) that unwittingly reinscribes such hierarchies even when otherwise critical of such rankings. Likewise, I mark the insufficiency in the term "women of color" given that it unwittingly omits light pigmentation in a color and generalizes about our differences, problematically describing ourselves through color as an ethnic or racializing optic.

10 Anzaldúa characterizes spirituality as a cultural borderlands in the preface to *Borderlands*, alongside the geographical, the psychological, and the sexual. She clarifies the centrality of spirituality in her 1987 work, and discusses critics' silence on the subject, in interviews later published in *Interviews/Entrevistas* (Anzaldúa 2000).

11 See Klor de Alva (1986), Ybarra-Fausto (1979), and Anaya (1989).

12 See Klor de Alva (1986). The scholar's translations in *Aztec Thought and Culture* were also quoted in an important anthology, *Aztlán: An Anthology of Mexican American Literature*, in the section "The Toltec (The Artist): He Makes Things Live" (Valdez and Steiner 1972, 347–53).

13 "Removed from the mystico-warrior vision of Tlacaél, it was these Nahua *tlamatinime* who elaborated a deeply poetic conception of the world, [hu]man, and divinity . . . Relying upon one of the many metaphors that the rich Náhuatl language possesses, they affirmed on innumerable occasions that perhaps the only possible way to speak truthful words on earth was through the path of poetry and art, which are "flower and song". . . . Poetry and art, in general, 'flowers and songs,' are for the *tlamatinime* occult and veiled expressions that with the wings of symbol and metaphor can lead a man to stutter, projecting him beyond the self, which in mysterious form, brings him closer perhaps to his root. They appear to affirm that true poetry implies a peculiar mode of knowledge, fruit of an authentic interior experience, or if one prefers, the result of an intuition." (My translation.)

14 See *In ixtli, in yollotl* (Nahuatl), [face and heart] "rostro y corazón" (Spanish) in León-Portilla (1988, 146–54). This is a concept that Anzaldúa appropriates and redefines in the anthology she edits, *Making Face, Making Soul: Creative and Critical Perspectives by Women of Color* (1990). " 'Making faces' is my metaphor for constructing one's identity. *'[U]sted es el modeador [sic] de su carne tanto como el de su alma.'* You are the shaper of your flesh as well as

of your soul. According to the ancient *nahuas*, one was put on earth to create one's 'face' (body) and 'heart' (soul). To them, the soul was a speaker of words and the body a doer of deeds" (xvi). It is interesting to compare these understandings with that of Roger Lipsey in *An Art of Our Own: The Spiritual in Twentieth-Century Art*: "Oneself as one might be. The reminder of what one has forgotten is a call to action. The spiritual in art offers a transient experience of intensity, of a larger world and larger self. One begins to care again, reawakened to old longings, to remorse, perhaps to new thoughts and feelings, almost always to a clarified sense of direction. This blend of hope and remorse is a sign that one has encountered the spiritual in art. The spiritual in art makes its contribution to the pilgrim's halting progress. It is a resource for those who look beyond, understand that there is work to do, and undertake it" (1988, 16).

15 On the Toltec/artist, see León-Portilla (1980, 208, and 1988, 160–171); on the *tlamatinime*, León-Portilla (1988, 62, 123–26; 1980, 200).

16 The quotation marks around "art" are meant to signal the questioning of what we take for granted as the meaning of art; at other times cultures, even subcultures, understood what we today call art differently. To speak of art without noticing such complexities is to perpetuate erroneously the idea that all people hold universal, timeless concepts of art, artist, and artmaking.

17 "The *calmecac* (literally, 'row of houses') was a set of priestly residences associated with the temples of Tenochtitlán. Children of nobles were brought here by their parents to receive an education in the priesthood. Chronicles differ on whether children entered the *calmecac* at age four or fifteen. Apparently, some promising commoner children could be enrolled by parents who wanted them to enter the priesthood, but they appear to have been a very small minority. In the Florentine Codex, Sahagún makes clear the association of the *calmecac* with the education of well-born members of the society.

"The *calmecac* curriculum apparently included astrology, star lore, divination and the calendars, hieroglyphic writing, and 'life's history' (*nemiliz tlacuilolli*); it is here that future scribes (not to mention priests and diviners) were started on their career trajectory. All nobles, including future rulers, received their education in one of the six or more *calmecac* located in Tenochtitlán. Following some years of education there, all those entering administration, law, or other important governmental positions would share a working knowledge of those subjects, including the use and role of the hieroglyphic writing" (Marcus 1992, 50–51).

18 See León-Portilla 1988, 63–70, and consider: "The formal structure of

a ceremony is as holistic as the universe it purports to reflect and respond to, for the ceremony contains other forms such as incantation, song (dance), and prayer, and it is itself the central mode of literary expression from which all allied songs and stories derive. The Lakota view all the ceremonies as related to one another in various explicit and implicit ways, as though each were one face of a multifaceted prism. This interlocking of the basic forms has led to much confusion among non-Indian collectors and commentators, and this complexity makes all simplistic treatments of American Indian literature more confusing than helpful. Indeed, the non-Indian tendency to separate things from one another — be they literary forms, species, or persons — causes a great deal of unnecessary difficulty with and misinterpretation of American Indian life and culture. It is reasonable, from an Indian point of view, that all literary forms should be interrelated, given the basic idea of unity and relatedness of all the phenomena of life. Separation of parts into this or that category is not agreeable to American Indians, and the attempt to separate essentially unified phenomena results in distortion" (Allen 1986, 62).

19 "Thanks to Christian incendiarism and the ravages of time, the once copious libraries of these books are now represented by no more than thirty or so texts" (Brotherston 1992, 50).

20 "The effort to unite two cultures (often turning the conquerors' culture to the advantage of the conquered) is probably easiest to detect in the realm of images and pictographs. The creation of a twin system of expression — pictographic and alphabetical — was not merely a sign of compromise or collaboration. It also represented discovery of new formal strategies for preserving two living traditions side by side. At the same time that they mastered Latin and massively adopted writing, painter-writers were preserving and enriching their pictographic heritage" (Gruzinski 1992, 158–60).

21 For two early discussions of the spiritual concerns of *Borderlands*, see A. Ramírez (1989, 185–87) and Cáliz-Montoro (1996). For sustained engagement with her notions of spirituality and further explorations of U.S. Latina/o spiritualities, see also the fine work of Medina (1998), Medina and Cadena (2002), and Lara (2005).

22 Julio Ramos's observations on the ex-voto are useful here: "El género del exvoto se inscribe en una economía de la reciprocidad, del intercambio de dones, y como tal trabaja fundamentalmente la mediación, la articulación entre distintos niveles de órdenes discontinuos. . . . Como si de algún modo la temática del viaje y de sus interrupciones condensara las condiciones mismas de producción del género y su insistente reflexión sobre el límite — límite entre

la vida y la muerte del sujeto accidentado—así como sobre la discontinuidad y la mediación entre tiempos y espacios diferenciados. Se trata entonces, en varios sentidos, de una forma que a lo largo de su historia (que por cierto antecede la colonización de América) registra lúcidamente el devenir de distintas concepciones de la estabilidad y el desequilibrio, de la causalidad y la contingencia, del accidente y la ley, del desastre y de la intervención de las mismas prácticas pictórico-narrativas como modos de contener y reparar la catástrofe" (1997, 7–8). ("The genre of the ex-voto is inscribed in an economy of reciprocity, of the exchange of gifts, and as such, fundamentally works mediation, the articulation between different levels of discontinuous orders. . . . As if in some way the theme of travel and its interruptions condensed the very conditions of the genre's production and its insistent reflection upon the limit— the limit between the life and death of the subject of the accident—as well as upon the discontinuity and mediation between differentiated times and spaces. We are dealing, then, in various senses, with a form that throughout its history (which indeed predates the colonization of America) lucidly registers the development of different conceptions of stability and equilibrium, causality and contingency, accident and law, disaster and the intervention of the same pictorial-narrative practices as modes of containing and repairing the catastrophe." (My translation.)

23 See, for example, Rebolledo (1995, 49–81).

24 "See that you shall die. See that you don't know when." Quoted in Amalia Mesa-Bains, "Codex Amalia: Venus Envy," in Draher (1992, 15).

25 On España's work, see Fregoso (1993), Noriega (1996, 207–28), and Huaco-Nuzum (1996). My discussion of España's video art draws on an earlier version of this portion of the chapter (L. Pérez 1996).

26 This is an idea España found useful in describing her work in "Nepantla'd Out:" "As a woman, and particularly as a Chicano artist, the challenge to articulate perception has hardly ever fallen easily upon me. Making fire is making fire. I seek new parameters within film and electronic media because those that do exist have posed severe creative limitations, borne of a different mood and world view. Trial and disgust in the editing room over industry codes and film capital standards forced me to give it up and speak in my own tongue. The challenge to reposition, begin transition, return spirit to the tribe embraced additional dimensions: adapting film language so that it more accurately articulates my vision—experimenting with approach until the artist's tools interpret form and style in ways more applicable to my own experience, in ways more relevant to me" (1995, 177).

27 I borrow the general term "perspective schema" from Elkins (1994, 9), who cautions, "Perspective proper, including its many methods and sometimes eccentric disciples, is thought to be a single thing, discovered in one form by Brunelleschi and elaborated upon by later workers. Behind this notion is the idea that perspective began in one place, Florence, and more or less at one time (c. 1413–1435). This sense of a unified origin is one of several unities that play parts in the modern concept of perspective. I suggest not that it is mistaken or that perspective has miscellaneous or exotic origins but rather that this unified origin was not perceived as such in the Renaissance and that Renaissance artists and writers saw many techniques where we see a single discovery" (8). Thus, "an interesting sign of the presence in our scholarship of an informal definition of 'meaningless' perspective unrelated to the passage of time is a particular kind of perspective picture that I will call a *perspective schema*" (9).

28 My thanks to the artist for discussing her series with me and clarifying many of the images, as well as for sharing relevant readings with me.

Chapter Two: Body, Dress

1 Following Bourdieu, dress may be read as one of the numerous and mundane forms of displaying cultural capital or its lack. Zoot suits in the 1940s and chola/o urban styles in the 1970s, punk attire in the 1970s and 1980s, African American urban styles of the 1980s and 1990s: all these styles of dress speak of specific historical moments in the United States, of different forms of cultural alterity and oppositional cultural politics with respect to mainstream norms of dress, behavior, and beliefs. In addition, all these moments in an alternative history of costume of the United States have contested, and to some degree transformed, mainstream and dominant cultures, even as they have been partially absorbed or exploited by these. On zoot suits, see Cosgrove (1989) and Sánchez-Tranquilino and Tagg (1991). On punk styles of England, see Hebdige (1988).

2 Consider, for example, the Austrian architect Adolf Loos's declaration in his 1908 "Ornament and Crime": "I have discovered the following truth and present it to the world: cultural evolution is the equivalent to the removal of ornament from articles in daily use" (quoted in Taylor 1997, 101). Writing on domestic service in the United States in 1992, Mary Romero discusses the importance of the appearance of domestic workers for their employers. For

some employers, the color of the domestic worker, like the requirement that a uniform be worn, boosts their own status, in their own eyes and socially, to the degree that a community is based on racialized identities (1992, 111–13).

3 "In South Carolina, employers typically expect to hire African American women as domestics; in New York, employers may expect their domestics to be Caribbean immigrants; however, in Los Angeles and Chicago they can expect to hire undocumented Latin American immigrants. Racial, class, and gender stratification so typifies domestic service that social expectations may relegate all lower-class women of color to the status of domestic" (Romero 1992, 71).

4 "The idea of the body as 'garment' was a widespread metaphor in antiquity," writes Stuart Smithers in a special issue of *Parabola* on clothing, "suggesting a metaphysics of clothing that can be traced back to the Genesis account of God clothing Adam and Eve in 'garments of skin'" (Smithers 1994, 7). And from Mark C. Taylor: "Strip away layer after fashionable layer and you discover not an unadorned body but a body that has become fashionable. With virtually everyone strapped to exercise machines that future generations of archeologists will surely see as direct descendants of medieval torture devices, it should be obvious that the body is no more natural than the clothes it wears" (Taylor 1997, 185). Performance art since the 1960s points to the body itself as socially constructed in explicit ways. The Paris-based performance artist Orlan, for example, films and displays herself before, during, and after cosmetic surgery and exhibits the flesh removed in the process (Hirschhorn 1996, 110–34; Taylor 1997, 139–43). With respect to the racialized garment of the skin, Susan S. Bean writes of the importance of dress in Gandhi's politics and charts his journey in political and spiritual consciousness through his attire. She writes that after he had attempted to dress correctly as a gentleman by English colonial standards in South Africa, "it had become clear [to him] that the color of one's skin was as much a part of one's costume as a frock coat, and this fundamental Indianness Gandhi would not have changed even if he could." The loincloth and shawl that most remember him by today, "his satyagrahi garb[,] was his own design, and expressed simplicity, asceticism, and identity with the masses." "By appearing in this eccentric fashion," Bean concludes, "he forced his colleagues to notice and accommodate his view of a truly Indian nationalism. He deliberately used costume not only to express his sociopolitical identity, but to manipulate social occasions to elicit acceptance of, if not agreement with, his position" (1994, 30–31).

5 "Performativity must be understood not as a singular or deliberate 'act,'

but, rather, as the reiterative and citational practice by which discourse produces the effects that it names" (Butler 1993, 2). "Performativity . . . is always a reiteration of a norm or set of norms, and to the extent that it acquires an act-like status in the present, it conceals or dissimulates the conventions of which it is a repetition" (12).

6 "Class, gender, sexuality, and even race and ethnicity—the determinate categories of analysis for modern and postmodern cultural critique—are themselves brought to crisis in dress codes and sumptuary regulation . . . the transvestite is the figure of and for that crisis, the uncanny supplement that marks the place of desire" (Garber 1992, 28).

7 "For many working-class women, women of color, and women of the middle and upper classes, the application of makeup serves as a daily ritual in which the woman, either consciously or not, has a hand in authoring or defining the image that she presents to the world. Cosmetics and dress remain, for some women, their only vehicle of self-expression and self-definition. For women of color, the factors that limit their individual potential are written in the color, ethnic features, and gender of their own faces and bodies. Makeup and other forms of masking sometimes are used to protect themselves against the harsh judgments of a society that deems them invisible or unacceptable" (Gutiérrez Spencer 1994, 69). My thanks to Juliana Martínez for bringing this essay to my attention.

8 The use of the idea of "bodies that matter" draws on both Judith Butler's *Bodies That Matter* and Avery Gordon's *Ghostly Matters: Haunting and the Sociological Imagination*. Butler's discussion of bodies that are socially devalued and discursively marginal, and Avery's discussion of the social significance of that which haunts because it is improperly or inappropriately buried within the social psyche, so to speak, provide particularly useful ways to think about the socially haunting presence of the gendered and racialized bodies of women of color in the United States.

9 Kohler (1963, 43), quoted in Smithers (1994).

10 For early discussion of this piece, see Yarbro-Bejarano (1993), Chabram-Dernersesian (1992), and L. Pérez (1999). See Enloe (1990) and A. Ross (1999) on gender and the garment industry.

11 My thanks to the artist for our conversation on November 10, 1999, which clarified aspects of the installation.

12 The dress was reinstalled for the artist's one-woman show, Transformations: The Art of Ester Hernandez, guest curated by Holly J. Barnett, at MACLA, San Jose Center for Latino Arts, 1998.

13 "*Chicana rasquache (domesticana)*, like its male counterpoint [*rasqua-chismo*], has grown not only out of both resistance to majority culture and affirmation of cultural values, but from women's restrictions within the culture. A defiance of an imposed Anglo-American cultural identity, and the defiance of restrictive gender identity within *Chicano* culture has inspired a female *raquacheism* [*sic*]. *Domesticana* comes as a spirit of Chicana emancipation grounded in advanced education, and to some degree, Anglo American expectations in a more open society. With new experiences of opportunity, *Chicanas* were able to challenge existing community restrictions regarding the role of women. Techniques of subversion through play with traditional imagery and cultural material are characteristic of *domesticana*" (Mesa-Bains 1995, 160).

14 Installed at the Whitney Museum at Philip Morris, New York City in 1993; the Williams College Museum of Art in 1994, and the Steinbaum Krauss Gallery, New York City in 1997, respectively.

15 *Chapter One* is situated within the historical spaces of autobiography and family genealogy, and within the cultural spaces of contemporary Catholic Mexican and Chicana/o cultures. *Chapter II* references the cultural history of the subjugation of women in the Muslim legacy of Hispanic cultures and in the colonial Mexico of the intellectual and poet Sor Juana Inés de la Cruz.

16 Steinbaum Krauss Gallery (1997b).

17 "Her giant Cihauteotl [*sic*] . . . is 'both a kind of archeological history and a mythic inventory,' Mesa-Bains said. The spirit's mossy skin is etched with symbols of Aztec culture. The marigolds on which she rests are 'flowers of the dead' in Chicano culture. As a landscape, she represents the Mexican people's struggle for land and their frequent displacement" (Wright 1998, 19).

18 "The second part of the exhibition, subtitled 'The Room of Miracles,' extends the notion of spiritual revisionism towards the material evidence of a long-lost past . . . What is striking about this collection of tagged specimens interspersed with magnifying mirrors and sample mounts is the way in which it carries the notion of the acquisition of culture through direct observation. Meaningfully, as the viewer identifies individual elements within the artwork such as a small statue of the Virgin of Guadalupe, a packet of seeds, a starfish, visually and discursively what is conveyed is a pragmatic recasting of Latin American art and culture as a diverse collection of obscured fragments whose importance lies in situating a space beyond intellectual verification" (Douglas 1997, 57).

19 For one reviewer of the exhibition, Susan Douglas, "*Cihuateotl (Woman*

of Cihuatlampa) (1997), is a key work. In the figure of a sleeping woman, it suggests ancient burial mounds, thus the home of the mythical Amazonas, warriors of legend" (1997, 57). For Alison Ferris, "On one level, Mesa-Bains reclaims women's association with nature in this work, an idea that some feminists reject because this association keeps women from being active participants in the creation of history and culture. However *Cihuateotl* is also marked with cultural symbols in the form of Aztec designs which balance the association with nature. Her body is the corpus of migration and displacement in the struggle for land experienced by generations of Mexicans within the continent." And also, "one could understand *Cihuateotl* as Mesa-Bains ironically offering herself as the 'nature' of cultural analysis. By providing the context in which her work is to be understood through myth, metaphor, and history, she allows neither her work nor herself to be reduced to evidence" (1998, 27).

20 "The reclining female nude since the Renaissance—one of the central images in Western painting—raises the question of the male gaze in more acute form than perhaps any other artistic stereotype. The woman is almost invariably shown as completely passive, an object for contemplation" (Chicago and Lucie-Smith 1999, 100). In the coffee table–style book he coedited with Judy Chicago, Edward Lucie-Smith unfortunately neutralizes to some degree the feminist insights he otherwise appropriates, given that the more relevant issue is not whether images are created for contemplation but rather whether these reproduce the perspectives of unequal, gendered power relations. See Parker's and Pollock's (1982) chapter "Painted Ladies," and Duncan's "The Modern Art Museum: It's a Man's World" (1995) from which the citations of their work in the text are taken.

21 On the tautology of Freudian thought: "Penis envy *is* phallus envy, phallus envy *is* fetish envy. It is not clear that it is possible to go 'beyond ideology' here; the ideology of the fetish is the ideology of phallocentrism, the ideology of heterosexuality" (Garber 1992: 119). And elsewhere, "phallocentrism is *loss* of estrus. . . . And Freud's attempt to make the fetish part of the *female* body is both denial and displacement" (120).

22 See Sjöö and Mor (1987, 21–32). On the repression of the "primitive" and the occluded contributions of a female theorist to psychoanalytic theory, see Gordon (1997, 31–60). Torgovnick observes that "for Jung on the eve of his nervous breakdown and subsequent travels in Africa, the 'terrible mother' played the same role he would later attribute to Africa and to the primitive in general: like Africa, the mother is forever an attractive, desired site of the

undifferentiated; but she is also feared as the potential absorber and destroyer of the self. This kind of thinking, this kind of intuitive association, is surprisingly common in male or male-identified primitivist thinking, even when it presents itself as historical or scientific rather than as purely imaginative" (1997, 40).

23 "None of the societies most often cited as authentic Goddess cultures actually confirms to our expectations. Not a single one provides clear evidence of a single, supreme female deity; not a single one exhibits the signs of matriarchal rule, or even of serious political power-sharing between the sexes; not a single one displays with any surety the enlightened attitudes towards social egalitarianism, nonviolent interpersonal and interstate relations, and ecological sensitivity which we have been led to anticipate. In each of these cases, the story of the Goddess is a fabrication in defiance of the facts" (P. Davis 1998, 83–84). See also Eller (2000).

24 Copper and mirrors and shells were found in the huge burial mounds of a people called Sarmations who are believed by Jeannine Davis-Kimball, their discoverer, to very possibly be the Amazons from the eastern steppes described by Herodotus. Some of these huge mounds, 60 feet high and 350 feet in diameter, were believed to belong to priestesses, for in them were found small clay or stone altars, bronze mirrors, bronze spoons, and seashells (Perlman 1997). Provided by the artist's gallery as part of her promotional materials.

25 Telephone conversation with Valdez, August 7, 2000. Victoria Delgadillo, of the now-defunct Mexican Spitfires, recalled (via email) several paper fashion shows, including one by Sean Carrillo, also part of that first paper fashion show. On Carrillo, see Porelli (1982) for press coverage of the March 1982 "Moda Chicana" show. My thanks to Delgadillo for sending me a copy.

26 On the garment industry, see Sassen (1998, 84). On art, see Duncan (1995, 102–32).

27 Bourdieu's sociological study of the concept and ideological function of cultural taste in France led him to formulate a complex notion of capital as three variably interrelated forms of "actually usable resources and powers— economic capital, cultural capital, and also social capital" (Bourdieu 1998, 114). The concept of cultural capital takes into account what is inherited from one's class background, such as table manners and distinctive forms of taste with respect to music, art, and behavior, as well as what is acquired (and/or unlearned) through education, or other forms of self-fashioning. "The exchange rate of the different kinds of capital is one of the fundamental stakes in the struggles between class fractions whose power and privileges are linked to one

or the other of these types. In particular, this exchange rate is a stake in the struggle over the dominant principle of domination (economic capital, cultural capital or social capital), which goes on at all times between the different fractions of the dominant class" (125). Of taste, Bourdieu observes, "those whom we find to our taste put into their practices a taste which does not differ from the taste we put into operation in perceiving their practices" (243).

28 The idea of "ambivalent mimicry" is informed by Judith Butler's fruitful ideas of performativity in the social sphere, and more specifically, her discussion of "ambivalent drag" (Butler 1993, 124), as well as the poststructuralist idea of ambivalent subject positions, and Homi Bhabha's reflections on the ambivalence of colonial mimicry (1994, 85–92).

29 Telephone conversation with the artist, March 31, 1999.

30 Whether they appear to be more female than male, or the opposite in other pieces, Gamboa's drawings repeatedly suggest androgyny, that is, the undecidability of whether we are looking at individuals who appear androgynous because, if they are women, they exceed gender expectations, or because they also could be read as bodies in gender drag, with large breasts as the result of hormones, and bikini bottoms indicating the possibility all forms of transgendered identities. But even if Gamboa's figures are taken to represent straight women, they are transgendered identities as well, in that the kind of desire, sexuality, and power represented in these bodies is transgressive of heterosexual idealizations and limitations of female-to-male desire.

31 Chicana/o and Mexican artists have extensively explored Sacred Heart heart imagery. See, for example, the exhibition catalog *El Corazón Sangrante/ The Bleeding Heart* (Debroise, Sussman, and Teitelbaum 1991). The New Mexico–based artist Delilah Montoya has written about its history in an unpublished catalog accompanying her *El Corazón Sagrado* series "Even the skillfully conceived Baroque Heart would not have become a dominant icon in the Americas, had it not been kept alive in principle and intuition by the native legacy of the yollotl. . . . Expressing the European concept of passion as well as the Nahua understanding of the soul, it is simultaneously the Nahua sacrificial heart and Mary's heart reflecting the heart of Christ. El Corazón Sagrado expresses a vision shared between two cultures" (7–8). See the artist's Web site for more on this series, http://sophia.smith.edu/~dmontoya. Chapter 6 more fully explores the uses of sacred heart imagery in Montoya's work and that of other Chicana artists.

32 "The space constituted by the global grid of cities, a space with new economic and political potentialities, is perhaps one of the most strategic spaces

for the formation of transnational identities and communities. This is a space that is both place centered in that it is embedded in particular and strategic locations; and it is transterritorial because it connects sites that are not geographically proximate yet are intensely connected to each other. As I argued earlier, it is not only the transmigration of capital that takes place in this global grid but also that of people, both rich (i.e., the new transnational professional workforce) and poor (i.e., most migrant workers), and it is a space for the transmigration of cultural forms, for the reterritorialization of 'local' subcultures. An important question is whether it is also a space for new politics, one going beyond the politics of culture and identity, though at least partly likely to be embedded in it" (Sassen 1998, xxxii). Also see Hall (1991) for earlier observations on "the erosion of the nation-state and the national identities that are in association with it" (25).

33 This and some of the other descriptions pertaining to this piece are from my unpublished interview with the artist, in Los Angeles, on February 23, 1996, and subsequent conversations.

34 On the problematic inclusions and exclusions of U.S. Latina/o and Latin American art, see Goldman (1994a, 317–43), Karp and Lavine (1991, 79–150), and Ríos-Bustamente and Marin (1998). See also Lindsay (1996), M. C. Ramírez (1996), and Yúdice (1996), in particular, in Mosquera (1996a).

35 See, for example, Broude and Garrard (1994), Chicago and Lucie-Smith (1999), Goldman (1988c; 1989), LaDuke (1992), Lippard (1990), Shohat (1998), and Young (1990).

36 See Barron, Bernstein, and Fort (2000a, 2000b).

37 For example, Garduño and Rodríguez (1992), Arceo-Frutos, Guzman, and Mesa-Bains (1993), Sullivan (1996), Goldman (1994a), and Henkes (1999). For other critics writing in interesting and insightful ways about Chicano visual art, see Barnet 1998; Cortez 2001; Davalos 2001; Gaspar de Alba 1998; Huacuja 2002, 2003; Romo 1999; Venegas 1977, 1990; and Yarbro-Bejarano 1998.

38 Jacinto Quirarte's 1973 *Mexican American Artists* did not include the work of contemporary Chicana artists, though it did include that of Chelo González Amezcua (b. 1903). A later essay (Quirarte 1992) includes López's work in its discussion of the history of Guadalupan imagery in folk and art histories.

39 See, for example, *Imagine* (1986), Griswold del Castillo, McKenna, and Yarbro-Bejarano (1991), *Le Démon des anges* (1989), and Gaspar de Alba (1998).

40 An anthology by Broude and Garrard (1994) includes the works of

López, Hernandez, and Mesa-Bains in three essays, one of which is coauthored by López herself, the other by Gloria Feman Orenstein, and the third by Suzanne Lacy, which includes a conversation with the Chicana artist Judy Baca. LaDuke (1992) includes essays on and images by López and the Chicana artist Patricia Rodríguez. Lippard (1990) includes the work or discussion of the works of López, Hernandez, Mesa-Bains, and Gamboa, along with that of some nine other Chicana artists.

41 Based on information in their résumés and conversations with the artists.

Chapter Three: Altar, Alter

1 For the first point, see Turner (1999, 8, 25) and Thompson (1993, 20). On the cultural hybridity of altars, see Beezley (1997, 92) and Gruzinski (1995, 50, 185–86).

2 Gruzinski (1995); Beezley (1997); Turner (1999, 20–21; 44).

3 Olalquiaga (1992, 49).

4 Mesa-Bains theorizes this aspect of her work in Mesa-Bains (1993c, 9). Jennifer González has similar criticism for Olalquiaga: "By overemphasizing the ironic use of material culture in contemporary art, Olalquiaga misses the point that many altar-installations, in particular those of Mesa-Bains, do not so much *erase* the religious connotations of the iconography they employ, but rather *redefine* this iconography by producing a hybrid mix of signs" (1996, 346).

5 For work by Latina/o religion scholars, see Díaz-Stevens and Stevens-Arroyo (1998). For work by scholars of feminist spiritualities and practices, see P. Davis (1998), Eller (2000), and Turner (1999). Queer spiritualities writers on the subject include Conner, Sparks, and Sparks (1997) and De la Huerta (1999). For a journalistic perspective, see Cimino and Lattin (1998).

6 Chicana/o art practices lend particular weight to David Harvey's Marxist reaffirmations regarding the relations between economic and cultural forms, including religious forms (1990, 238, 292).

7 On baby boomer spirituality, see Clark (1993) and the well-documented work of the religion journalists Cimino and Lattin (1998) on contemporary religiosity in the United States. Regarding spirituality and contemporary art, see D. A. Ross (1997) on the work of Bill Viola, and Grey (1998), Gablik (1991), and Haynes (1997) for other recent efforts by Euroamerican artists and writers

to bring a socially relevant spirituality and spiritually conscious art practice back into art world discourse.

8 "Los imaginarios coloniales, como los de hoy, practican la descontextualización y el reaprovechamiento, la destructuración y la restructuración de los lenguajes. La mezcla de referencias, la confusión de los registros étnicos y culturales, la imbricación de lo vivido y de la ficción, la difusión de las drogas, la multiplicación de los soportes de la imagen también hacen de los imaginarios barrocos de la Nueva España una prefiguración de nuestros imaginarios neobarrocos o posmodernos, así como el cuerpo barroco en sus nexos físicos con la imagen religiosa anunciaba el cuerpo electrónico unido a sus máquinas, walkmans, videocaseteras, computadoras. . . . Ese mundo de la imagen y del espectáculo es, más que nunca, el de lo híbrido, del sincretismo y de la mezcla, de la confusión de las razas y de las lenguas, como ya lo era en la Nueva España. [The colonial imaginaries, like those of today, practice decontextualization and reuse, destructuring and restructuring of languages. The mixture of references, the confusion of ethnic and cultural registers, the imbrication of the lived and of fiction, the diffusion of drugs, the multiplication of the image's supports also make of the baroque imaginary of New Spain a prefiguration of our neobaroque or postmodern imaginaries, just as the baroque body in its physical links to the religious image announced the electronic body, linked to its machines, walkmans, video players, computers. . . . That world of the image and spectacle is, more than ever, that of the hybrid, of syncretism and mixture, of the confusion of races and languages, as it already was in New Spain.]" (Gruzinski 1995, 214–15).

9 As the feminist scholar Kay Turner points out, throughout patriarchal cultures worldwide, "the home altar . . . has for centuries encoded a visual language through which objects 'speak' to the distinctive concerns of women's 'hidden' culture" (1999, 20–21). Turner's study of the post-1960s widespread resurgence of the ancient tradition of domestic and artistic altar building in the United States revealed that the former (domestic altar building) is a largely female-based practice, largely rooted in Roman Catholic culture of various ethnicities, and that in Catholic homes, it is mother-centered (44). Turner's rich study reflects on the various forms of power reversals that the practice of keeping domestic altars enacts, such as placing the record of family history, and even more specifically matrilineal history, in women's hands, "mak[ing] men dependent on women for divine intercession in insuring the prosperity and protection of the family" (44), and perhaps most importantly, allowing for women's participation in spiritual expression, particularly given their un-

equal footing with men in the world's major, patriarchal religions. See P. Davis (1998) and Eller (2000) for criticism of the fallacies within goddess-centered writing and the scholarship from which it extrapolates.

10 By definition, what is referred to as the folk Catholicism of Mexican and Mexican American communities is the mixture of surviving "pagan" beliefs and practices, but the term privileges the predominance of the Christian over the indigenous and other cultural strata, such as the secret Jewish culture of the Southwest. The recent flowering of research in U.S. Latina/o theology contests such designations as inaccurate and ethnocentric, arguing for a more complex understanding of the effects of indigenous and African-diaspora derived belief systems, even to the extent of arguing that Eurocentric Christian discourse and practices have been selectively used as vehicles to preserve or appropriately "translate" non-Western systems of belief. See, for example, Díaz-Stevens and Stevens-Arroyo (1998); Isasi-Díaz (1996).

11 See González-Wippler (1995), Pérez y Mena (1997), Isasi-Díaz (1996), Lindsay (1996), and Mosquera (1996b).

12 Telephone conversation on July 31, 2000, with the artist René Yañez, the first and long-term director of San Francisco's Galería de la Raza.

13 See Davalos (1998; 2001) for a discussion of the politics of exhibition displays, including those of Days of the Dead, at the Mexican Fine Arts Center Museum in Chicago.

14 Other artists, for example, who explore(d) the altar form in mixed-media installations include the Mexican Spitfires (Victoria Delgadillo, Elizabeth Delgadillo, and Patricia Valencia) and Pat Gomez, from Los Angeles, and Pilar Agüero, in San Jose.

15 Statement by the artist during a presentation of her work at California State University, Monterey Bay, National Association of Chicana and Chicano Studies Northern Foco Conference, February 13, 1999.

16 " 'Among other things,' [Paredes] suggests, 'folklore helps create a feeling of unity and homogeneity that enhances the dignity of the group and helps them to face with greater confidence the challenges of what to them [is?] a hostile world.' Paredes points out that the Mexican-descent population in Texas has suffered a particularly difficult history of exploitation as an ethnic group. . . . have compelled them to develop a strategy of survival and, indeed, resistance. We suggest that their seeming insistence on maintaining a distinctive cultural aesthetic is an important part of this strategy" (Seriff and Limón 1986, 45). In their study on the votive paintings of Mexican immigrants to the United States, Durand and Massey essentially confirm Paredes's understand-

ing of the political and psychological effects of cultural retention: "Through faith and devotion to familiar icons people are able to make sense of the alienating and disjointed experiences of life in a foreign society. Holy images provide a cultural anchor for people adrift in a sea of strange experiences, exotic tongues, and odd customs. . . . to construct an inner Mexico with the alien material culture of the United States" (1995, 63).

17 As to her art school experiences: "And so the anger, the pride and self-healing had to come out as Chicano art—an art that was criticized by the faculty and white students as being too political, not universal, not hard-edge, not pop art, not avant-garde, too figurative, too colorful, too folksy, too primitive, bah, bah, bah! . . . What they failed to see was that the art I was creating functioned in the same way as the *salvia* (aloe vera) plant when its cool liquid is applied to a burn or an abrasion. It helped to heal the wounds inflicted by discrimination and racism" (Lomas Garza 1991, 13). See also the artist's website, http://www.carmenlomasgarza.com.

18 "In her more than twenty-year career Carmen Lomas Garza has presented both historiography and autobiography in her *Monitos* paintings. Born of the *lottery tables* (lottery cards), these doll-like figures have joined the tradition of codices and ex-voto in their direct and sincere narrative" (Mesa-Bains 1991a, 39).

19 Giffords (1991), quoted in Durand and Massey (1995, 23).

20 Just as folk healers were often the only source of health care for Mexican Americans because "no Anglo doctor would accept Mexican patients" (Limón 1994, 181), *curandera/o-* and other folk-inspired art has been a refuge for many Chicana/o artists from a Eurocentric art and mass media tradition that is damaging not only in its exclusions but also in its racist, dehumanizing depictions of Mexicans and Mexican Americans.

21 On Santa Barraza and her work, see Herrera-Sobek (2001). In revolutionary and post-Revolutionary Mexico, "Ex-votos . . . embodied the ideal of *mestizaje*, or mixture, promoted by the Revolution" (Durand and Massey 1995, 42), which partly explains why this increasingly popularized but once elite religious art form was collected by the generation of the Mexican Muralists and was such a major influence on Frida Kahlo (34–40).

22 "Votive practices were well known in Mesoamerica before the conquest" (Durand and Massey 1995, 12). "Because votive painting has its roots in Pre-Christian practices, Mexican priests have always been ambivalent, and at times hostile, toward this popular artistic tradition" (9).

23 Barraza studied at the University of Texas in Austin with Linda Schele,

a scholar and painter who deciphered Mayan glyphs, and has extensively studied through her own work codex conventions and other aspects of pre-Columbian aesthetics (Barraza 2006).The highly codified nature of pre-Columbian glyphs, their placement, color, and so on, is studied in the video *Tlacuilo* by Enrique Escalona (1988). See also Boone (2000).

24 See chapter 1 for more detailed discussion of codices and their distinctive visual histories and appeal to Chicana artists.

25 On Mexican and Chicano nationalist discourse and the Malinche, see Alarcón (1989) and Del Castillo (1974).

26 Interview with the artist, in her San Francisco studio, 1999. For information about *Mujeres Muralistas*, see Ochoa (1993), Cockcroft, Weber, and Cockcroft (1977), and the interview with the artist in Cockcroft and Barnet-Sánchez (1990). LaDuke (1992) discusses both Rodríguez's murals and box constructions.

27 Interview with the artist, 1999.

28 See Lippard (1990, 54) for an image.

29 For an overview of Valdez's performance and painting, and a theory of her aesthetics, see Mesa-Bains (1999). See Romo (1999) for the images discussed in this section and essays, and Rangel (1999) for an interview with the artist. This section draws as well on my own interview with the artist on February 23, 1996, and a telephone conversation on August 7, 2000.

30 The artist expressed discomfort with my idea of sacrifice in relation to some of these tables. Telephone conversation with the artist, August 7, 2000.

31 Valdez has said that the watermelon represents a heart and, on some level, the juice represents blood; see Rangel (1999, 4).

32 See, for example, *The Kitchen, Brown Huevos, Chile y Café, What Happened*, and *Noche de Sandía*.

33 Telephone conversation with the artist, spring 1999.

34 Turner (1999) identifies the autobiographical and collective historic character of the altar as one of its defining features, along with its politics of relationship building.

35 See Díaz (1998).

36 For excellent discussions on the murdered women of Juárez, see Schmidt Camacho (2004), Fregoso (2003, 2000), and the entire issue of *Chicana/Latina Studies: The Journal of Mujeres Activas en Letras y Cambio Social* (vol. 4, no. 1, Fall 2004) dedicated to the topic. See also the discussion of Celia Alvarez Muñoz's pioneering installation *Fibra y Furia*, addressing the Juarez disappearances, in the following chapter.

37 As noted earlier, the perceptive discussion of the social meaning and call for reckoning in the world of the living that Avery Gordon has advanced in her very fine book (1997) directly informs and inspires my own thinking on all matters pertaining to the ghostly.

38 More images and text are reproduced in Leclerc, Villa, and Dear (1999, 125–30).

39 Racialized homosexuality and desire across it as such, the conflict between patriarchal and homophobic traditional Mexican American culture, and spirituality are central topics in the late Gil Cuadros's collection of short stories *City of God* (1994).

40 See Fregoso (1993) for an excellent discussion of the video.

41 On "altar photography" in Montoya and Vargas, see Sorell (1999).

42 For a more extended consideration of *Ruin*, see L. Pérez (1999/2000).

43 See her unpublished (1994) photocopied catalog text to the *El Corazón Sagrado* exhibition.

44 See López Pulido (2000) for a sensitive and thoughtful study of the "practical" and popular religiosity of New Mexico's *penitente* brotherhoods.

45 Artist's statement, San Antonio Art League Museum, Annual Artist of the Year Exhibition, 1998, 1.

46 For a very fine essay describing the coexistence of the spiritual and the political in Vargas's work, and describing it as "a lifelong meditation on death and love . . . as the transcendent forces that mold all lives," see Lippard (2000a). I am grateful to the artist for sharing her unpublished notes on this piece with me, which allowed my to return to my original drafts of this section and rethink them with her own intentions and insights in view.

47 Installed as part of the *Imágenes e historias*/Images and Histories (1999–2000) exhibition.

48 On the variably spelled khora, or *kora*, as the undifferentiated primordial stuff of which the material world is made, see Plato's *Timaeus*. For its use to describe the lack of the presence of the female perspective within male-centered language and culture, see Kristeva (1985), and see Derrida (1996) on its general use as that outside of the socially coded.

49 On Paredes, see Saldívar (1997). On the contributions of U.S. women of color see Sandoval (2000). Since the civil rights era, gender and sexuality-based notions of "otherness" have also become more widely challenged, alongside "race."

Chapter Four: *Tierra*, Land

1 Anti-Spanish, alongside anti-Native American racism, no doubt fed into anti-Mexican sentiments. See Dussel (2000) on northern European imperialism and the rise of anti-Spanish sentiment.

2 This is the central argument of the thoughtful, spiritually grounded documentary *San Ce Juan* (2005) by the journalists Patrisia Gonzales and Roberto Rodriguez that investigates the development of the concept of Aztlán from colonial-era codices and among *indígena* elders and Chicana/o and other Latina/o youth today. For them, Aztlán ultimately signals inclusion and the abiding presence of the descendants of the original inhabitants of the continent, comparable to that of the steady march of the ant. See also Gonzales's *The Mud People. Chronicles, Testimonies, and Remembrances* (2003).

3 For a collection of essays on Aztlán, including the foundational Chicana/o movement manifesto, "El Plan Espiritual de Aztlán," see Anaya and Lomelí (1989). On the Mexican American history of the U.S. Southwest and West Coast during the nineteenth and early twentieth centuries, see Acuña (1981) and Montejano (1987), and for feminist correctives of male-centered historiography, see Ruiz (1998), D. González (1999), E. Pérez (1999), and Castañeda (1993, 1990). For a history of the Mexican American community from 1930 to 1960, see M. T. García (1989). For scholarship on the history of the post-1965 Chicana/o movement, see C. Muñoz (1989), A. García (1997), and Ruiz (1998).

4 "If space is indeed to be thought of as a system of 'containers' of social power (to use the imagery of Foucault), then it follows that the accumulation of capital is perpetually deconstructing that social power by re-shaping its geographical bases. Put the other way round, any struggle to reconstitute power relations is a struggle to reorganize their spatial bases. It is in this light that we can better understand 'why capitalism is continually reterritorializing with one hand what it was deterritorializing with the other' (Deleuze and Guattari, 1984)" (Harvey 1990, 237–38). "Spatial and temporal practices are never neutral in social affairs. They always express some kind of class or other social content, and are more often than not the focus of intense social struggle. That this is so becomes doubly obvious when we consider the ways in which space and time connect with money, and the way that connection becomes even more tightly organized with the development of capitalism. Time and space both get defined through the organization of social practices fundamental to commodity production. But the dynamic force of capital accumulation (and over accumulation), together with conditions of social struggle, renders

the relations unstable. . . . During phases of maximal change, the spatial and temporal bases for reproduction of the social order are subject to the severest disruption. . . . it is exactly at such moments that major shifts in systems of representations, cultural forms, and philosophical sentiment occur" (239). On the politics of place, see also Lefebvre (1991); Foucault (1980, 1987); de Certeau (1988).

5 "The power of place—the power of ordinary urban landscapes to nurture citizens' public memory, to encompass shared time in the form of shared territory—remains untapped for most working people's neighborhoods in most American cities, and for most ethnic history and most women's history. The sense of civic identity that shared history can convey is missing. And even bitter experiences and fights communities have lost need to be remembered—so as not to diminish their importance" (Hayden 1995, 9, 11). For the power of place regarding the natural world see Swan (1991).

6 See Kaplan (1996) for a discussion of geographical and cultural deterritorializations.

7 "The actual physical borderlands that I'm dealing with in this book is the Texas-U.S [sic] Southwest/Mexican border. The psychological borderlands, the sexual borderlands and the spiritual borderlands are not particular to the Southwest. In fact, the Borderlands are physically present wherever two or more cultures edge each other, where people of different races occupy the same territory, where under, lower, middle and upper classes touch, where the space between two individuals shrink with intimacy" (preface).

8 On Mexican nationalist dicourses and the role of *mestizaje* see Widdifield (1996) and Carrera (2003).

9 In Nahua and Maya thought, the interior of the mountain or its peaks is one of the geographical dwelling places of the s/Spirit(s) of the community; in the Nahua world, it was described as the *altepeyollotl* (Carrasco 1990, 70).

10 I am indebted to the artist and to my friends Jean-Pierre Larochette and Yael Lurie for sharing their profound knowledge of, and original insights on, the cross-cultural history of weaving and for their own fascinating, culturally innovative explorations within the medium of tapestry.

11 The quotes are taken from a lecture the artist delivered on her work on April 20, 1999, at the University of California, Berkeley. My discussion of her work also draws on interviews with the artist at her home in 1999 and 2005.

12 For example, on May 16, 2000, *La Voz de Aztlán* (Whittier, Calif.) circulated an e-mail titled "Arizona Vigilantes Shed More Mexican Blood at the Border." The article reported that "two Arizona ranchers on horseback and armed with high power hunting rifles shot and critically wounded an undocu-

mented Mexican worker [who] attempted to cross the border near Sasabe, Arizona on Friday. Four other young men accompanying 20 year old Miguel Angel Palofox Aguerrin of Guasave Sinaloa are feared dead at the hands of the vigilantes."

13 Rosa Martha Villarreal's *Doctor Magdalena*, discussed in the next chapter, also reproduces an image of Mictlantecuhtli, described as "*lord of the dead; Custodian of the bones of all past human generations*; ceramic; from Tierra Blanca, Veracruz; Totonac: AD 600–900. Museo de Antropología de la Universidad Veracruzana, Jalapa, Veracruz, Mexico" (1995, unnumbered last page).

14 Another project addressing the exploitation of gendered, racialized, and undocumented labor is Christina Fernandez's photo essay of actual sweatshops with fictionalized narrative, *Manuela S-t-i-t-c-h-e-d*. See Leclerc, Villa, and Dear (1999, 50–55) for images.

15 In another study on the Los Angeles garment industry today, Steve Nutter writes that "the fastest growing manufacturing job in Los Angeles is 'sewing machine operator.'" And that "the typical garment worker is a young, non-English-speaking immigrant woman with no prior sewing skills. . . . She is probably from Mexico, perhaps stopping to work in a border maquila before crossing over. . . . Mexicans comprise 75 percent of workers in L.A.'s apparel industry. . . . The majority of immigrants working in L.A.'s industry today arrived in the last fifteen years, and are undocumented" (1999, 200, 206, 207).

16 Quoted from http://home.earthlink.net/~almalopez/1848/juan.html, accessed March 18, 1999. See Alma Lopez's current Web site for images (http://www.almalopez.net). An excellent image, and a version of the text quoted above, can be found in Leclerc, Villa, and Dear (1999, 56–57).

17 The lunar rather than the usual solar mandorla around canonized Christian saints effectively marks the outsider status of the popular "saint," as well as the rebellious nature, in the tradition of Coyolxauhqui, of economic migrants who will not be stopped by legal restrictions at the border.

18 On Lopez's queer politics, see Calvo (2004, 2000). On "Our Lady," see also Lara (forthcoming). Iglesias Prieto's interviews revealed that competition for the flirtatious attention of and subsequent "rewards" from male managers was stimulated by these men among what were often very young workers. Other women told of job applications entailing medical examinations where they were asked if they were still virgins and monthly medical examinations to monitor their sexuality. Iglesias Prieto suggested that a Catholic paternalistic discourse encouraging sexual inexperience served these transnational assembly factories in that it allowed them to try to control pregnancies that

would involve their having to pay maternity leaves. Paternalistic discourses of the workplace as a big family of daughters cared for by the male heads also encouraged worker submission to highly exploitative work conditions (1997, chaps. 4 and 6). On gender and the Mexican *maquiladora* industry, see also Fernández-Kelly (1983a, 1983b); Tiano (1990) and Cravey (1998).

19 Daniel (1999). "More than fifty of the young women and teens were raped before being beaten or stabbed to death" (Stack 1999). Another writer reviewing Muñoz's exhibition noted of Ciudad Juárez that "more than 800 incidents of rape were reported in the first nine months of this year [1998]" (Mitchell 1999, 6c). See Lourdes Portillo's film on this matter and my own discussion of *Señorita Extraviada* in chapter 3.

20 Laura Alvarez, unpublished artist's statement, 1997–98.

21 See Leclerc, Villa and Dear (1999, 108), and Leclerc and Diaz (1998, 16–21) for more D.A.S. images and text.

22 Text downloaded from a file sent electronically from the artist.

23 See the section on López's *The Nanny*, in chapter 3.

24 For images of the series, see Arceo-Frutos, Guzman, and Mesa-Bains (1993, 82–85).

25 On Juana Alicia and other Chicana muralists, including the San Francisco–based Mujeres Muralistas and Judy Baca, see Goldman (1990) and Cockroft and Barnet-Sánchez (1990). For an excellent study of the politics of public art in one of Judy Baca's murals, see Doss (1995). On Chicana/Latina women's art collectives, see Ochoa (2003).

26 My thanks to the artist and Emmanuel Montoya for discussing the works in this section with me.

27 The third and final novel, *Treasures in Heaven*, was published by Chronicle Books, San Francisco, 2000.

28 Interview in Seattle with the author on April 26, 1999. An Oregon book column, "Book Spy," quoted the author in an interview on November 18, 1998, with a slight variation: "There are so many stories—somebody once said that there are only really twelve plots that anybody can use, and we're all writing variations on them, and to a certain extent that's true—and Shakespeare probably knew all of them and wrote variations on all of them. But it's also just the word play that he used and the expansive vocabulary, and the interaction, being able to bring these characters to life, and how many hundreds of years later we're still excited by these people. And the same is true with the stories in the Bible, many of which are mythic and probably variations of older stories. If you saw any of the Bill Moyer's special on Genesis, you can tell how everybody

has a [different] take on one Bible story, and it's very interesting to hear writers and scholars discuss these stories because they all brought completely different sensibilities to them and took away completely different outcomes and lessons from them." http://www.oregonlive.com/books/9811/bk981118bs_alcala.html.

29 Even before Shelly has fully considered that she might descend from the Opata, she realizes, like many other Chicana/os, that she does not know a lot about her ancestors. "I really didn't know very much about my family. People from Mexico, my grandmother born in Arizona—was it Tucson or Nogales? Maybe it was Phoenix. Or maybe it was that town in New Mexico way down in a corner of the map. They were people who had moved and moved again as war, starvation, work, and fate led them from town to town, city to city. Here were a few relatives, there a few others. My father's family was the same way, working all over the United States for the railroad before settling in California. At this remove, we were all separated by name, by religion, by who my aunts and uncles married. I knew some of them had Anglicized their names and tried to blend in. . . . Until now, I had felt that my family existed on the frayed hem of history—jetsam left by the high tide on the beach of time. In spite of all of the brave talk about multiculturalism and diversity, no one really cared what happened to Mexican Americans in the Southwest as long as they stayed in their place. But I wasn't sure what that place was anymore" (160–61).

30 On Cihuatlampa, the heavenly home of the Cihuatateo, see the Mesa-Bains section in chapter 2. On Coyolxauhqui, see the section in the following chapter on Ana Garcia, Elba G. Rios, and Alma E. Cervantes's *Coyolxauhqui* CD-ROM.

31 On this play, also see Mayorga (2001).

Chapter Five: Book, Art

1 For a sampling of the diverse possibilities of the book form, see Rothenberg and Guss (1996). On book art, see Drucker (1995).

2 The "writing" by graffiti artists, an illegal form of art making that is considered vandalism and an eyesore by the mainstream, makes quite visible the social and political character of the conditions, character, content, and reception of artist's markings. On the difference between Mexican American graffiti and Chicano murals, see Sánchez-Tranquilino (1995); on graffiti in Los Angeles, see Phillips (1999).

3 "The average comic book reader, according to industry statistics, is a 20-

year old male; in fact, 95% of comic book readership is male. The 5% who do not fit into this profile—women readers—try alternately to fit into the role constructed for the predominantly male comic book reader and to resist that construction" (Nyberg 1995, 205).

4 Marshall McLuhan (1964), like Walter Benjamin (1985) before him, wrote of the ways in which the development of new technologies gives rise to new cultural sensibilities and societal forms.

5 See Wolf (1995) for an excellent discussion of this piece and the issues it raises. Images of the piece can be seen in Griswold del Castillo, McKenna, and Yarbro-Bejarano (1991).

6 In an early statement on her book art in this series, Muñoz wrote, "My works are a narrative of visual and verbal expression. A love of story-telling, toys and books brought me to bookworks as an art form. Through them I reveal my bilingual and bicultural heritage . . . from growing up in the border town of El Paso. I gently poke fun at myself and my culture. I call the works enlightenment stories, because they help me to synthesize my own history" (Huerta 1986).

7 The other pieces in the "Enlightenment Series" are: *Personal Salvation* (#5, 1982), *Sangre de Cristo* (#7, 1983), *Ave Maria Purisima!* (#8, 1983), and *La Yodo* (#9, 1983). My thanks to the artist for correspondence regarding her work, including copies of her press reviews.

8 Quoted in Sasser (1988, 57). "My choice to name the works The Enlightenment Series is a spin on the twist that occurred with [the] Age of Enlightenment that questioned religion. All the tales are little morality spoofs. Not solely about religion, but about perception and the issues of photography. . . . One of photography's strength[s] and weakness[es] deals with [the] concept of documentation, and credibility, another is exploiting romanticism with a capital R. . . . The little tales are dark if examined closely." Muñoz, email, July 14, 2000.

9 Davies (1997, 168).

10 Gleason (1988, 4).

11 Renny Pritikin wrote of the piece: "Munoz is pulling off a double bilingual play on words, referring both to her origins as a book artist who is scattering the pages of the book onto the gallery walls, and breaking the bindings of what is formally possible. A third subtext refers to upsetting the reductive expectations placed on her as an Hispanic woman artist" (1989, 1).

12 Kutner (1991, 5c).

13 See Hayden (1995, chapter 8).

14 See DellaFlora (1996a, 1996b).

15 Also see Lippard (1997, 24–25).

16 The first quotation is from the artist's unpublished notes on "Codex Delilah," kindly provided by the artist. The second from http://sophia.smith .edu/~dmontoya/Artist Statement.html, accessed June 27, 2000.

17 Ibid.

18 From the artist's unpublished notes, 5–6.

19 Telephone interview with the artist, September 1, 1998.

20 Ibid.

21 Personal conversations with the artist, and in public presentations by the artist of her work.

22 On *écriture feminine*, see Moi (1985). As Moi points out, the concept is understood differently by the French women writers who are associated with it. Of particular importance is the distinction that "feminine" does not necessarily refer only to the biologically female but to all that which is perceived as lack or margin with respect to an equally contested notion of the masculine and the male. Moi's careful discussion of Hélène Cixous's writing and concepts is especially pertinent: "Cixous is adamant that even the term écriture feminine or 'feminine writing' is abhorrent to her, since terms like 'masculine' and 'feminine' themselves imprison us within a binary logic, within the 'classical vision of sexual opposition between men and women' (Conley, 129). She has therefore chosen to speak either of a 'writing said to be feminine' (or masculine) or, more recently, of a 'decipherable libidinal femininity which can be read in writing produced by a male or a female' (Conley, 129). She thus warns against the dangers of confusing the sex of the author with the 'sex' of the writing he or she produces" (108). Moi's empirical notion of sexual identity (i.e., one's sex as male or female) would most likely be rejected by Cixous, given its implication that biological sex is indeed neatly or naturally divided into female and male. Garber takes up the inadequacy and inaccuracy of scientific languages with respect to hermaphrodites, bisexuals, and cross-dressers in *Vested Interests*. Butler does as well in *Gender Trouble*.

23 See J. González (1996) for discussion of Benjamin's thought and the artist's work.

24 It should be noted that the gun is an ambiguous symbol, given the girls' own toy guns symbolizing their gender-bending as girl children. See Sandra Ortiz Taylor's *Homage to a Tree House* and *Winifred, Her Story*, in the "La Galería" section of the book for a similarly ambivalent use of materials.

25 "She has this terrible aversion to boys and their wild ways, always call-

ing them 'poopy boys,' as if they are not quite human, mainly because she and her three sisters had to iron their eight brothers' shirts and wait on them all the time like they were kings. Now, when she stares into our closet, she maybe has the feeling her plan to be the mother of little girls has not quite worked out the way she always thought it would. . . . Part of her would surely like us to put on our Mother And Daughter dresses and join her in this tranquillity and beauty. But the Ortiz y Cabares part of her believes: What will be will be. This part makes resignation and perhaps even love possible" (84).

26 See Castañeda (1993, 1990) for the historical roots in nineteenth-century California of the polarizing idealization of the decent and cultured "Spanish" señorita versus the loose, uncouth Mexican woman.

27 Robbins helped to produce the first all-women comic in 1970, called *It Ain't Me Babe: Women's Liberation*. Her own character in the collection was called Belinda Berkeley. She also produced one of the first comics featuring a lesbian protagonist, *Sandy Comes Out*, in *Wimmen's Comix* (1973, no. 1), and another first, a women's anthology comic on women's views of sex, *Wet Satin: Women's Erotic Fantasies* (1976) (Robbins 1996, 87, 91, 94).

28 "By 1950, more than one quarter of the comic books published were romance comics. This was the same year that a graph in *Newsdealer* magazine showed that females ages seventeen to twenty-five were reading more comic books than guys. It doesn't take a rocket scientist to figure out what kind of comics they were reading" (Robbins 1999, 54). Keep in mind that "the size of the comics industry doubled between 1946 and 1949. By the late 1940s, one in three periodicals sold in America was a comic book" (11). And that "from 1961 to 1963, romance comics were still one of the top two genres of comic books on the newsstands. But from 1964 onward, that list is dominated by superhero comics. And as superheroes returned, romance went out the door" (77).

29 Laura Molina's cover art, including that of the projected second edition of the comic book, and other artwork can be seen at http://www.nakeddave .com. She also provides a link to Robbins's review, "Las Cartoonistas." Rodri-guez's *No More* is reproduced in Chicago and Lucie-Smith (1999, 111).

30 See Nyberg (1995, 205) on comic book audiences. R. Sullivan Lee reported in 1996 that while "sales have dropped 20% since 1993. . . . 'Bad girl' comics are booming. While American standards of literacy are dropping, college students still seem able to handle comics, especially when the cartoons show busty viragoes with names like Lady Death, Barb Wire and Avengelyne. Batman in a bustier; Captain America in a camisole." Newspaper comic strips

are "the most popular form of comic arts," "generating revenues of over 400 million dollars annually" (Brabant and Mooney 1997). In the popular comic strips studied by Brabant and Mooney over a twenty-year period and analyzed in 1994, "males continued to appear more often than females, and females remained more often in the home than did males. Further, females continued to be overrepresented in home and child care activities, and more likely to be pictured passively [as] background non-participants. Women were also less likely than men to appear in career activities" (276–77). In a newspaper article reporting on growing consciousness of the hypersexualization of female animated characters in video games, Neva Chonin observes, "the fact remains that most female characters are created by male developers. Not surprisingly, there is often a gender gap when it comes to deciding a woman's most appealing assets. Men concentrate on the mysteries of the feminine form; women are inspired by, well, other things" (2000, E4).

31 Yolanda López's *Tableau Vivant* (1978), a live installation or performance and part of her *Guadalupe Series* (1978), was perhaps the first to explicitly link the comic book superhero tradition, through a "Wonder Woman" comic book, to Virgen de Guadalupe iconographical elements, the female body (her own, in running shorts), and the artist.

32 Rodriguez's *LMA* series recalls Juana Alicia's similarly titled, four-piece *Mujeres de Mucho Garbo* series.

33 Rodriguez's web site is http://www.isisrodriguez.com.

34 Rodriguez had three other solo shows in smaller venues, including the San Francisco cafes Pancho Villa and the Bearded Lady.

35 Rodriguez explained that she got into stripping after she interviewed a stripper for a paper on the sex industry in school, at the San Francisco Art Institute, because she was in debt and "wanted things that money can buy, adventure, and freedom" (Burnside 1997, 8). The artist spoke of the growing exploitation and endangering of the strippers during her seven-year career: clubs charging strippers exorbitant stage fees, lengthening shows, the removal of glass partitions between performers and clients in peep shows, forcing the lap dancers to perform nude, the creation of unsupervised private rooms that encouraged prostitution. Rodriguez talks about Mitchell Brothers, a club that had "champagne nights, so the girls would get drunk and be easier targets for the men. It was then that I became aware of a lot more drugs in the clubs on both sides of the stage" (8).

36 One brief calendar item in the *San Francisco Weekly* read: "Rodriguez, who specifically creates her pieces for the female audience, 'wants people to

know she [is] creating art for women, stuff that will make them happy, about our dreams and adventures.' You will get happy looking at her colorful art, and each time you look, it will draw you in to see even more" (Martin 1997, 12). In another brief write-up of the show, the journalist quoted Rodriguez saying that "the exhibition is about women learning to rebel" (*Spunk!* 1997: n.p.).

37 "If girls are in the industry they are afraid to speak. A lot of women are unhappy with the way things are done, and they don't have the backing of the feminists who should be treating this like a labor issue. We need to take the sex industry issues to the level of labor, instead of it being seen as a moral issue, it's a job. Women in the industry don't sit around talking about freedom of sexual expression. It's an anxiety job; time is everything. If you sit around chit chatting about politics in the dressing room you're gonna miss that next guy who spends $500 on a few rounds. Feminists don't see it as a job, they see it as a symbol of freedom, the glory of the whore, like some kind of fantasy and we're being put in this symbol heavy arena. We could give a shit about that" (M. S. Lee 2000, 29–30).

38 After the Mexican feminist magazine *fem* featured Yolanda López's *The Virgen of Guadalupe Goes for a Walk* (1978), an image of the Guadalupe in high-heeled mule sandals, on its June–July 1984 cover, it received bomb threats (Lippard 1990, 42). In Ester Hernandez's more recent case, the artist received death threats by telephone after her image *La Ofrenda* (1988) appeared on the cover of the first edition of *Chicana Lesbians: The Girls Our Mothers Warned Us About* (Trujillo, 1991). Personal communication with the artist.

39 Usage among Chicana/os of the words "La Raza" (The Race) refers to the Mexican philosopher José Vasconcelos's concept in his book *La raza cósmica* (1925) of the American continent as the birthplace of a future "cosmic race" that had already begun to synthesize all the great "races" of the world. Vasconcelos's idea, however, is not without its own serious contradictions in that it was still inserted within the very Darwinian racialist discourse it tried to displace. Vasconcelos, for example, believed that, governed by a universal aesthetic criterion, less attractive people, particularly the Indigenous and African-origined, following European standards, would willingly refrain from reproducing themselves (30–32). The early Chicana/o movement, however, identified with the idea of a mixed, or *mestizo*, people as a sign of the future beyond the narrow and racist anti-miscegenation views still quite prevalent through the twentieth century into the 1970s.

40 See, for example, Nieva (1969), a native Mexica (or "Aztec") scholar, and the work of the contemporary scholar Arturo Dávila (1999) for work prob-

lematizing the accounts of the Spanish colonizers with respect to the ubiquity and extent of blood sacrifice among the Mexica.

41 Telephone conversation, June 2000.

42 Yolotl González argues that a close review of the literature collected during the colonial period contradicts the hypothesis of the German scholar Eduardo Soler that Huitzilopochtli represented the sun, and Coyolxauhqui the moon. Carmen Aguilera thinks that Coyolxauhqui was turned into the Milky Way, not the moon. Beatriz Barba de Piña Chan makes an important connection between Coyolxauhqui and the concept of ollin and points out that the goddess of the necklace of human hearts and hands is not Coatlicue but Teoyoamiqui, the goddess who gives honor to those who have died.

43 See *Irene Perez: Cruzando La Línea*, the exhibition publication of her show that was up March 9 to April 27, 1996, at La Raza/Galería Posada in Sacramento, California. The San Francisco Women's Building two-wall mural *Maestrapeace* was created collaboratively by Juana Alicia, Miranda Bergman, Edythe Boone, Susan Kelk Cervantes, Meera Desai, Yvonne Littleton, and Perez.

44 Correspondence from the artist, August 4, 2000.

45 ASCO ("nausea") is a Los Angeles-based collective; their earliest works can be traced to 1972. They worked in various media and had different members at different times. The founding group was formed by Harry Gamboa Jr., Gronk (Glugio Nicandro), Patssi Valdez, and Willie Herron. Kosiba-Vargas described their work as "dominated by stark allusions to the absurdities of life in post-modern Los Angeles" (1988, 4) and "an integral part of the Chicano cultural underground through its promulgation of an experimental aesthetic and avant-garde art style counter to Chicano art and dominant art" (5). Later members included Diane Gamboa and Barbara Carrasco. Also see H. Gamboa (1998) and Chavoya (2000) on ASCO.

46 Habell-Pallán observes of the medium of circulation of Norte's work that "although her narratives do not circulate in the mainstream media, the grassroots nature of their distribution allows them to reach people . . . who do not have easy access to feminist discourse. Producing spoken-word narratives—which are performed and heard at coffee shops, high schools, community centers, performance spaces, universities, and the homes of her listeners in their CD/cassette form—transforms the social space in which Norte moves and momentarily produces a discourse that unfixes, displaces, and refigures images of Chicanas, Los Angeles, and the border" (1997, 266). See also Lipsitz (1994) and Hicks (1991, 112, 117) for brief references to her work.

47 One of the narrative strategies repeated throughout the collection is stream of consciousness associations back and forth between present and past.

48 Produced by Peter Sellars, these works, *The Screens/Los Biombos*, and *The Story of a Soldier/(Historia de un soldado)* have traveled in Europe, with Alvárez reading from her poetry before the performances.

49 The L.A. Coyotas, founded in 1996, are Aida Salazar, Alma Lopez, Christina Fernandez, Consuelo Flores, Gloria Alvárez, Maria Elena Fernandez, Patricia Valencia, Raquel Salinas, Reina Prado, and Sol Alvarez. Information about the L.A. Coyotas was accessed March 18, 1999, through Alma Lopez's Web site: http://home.earthlink.net/~almalopez/coyotas/coyotxt .html. A more recent account can be found at Lopez's current Web site, www .almalopez.net.

50 In 1991, Alvárez published two chapbooks, *La Excusa/The Excuse* and *Emerging en un mar de olanes*. She collaborated in two artists' books, *Calacas machetiras* (1992), which she edited, and *Rumbos de expresión* (1985). She edited the anthology *Espejo-Voz* (1991) and her work appeared in *Chicana Creativity and Criticism: New Frontiers in American Literature* (Herrera-Sobek and Viramontes 1996) and *Invocation L.A: Urban Multicultural Poetry* (Clinton, Foster, and Quiñonez 1989).

51 On Alvárez's poetry, also see Villa (2000, 147–50).

52 Alvárez does not italicize the Spanish as a foreign language. Accordingly, quotations from her poems here follow her own usage.

53 The English version of "Come Union" is:

> I occupy
> your body
> You are
> liquid
> impetuous
> clear
> you unfold
> tears
> I know you
> pleated skin
> wide skirts
> thick hips
> under
> curtains of thirst

coffee
brown
aroma
I take
drink
your flesh
I celebrate
myself

Chapter Six: Face, Heart

1 On *difrasismo*, see León-Portilla (1963); Carrasco (1990); Arteaga (1997).

2 See Venegas (1977), Chabram-Dernersesian (1992), Quirarte (1992), Trujillo (1998), L. Pérez (1999), Prado (2000), Calvo (2004, 2000), and Lara (forthcoming).

3 Contrast this to the debatable, and certainly over-simplified, claims made by Robert Henkes in an anthology whose own images do not bear out the following assertion: "Devout ties to their faith have led many Latin Americans to depict saintly images, especially the Blessed Virgin and the image of Christ. Women have patterned their lives after the Blessed Mother and have had patron saints intercede for earthly favors. . . . Shrines, chapels and sanctuaries are essential installations of the three-dimensional artist. The world outside of Catholicism may find it difficult to accept these works. Nonetheless, such works are essential for the viewer to understand the position of the Latin American artist in the mainstream of American art" (1999, 233).

4 On Moraga's work, see Yarbro-Bejarano (2001).

5 Antonia Castañeda's studies of Native American women in nineteenth-century California reveal the same logic at play in the rationalization of rape and other physical violence against them by the Spanish, Mexicans, and then Anglos (1993, 1990).

6 See L. Pérez (1999) for a more detailed discussion of Chicana feminist challenges to Chicano nationalism and Chicana feminist lesbian challenges to both as early as the late 1960s and the 1970s.

7 See, for example, Lippard (1990), Griswold del Castillo, McKenna, and Yarbro-Bejarano (1991, 64, 323, 324), Broude and Garrard (1994, 182), Chicago and Lucie-Smith (1999, 31). Essays and scholarship on this work include Venegas (1977), Chabram-Dernersesian (1992), Yarbro-Bejarano (1993), and

Trujillo (1998). See L. Pérez (1999) also for more detailed discussion of Ester Hernandez's *La Ofrenda* and other work.

8 See Yarbro-Bejarano (1998), Jones (1998), and Venegas (1990) on Aguilar's work. For images from her *Latina Lesbians* series, see Neumaier (1995). Also see Hammond (2000).

9 Some of these observations are based on a telephone interview with the artist, July 9, 2000.

10 Valencia (1996), unpublished performance/exhibition statement.

Conclusion: Self, Other

1 In his later work, Derrida observed that a naïve opposition is made between reason and religion, pointing out that they both have the same source in faith, trust, and a fundamental not knowing (1996, 28). Chakrabarty has pointed to the tautological discounting, in Western scholarship, of religious cultural differences that structure the social realities they purport to study in cultures such as those of India where labor among certain sectors, for example, is permeated by religious belief. "A proposition of radical untranslatability therefore comes as a problem to the universal categories that sustain the historian's enterprise. But it is also a false problem created by the very nature of the universal itself that aims to function as a supervening general construction mediating between all the particulars on the ground. The secular code of historical and humanist time—that is, a time bereft of gods and spirits—is one such universal. Claims about agency on behalf of the religious, the supernatural, the divine, and the ghostly have to be mediated in terms of this universal. . . . Writing about the presence of gods and spirits in the secular language of history or sociology would therefore be like an act of translating into a universal language what belongs to a field of differences (1997, 39). For poststructuralist approaches to religion, faith, and related matters, see Heelas (1998) and Taylor (1998).

2 Mesa-Bains (1993b, 9).

3 See Black (1999) for a study of the uses of Catholic visual language among some Chicana artists.

4 "The March 1999 estimate of the Hispanic population in the United States was 31.7 million or 11.7 percent of the total population. Nearly two-thirds of all Hispanics were of Mexican origin (65.2 percent)," U.S. Census Bureau (2000, 1). That is, the population of Mexican Americans was estimated

to be 20,668,400. In the population at large, as well as "among Latino groups, people of Mexican origin had the lowest proportion with a high school diploma or more (49.7)" and the lowest proportion with a bachelor's degree (U.S. Census Bureau 2000, 2). Along with other Latina/os, they "are concentrated in high unemployment industries." Latina/os had the lowest per capita income, at $11,434 annually, compared to $12, 957 for African Americans, and $22,952 for "Whites." "In 1998, 11.8% of Hispanic full-time, year-round workers in families with children were poor, whereas for White and Black families those figures were 3.0% and 7.8%, respectively." "In 1997, more than one-half of Puerto Rican and Mexican children (51.0% and 50.6%, respectively)," were poor. National Council of La Raza (1997, 6; 1999, 2, 1, 2). In California, the state with the largest Latina/o population, between 1990 and 1997, "3 Latino males were added to the prison population for every one added to California's four-year public universities" (http://www.justicepolicy .org/article.php?id=38, accessed March 14, 2007). As of July 1, 2000, the states with the highest Latina/o estimated populations were California (10,647,000); Texas (5,875,000); New York (2,805,000); Florida (2,390,000); Illinois (1,267, 000); and Arizona (1,071,000) (U.S. Census Bureau 2000, 7).

5 On museums and funding, see Heilbrun and Gray (1993), Robison, Freeman, and Riley (1994), and Alexander (1996). On the cultural politics of art museums, see Karp and Lavine (1991), Bennett (1995), and Duncan (1995). For Latina/os and museums, see Ríos-Bustamante and Marin (1998). For Latina/o cultural and arts organization funding, see Orozco (1998), and National Association of Latino Arts and Culture (1996). For Latina/os and the politics of exhibitions, see Goldman (1987, 1994a), the Livingston and Beardsley and the Marzio essays in Karp and Lavine (1991), Gonzalez and Tonelli (1992); M. C. Ramírez (1996); Yúdice (1996b); and Gaspar de Alba (1998).

6 Robinson and Filicko study a range of surveys measuring public support of the arts, noting the limitations and uneven results among some of them. The quote, however, is a summary by the authors of the data of one of the more stable surveys over the past several decades, the national "Americans and the Arts" series (2000, 114). Another particularly reliable survey, the General Social Survey of 1993, showed that "majorities of the American public did not express hostility or smug indifference toward the arts" (121).

works cited

Artist's Statements, Interviews, Lectures, and Correspondence

Aguilar, Laura. 2000. Telephone interview with the author. July 9.

Alcalá, Kathleen. 1999. Interview with the author. Seattle, Wash. April 26.

Alicia, Juana. N.d. "Artist's Statement."

———. N.d. E-mail correspondence.

———. N.d. "Statement on Mural Making."

Alicia, Juana, and Emmanuel C. Montoya. N.d. "Proposal for New International Terminal Gateroom Wall San Francisco International Airport."

Alvarez, Laura E. N.d. "Treatment." Unpublished manuscript.

———. 1997–1998. "The Double Agent Sirvienta Rock Opera." Artist's statement.

———. 2000. E-mail correspondence.

Barraza, Santa Contreras. 1992. "Artist Statement." In *Santa Barraza*, catalogue for exhibition curated by Tere Romo, March 8–April 11, 1992.

———. 2006. Lecture at University of California, Berkeley. February 17.

Carrasco, Barbara. N.d. "Artist Statement."

———. 1999. Telephone conversation with the author. Spring.

Cervantes, Alma. 2000. Telephone conversation with the author. June.

Cervántez, Yreina D. N.d. "Artist Statement/Catalog."

———. N.d. "Artist's Statement."

———. N.d. "Nepantla—Mi Nepantla—Beyond Nepantla." Slide text sheet.

———. N.d. "Black Legs, An Education." Artist's statement.

———. N.d. Telephone conversation with the author.

———. 1996. Interview with the author. Los Angeles. February 23.

———. 1997. Telephone conversation with the author. October 21.

———. 1998. Lecture at the University of California, Berkeley, Chicana/o Studies 141 course. May 7.

———. 1998. Telephone conversation with the author. October 30.

———. 1999. Telephone conversation with the author. November 16.

España, Frances Salomé. 1995. Screening and lecture, Department of Ethnic Studies, University of California, Berkeley. May 3.

———. 1996. Interview with the author. Los Angeles. February.

Fernandez, Christina. 1998. Correspondence. November 4.

———. 1999. Correspondence. May 25, August 13.

———. 2000. Correspondence. August 2.

Gamboa, Diane. 1999a. "Altered State." Unpublished artist's statement.

———. 1999b. " 'The Brush Off, the Ink Blot, and the Right Angle." Unpublished artist's statement.

———. 1999c. "The Nature of the Works of Diane Gamboa." Unpublished artist's statement.

———. 1999d. Telephone conversation with the author. March 31.

Hernandez, Ester. 1998. "Immigrant Woman's Dress." Unpublished artist's statement.

———. 1999. Conversation with the author. November 10.

Lopez, Alma. 2000. E-mail correspondence. July 28.

López, Yolanda M. 1996. "Yolanda López: Chicana Artist. A Presentation on Bay Artists." Lecture/ presentation, University of California, Berkeley. February 7.

———. 1998. "Cactus Hearts / Barbed Wire Dreams: Media Myths and Mexicans." Exhibition publication essay. September 6–October 1. Includes "Artist's Statement."

———. 1999. Telephone conversation. November 10.

———. 2001. "The Virgin of Guadalupe on the Road to Aztlan." Lecture / slides. Los Angeles County Museum of Art.

Mesa-Bains, Amalia. 1999. Lecture / slides. California State University, Monterey Bay, National Association of Chicana and Chicano Studies Northern Foco Conference. February 13.

———. 2000. Telephone conversation. February.

Montoya, Delilah. N.d. "Introduction. Codex Delilah: A Journey from Mechica to Chicana." With text by Cecilio García Camarillo. Slide descriptions.

———. N.d. "Codex Delilah #2: Six Deer Journey from Mexicatl to Chicana." Lecture/description.

———. N.d. Unpublished notes on *Codex Delilah #2: Six Deer Journey From Mexicatl to Chicana.*

———. 1994. "El Corazón Sagrado: The Corazon Sagrado." Unpublished exhibition essay.

———. 1998. E-mail correspondence. June 10.

———. 1998. Telephone interview with the author. September 1.

———. 1999. E-mail correspondence. July 12, August 4.

———. 2000. "Artist Statement." http://sophia.smith.edu/~dmontoya/ArtistStatement.html. Downloaded June 27, 2000.

———. 2002. Telephone conversation with the author. March 18.

Muñoz, Celia Alvarez. 2000. E-mail correspondence. June 13, 18, 26, 30; July 1, 3, 12, 13, 14.

Norte, Marisela. 2000. E-mail and postal correspondence. July 27; August 3, 4, 28.

Rodríguez, Celia Herrera. 1999. "Imágenes e Historias: Chicana Altar Inspired Art. Celia Herrera Rodríguez. Artist Notes." Unpublished.

———. 2000. Interview with the author. Artist's home, Oakland. January 9.

Rodriguez, Isis. 2000. E-mail correspondence. June 27, 28; July 29, 30; August 1, 8.

———. 2000. Interview with the author, San Francisco. Summer.

Rodríguez, Patricia. 1999. Interview with the author, San Francisco. Summer.

———. 1999. Lecture / slide presentation, University of California, Berkeley. CS 180 class. November 11.

Underwood, Consuelo Jiménez. 1999. Interview with the author at the artist's home. Summer.

———. 1999. Lecture, University of California, Berkeley, Celia Rodríguez's class. April 20.

———. 2005. Interview with the author. Cupertino, Calif. August.

Valdez, Patssi. 1996. Interview with the author. Los Angeles. February 23.

———. 2000. Telephone conversation with the author. August 7.

Valencia, Patricia. 1995. "Ramona: Performance by Aida Salazar and Patricia Valencia. Text by Aida Salazar. Installation by Patricia Valencia." Artist's statement.

———. 1996. Unpublished performance/installation statement.

———. 1999. Correspondence. October 12.

Vargas, Kathy. 1998. Artist's Statement. San Antonio Art League Museum, Annual Artist of the Year Exhibition.

———. 2000. E-mail correspondence. July 27, 30, August 7.

Yañez, Rene. 2000. Telephone conversation with the author. July 31.

Published Sources

Abram, David. 1997. *The Spell of the Sensuous*. New York: Vintage Books.

Acuña, Rodolfo. 1981. *Occupied America: A History of Chicanos*. New York: Harper and Row. Originally published in 1972 as *Occupied America: The Chicano's Struggle Toward Liberation*. San Francisco: Canfield Press.

Agreda, Mary. 1978. *The Mystical City of God*. Translated by Fiscar Marison (Rev. George J. Blatter). Abridged ed. Rockford, Ill.: Tan Books and Publishers.

Alarcón, Norma. 1989. "Traduttora, Traditora: A Paradigmatic Figure of Chicana Feminism." *Cultural Critique* 13 (fall): 57–87.

———. 1990. "Chicana Feminism: In the Tracks of 'The' Native Woman." *Cultural Studies* 4 (October): 248–56.

———. 1996. "Anzaldua's Frontera: Inscribing Gynetics." In *Displacement, Diaspora, and Geographies of Identity*, edited by Smadar Lavie and Ted Swedenburg, 35–58. Durham, N.C.: Duke University Press.

Alba, Victoria. 1993. "Against the Grain: Consuelo Jimenez Underwood and Kay Sekimachi Discuss Ancestral Influences Found in Their Work." *Fiberarts* 20, no. 2 (September / October): 35–41.

Alcalá, Kathleen. 1997. *Spirits of the Ordinary: A Tale of Casas Grandes*. San Francisco: Chronicle Books.

———. 1998. *The Flower in the Skull*. San Diego: Harcourt, Brace.

———. 2000. *Treasures in Heaven*. San Francisco: Chronicle Books.

Alexander, Victoria D. 1996. *Museums and Money. The Impact of Funding on Exhibitions, Scholarship, and Management*. Bloomington: Indiana University Press.

Allen, Paula Gunn. 1986. The *Sacred Hoop: Recovering the Feminine in American Indian Traditions*. Boston: Beacon Press.

———. 1998. *Off the Reservation: Reflections on Boundary-Busting, Border Crossing Loose Canons*. Boston: Beacon Press.

Alvárez, Gloria. 2004/2005. *Centerground*. CD, produced by Carlos Ramirez and Carlos De la Torre. Compton, Calif.: Centerground.

Anaya, Rudolfo A. 1989. "Aztlán: A Homeland without Boundaries." In *Aztlán: Essays on the Chicano Homeland*, edited by Rudolfo A. Anaya and Francisco Lomelí, 230–41. Albuquerque, N.M.: Academia / El Norte Publications.

Anaya, Rudolfo A., and Francisco Lomelí, eds. 1989. *Aztlán: Essays on the Chicano Homeland*. Albuquerque, N.M.: Academia / El Norte Publications.

Anderson, Richard Feather. 1991. "Geomancy." In *The Power of Place: Sacred*

Ground in Natural and Human Environments, edited by James A. Swan. Wheaton, Ill.: Quest Books. 191–200.

Anzaldúa, Gloria E. 1987. *Borderlands /La Frontera. The New Mestiza*. San Francisco: Aunt Lute Books.

———, ed. 1990. *Making Face, Making Soul: Haciendo Caras: Creative and Critical Perspectives by Women of Color*. San Francisco: Aunt Lute Books.

———. 1993. "Chicana Artists: Exploring *nepantla, el lugar de la frontera*." *NACLA Report on the Americas*. Report on Women 27, no. 1 (July/August): 37–42.

———. 2000. *Interviews / Entrevistas*. Edited by AnaLouise Keating. New York: Routledge.

———. 2002. "now let us shift . . . the path of conocimiento . . . inner work, public acts." In *This Bridge We Call Home: Radical Visions for Transformation*, edited by Gloria E. Anzaldúa and AnaLouise Keating. New York and London: Routledge. 540–578.

Arceo-Frutos, Rene, Juana Guzman, and Amalia Mesa-Bains, curators and eds. 1993. *Art of the Other Mexico: Sources and Meanings*. Chicago: Mexican Fine Arts Center Museum.

Armstrong, Robert Plant. 1981. *The Powers of Presence: Consciousness, Myth, and Affecting Presence*. Philadelphia: University of Pennsylvania Press.

Arrizón, Alicia. 1999. *Latina Performance: Traversing the Stage*. Bloomington: Indiana University Press.

Arrizón, Alicia, and Lillian Manzor. 2000. *Latinas on Stage*. Berkeley, Calif.: Third Woman Press.

Arteaga, Alfred. 1997. "Mestizaje / *Difrasismo*." In *Chicano Poetics: Heterotexts and Hybridities*, 5–19. Cambridge: Cambridge University Press.

Barnet, Holly J., guest curator. 1998. "Transformations: The Art of Ester Hernandez." In *Transformations: A 25 Year Retrospective. The Art of Ester Hernandez* (exhibition catalog). MACLA San Jose Center for Latino Arts.

Barnett, Alan W. 1984. *Community Murals: The People's Art*. Cranbury, N.J.: Associated University Presses.

Barron, Stephanie, Sheri Bernstein, and Ilene Susan Fort, eds. 2000a. *Made in California: Art, Image, and Identity, 1900–2000*. Exhibition catalog. Berkeley: University of California Press.

———. 2006b. *Reading California: Art, Image, and Identity, 1900–2000*. Berkeley: University of California Press.

Barthes, Roland. 1981. *Camera Lucida: Reflections on Photography*. Translated by Richard Howard. New York: Hill and Wang.

Bean, Susan S. 1994. "The Fabric of Independence." *Parabola* 19, no. 3 (August 1994): 29–33.

Beardsley, John, and Jane Livingston, curators and eds. 1987. *Hispanic Art in the United States: Thirty Contemporary Painters and Sculptors.* New York: Abbeville Press.

Beezley, William H. 1997. "Home Altars: Private Reflections of Public Life." In *Home Altars of Mexico*, ed. Ramón Gutiérrez, 91–107. Albuquerque: University of New Mexico Press.

Benjamin, Walter. 1985. [1968]. "The Work of Art in the Age of Mechanical Reproduction." In *Illuminations*, edited by Hannah Arendt. Translated by Harry Zohn. New York: Schocken Books. 217–51. Essay originally published in German in 1936.

Bennett, Tony. 1992. "Putting Policy into Cultural Studies." In *Cultural Studies*, edited by Lawrence Grossberg, Cary Nelson, and Paul Treichler, 23–37. New York: Routledge.

———. 1995. *The Birth of the Museum: History, Theory, Politics.* London: Routledge.

Bhabha, Homi. 1994. "Of Mimicry and Man: The Ambivalence of Colonial Discourse." In *The Location of Culture*, 85–92. London: Routledge.

———. 1998. "Culture and Policy." In *Culture: A Reformer's Science*, 189–213. London: Thousand Oaks.

Black, Charlene Villaseñor. 1999. "Sacred Cults, Subversive Icons: Chicanas and Pictorial Language of Catholicism." In *Speaking Chicana: Voice, Power, and Identity*, edited by D. Leticia Galindo and Maria Dolores Gonzales, 134–74. Tucson: University of Arizona Press.

Bolton, Richard, ed. 1992. *Culture Wars. Documents from the Recent Controversies in the Arts.* New York: New Press.

Boone, Elizabeth Hill. 2000. *Stories in Red and Black: Pictorial Histories of the Aztecs and Mixtecs.* Austin: University of Texas Press.

Bourdieu, Pierre. 1998. [1979]. *Distinction: A Social Critique of the Judgment of Taste.* Translated by Richard Nice. Cambridge: Harvard University Press.

Brabant, Sarah, and Linda A. Mooney. 1997. "Sex Role Stereotyping in the Sunday Comics: A Twenty Year Update." *Sex Roles: A Journal of Research* 37, nos. 3–4 (August 1997): 269–81.

Brotherston, Gordon. 1992. *Book of the Fourth World: Reading the Native Americas through Their Literature.* New York: Cambridge University Press.

Broude, Norma, and Mary D. Garrard, eds. 1994. *The Power of Feminist Art: The American Movement of the 1970s, History and Impact.* New York: Harry N. Abrams.

Bürger, Peter. 1984. [German 1974]. *Theory of the Avant-Garde.* Translated by Michael Shaw. Minneapolis: University of Minnesota Press.

Burnham, Linda. 1986. "Art with a Chicano Accent." *High Performance #35*, vol. 9, no. 3.

Burnside, Bob. 1997. "Diary of a Comic Stripper." *Castro Star* (San Francisco), July, 8–9.

Butler, Judith. 1993. *Bodies That Matter: On the Discursive Limits of "Sex."* New York: Routledge.

Cáliz-Montoro, Carmen. 1996. "Poetry Is Not Made of Words: A Study of Aesthetics of the Borderlands in Gloria Anzaldua and Marlene Nourbese Philip." Ph.D. diss. Department of Comparative Literature, University of Toronto.

Calvo, Luz. 2000. "Impassioned Icons: Alma Lopez and Queer Chicana Visual Desire." Paper presented at the American Studies Association meeting 2000. http://epsilon3.georgetown.edu/~coventrm/asa2000/panel6/calvo .html, accessed August 23, 2006.

———. 2004. "Art Comes for the Archbishop: The Semiotics of Contemporary Chicana Feminism and the Work of Alma Lopez." *Meridians: Feminism, Race, Transnationalism* 5.1: 201–224.

Carrasco, David. 1990. *Religions of Mesoamerica: Cosmovision and Ceremonial Centers*. San Francisco: Harper and Row.

Carrera, Magali M. 2003. *Imagining Identity in New Spain: Race, Lineage, and the Colonial Body in Portraiture and Casta Paintings*. Austin: University of Texas Press.

Castañeda, Antonia. 1990. "The Political Economy of Nineteenth Century Stereotypes of Californianas." In *Between Borders: Essays on Mexicana / Chicana History*, edited by Adelaida R. Del Castillo, 213–36. Encino, Calif.: Floricanto Press.

———. 1993. "Sexual Violence in the Politics and Policies of Conquest: Amerindian Women and the Spanish Conquest of Alta California." In *Building with Our Hands: New Directions in Chicana Studies*, edited by Adela de la Torre and Beatríz M. Pesquerra, 15–33. Berkeley: University of California Press.

Castillo, Ana. 1994. *Massacre of the Dreamers: Essays on Xicanisma*. Albuquerque: University of New Mexico Press.

———, ed. 1996. *Goddess of the Americas: La Diosa de las Américas: Writings on the Virgin of Guadalupe*. New York: Riverhead Books.

Centro Cultural de la Raza / Museum of Contemporary Art. 1993. *La Frontera / The Border. Art about the Mexico / United States Border Experience* (catalogue for exhibition curated by Patricio Chávez and Madeleine Grynsztejn). San Diego: Centro Cultural de la Raza / Museum of Contemporary Art.

Chabram-Dernersesian, Angie. 1992. "I Throw Punches for My Race, but I Don't Want to Be a Man: Writing Us—Chica-nos (Girl / Us) Chicanas—into the Movement Script." In *Cultural Studies*, edited by Lawrence Grossberg, Cary Nelson, and Paul Treichler, 81–95. New York: Routledge.

Chakrabarty, Dipesh. 1997. "The Time of History and the Times of Gods." In *The Politics of Culture in the Shadow of Capital*, edited by Lisa Lowe and David Lloyd, 35–60. Durham, N.C.: Duke University Press.

Chávez, Patricio. 1993. "Multi-Correct Politically Cultural." In *La Frontera / The Border: Art about the Mexico / United States Border Experience*, by Centro Cultural de la Raza / Museum of Contemporary Art, 3–22. San Diego: Centro Cultural de la Raza / Museum of Contemporary Art.

Chavoya, C. Ondine. 2000. "Orphans of Modernism: The Performance Art of ASCO." In *Corpus Delecti: Performance Art of the Americas*, edited by Coco Fusco, 240–63. London: Routledge.

Cherbo, Joni M., and Margaret J. Wyszomirski. 2000a. "Mapping the Public Life of the Arts in America." In *The Public Life of the Arts in America*, 3–21. New Brunswick, N.J.: Rutgers University Press.

———, eds. 2000b. *The Public Life of the Arts in America*. New Brunswick, N.J.: Rutgers University Press.

Chicago, Judy, and Edward Lucie-Smith. 1999. *Women and Art: Contested Territory*. New York: Watson-Guptill.

Chinchilla, Madame. 1997. *Stewed, Screwed, and Tattooed*. Mendocino, Calif.: Isadore Press.

Chonin, Neva. 2000. "Women Warriors: Forget Lara Croft: The New Video Game Heroines are Smarter, Better Trained, and Dressed to Kill." *San Francisco Chronicle*, July 6, E1, E4.

Christ, Carol P. 1997. *Rebirth of the Goddess: Finding Meaning in Feminist Spirituality*. New York: Routledge.

Cimino, Richard, and Don Lattin. 1998. *Shopping for Faith: American Religion in the New Millennium*. San Francisco.: Jossey-Bass.

Cisneros, Sandra. 1991. *Woman Hollering Creek and Other Stories*. New York: Random House.

———. 1996. "Guadalupe the Sex Goddess." In *Goddess of the Americas: La Diosa de las América: Writings on the Virgin of Guadalupe*, edited by Ana Castillo, 46–51. New York: Riverhead Books.

Clark, Wade Roof. 1993. *A Generation of Seekers. The Spiritual Journeys of the Baby Boomer Generation*. New York: HarperCollins.

Clinton, Michelle T., Sesshu Foster, and Naomi Quiñones, eds. 1989. *Invocation L.A.: Multi-cultural Poetry*. Albuquerque, N.M.: West End Press.

Cockcroft, Eva Sperling, and Holly Barnet-Sánchez, eds. 1990. *Signs from the Heart: California Chicano Murals.* Venice, Calif.: Social and Public Art Resource Center.

Cockcroft, Eva Sperling, John Weber, and Jim Cockcroft. 1977. *Toward a People's Art: The Contemporary Mural Movement.* New York: E. P. Dutton.

Conner, Randy P., David Sparks, and Mariya Sparks. 1997. *Cassell's Encyclopedia of Queer Myth, Symbol and Spirit.* London: Cassell.

Corpi, Lucha. 1992. *Eulogy for a Brown Angel: A Mystery Novel.* Houston, Tex.: Arte Publico Press.

———. 1995. *Cactus Blood: A Mystery Novel.* Houston, Tex.: Arte Publico Press.

———. 1999. *Black Widow's Wardrobe: A Gloria Damasco Mystery.* Houston, Tex.: Arte Publico Press.

Cortez, Constance, curator and ed. 1999. *Imagenes e Historias /Images and Histories: Chicana Altar-Inspired Art.* Medford, Mass.: Tufts University Gallery.

———. 2001. "A New Aztlan: *Nepantla* (and Other Stories of Transmogrification." In *The Road to Aztlan: Art from a Mythic Homeland*, edited by Virginia M. Fields and Victor Zamudio-Taylor, 358–73. Los Angeles: Los Angeles County Museum.

Cortez, Jaime. 2001. "Interview with Ester Hernandez." Publication for the exhibition Ester Hernandez: Prints, Pastels, Installations. September 25–November 17.

Cosgrove, Stuart. 1989. [1984]. "The Zoot Suit and Style Warfare." In *Zoot Suits and Second Hand Dresses*, edited by Angela McRobbie, 3–22. Boston: Unwin Hyman.

Cravey, Altha J. 1998. *Women and Work in Mexico's Maquiladoras.* Oxford: Rowman and Littlefield.

Cruz, Resurrección. 2001. *Santora: The Good Daughter.* San Francisco: Xipactli Press.

Cuadros, Gil. 1994. *City of God.* Monroe, Ore.: City Lights Books.

Cunneen, Sally. 1996. *In Search of Mary: The Woman and the Symbol.* New York: Ballantine Books.

Daniel, Mike. 1999. "Price of Vanity: Artist Takes Fashion Fads Apart at Seams." *Dallas Morning News*, August 27.

Davalos, Karen Mary. 1998. "Exhibiting Mestizaje: The Poetics and Experience of the Mexican Fine Arts Center Museum." In *Latinos in Museums: A Heritage Reclaimed*, edited by Antonio Ríos-Bustamante and Christine Marin, 39–66. Malabar, Fla.: Krieger Publishing Company.

———. 2001. *Exhibiting Mestizaje: Mexican (American) Museums in the Diaspora.* Albuquerque: University of New Mexico Press.

Davies, Hugh M., and Ronald J. Onorato. 1997. *Blurring the Boundaries: Installation Art, 1969–1996*. San Diego: Museum of Contemporary Art.

Dávila, Arturo. 1999. "Conquista espiritual o satanización del panteón Aztekatl." Part 1. *Nueva Revista de Crítica Literaria Latinoamericana*. Lima-Hanover. Año XXIV. No. 49. 1er. Semestre: 99–118.

Davis, Erik. 1998. *Techgnosis: Myth, Magic, and Mysticism in the Age of Information*. New York, N.Y.: Harmony Books / Crown Publishers.

Davis, Philip G. 1998. *Goddess Unmasked: The Rise of Neopagan Feminist Spirituality*. Dallas: Spence Publishing Company.

Debroise, Olivier, Elisabeth Sussman, and Matthew Teitelbaum, curators. 1991. *El Corazón Sangrante / The Bleeding Heart* (exhibition catalogue). Boston: Institute of Contemporary Art / First University of Washington Press.

de Certeau, Michel. 1988. [1984]. *The Practice of Everyday Life*. Translated by Steven Rendall. Berkeley: University of California Press.

De la Huerta, Christian. 1999. *Coming Out Spiritually: The Next Step*. New York: Jeremy P. Tarcher / Putnam.

Del Castillo, Adelaida R. 1974. "Malintzín Tenepal: A Preliminary Look into a New Perspective." *Encuentro Femenil* 1, no. 2:58–77. Reprinted in A. García 1997.

———, ed. 1990. *Between Borders: Essays on Mexicana / Chicana History*. Encino, Calif.: Floricanto Press.

DellaFlora, Anthony. 1996a. "Mundane, Common Images Paint Wonderful Portrait." *Albuquerque Journal*, May 12, D1–2.

———. 1996b. "Roswell Exhibit Opens Door to Invisible Community." *Albuquerque Journal*, May 12, D1–2.

DeLoria, Vine Jr. 1994. *God Is Red: A Native View of Religion*. Golden, Colo.: Fulcrum.

———. 1999. *For This Land: Writings on Religion in America*. New York: Routledge.

Le Démon des anges: 16 Artistes "Chicanos" al voltant de Los Angeles. 1989. Exhibition catalog. Barcelona: Generalitat de Catalunya, Departament de Cultura; Nantes: Centre de recherche pour le développement culturel. Centre d'Art Santa Monica.

Derrida, Jacques. 1996. "Faith and Knowledge: The Two Sources of 'Religion' at the Limits of Reason Alone." In *Religion*, edited by Jacques Derrida and Gianni Vattimo. Stanford, Calif.: Stanford University Press.

Díaz, Rafael M. 1998. *Latino Gay Men and HIV: Culture, Sexuality, and Risk Behavior*. New York: Routledge.

Díaz-Stevens, Ana María, and Anthony M. Stevens-Arroyo. 1998. *Recogniz-*

ing the Latino Resurgence in U.S. Religion: The Emmaus Paradigm. Boulder, Colo.: Westview Press.

Doss, Erika. 1995. "Raising Community Consciousness with Public Art: The Guadalupe Mural Project." In *Spirit Poles and Flying Pigs: Public Art and Cultural Democracy in American Communities,* 157–96. Washington: Smithsonian Institution Press.

Douglas, Susan. 1997. "Amalia Mesa-Bains." *Parachute* 87 (July–September): 57.

Draher, Patricia, ed. 1992. *The Chicano Codices: Encountering Art of the Americas.* San Francisco: The Mexican Museum.

Drucker, Johanna. 1995. *The Century of Artists' Books.* New York City: Granary Books.

Duncan, Carol. 1991. "Art Museums and the Ritual of Citizenship." In *Exhibiting Cultures: The Poetics and Politics of Museum Display,* edited by Ivan Karp and Steven D. Lavine, 88–103. Washington: Smithsonian Institution.

———. 1995. *Civilizing Rituals: Inside Public Art Museums.* London: Routledge.

Duncombe, Stephen. 1997. *Notes from the Underground: Zines and the Politics of Alternative Culture.* London: Verso.

Durand, Jorge, and Douglas S. Massey. 1995. *Miracles on the Border: Retablos of Mexican Migrants to the United States.* Tucson: University of Arizona Press.

Dussel, Enrique. 1998. *Ética de la Liberación en la Edad de la Globalización y de la Exclusión.* Madrid: Editorial Trotta.

———. 2000. "Europe, Modernity, and Eurocentrism." *Nepantla: Views from the South* 1, no. 3: 465–78.

Elkins, James. 1994. *The Poetics of Perspective.* Ithaca, N.Y.: Cornell University Press.

Eller, Cynthia. 2000. *The Myth of Matriarchal Prehistory: Why An Invented Past Won't Give Women a Future.* Boston: Beacon Press.

Enloe, Cynthia. 1990. [1989]. *Bananas, Beaches and Bases: Making Feminist Sense of International Politics.* Berkeley: University of California Press.

Ennis, Michael. 1990. "The Ties That Bind." *Texas Monthly,* September, 30–33.

Escalona, Enrique. 1988. *Tlacuilo.* Video, 57 min. Centro de Investigaciones y Estudios Superiores en Antropología Social (CIESAS). Estudios Churubusco-Azteca, S.A.

España, Frances Salomé. 1995. "Nepantla'd Out." *Felix: Journal of Media Arts and Communications* 2, no. 1 (1995): 176–78.

Fanon, Frantz. 1967. [1952]. *Black Skin, White Masks.* 1952. Translated by Charles Lam Markmann. New York: Grove Press.

Felps, Paula. 1999. "One Woman's Fury: Arlington Artist Uses New Exhibit to Protest Exploitation of Women." *Arlington Morning News*, August 29, x and 4c.

Fernández-Kelly, María Patricia. 1983a. *For We Are Sold, I and My People: Women and Industry in Mexico's Frontier*. Albany, N.Y.: State University of New York Press.

———. 1983b. "Mexican Border Industrialization, Female Labor Force Participation and Migration." In *Women, Men, and the International Division of Labor*, edited by June Nash and María Patricia Fernández-Kelly, 205–23. Albany, N.Y.: State University of New York Press.

Ferris, Alison. 1998. "Amalia Mesa-Bains." In *Memorable Histories and Historic Memories* (exhibition catalog), 24–27. Brunswick, Maine: Bowdoin College.

Foley, Neil. 1997. *The White Scourge: Mexicans, Blacks, and Poor Whites in Texas Cotton Culture*. Berkeley: University of California Press.

Foucault, Michel. 1977. [1975]. *Discipline and Punish: The Birth of the Prison*. Translated by Alan Sheridan. New York: Vintage.

———. 1980. *Power / Knowledge: Selected Interviews and Other Writings, 1972–1977*. Edited by Colin Gordon. New York: Pantheon Books.

———. 1987. "Of Other Spaces." *Diacritics* 16:22–27.

Fregoso, Rosa Linda. 1993. *The Bronze Screen: Chicana and Chicano Film Culture*. Minneapolis: University of Minnesota Press.

———. 2000. "Voices without Echo: The Global Gendered Apartheid." *Emergences* 10, no. 1 (May): 137–56.

———, ed. 2001. *Lourdes Portillo: The Devil Never Sleeps and Other Films*. Austin: University of Texas Press.

———. 2003. "Toward a Planetary Civil Society." In *Mexicana Encounters: The Making of Social Identities on the Borderlands*, 1–29. Berkeley: University of California Press.

Fuller, Diana, and Daniela Salvioni. 2002. *Art/Women/California, 1950–2000*. San Jose: San Jose Museum of Art.

Furst, Jill Leslie McKeever. 1995. *The Natural History of the Soul in Mexico*. New Haven, Conn: Yale University Press.

Fusco, Coco. 1995. *English Is Broken Here: Notes on Cultural Fusion in the Americas*. New York: New Press.

Gablik, Suzi. 1991. *The Reenchantment of Art*. New York: Thames and Hudson.

Gamboa, Harry Jr. 1989. "Barbara Carrasco." Galería de la Raza Artist Monograph Series no. 3, January.

———. 1991. "In the City of Angels, Chameleons, and Phantoms: Asco,

a Case Study of Chicano Art in Urban Tones (or Asco Was a Four-Member Word)." In *Chicano Art: Resistance and Affirmation, 1965–1985*, edited by Richard Griswold del Castillo, Teresa McKenna, and Yvonne Yarbro-Bejarano, 121–30. Los Angeles: Wight Art Gallery and University of California Press.

———. 1998. *Urban Exile: The Collected Writings of Harry Gamboa, Jr.* Edited by Chon Noriega. Minneapolis: University of Minnesota Press.

Garber, Marjorie B. 1992. *Vested Interests: Cross-Dressing and Cultural Anxiety.* New York: Routledge.

García, Alma M., ed. 1997. *Chicana Feminist Thought: The Basic Historical Writings.* New York and London: Routledge.

Garcia, Ana, Elba Rios, and Alma Cervantes. 2000. *Coyolxauhqui. An Ancient Myth, Chicanas Today.* Interactive CD-ROM. Master's thesis. California State University, Hayward.

García, Mario T. 1989. *Mexican Americans: Leadership, Ideology, and Identity.* New Haven: Yale University Press.

Garduño, Blanca, and José Antonio Rodríguez, eds. 1992. *Pasión por Frida.* Mexico: Instituto Nacional de Bellas Artes.

Gaspar de Alba, Alicia. 1998. *Chicano Art: Inside/Outside the Master's House.* Austin: University of Texas Press.

Gates, Henry Louis Jr. 1986. "Editor's Introduction: Writing 'Race' and the Difference It Makes." In *"Race," Writing, and Difference*, 1–20. Chicago: University of Chicago Press.

———. 1988. *The Signifying Monkey: A Theory of African-American Literary Criticism.* New York: Oxford University Press.

Giffords, Gloria Fraser. 1991. "The Art of Private Devotion: Retablo Painting of Mexico." In *The Art of Private Devotion: Retablo Painting of Mexico*, edited and curated by Gloria Fraser Giffords, 33–63. Dallas: InterCultura and The Meadows Museum, Southern Methodist University.

Gleason, Ron. 1988. "Postales y Sin Remedio: A Series of Paintings and an Installation by Celia Alvarez Munoz." *Tyler Museum of Art Review* (September–November): 2–4.

Goddard, Dan. 1990. "Artists Forge Links between Eras." *San Antonio Express*, July 7.

Goldman, Shifra M. 1987. "Homogenizing Hispanic Art." *New Art Examiner* (September), 30–33.

———. 1988a. "A Contemporary Moralist." *Artweek* (April 23), 3.

———. 1988b. "Latin Visions and Revisions." *Art in America* (May), 138–49, 198–99.

————. 1988c. " 'Portraying Ourselves': Contemporary Chicana Artists." In *Feminist Art Criticism: An Anthology*, edited by Arlene Raven et al., 187–205. Ann Arbor: University of Michigan Press.

————. 1989. "Assembling the Capirotada." In *Chicano Aesthetics: Rasquachismo*. Catalog of exhibition curated by Tomás Ybarra-Frausto, Shifra M. Goldman, and John L. Aguilar, 9–10. Phoenix: Movimiento Artistico del Rio Salado (MARS).

————. 1990. "How, Why, Where, and When It All Happened: Chicano Murals in California." In *Signs from the Heart: California Chicano Murals*, edited by Eva Sperling Cockcroft and Holly Barnet-Sanchez, 22–53. Venice, Calif.: Social and Public Art Resource Center.

————. 1994a. *Dimensions of the Americas. Art and Social Change in Latin America and the United States*. Chicago: University of Chicago Press.

————. 1994b. "Looking a Gift Horse in the Mouth." In *Dimensions of the Americas. Art and Social Change in Latin America and the United States*, 317–25. Chicago: University of Chicago Press.

————. 1994c. "Metropolitan Splendors." In *Dimensions of the Americas. Art and Social Change in Latin America and the United States*, 326–33. Chicago: University of Chicago Press.

————. 1994d. "Mujeres de California: Latin American Women Artists." In *Dimensions of the Americas. Art and Social Change in Latin America and the United States*, 212–35. Chicago: University of Chicago Press.

————. 2001. "When the Earth(ly) Saints Come Marching In: The Life and Art of Santa Barraza." In *Santa Barraza: Artist of the Borderlands*, edited by María Herrera-Sobek, 51–66. College Station: Texas A & M University Press.

Goldman, Shifra M., and Tomás Ybarra-Frausto. 1985. "Introduction." In *Arte Chicano: A Comprehensive Annotated Bibliography of Chicano Art, 1965–1981*, 3–55. Berkeley: Chicano Studies Library Publications Unit, University of California.

————. 1991. "The Political and Social Contexts of Chicano Art In *Chicano Art: Resistance and Affirmation, 1965–1985*, edited by Richard Griswold del Castillo, Teresa McKenna, and Yvonne Yarbro-Bejarano, 83–95. Los Angeles: Wight Art Gallery, University of California, Los Angeles.

Gómez-Peña, Guillermo. 1986. "A New Artistic Continent." In *Made in Aztlan*, edited by Philip Brookman and Guillermo Gómez-Peña, 86–97. San Diego: Tolteca Productions, Centro Cultural de la Raza.

————. 1993. "The Multicultural Paradigm: An Open Letter to the National Arts Community." In *Warrior for Gringostroika: Essays, Performance Texts, and Poetry*, 45–54. Saint Paul, Minn.: Graywolf Press.

————. 1996. *The New World Border: Prophecies, Poems and Loqueras for the End of the Century*. San Francisco: City Lights Books.

Gonzales, Patrisia. 2003. *The Mud People: Chronicles, Testimonios and Remembrances*. San Jose, Calif.: Chusma House Publications.

Gonzalez, Alicia M., and Edith A. Tonelli. 1992. "*Compañeros* and Partners: The CARA Project." In *Museums and Communities: The Politics of Public Culture*, edited by Ivan Karp, Christine Mullen Kreamer, and Steven D. Lavine, 262–84. Washington: Smithsonian Institution.

González, Deena J. 1998. "Speaking Secrets: Living Chicana Theory." In *Living Chicana Theory*, edited by Carla Trujillo, 46–77. Berkeley, Calif.: Third Woman Press.

————. 1999. *Refusing the Favor: The Spanish-Mexican Women of Santa Fe*. New York: Oxford University Press.

González, Jennifer. 1995. "Autotopographies." In *Prosthetic Territories: Politics and Hypertechnologies*, edited by Gabriel Brahm Jr. and Mark Driscoll, 133–149. Boulder, Colo.: Westview Press.

————. 1996. "Siting Histories: Material Culture and the Politics of Display in the Work of Fred Wilson, Pepón Osorio, and Amalia Mesa-Bains, 1985–1995." Ph.D. diss., History of Consciousness, University of California, Santa Cruz.

González, Rita (photography), and Ramón García (text). 1999. "St. Francis of Aztlán." In *La Vida Latina in L.A.: Urban Latino Cultures*, edited by Gustavo Leclerc, Raul Villa, and Michael J. Dear, 125–30. Thousand Oaks: Sage Publications, in association with Southern California Studies Center of the University of Southern California.

González-Wippler, Migene. 1995. "Santería: Its Dynamics and Multiple Roots." In *Enigmatic Powers: Syncretism with African and Indigenous Peoples' Religions among Latinos*, edited by Anthony M. Stevens-Arroyo and Andres I. Pérez y Mena, 99–111. Decatur, Ga.: Association for Hispanic Theological Education.

Goodall, H. L. Jr. 1996. *Divine Signs: Connecting Spirit to Community*. Carbondale, Ill.: Southern Illinois University Press.

Goodrich, Terry Lee. 1999. "Slayings Spark Fury of Exhibit: Arlington Artist Sees Link between Fashion Exploitation, Slain Women." *Star-Telegram* (Dallas/Fort Worth), August 21.

Gopnick, Adam. 1990. "Comics." In *High and Low: Modern Art, Popular Culture*, by Kirk Varnedoe and Adam Gopnik, 153–230. New York: Museum of Modern Art.

Gordon, Avery F. 1997. *Ghostly Matters: Haunting and the Sociological Imagination*. Minneapolis: University of Minnesota Press.

Grey, Alex. 1998. *The Mission of Art*. Boston: Shambhala.

Griswold del Castillo, Richard, Teresa McKenna, and Yvonne Yarbro-Bejarano, eds. 1991. *Chicano Art: Resistance and Affirmation, 1965–1985*. Los Angeles: Wight Art Gallery and University of California Press.

Grossberg, Lawrence, Cary Nelson, and Paul Treichler. 1992. *Cultural Studies*. New York: Routledge.

Gruzinski, Serge. 1992. *Painting the Conquest: The Mexican Indians and the European Renaissance*. Translated by Deke Dusinberre. Paris: Flamarrion.

———. 1995. [1994]. *La guerra de las imágienes: De Cristóbal Colón a "Blade Runner" (1492–2019)*. Mexico: Fondo de Cultura Económica.

Gutiérrez, Charlene. N.d. "San Francisco Artist Isis Rodriguez Inks Feminist Whimsy into the World of Cartoons." *Frontera* 2:18.

Gutiérrez Spencer, Laura. 1994. "Mirrors and Masks: Female Subjectivity in Chicana Poetry." *Frontiers* 15, no. 2 (1994): 69–86.

Habell-Pallán, Michelle. 1997. "No Cultural Icons: Marisela Norte." In *Women Transforming Politics: An Alternative Reader*, edited by Cathy J. Cohen, Kathleen B. Jones, and Joan C. Tronto. New York: New York University Press.

———. 2005. "No Cultural Icon: Marisela Norte and Spoken Word—East L.A. Noir and the U.S./Mexico Border." In *Loca Motion: The Travels of Chicana and Latina Popular Culture*, 43–80. New York: New York University Press.

Hall, Stuart. 1991. "The Local and the Global: Globalization and Ethnicity." In *Culture, Globalization and the World System*, edited by Anthony D. King, 19–39. London: Macmillan.

Hammond, Harmony. 2000. *Lesbian Art in America: A Contemporary History*. New York: Rizzoli.

Harlan, Theresa. 1996. "My Indígena Self: A Talk with Irene Pérez." In *Irene Pérez: Cruzando La Línea* (exhibition catalogue). March 9–April 27. Sacramento, Calif.: La Raza/Galería Posada.

Harvey, David. 1990. [1989.] *The Condition of Postmodernity: An Enquiry into the Origins of Social Change*. Cambridge, Mass.: Blackwell.

Hayden, Dolores. 1995. "Reinterpreting Latina History at the Embassy Auditorium." In *The Power of Place: Urban Landscapes as Public History*, 188–209. Cambridge, Mass.: MIT Press.

Haynes, Deborah J. 1997. *The Vocation of the Artist*. Cambridge: Cambridge University Press.

Heartney, Eleanor. 1997. *Critical Condition: American Culture at the Crossroads*. Cambridge: Cambridge University Press.

Hebdige, Dick. 1988. [1979]. *Subculture: The Meaning of Style*. London: Routledge.

Heelas, Paul, ed. 1998. *Religion, Modernity, Postmodernity*. Oxford: Blackwell.

Heilbrun, James, and Charles M. Gray. 1993. *The Economics of Art and Culture*. New York: Cambridge University Press.

Henkes, Robert. 1999. *Latin American Women Artists of the United States: The Works of Thirty-Three Twentieth-Century Women*. Jefferson, N.C.: McFarland.

Hernandez, Deluvina. 1970. "La Raza Satellite System." *Aztlán* 1, no. 1 (spring): 13–36.

Herrera, Hayden. 1983. *Frida: A Biography of Frida Kahlo*. New York: Harper Colophon.

Herrera-Sobek, María. 2001. *Santa Barraza: Artist of the Borderlands*. College Station: Texas A & M University Press.

Herrera-Sobek, María, and Helena María Viramontes, eds. 1996. *Chicana Creativity and Criticism*. Albuquerque: University of New Mexico Press.

Hicks, D. Emily. 1991. *Border Writing: The Multidimensional Text*. Minneapolis: University of Minnesota Press.

Hillman, James. 1992. [1975]. *Re-Visioning Psychology*. New York: Harper Perennial.

Hirschhorn, Michelle. 1996. "Orlan: Artist in the Post-Human Age of Mechanical Reincarnation: Body as Ready (to Be Re-) Made." In *Generations and Geographies in the Visual Arts: Feminist Readings*, edited by Griselda Pollock, 110–34. New York: Routledge.

Huaco-Nuzum, Carmen. 1996. "(Re)constructing Chicana, Mestiza Representation: Frances Salomé España's *Spitfire* (1991)." In *The Ethnic Eye: Latino Media Arts*, edited by Chon A. Noriega and Ana M. López, 260–74. Minneapolis: University of Minnesota Press.

Huacuja, Judith L. 2002. "Chicana Critical Pedagogies: Chicana Art as Critique and Intervention." http://latino.si.edu/researchandmuseums/presentations/huacaya.html (accessed August 10, 2006).

———. 2003. "Borderlands Critical Subjectivity in Recent Chicana Art." *Frontiers* 24 (2/3): 104–21.

Huerta, Benito, curator. 1986. *New Talent in Texas*. Chulas Fronteras exhibition catalog.

Iglesias Prieto, Norma. 1997. [1985]. *Beautiful Flowers of the Maquiladora: Life Histories of Women Workers in Tijuana*. Translated by Michael Stone with Gabrielle Winkler. Austin: University of Texas Press.

Imagine: International Chicano Poetry Journal. 1986. Arte Chicano issue. 3, no. 1/2 (summer–winter).

Isasi-Díaz, Ada María. 1996. *Mujerista Theology: A Theology for the Twenty-First Century*. Maryknoll, N.Y.: Orbis Books.

Johnson, Elizabeth A. 2003. *Truly Our Sister: A Theology of Mary in the Communion of Saints*. New York: Continuum.

Johnson, Steven. 1997. *Interface Culture: How New Technology Transforms the Way We Create and Communicate*. New York: Basic Books.

Jones, Amelia. 1998. "Dispersed Subjects and the Demise of the 'Individual': 1990s Bodies in / as Art." In *Body Art: Performing the Subject*, 197–240. Minneapolis: University of Minnesota Press.

Kaplan, Caren. 1996. *Questions of Travel: Postmodern Discourses of Displacement*. Durham, N.C.: Duke University Press.

Karp, Ivan, Christine Mullen Kreamer, and Steven D. Lavine, eds. 1992. *Museums and Communities: The Politics of Public Culture*. Washington: Smithsonian Institution.

Karp, Ivan, and Steven D. Lavine, eds. 1991. *Exhibiting Cultures: The Poetics and Politics of Museum Display*. Washington: Smithsonian Institution.

Keller, Gary, Mary Erickson, Kaytie Johnson, and Joaquín Alvarado. 2002. *Contemporary Chicana and Chicano Art. Vols. 1 and 2. Artists, Works, Culture, and Education*. Tempe, Ariz.: Bilingual Press / Editorial Bilingue.

Keller, Gary, Mary Erickson, and Pat Villeneuve. 2004. *Chicano Art for Our Millennium: Collected Works from the Arizona State University Community*. Tempe, Ariz.: Bilingual Press / Editorial Bilingue.

Kiev, Ari. 1968. *Curanderismo: Mexican-American Folk Psychiatry*. New York: Free Press.

Klor de Alva, J. Jorge. 1986. "California Chicano Literature and Pre-Columbian Motifs: Foil and Fetish." *Confluencia: Revista Hispánica de Cultura y Literatura* 1 (1986): 18–26.

———. 1988. "Contar vidas: La autobiografía confesional y la reconstrucción del ser nahua." *Arbor* 515–16 (1988): 49–78. (Journal of the Consejo Superior de Investigaciones Científicas, Madrid.)

———. 1999. "Telling Lives: Confessional Autobiography and the Reconstruction of the Nahua Self." In *Spiritual Encounters: Interactions between Christianity and Native Religions in Colonial America*, edited by Fernando Cervantes and Nicholas Griffiths. Lincoln: University of Nebraska Press.

Kohler, Carl. 1963. [1825, 1876]. *A History of Costume*. Edited and augmented by Emma Von Sichart. Translated by Alexander K. Dallas. New York: Dover.

Kosiba-Vargas, S. Zaneta. 1988. "Harry Gamboa and ASCO: The Emergence and Development of a Chicano Art Group, 1971–1987." Ph.D. diss., American Cultures Program, University of Michigan, Ann Arbor.

Kristeva, Julia. 1985. [1974]. *Revolution in Poetic Language*. New York: Columbia University Press.

Kurin, Richard. 1997a. "Brokering the Smithsonian's 150th Anniversary." In *Reflections of a Culture Broker: A View from the Smithsonian*, 29–56. Washington: Smithsonian Institution Press.

———. 1997b. "Debating Racially and Culturally Specific Museums." In *Reflections of a Culture Broker: A View from the Smithsonian*, 94–108. Washington: Smithsonian Institution Press.

Kutner, Janet. 1984. "Gallery Marathon: Art Lovers Can Choose from a Host of Fall Exhibits at Local Showcases." *Dallas Morning News*. September 11, E1–2.

———. 1991. "Breaking New Ground at DMA." *Dallas Morning News*. June 25, C5 and C10.

LaDuke, Betty. 1992. "Chicana Artist Patricia Rodriguez: Public Murals, Private Visions." In *Women Artists: Multi-Cultural Visions*, edited by Betty LaDuke, 93–102. Trenton, N.J.: Red Sea Press.

Lara, Irene. 2005a. "Bruja Positionalities: Toward a Chicana/Latina Spiritual Activism." *Chicana/Latina Studies* 4.2 (spring): 10–45.

———. 2005b. "Daughter of Coatlicue: An Interview with Gloria Anzaldúa." In *Entre mundos/Among Worlds: New Perspectives on Gloria E. Anzaldúa*, edited by AnaLouise Keating. New York: Palgrave Macmillan.

———. Forthcoming. "Decolonizing the Sexuality/Spirituality Split: Alma Lopez's 'Our Lady.'" *Frontiers: A Journal of Women's Studies*.

Latino Issues Forum (LIF). 2000. "The Latino Vote 2000." http://www.lif.org/vote/_2000.html.

Laurie, Marilyn. 1994. "Corporate Funding for the Arts." In *The Arts in the World Economy: Public Policy and Private Philanthropy for a Global Cultural Community*, edited by Olin Robison, Robert Freeman, and Charles A. Riley II, 67–76. Hanover, N.H.: University Press of New England.

Leclerc, Gustavo, and Ulises Diaz. 1998. *Ciudad Híbrida: Hybrid City: The Production of Art in "Alien Territory."* Los Angeles: SCI-Arc Public Access Press; SC2, Southern California Studies Center; and Adobe L.A.

Leclerc, Gustavo, Raul Villa, and Michael J. Dear. 1999. *La Vida Latina in L.A.: Urban Latino Cultures*. Thousand Oaks: Sage Publications, in association with Southern California Studies Center of the University of Southern California.

Lee, Min Sook. 2000. "Comic Stripping: Sex Work and the Art of Isis Rodriguez." *Mix: Independent Art and Culture* 26, no. 1 (summer): 25–31.

Lee, R. Sullivan. 1996. "Batman in a Bustier: Comic Books Featuring Big-

Breasted, Female Superheroes Are Perking Up a Currently Moribund Comics Market." *Forbes*, April 8, 37.

Lefebvre, Henri. 1991. [1974]. *The Production of Space*. Translated by Donald Nicholson-Smith. Oxford: Blackwell.

Lemeh, Dori. 2001. "El Poder de la Mujer: Woman's Power." In *Santa Barraza: Artist of the Borderlands*, edited by María Herrera-Sobek, 76–87. College Station: Texas A & M University Press.

León-Portilla, Miguel. 1963. *Aztec Thought and Culture: A Study of the Ancient Nahuatl Mind*. Translated by Jack Emory Davis. Norman: University of Oklahoma Press.

———, ed. 1980. *Native Mesoamerican Spirituality: Ancient Myths, Discourses, Stories, Doctrines, Hymns, Poems from the Aztec, Yucatec, Quiche-Maya and Other Sacred Traditions*. Translated by Miguel León-Portilla, J. O. Arthur Anderson, Charles E. Dibble, and Munro S. Edmonson. Ramsey, N.J.: Paulist Press.

———. 1988. [1961]. *Los antiguos mexicanos a través de sus crónicas y cantares*. Mexico: Fondo de Cultura Económica.

———. 1990. [1976]. *Endangered Cultures*. Translated by Julie Goodson-Lawes. Dallas: Southern Methodist University Press.

———. 1993. [1956]. *La filosofía náhuatl estudiada en sus fuentes*. Mexico: Universidad Nacional Autónoma de México.

Leuthold, Steven. 1998. *Indigenous Aesthetics: Native Art, Media, and Identity*. Austin: University of Texas Press.

Limón, José E. 1994. *Dancing with the Devil: Society and Cultural Poetics in Mexican-American South Texas*. Madison: University of Wisconsin Press.

———. 1998. *American Encounters: Greater Mexico, the United States, and the Erotics of Culture*. Boston: Beacon Press.

Lindsay, Arturo, ed. 1996. *Santería Aesthetics in Contemporary Latin American Art*. Washington: Smithsonian Institution Press.

Lippard, Lucy R. 1990. *Mixed Blessings: New Art in a Multicultural America*. New York: Pantheon Books.

———. 1996. "Listening to Roswell's Heartbeat: Celia Munoz's *Herencia*." In *Celia Alvarez Munoz: Herencia: Now What?* Exhibition publication. Roswell, N.M.: Roswell Museum and Art Center.

———. 1997. *The Lure of the Local: Senses of Place in a Multicentered Society*. New York: New Press.

———. 2000a. "Concrete Sorrows, Transparent Joys." In *Kathy Vargas: Photographs, 1971–2000*, by Kathy Vargas, 14–27. San Antonio, Tex.: Marion Koogler McNay Art Museum.

————. 2000b. *Mixed Blessings: New Art in a Multicultural America*. New York: New Press.

Lipsey, Roger. 1988. *An Art of Our Own: The Spiritual in Twentieth Century Art*. Boston: Shambhala.

Lipsitz, George. 1994. "They Know What Time It Is." In *Microphone Fiends: Youth Music and Youth Culture*, edited by Andrew Ross and Tricia Rose. New York: Routledge.

Lomas Garza, Carmen. 1991. "Pedacito de mi Corazón." In *Carmen Lomas Garza: Pedacito de mi Corazón*, 11–13. Austin, Tex.: Laguna Gloria Art Museum.

Lopez, Alma. 1999. "187: The Linea." http://home.earthlink.net/~almalopez/1848/juan.html. Accessed March 3, 1999.

————. 2000. "Mermaids, Butterflies and Princesses." http://home.earthlink.net/~almalopez/idx/idxtxt4.html. Accessed March 16, 2000.

————. 2001. "Silencing Our Lady: La Respuesta de Alma." *Aztlán* 26, no. 2 (fall): 249–67.

López, Yolanda M. 1978. *Yolanda M. Lopez: Works: 1975–1978*. San Diego: self-published.

López Austin, Alfredo. 1988. [1980]. *The Human Body and Ideology: Concepts of the Ancient Nahuas*. 2 vols. Translated by Thelma Ortiz de Montellano and Bernard Ortiz de Montellano. Salt Lake City: University of Utah Press.

López Pulido, Alberto. 2000. *The Sacred World of the Penitentes*. Sashington: Smithsonian Institution.

Marcus, Joyce. 1992. *Mesoamerican Writing Systems: Propaganda, Myth, and History in Four Ancient Civilizations*. Princeton, N.J.: Princeton University Press.

Marin, Cheech. 2002. *Chicano Visions: American Painters on the Verge*. Boston: Bullfinch Press.

Martin, Bonnie. 1997. "Bay Area Now Celebrates Emerging Artists." *San Francisco Weekly*, July 16–22, 12.

Mayorga, Irma. 2001. "Afterword: A Homecoming." In *The Hungry Woman: A Mexican Medea*, by Cherríe Moraga, 155–65. Albuquerque, N.M.: West End Press.

McClintock, Anne. 1995. *Imperial Leather: Race, Gender, and Sexuality in the Colonial Contest*. New York: Routledge.

McCracken, Ellen. 1999. "Remapping Religious Space: Orthodox and Non-Orthodox Religious Culture." In *New Latina Narrative: The Feminine Space of Postmodern Ethnicity*, 95–149. Tucson: University of Arizona Press.

McDowell, Linda. 1999. *Gender, Identity, and Place: Understanding Feminist Geographies*. Minneapolis: University of Minnesota Press.

McLuhan, Marshall. 1964. *Understanding Media: The Extensions of Man*. New York: McGraw-Hill.

Medina, Lara. 1998. "Lose Espíritus Siguen Hablando." In *Living Chicana Theory*, edited by Carla Trujillo, 189–213. Berkeley, Calif.: Third Woman Press.

Medina, Lara, and Gilbert R. Cadena. 2002. "Días de los Muertos: Public Ritual, Community Renewal, and Popular Religion in Los Angeles." In *Horizons of the Sacred: Mexican Traditions and U.S. Catholicism*, edited by Timothy Matovina and Gary Riebe-Estrella, 69–94. Ithaca, N.Y.: Cornell University Press.

Mesa-Bains, Amalia. 1990. "Quest for Identity: Profile of Two Chicana Muralists based on Interviews with Judith F. Baca and Patricia Rodriguez." In *Signs from the Heart: California Chicano Murals*, edited by Eva Sperling Cockcroft and Holly Barnet Sánchez, 68–83. Venice, Calif.: Social and Public Art Resource Center.

———. 1991a. "Chicano Chronicle and Cosmology: The Works of Carmen Lomas Garza." In *Carmen Lomas Garza: Pedacito de mi Corazon* (catalogue for exhibition curated by Peter Mears), 14–39. Austin, Tex.: Laguna Gloria Museum.

———. 1991b. "El Mundo Femenino: Chicana Artists of the Movement — A Commentary on Development and Production." In *Chicano Art: Resistance and Affirmation, 1965–1985*, edited by Richard Griswold del Castillo, Teresa McKenna, and Yvonne Yarbro-Bejarano, 131–40. Los Angeles: Wight Art Gallery and University of California Press.

———. 1993a. "Art of the Other México: Sources and Meanings /Arte del Otro Mexico: Fuentes y Significados." In *Art of the Other Mexico: Sources and Meanings*, edited by Rene Arceo-Frutos, Juana Guzman, and Amalia Mesa-Bains, 14–73. Chicago: Mexican Fine Arts Center Museum.

———. 1993b. "The Interior Life: The Works of Patssi Valdez." In *The Painted World of Patssi Valdez* (exhibition catalog). May 5–July 4. Boathouse Gallery, Plaza de la Raza.

———. 1993c. "Curatorial Statement." *Ceremony of Spirit: Nature and Memory in Contemporary Latino Art*, 9–17. San Francisco: Mexican Museum.

———. 1995. "*Domesticana*: The Sensibility of Chicana Rasquache." In *Distant Relations: Cercanías Distantes / Clann i Gcéin. Chicano, Irish, Mexican Art and Critical Writing*, edited by Trisha Ziff, 156–63. Santa Monica, Calif.: Smart Art Press.

———. 1999. "Patssi Valdez: Glamour, Domestic Ruin and Regeneration." In *Patssi Valdez: A Precarious Comfort/ Una comodidad precaria*. Catalog of exhibition curated by Tere Romo, 33–45. San Francisco: Mexican Museum.

————. 2001. "Text and Textile: The Works of Ester Hernandez." In exhibition catalogue for Ester Hernandez: Everyday Passions: Prints, Pastels, Installations. Exhibit. September 25–November 17.

Mexican Museum. 1992. *The Chicano Codices. Encountering Art of the Americas*. Catalogue for exhibition curated by Marcos Sánchez-Tranquilino. San Francisco: Mexican Museum.

————. 1999. *Patssi Valdez. A Precarious Comfort. Una comodidad precaria*. Catalogue for exhibition curated by Tere Romo. San Francisco: Mexican Museum.

Mifflin, Margot. 1997. *Bodies of Subversion: A Secret History of Women and Tattoo*. New York: Juno Books.

Mignolo, Walter D. 1994. "Signs and Their Transmission: The Question of the Book in the New World." In *Writing without Words*, edited by Elizabeth Hill Boone and Walter D. Mignolo, 220–70. Durham, N.C.: Duke University Press.

Mitchell, Charles Dee. 1999. "Houston, Arlington Artists Create Works Worlds Apart." *Dallas Morning News*, September 25, C1, C6.

Moi, Toril. 1985. *Sexual /Textual Politics: Feminist Literary Theory*. London: Routledge.

Molina, Laura. 1996. *Cihualyaomiquiz: The Jaguar*. Self-published. P.O. Box 660341, Arcadia, Calif. 91066-0341.

Montejano, David. 1987. *Anglos and Mexicans in the Making of Texas, 1836–1986*. Austin: University of Texas Press.

Moraga, Cherrié. 1983. *Loving in the War Years: Lo que nunca pasó por sus labios*. Boston: South End Press.

————. 1993. *The Last Generation: Prose and Poetry*. Boston: South End Press.

————. 1994. *Heroes and Saints and Other Plays: Giving up the Ghost, Shadow of a Man, Heroes and Saints*. Albuquerque, N.M.: West End Press.

————. 2000. *The Hungry Woman: A Mexican Medea*. In *Out of the Fringe: Contemporary Latina/Latino Theatre and Performance*, edited by Caridad Svich and Maria Teresa Marrero, 289–362. New York: Theatre Communications Group.

————. 2001. *The Hungry Woman/ Heart of the Earth*. Albuquerque, N.M.: West End Press.

Mort, Jo-Ann. 1999. [1997]. "'They Want to Kill Us for a Little Money': Sweatshop Workers Speak Out." In *No Sweat: Fashion, Free Trade, and the Rights of Garment Workers*, edited by Andrew Ross, 193–97. New York: Verso.

Mosquera, Gerardo, ed. 1996a. *Beyond the Fantastic: Contemporary Art Criti-*

cism from Latin America. London: The Institute of International Visual Arts; Cambridge, Mass.: MIT Press.

―――. 1996b. "Elegguá at the (Post?)Modern Crossroads: The Presence of Africa in the Visual Art of Cuba." In *Santería Aesthetics in Contemporary Latin American Art*, edited by Arturo Lindsay, 225–58. Washington: Smithsonian Institution Press.

Mudimbe, V. Y. 1988. *The Invention of Africa: Gnosis, Philosophy, and the Order of Knowledge*. Bloomington: Indiana University Press.

Muñoz, Carlos. 1989. *Youth, Identity, and Power: The Chicano Movement*. London: Verso.

Muñoz, Celia Alvarez. 1991. *If Walls Could Speak / Si Las Paredes Hablaran*. Arlington, Tex.: Enlightenment Press.

Muñoz, José Esteban. 1999. *Disidentifications: Queers of Color and the Performance of Politics*. Minneapolis: University of Minnesota Press.

National Association of Latino Arts and Culture (NALAC). 1996. *Latino Arts and Cultural Organizations in the United States: A Historical Survey and Current Assessment*. San Antonio, Tex.: NALAC.

National Council of La Raza. 1997. "Hispanic Unemployment Issue Brief." Washington, D.C.: National Council of La Raza.

―――. 1998. "Hispanic Poverty Fact Sheet." Washington, D.C.: National Council of La Raza.

Neumaier, Diane, ed. 1995. *Reframings: New American Feminist Photographers*. Philadelphia: Temple University Press.

NietoGomez, Anna. 1976. "Chicana Feminism." *Caracol* 2, no. 5: 3–5. Reprinted in A. García 1997.

―――. 1995. "La Chicana—Legacy of Suffering and Self-Denial." *Scene* 8, no. 1: 22–24. Reprinted in A. García 1997.

Nieva, María del Carmen. 1969. "Mexikayotl." *Esencia del Mexicano: Filosofía Nahuatl*. Mexico: Editorial Orion.

Noriega, Chon A., ed. 1992. *Chicana/os and Film: Representation and Resistance*. Minneapolis: University of Minnesota Press.

―――, curator. 1995. *From the West: Chicano Narrative Photography*. San Francisco: Mexican Museum.

―――. 1996. "Talking Heads, Body Politic: The Plural Self of Chicano Experimental Video." In *Resolutions: Contemporary Video Practices*, edited by Michael Renov and Erika Suderberg, 207–28. Minneapolis: University of Minneapolis Press.

―――, ed. 1998. *Urban Exile: The Collected Writings of Harry Gamboa, Jr.* Minneapolis: University of Minnesota Press.

————. 2000. *Shot in America: Television, the State, and the Rise of Chicano Cinema.* Minneapolis: University of Minnesota Press.

Noriega, Chon A., and Ana M. López, eds. 1996. *The Ethnic Eye: Latino Media Arts.* Minneapolis: University of Minnesota Press.

Norte, Marisela. 1991. *Norte / Word.* Cassette recording. Lawndale, Calif.: New Alliance Records.

Nutter, Steve. 1999. "The Structure and Growth of the Los Angeles Garment Industry." In *No Sweat: Fashion, Free Trade, and the Rights of Garment Workers,* edited by Andrew Ross, 199–213. New York: Verso.

Nyberg, Amy Kiste. 1995. "Comic Books and Women Readers: Trespassers in Masculine Territory?" In *Gender in Popular Culture: Images of Men and Women in Literature, Visual Media, and Material Culture,* edited by Peter C. Rollins and Susan W. Rollins, 205–24. Cleveland, Okla.: Ridgemont Press.

Ochoa, María. 2003. *Creative Collectives: Chicana Painters Working in Community.* Albuquerque: University of New Mexico Press.

Olalquiaga, Celeste. 1992. *Megalopolis: Contemporary Cultural Sensibilities.* Minneapolis: University of Minnesota Press.

Orozco, Cynthia E. 1998. "Chicano and Latino Art and Culture Institutions in the Southwest: The Politics of Space, Race, and Money." In *Latinos in Museums: A Heritage Reclaimed,* edited by Antonio Ríos-Bustamante and Christine Marin, 95–107. Malabar, Fla.: Krieger Publishing Company.

Parker, Rozsika, and Griselda Pollock. 1982. [1981]. *Old Mistresses: Women, Art, and Ideology.* New York: Pantheon Books.

Pérez, Emma. 1991. "Sexuality and Discourse: Notes from a Chicana Survivor." In *Chicana Lesbians: The Girls Our Mothers Warned Us About,* edited by Carla Trujillo, 159–84. Berkeley, Calif.: Third Woman Press.

————. 1998. "Irigaray's Female Symbolic in the Making of Chicana Lesbian Sitios y Lenguas (Sites and Discourses)." In *Living Chicana Theory,* edited by Carla Trujillo, 87–101. Berkeley, Calif.: Third Woman Press.

————. 1999. *The Decolonial Imaginary: Writing Chicanas into History.* Bloomington: Indiana University Press.

Perez, Gilberto. 1998. *The Material Ghost: Films and Their Medium.* Baltimore: Johns Hopkins University Press.

Pérez, Laura E. 1990. *Contextos y proyectos de la vanguardia literaria nicaraguense, 1927–1936.* Ph.D. diss., Department of Romance Languages and Literatures, Harvard University.

————. 1996. "Sightings of the Spirit: Frances Salome España's Possessed Video Work." Paper presented at National Association of Chicana and Chicano Studies meeting. Spokane, Wash., March 22.

———. 1998a. "On the Altars of Alterity: Celia Rodriguez's Altar and Performance Art and Alex Donis's 'My Cathedral.'" Paper presented at American Studies Association meeting, Seattle, Wash., November 19.

———. 1998b. "Spirit Glyphs: Reimagining Art and Artist in the Work of Chicana *Tlamatinime*." *Modern Fiction Studies* 44, no. 1 (spring): 36–76.

———. 1999. "El *desorden*, Nationalism, and Chicana/o Aesthetics." In *Between Woman and Nation: Nationalisms, Transnational Feminisms, and the State*, edited by Caren Kaplan, Norma Alarcón, and Minoo Moallem, 19–46. Durham, N.C.: Duke University Press.

———. 1999/2000. "That Which Remains: On Christina Fernandez's *Ruins*." Exhibition publication. Los Angeles: Los Angeles Center for Photographic Studies / Framework Press.

———. 2002. "Writing on the Social Body: Dresses and Body Ornamentation in Contemporary Chicana Art." In *Millennial Anxieties: Chicana and Chicano Cultural Studies in the Twenty-First Century*, edited by Arturo J. Aldama and Naomi H. Quiñonez, 30–63. Bloomington: Indiana University Press.

Pérez y Mena, Andrés I. 1995. "Puerto Rican Spiritism as a Transfeature of Afro-Latin Religion." In *Enigmatic Powers: Syncretism with African and Indigenous Peoples' Religions among Latinos*, edited by Anthony M. Stevens-Arroyo and Andres I. Pérez y Mena, 137–55. Decatur, Ga.: Association for Hispanic Theological Education.

Perlman, David. 1997. "Evidence of Long-lost Amazon Tribes Uncovered." *San Francisco Chronicle*, January 28, A1–A5.

Phillips, Susan A. 1999. *Wallbangin': Graffiti and Gangs in L.A.* Chicago: University of Chicago Press.

Pisarz, Gabrielle. 1998. Lecture delivered in the Department of Ethnic Studies, University of California.

Porelli, Cathie. 1982. "'Moda Chicana' Paving Stylish Trail with Paper." *San Gabriel Valley Tribune*, March 14, C1.

Prado Saldivar, Reina Alejandra. 2000. "Goddesses, Sirenas, Lupes y Angel Cholas: The Work of Alma López." *Aztlán* 25, no. 1 (spring): 195–201.

Price, Sally. 1989. *Primitive Art in Civilized Places*. Chicago: University of Chicago Press.

Pritikin, Renny. 1989. "Celia Munoz: Rompiendo La Liga. December 15, 1989–January 20, 1990." Curator's Exhibition Statement.

Quijano, Aníbal. 2000. "Coloniality of Power, Eurocentrism, and Latin America." *Nepantla: Views from the South* 1, no. 3 (2000): 533–80.

Quintana, Alvina E. 1996. *Home Girls: Chicana Literary Voices*. Philadelphia: Temple University Press.

Quirarte, Jacinto. 1973. *Mexican American Artists*. Austin: University of Texas Press.

———. 1991. "Exhibitions of Chicano Art: 1965 to the Present." In *Chicano Art: Resistance and Affirmation, 1965–1985*, edited by Richard Griswold del Castillo, Teresa McKenna, and Yvonne Yarbro-Bejarano, 163–79. Los Angeles: Wight Art Gallery and University of California Press.

———. 1992. "Sources of Chicano Art: Our Lady of Guadalupe." *MELUS* 15.1 (January): 13–26.

Ramírez, Arthur. 1989. Review of *Borderlands /La Frontera: The New Mestiza*, by Gloria Anzaldúa. *The Americas Review* (fall–winter 1989): 185–87.

Ramírez, Mari Carmen. 1996. "Beyond 'the Fantastic': Framing Identity in U.S. Exhibitions of Latin American Art." In *Beyond the Fantastic: Contemporary Art Criticism from Latin America*, edited by Gerardo Mosquera, 229–46. London: The Institute of International Visual Arts; Cambridge, Mass.: MIT Press.

Ramos, Julio. 1997. "Memorial de un accidente: Contingencia y tecnologfa en los exvotos de la Virgen de Quinche." Keynote address. New York University and Columbia University Graduate Student Conference, New York City, February 1.

Rangel, Jeffery. 1999. "Interview with Patssi Valdez." May 26. Smithsonian Archives of American Art.

Rebolledo, Tey Diana. 1995. *Women Singing in the Snow: A Cultural Analysis of Chicana Literature*. Tucson: University of Arizona Press.

Rebolledo, Tey Diana, and Eliana S. Rivero. 1993. *Infinite Divisions: An Anthology of Chicana Literature*. Tucson: University of Arizona Press.

Reichel-Dolmatoff, Elizabeth. 1998. Foreword to *Body Decoration: A World Survey*, edited by Karl Groning, 12–15. New York: Vendome Press.

Richard, Nelly. 1996. "Postmodern Decentredness and Cultural Periphery: The Disalignments and Realignments of Cultural Power." In *Beyond the Fantastic: Contemporary Art Criticism from Latin America*, edited by Gerardo Mosquera, 260–69. London: The Institute of International Visual Arts; Cambridge, Mass.: MIT Press.

Riley, Charles A. II. 1994. "Introduction." In *The Arts in the World Economy: Public Policy and Private Philanthropy for a Global Cultural Community*, edited by Olin Robison, Robert Freeman, and Charles A. Riley II, xiii–xxii. Hanover, N.H.: University Press of New England.

Ríos-Bustamante, Antonio. 1998. "Summary of the 1991–1992 National Survey of Latino and Native American Professional Museum Personnel." In *Latinos in Museums: A Heritage Reclaimed*, edited by Antonio Ríos-Bustamante and Christine Marin, 131–39. Malabar, Fla.: Krieger Publishing Company.

Ríos-Bustamante, Antonio, and Christine Marin, eds. 1998. *Latinos in Museums: A Heritage Reclaimed*. Malabar, Fla.: Krieger Publishing Company.

Robbins, Trina. 1996. *The Great Women Superheroes*. Northampton, Mass.: Kitchen Sink Press.

———. 1999. *From Girls to Grrrlz: A History of Women Comics from Teens to Zines*. San Francisco: Chronicle Books.

———. 2002. "Las Cartoonistas." http://www.nakeddave.com/Innate.html.

Robins, Kevin. 1996. *Into the Image: Culture and Politics in the Field of Vision*. London: Routledge.

Robinson, John P., and Therese Filicko. 2000. "American Public Opinion about the Arts and Culture: The Unceasing War with Philistia." In *The Public Life of the Arts in America*, edited by Joni M. Cherbo and Margaret J. Wyszomirski, 108–37. New Brunswick, N.J.: Rutgers University Press.

Robison, Olin, Robert Freeman, and Charles A. Riley II, eds. 1994. *The Arts in the World Economy: Public Policy and Private Philanthropy for a Global Cultural Community*. Hanover, N.H.: University Press of New England.

Rodríguez, Celia Herrera. 1996. "Celia Herrera Rodríguez." *Pentimenta: A Publication of LVA: Lesbians in the Visual Arts* (Winter 1996–97): 10–11.

Rodriguez, Jeannette. 1994. *Our Lady of Guadalupe: Faith and Empowerment Among Mexican-American Women*. Austin: University of Texas Press.

Romero, Mary. 1992. *Maid in the U.S.A.* New York: Routledge.

Romo, Tere, curator. 1999. *Patssi Valdez: A Precarious Comfort/ Una comodidad precaria*. San Francisco: Mexican Museum.

Rosaldo, Renato. 1994. "Cultural Citizenship and Educational Democracy." *Cultural Anthropology* 9, no. 3: 402–11.

Ross, Andrew, ed. 1999. [1997]. *No Sweat: Fashion, Free Trade, and the Rights of Garment Workers*. New York: Verso.

Ross, David A. 1997. "Foreword: A Feeling for the Things Themselves." In *Bill Viola* (exhibition catalogue), 19–29. New York: Whitney Museum of Art in association with Flammarion, Paris.

Rothenberg, Jerome, and David Guss. 1996. *The Book, Spiritual Instrument*. New York City: New Granary Books. Originally published in *New Wilderness Letter #11*, Charlie Morrow and The New Wilderness Foundation, 1982.

Ruiz, Vicki L. 1998. *From Out of the Shadows: Mexican Women in Twentieth-Century America*. New York: Oxford University Press.

Rushing, Janice Hocker. 1993. "Power, Other, and Spirit in Cultural Texts." *Western Journal of Communication* 57 (spring): 159–68.

Said, Edward W. 1994. [1978]. *Orientalism*. New York: Vintage.

Saldívar, José David. 1997. *Border Matters: Remapping American Cultural Studies*. Berkeley: University of California Press.

Saldívar-Hull, Sonia. 2000. *Feminism on the Border: Chicana Gender Politics and Literature.* Berkeley: University of California Press.

Salvo, Dana. 1997. *Home Altars of Mexico.* Edited by Ramón A. Gutierrez. Albuquerque: University of New Mexico Press.

San Angelo Museum of Art. 1988. "Vistas Series: Celia Munoz. Books and Installations." Exhibition information sheet.

Sánchez, Marta Ester. 1985. *Contemporary Chicana Poetry: A Critical Approach to an Emerging Literature.* Berkeley: University of California Press.

Sánchez-Tranquilino, Marcos. 1995. "Space, Power, and Youth Culture: Mexican American Graffiti and Chicano Murals in East Los Angeles, 1972–1978." In *Looking High and Low: Art and Cultural Identity,* edited by Brenda Jo Bright and Liza Bakewell, 55–88. Tucson: University of Arizona Press.

Sánchez-Tranquilino, Marcos, and John Tagg. 1991. "The Pachuco's Flayed Hide: The Museum, Identity, and *Buenas Garras.*" In *Chicano Art: Resistance and Affirmation, 1965–1985,* edited by Richard Griswold del Castillo, Teresa McKenna, and Yvonne Yarbro-Bejarano, 97–108. Los Angeles: Wight Art Gallery and University of California Press.

Sandoval, Chela. 2000. *Methodology of the Oppressed.* Minneapolis: University of Minnesota Press.

Sassen, Saskia. 1998. *Globalization and Its Discontents: Essays on the New Mobility of People and Money.* New York: New Press.

Sasser, Elizabeth Skidmore. 1988. "West Texas Letter." *Art Space* 12, no. 4 (fall 1988): 58.

Saunders, Frances Stonor. 1999. *The Cultural Cold War: The CIA and the World of Arts and Letters.* New York: New Press.

Schmidt Camacho, Alicia. 2004. "Body Counts on the Mexico–U.S. Border: Feminicidio, Reification, and the Theft of Mexicana Subjectivity." *Chicana/Latina Studies* 4, no. 1 (fall): 22–60.

Selz, Peter. 2006. *Art of Engagement: Visual Poetics in California and Beyond.* Berkeley: University of California Press and San José Museum of Art.

Seggerman, Helen-Louise. 1990. "Conversations with Grace Russak and Lisa Palmer." *Latin American Art* 2, no. 2 (spring 1990): 29–32.

Seriff, Suzanne, and Jose Limón. 1986. "Bits and Pieces: The Mexican American Folk Aesthetic." In *Art among Us / Arte entre nosotros: Mexican American Folk Art of San Antonio,* by Pat Jasper and Kay Turner, 40–49. San Antonio, Tex.: San Antonio Museum of Art.

Shohat, Ella, ed. 1998. *Talking Visions: Multicultural Feminism in a Transnational Age.* New York: MIT Press.

Sjöö, Monica, and Barbara Mor. 1987. *The Great Cosmic Mother: Rediscovering the Religion of the Earth.* San Francisco: Harper and Row.

Smithers, Stuart. 1994. "Bodies of Sleep, Garments of Skins." *Parabola* 19, no. 3 (August): 6–10.

Sorell, Victor Alejandro. 1999. "Behold Their Natural Affinities: Revelations about the Confluence of Chicana Photography and Altarmaking." In *Imagenes e Historias /Images and Histories: Chicana Altar-Inspired Art*, edited by Constance Cortez, 21–28. Medford, Mass.: Tufts University Gallery.

Spunk! 1997. Photocopy. July. San Francisco area. No author, title, or page number.

Stack, Megan K. 1999. "Artist Presents Haunting Reality of Juarez Killings." *Austin American-Statesman*, September 8, B7.

Steinbaum Krauss Gallery. 1997a. "Amalia Mesa-Bains: Cihuatlampa, the Place of the Giant Women." Videorecording of opening reception and installation.

———. 1997b. "Venus Envy Chapter III: Cihuatlampa, the Place of the Giant Women." New York: Steinbaum Krauss Gallery.

Stellweg, Carla. 1989. "Stepping into the Mainstream: The Latin American Art Market." *Latin American Art* 1, no. 1 (spring): 29–34.

Stevens-Arroyo, Anthony M., and Andres I. Pérez y Mena, eds. 1995. *Enigmatic Powers: Syncretism with African and Indigenous Peoples' Religions among Latinos*. Decatur, Ga.: Association for Hispanic Theological Education.

Sullivan, Edward J. 1990. "Conversation with Art Dealer Mary-Anne Martin." *Latin American Art* 2, no.3 (summer): 25–28.

———, ed. 1996. *Latin American Art in the Twentieth Century*. London: Phaidon Press Limited.

Swan, James, ed. 1991. *The Power of Place: Sacred Ground in Natural and Human Environments: An Anthology*. Wheaton, Ill.: Quest Books.

Taussig, Michael. 1987. *Shamanism, Colonialism, and the Wild Man: A Study in Terror and Healing*. Chicago: University of Chicago Press.

———. 1997. *The Magic of the State*. New York: Routledge.

Taylor, Mark C. 1997. *Hiding*. Chicago: University of Chicago Press.

———, ed. 1998. *Critical Terms for Religious Studies*. Chicago: University of Chicago Press.

Taylor, Sheila Ortiz, and Sandra Ortiz Taylor. 1996. *Imaginary Parents: A Family Autobiography*. Albuquerque: University of New Mexico Press.

Thompson, Robert Farris. 1993. *Face of the Gods: Art and Altars of Africa and the African Americas*. New York: Museum for African Art; Munich: Prestel-Verlag.

Tiano, Susan. 1990. "Maquiladora Women: A New Category of Workers?" In *Women Workers and Global Restructuring*, edited by Kathryn Ward, 193–247.

Ithaca, N.Y.: ILR Press, School of Industrial and Labor Relations, Cornell University.

Torgovnick, Marianna. 1997. *Primitive Passions: Men, Women, and the Quest for Ecstasy*. New York: Alfred A. Knopf.

Trujillo, Carla. 1991. "Chicana Lesbians: Fear and Loathing in the Chicano Community." In *Chicana Lesbians: The Girls Our Mothers Warned Us About*, edited by Carla Trujillo, 186–94. Berkeley, Calif.: Third Woman Press.

———. 1998. "La Virgen de Guadalupe and Her Reconstruction in Chicana Lesbian Desire." In *Living Chicana Theory*, edited by Carla Trujillo, 214–31. Berkeley, Calif.: Third Woman Press.

Tucker, Michael. 1992. *Dreaming with Open Eyes: The Shamanic Spirit in Twentieth-Century Art and Culture*. London: Aquarian / Harper Collins.

Turner, Kay. 1999. *Beautiful Necessity: The Art and Meaning of Women's Altars*. New York: Thames and Hudson.

———. 1982. "Mexican American Home Altars: Towards Their Interpretation." *Aztlán* 13: 309–26.

Tyson, Janet. 1990. "Viewing Life from Eclectic Points." *Fort Worth Star-Telegram*, August 13, 7.

United States Census Bureau. N.d. "Projected State Populations, by Sex, Race, and Hispanic Origin: 1995–2025." http://www.census.gov/population/projections/state/stpjrace.txt.

———. 2000. "The Hispanic Population in the United States March 1999." Current Population Reports P20–527. http://www.census.gov.

Valdez, Luis, and Stan Steiner. 1972. *Aztlan: An Anthology of Mexican American Literature*. New York: Vintage Books.

Valdez, Patssi. 1993. *The Painted World of Patssi Valdez*. Boathouse Gallery exhibition catalog, May 5–July 4. Plaza de la Raza, Los Angeles.

Vale, V., ed. 1996. *Zines! Vol. I*. San Francisco: V / Search Publications.

———. 1997. *Zines! Vol. II*. San Francisco: V / Search Publications.

Vargas, Kathy. 2000. *Kathy Vargas. Photographs, 1971–2000*. Catalog of exhibition curated by Lucy Lippard and MaLin Wilson-Powell. San Antonio, Tex.: Marion Koogler McNay Art Museum.

Varghese, Roy Abraham. 2000. *God-Sent: A History of Accredited Apparitions of Mary*. New York: Crossroad Publishing Company.

Venegas, Sybil. 1977. "The Artists and Their Work—The Role of the Chicana Artist." *Chismearte* 1, no. 4 (fall/winter 1977): 3, 5.

———. 1990. "Image and Identity: Recent Chicana Art from 'La Reina del Pueblo de Los Angeles de la Porcincula.'" Exhibition publication. Los Angeles: Labana Art Gallery, Loyola Marymount University.

Villa, Raúl. 2000. *Barrio-Logos: Space and Place in Urban Chicano Literature and Culture.* Austin: University of Texas Press.

Villarreal, Rosa Martha. 1995. *Doctor Magdalena: Novella.* Berkeley, Calif.: TQS Publications.

Visser, Deirdre. 1997. "Isis Rodriguez at Galería de la Raza." *Artweek* 28 (September): 23.

Warner, Marina. 1983 [1976]. *Alone of All Her Sex: The Myth and Cult of the Virgin Mary.* New York: Vintage Books.

Widdifield, Stacie C. 1996. *The Embodiment of the National in Nineteenth-Century Mexican Painting.* Tucson: University of Arizona Press.

Wolf, Bryan. 1995. "The Responsibility to Dream." *Profession* 95:19–26.

Wright, Virginia. 1998. "History from a Woman's Point of View: Bowdoin College Exhibit Shows Feminism is Not a Universal Dogma. *Times Record* (Mid-coast Maine), October 8[?], 17 and 19.

Wylie, Lindsey. 2000. "Consuelo Underwood." "Imágenes e historias / Images and Histories" exhibition materials. Santa Clara University Museum.

Yarbro-Bejarano, Yvonne. 1993. "Turning It Around." *Crossroads* 31 (May): 15, 17.

———. 1994. "Gloria Anzaldúa's *Borderlands /La Frontera*: Cultural Studies, 'Difference,' and the Non-Unitary Subject." *Cultural Studies* (fall): 5–28.

———. 1998. "Laying It Bare: The Queer / Colored Body in Photography by Laura Aguilar." In *Living Chicana Theory*, edited by Carla Trujillo, 277–305. Berkeley, Calif.: Third Woman Press.

———. 2001. *The Wounded Heart: Writing on Cherríe Moraga.* Austin: University of Texas Press.

Ybarra-Frausto, Tomás. 1979. "Alurista's Poetics: The Oral, the Bilingual, the Pre-Columbian." In *Modern Chicano Writers: A Collection of Critical Essays*, edited by Joseph Sommers and Tomás Ybarra-Frausto, 117–32. Englewood Cliffs, N.J.: Prentice Hall.

———. 1984. "Altars and Altarmakers: The Social Context." In *Ofrendas.* Unpaginated exhibition catalogue. Sacramento, Calif.: La Raza Bookstore / Galería Posada.

———. 1987. "Sanctums of the Spirit—The Altars of Amalia Mesa-Bains." In *Amalia Mesa Bains: Grotto of the Virgins* (exhibition publication), 2–9. New York: INTAR Latin American Gallery.

———. 1988. "Cultural Context." In *Ceremony of Memory: New Expressions in Spirituality among Contemporary Hispanic Artists*, 9–13. Santa Fe, N.M.: Center for Contemporary Arts of Santa Fe.

———. 1991a. "The Chicano Movement / The Movement of Chicano Art."

In *Exhibiting Cultures: The Poetics and Politics of Museum Display*, edited by Ivan Karp and Steven D. Lavine, 128–150. Washington: Smithsonian Institution.

———. 1991b. "Rasquachismo: A Chicano Sensibility." In *Chicano Art: Resistance and Affirmation, 1965–1985*, edited by Richard Griswold del Castillo, Teresa McKenna, and Yvonne Yarbro-Bejarano, 155–62. Los Angeles: Wight Art Gallery and University of California Press.

Young, Louis, ed. 1990. *The Decade Show: Frameworks of Identity in the 1980s* (exhibition catalog). New York: Museum of Contemporary Hispanic Art, New Museum of Contemporary Art, Studio Museum of Harlem.

Yúdice, George. 1996. "Transnational Cultural Brokering of Art." In *Beyond the Fantastic: Contemporary Art Criticism from Latin America*, edited by Gerardo Mosquera, 196–215. London: The Institute of International Visual Arts; Cambridge, Mass.: MIT Press.

Zamudio-Taylor, Victor. 1996. "Chicano Art." In *Latin American Art in the Twentieth Century*, edited by Edward J. Sullivan, 315–29. London: Phaidon Press.

———. 2001. "Inventing Tradition, Negotiating Modernism: Chicano/a Art and the Pre-Columbian Past." In *The Road to Aztlán: Art from a Mythic Homeland*, edited by Virgina M. Fields and Victor Zamudio-Taylor, 342–57. Los Angeles: Los Angeles County Museum.

Zweig, Janet. 1998. "Artists, Books, Zines. (Art Publications)." *Afterimage* 26, no. 1 (July–August): 4.

Abram, David, 29
aesthetic, 7
African diaspora, 3; religions of, 9,
 18, 21, 95–96, 309 n. 1; altar forms
 of, 116, 299
Agueda Martínez, 106
Aguilar, Laura, 345 n. 8; *Stillness* and
 Motion series, 284, 286–88
Aguilera, Carmen, 247, 250, 342 n. 42
AIDS, 123
Alarcón, Norma, 21
Alba, Victoria, 164
Alcalá, Kathleen, 95, 196–200
Alexander, Victoria D., 204, 346 n. 5
Alicia, Juana, 191–95, 340 n. 32, 342
 n. 43
alienation, 106
aliens, 160, 211
Allen, Paula Gunn, 44–45, 312 n. 3
alma en pena (soul in purgatory), 36
altar-installations, 136, 150, 160, 333
 n. 9
altars, "altars," 6, 7, 91–97, 114, 117–22,
 144; photography and, 129–41
alter, 91–92, 143–45
alterity, 6, 90; cultural and sexual,
 124, 152
Alvárez, Gloria, 252–56, 343 n. 49

Alvarez, Laura, 4, 56, 181–87
amatl paper, 160, 218
amoxtli, 29. See also *códices*
Anaya, Rudolfo, 25, 332 n. 3
androgyny, 67, *75*, 324 n. 30
Anima, 35, 127–29
Anzaldúa, Gloria, 15; *Borderlands/La
 Frontera*, 24, 30; *Making Face,
 Making Soul*, 45, 143, 257, 314–
 15 n. 14; Aztlán and, 150–51, 176,
 201; patriarchal Mexica criticized
 by, 272; Nahua goddesses and
 Guadalupe syncretized by, 280; on
 recovery of the Indigenous, 313 n. 7;
 borderlands defined by, 333 n. 7
Aquinas, Thomas, 261
Arceo-Frutos, Rene, 335 n. 24
archetypes, 31–32, 118
art, "art," 95–96; culturally non-
 universal definition of, 7, 315 n. 16;
 social and political effects of, 22;
 as ephemeral fashion, 69; craft vs.,
 70; postmodern, 98; popular vs.
 high, 104; as healing path, 122;
 spirituality and contemporary, 326
 n. 7
artists, 27–28, 313 n. 6
art world, 69, 153

ASCO, 68, 250, 342 n. 45; *Walking Mural*, 267
atheism, 2
Augustine, Saint, 261
avant-garde, 10–11, 301, 305
Aztlán, "Aztlán": in González's *St. Francis of Aztlán*, 127; in Gonzales's and Rodriguez's *San Ce Juan*, 147–51, 200, 332 nn. 2–3; in Montoya's *Codex Delilah*, 215; *Aztlán: An Anthology of Mexican American Literature*, 314 n. 1

Baca, Judy, 326 n. 40, 335 n. 25
Bachelard, Gaston, 229–30
Barba de Piña Chan, Beatriz, 342 n. 42
Barraza, Santa Contreras, 15, 94, 104, 108–12, 122, 281, 329 n. 21
"barrio sensibility," 98
Barthes, Roland, 129, 130
Benjamin, Walter, 225, 337 n. 4, 338 n. 23
Bhabha, Homi, 324 n. 28
bilingualism, 255
Black, Charlene Villaseñor, 310 n. 3
Boltanski, Christian, 130
borderlands, 32, 164–65
Botticelli, Sandro, 273
Bourdieu, Pierre, 22, 70, 178, 318 n. 1, 323 n. 27
Brabant, Sarah, 340 n. 30
Brotherston, Gordon, 29
bruja, 21, 104–6, 260, 313 n. 5, 329 n. 20
Buddhism, 3, 8, 93, 158, 299
Bürger, Peter, 22, 310 n. 1
Burnham, Linda, 250
Butler, Judith, 203, 258, 319–20 n. 5, 320 n. 8, 324 n. 28, 338 n. 22

cajas, 5, 94, 112–14, 187–91
calaveras, 116, 128, 161

calmecacs, 11, 315–16 n. 17
Calvo, Luz, 266, 334 n. 18, 344 n. 2
Camarillo, Al, 213
Carrasco, Barbara, 15, 116–22, 127, 342 n. 45
Carrasco, David, 311 n. 9, 333 n. 9, 344 n. 1
Carrillo, Sean, 323 n. 25
Castañeda, Antonia, 272, 332 n. 3, 339 n. 26, 344 n. 5
Castillo, Ana, 15, 19, 263
Catholicism, Roman, 93–96, 125
CD-ROM, 5, 247–50
Central America, 273
Ceremony of Memory, 24
Cervantes, Alma, 247–50
Cervántez, Yreina D., 15, 231, 249; *Nepantla* triptych, 37–45, 95; concept of *altepetl* and, 150; *Tierra Firme* and *La Ruta Turquesa*, 160–63, 200; *Black Legs*, 219–23; self-portraits of, 281, 283–84, 292; *Danza Ocelotl*, 284
Chakrabarty, Dipesh, 310 n. 1, 345 n. 1
Chávez, César, 117–18, 163–64
Chavez, Denise, 310 n. 3
Chávez, Patricio, 303
Chicago, Judy, 231, 339 n. 29, 344 n. 7
"Chicana," "Chicano," 12
Chicano Art: Resistance and Affirmation (CARA) exhibition, 117, 206, 304
Chicano Codices, The, 27, 317 n. 24
Chicano Visions: American Painters on the Verge (exhibition), 266, 304
Chonin, Neva, 339 n. 30
Christianity, 93–96
Cihuacoatl, 260
Cihuatateo, 202
Cihuatlampa, 60, 62
Cisneros, Sandra, 15, 33, 259–60, 263
civil rights, 92

Cixous, Hélène, 338

Coatlicue, 33, 56, 249, 260, 273, 317 n. 23

códices, 5, 22, 30, 33–35, 108, 110, 215–19, 225

Cohen, Leonard, 1

comics, comic books, 218, 250, 340 n. 31

Conner, Sparks, and Sparks, 92, 326 n. 5

Corpi, Lucha, 241–44, 310 n. 3

Cortez, Constance, 118

Cotera, Martha, 9, 269

Coyolxauhqui: Cervántez's use of, 44, 84, 85, 110, 284; Hernandez's use of, 57, 273; in Lopez's *California Fashions Slaves* and *Juan Soldado*, 169, 174; in Moraga's *The Hungry Woman*, 202; in Garcia's, Rios's, and Cervantes's *Coyolxauhqui*, 247–50

Crow Woman, 218–19

Crumb, Robert, 232

Cruz, Resurrección, 262

Cuadros, Gil, 331 n. 39

cultura cura (culture cures), 30, 57, 106, 174

cultural capital, 70, 124

cultural evolution(ist) thought, 3, 20, 41, 318 n. 2, 322 n. 22

cultural studies, 13

Cunneen, Sally, 259

curandera (healer), 21, 104–6, 260, 313 n. 5, 329 n. 20

curanderismo, 98, 104, 313 n. 5

Davis, Eric, 205, 219

Days of the Dead, 35, 57, 88, 96–97, 122, 124, 127–28, 244, 328 n. 13

Dear, Michael J., 182, 331 n. 38, 334 n. 16, 335 n. 21

de Certeau, Michel, 187, 333 n. 4

decolonizing, 4, 8, 12, 15, 21, 262, 269, 284

Del Castillo, Adelaida, 269

Deleuze, Gilles, 144, 332 n. 4

Del Río, Dolores, 98

Delgadillo, Victoria, 323 n. 25

Derrida, Jacques, 14–15, 331 n. 48, 345 n. 1

DeSaisset Museum, 118

desaparecidos (the "disappeared"), 124–25, 130, 143, 178–81

desire: sexual and social, 69–81; same-sex, 176–77; racialized, 331 n. 39

deterritorialization, 149, 198

Díaz-Stevens, Ana María, 94, 309 n. 1, 326 n. 5

difference, 6, 90, 124, 152

difrasismo, 14–15, 257, 311 n. 9, 344 n. 1

digital culture, 129

digital photography, 132, 134, 247–50

diphrasm, 14–15, 257, 311 n. 9, 344 n. 1

disappeared, 124–25, 130, 143, 178–81

discourse, discourses, 8, 19, 20, 23, 81, 96, 128; of civilization and modernization, 21; of tourism, 54; patriarchal and Eurocentric, 63, 66; of modernity and tattoos, 82; Roman Catholic, 125; post-Enlightenment, 143–44, 242; of "Manifest Destiny" and anti-Mexicanism, 146–47; on visual art, 223–25; Mexican nationalist, 333 n. 8; Darwinian, 341 n. 39

disembodiment. *See* ghostly

disidentification, 151

do-it-yourself spiritualities, 9

domestic violence, 244

domestic work, 52

domesticana, "domesticana," 59, 98, 321 n. 13

Douglas, Susan, 321 n. 19

drag, 122

Drucker, Johanna, 215, 336 n. 1
Du Bois, W. E. B., 144
Duncan, Carol, 63, 88, 346 n. 5
Duncombe, Stephen, 240
Durand, Jorge, 19, 21, 22, 328–29
 n. 16
Durham, Jimmie, 158–59
Dussel, Enrique, 144, 311 n. 5

écriture feminine, 224, 338 n. 22
Enloe, Cynthia, 173
epistemologies, 32
España, Frances Salomé, 15, 35–37,
 132
essentialisms, 23
ex-votos, 104, 316 n. 22

face and soul, 90
facultad, 32
Fanon, Frantz, 10, 21, 84, 144
Felps, Paula, 178, 181
fem (magazine), 341 n. 38
feminism, 9, 311 n. 7
Fernandez, Christina, 15, 130–33, 331
 n. 42, 343 n. 49
Ferris, Allison, 322 n. 19
Fierro, Josefina, 214
"folk," folklore, 104, 123, 328–29
Foucault, Michel, 36, 144, 332 n. 4,
 333 n. 4
Fregoso, Rosa Linda, 106, 122–23, 311
 n. 8, 331 n. 40
Freud, Sigmund, 1, 66, 223–25, 322
 n. 21, 338 n. 22
Furst, Julie Leslie McKeever, 110
Fusco, Coco, 82, 189

Galería de la Raza, 96, 232, 328 n. 12
Gamboa, Diane, 72, 74, 81, 117, 342
 n. 45
Gamboa, Harry, Jr., 117, 267, 342
 n. 45
Gandhi, Mahatma, 319 n. 4

Garber, Marjorie, 61–62, 258
García, Alma, 9, 259, 269, 272, 299,
 311 nn. 6–7, 332 n. 3
Garcia, Ana, 247–50
García, Ramón, 125
garments, 50–51, 70, 169–74, 334 n. 14
Garza, Carmen Lomas, 15, 104–6, 229
Gaspar de Alba, Alicia, 303–4, 311
 nn. 7–8, 346 n. 5
Gates, Henry Louis, Jr., 17, 310–11
 n. 4
gaze, 85, 322 n. 20
Genet, Jean, 253
ghostly: as socially spectral, 5, 51; in
 Cervántez's *Nepantla* triptych, 37–
 45, 284; in Hernandez's *Immigrant
 Woman's Dress*, 59; photographic
 image and, 129, 130; in Rodríguez's
 Red Roots/Black Roots/Earth, 141; in
 Lopez's *California Fashions Slaves*,
 169; in González's *The Love that
 Stains*, 292; aesthetics of, 300
globalization, 96, 98, 100
glyphs, 22, 26–29, 33, 34, 108, 215–19
God, 110, 143
goddesses, 66, 85, 93, 98, 114, 299
Goldman, Shifra: on Chicana art, 87,
 311 n. 7, 325 n. 34; *rasquachismo* and,
 99; on Carrasco's *Here Lies/Hear
 Lies* series, 117, 335 n. 25; on politics
 of exhibitions, 303, 346 n. 5
Gómez-Peña, Guillermo, 82, 189, 303
Gonzáles, Patrisia, 146, 332 n. 2
González, Jennifer, 97–99, 338 n. 23
González, Maya, 292
González, Rita, 15, 125–27
González, Yolotl, 342 n. 42
Goodall, H. L., Jr., 312 n. 1
Goodrich, Terry Lee, 181
Gopnik, Adam, 238
Gordon, Avery, 49, 320 n. 8, 322 n. 22,
 331 n. 37

graphic novels, 240

Gray, Charles M., 305, 346 n. 5

Grey, Alex, 122, 313 n. 6, 326 n. 7

Griswold del Castillo, Richard, 311 nn. 7–8, 337 n. 5, 344 n. 7

Gronk (Glugio Nicandro), 68, 342 n. 45

Gruzinski, Serge, 93, 316 n. 20, 326 nn. 1–2

Guattari, Felix, 144, 332 n. 4

Gutiérrez, Charlene, 232

Habell-Pallán, Michelle, 342 n. 46

Hall, Stuart, 144, 325 n. 32

Harvey, David, 311 n. 7, 326 n. 6, 332–33 n. 4

haunting, 115, 124–25, 169, 213–15, 295–96

Hayden, Dolores, 150, 211, 333 n. 5, 337 n. 13

healing, 124

heart, 11, 110, 160, 330 n. 31

Hebdige, Dick, 50, 318 n. 1

Heilbrun, James, 305, 346 n. 5

Henkes, Robert, 344 n. 3

"herstories," 94

Hernandez, Ester, 15; *Immigrant Woman's Dress*, 57–59, 273; *Sun Mad*, 87; Virgin of Guadalupe iconography and, 231; *Libertad/Liberty*, 267, 345 n. 7; *Full Moon/Luna Llena*, 273, 279–80, 281; *La Ofrenda*, 341 n. 38, 264

Herrera, Hayden, 284

Heyden, Doris, 247

Hillman, James, 31

Hinduism, 3

Hispano, 134

home, homeland, 151, 178, 190–91

Huerta, Salomon, 284

Huichol, 163

Hurston, Zora Neale, 222

hybrid art practices, 7, 45–46, 49

hybrid spiritualities, 2–4, 7, 22

icon, 118, 132

Iglesias Prieto, Norma, 181, 334 n. 18

Imágenes e historias / Images and Histories (exhibition), 118, 168, 331 n. 47

Indigenous, 26, 151–59; Chicanas and, 8–9; perdurability of religious cultural cores, 95–96; Christianity and, 309 n. 1; in Rodríguez's art work, 141–42; dispossession of land and, 147; in Villarreal's *Doctor Magdalena*, 245

In ixtli, in yollotl / rostro y corazón (face and heart), 28, 41, 257, 314–15 n. 14

In'Laketch, 145, 306–7

installations, 4; mixed-media, 328 n. 14; Muñoz's *Fibra y Furia*, 330 n. 36; Montoya's works, 134–36; Vargas's *State of Grace*, 138; by Rodríguez, 141–43, 151–59; Mesa-Bains's *Venus Envy*, 223–25; López's *Tableau Vivant*, 340 n. 31; Isis Rodriguez's *My Life as a Comic Stripper*, 236–37

Irigaray, Luce, 144

Ix Chel, 219

jaguar (*ocelotl*), 85, 283–84

Jaramillo, Don Pedrito, 105–6

Jews, 3, 9, 328 n. 10

Johnson, Elizabeth A., 259

Jones, Amelia, 286, 345 n. 8

Juan Soldado, 118, 174

Juárez, Ciudad, 124, 330 n. 36

Jung, Carl, 322 n. 22

Kahlo, Frida, 82, 98, 281, 283–84, 292, 329 n. 21

khora, kora, 143, 331 n. 48

kitsch, 98, 127

Klor de Alva, Jorge, 29, 36–37

Kohler, Carl, 52
Kristeva, Julia, 144, 331 n. 48
Kurin, Richard, 304
Kutner, Janet, 207

Lacan, Jacques, 66
L. A. Coyotas, 253, 343 n. 49
LaDuke, Betty, 114, 326 n. 40, 330
 n. 26
La Llorona [Weeping Woman], 110,
 215, 260
Laurie, Marilyn, 304
Leclerc, Gustavo, 182, 331 n. 38, 334
 n. 16, 335 n. 21
Lee, Min Sook, 232, 233, 341 n. 37
León-Portilla, Miguel, 17, 26, 41,
 269, 280, 311 n. 9, 314–15 n. 14,
 315 n. 15, 344 n. 1
lesbianism, 269
Limón, José, 104, 328 n. 16, 329 n. 20
Lippard, Lucy R., 86, 138, 213, 331
 n. 46, 338 n. 15, 341 n. 38, 344 n. 7
Lipsey, Roger, 315 n. 14
Loos, Adolf, 318 n. 2
Lopez, Alma, 169–77, 249, 264–67,
 280, 343 n. 49
López, Yolanda, 15; *The Nanny*, 52–
 57, 280, 281; *When You Think of
 Mexico: Commercial Images of Mexi-
 cans*, 55, 122; "Who's the Illegal
 Alien, Pilgrim?," 148, 335 n. 23;
 Rodriguez's Superhero Virgins
 and, 231; *Guadalupe Walking*, 264;
 Guadalupe triptych and series,
 272–78; *Tableau Vivant*, 340 n. 31;
 *The Virgen of Guadalupe Goes for a
 Walk*, 341 n. 38
"Los Cartoonists" (exhibition),
 230–31
Lucie-Smith, Edward, 231, 322 n. 20,
 339 n. 29, 344 n. 7
Luna, James, 158–59

Madres de la Plaza de Mayo, Las,
 124–25
Maestrapeace (mural), 250, 281, 342
 n. 43
makeup, 320 n. 7
Malinalli (Malintzen Tenepal; La Ma-
 linche; Doña Marina), 110, 215, 244,
 260, 269, 330 n. 25
marianismo, 269
Marin, Cheech, 266, 304
Martí, José, 144
Martinez, Cesar, 266
Martinez, Demetria, 310 n. 3
Martinez, Elizabeth "Betita," 9, 269
Marx, Karl, 310 n. 1, 312 n. 2
Mary of Agreda, 260–62
Massey, Douglas S., 19, 21, 22, 328
 n. 16
mass media, 5, 238
Maya, 84, 108, 269, 289–92, 329 n. 23
Mayahuel, 108, 260, 280, 289–92
McCracken, Ellen, 310 n. 3
McDowell, Linda, 203
McLuhan, Marshall, 337 n. 4
media, 52, 70, 108
memory, 23–24, 123
Mesa-Bains, Amalia, 15, 23; *Venus
 Envy*, 59–68, 223–25, 267; *The
 Amazona's Mirror*, 62, 66; *Cihua-
 teotl (Woman of Cihuatlampa),
 Archaeology Table*, 62, 92, 326 n. 4;
 altar to Saint Theresa of Avila, 94;
 altar-installation medium and, 97–
 101; Patssi Valdez and, 114, 330
 n. 29; "politicizing spirituality,"
 297; on Garza's *monito* paintings,
 329 n. 18
mestiza/o identity, 21, 26, 33, 87, 108
mestizaje, 146, 151–59, 329 n. 21
Mexican Fine Arts Museum, 88, 328
 n. 13

Mexican Muralists, 329 n. 21

Mexican Spitfires, 37, 54, 292, 323
 n. 25, 328 n. 14

Mictlán, Mictlantecuhtli, 166,
 334 n. 13

Mignolo, Walter, 26, 27

"minority," 124

Moi, Toril, 338 n. 22

Molina, Laura, 4, 230–31, 238–41,
 280, 339 n. 29

monito paintings, 104–6, 329 n. 18

Montoya, Delilah, 15, 134–37, 215–19,
 225

Moraga, Cherríe, 15, 17, 33–35, 200–
 204, 240, 263–64

Moreno, Luisa, 214

Mort, Jo-Ann, 173

Mosquera, Gerardo, 303

mothers, 125, 289

Mother Teresa, 118

Mudimbe, V. Y., 144

Mujeres Muralistas, 86, 112, 250, 330
 n. 26, 335 n. 25

multiculturalism, 7, 299, 301, 303

multiethnicities, 9

Muñoz, Celia Alvarez, 150, 176–81,
 206–15, 330 n. 36

Muñoz, José E., 151, 258

Muñoz, Susana, 122

murals, 136–37, 144, 150, 250, 267,
 335 n. 25

Musée Puech Denys, 136

museums, 346 nn. 5–6

Muslims, 224

National Association of Latino Arts
 and Culture (NALAC), 89, 346 n. 5

neopaganism, 93, 96

nepantla, 21, 29, 32, 36–45, 312–13 n. 4

nepantlism, 22, 30, 41, 44, 45, 151

New Age, 2, 9

nichos, 94, 112

NietoGomez, Anna, 9, 259, 269

Norte, Marisela, 250, 252, 253

Oakland Museum, 57

ocelotl (jaguar), 85, 283–84

ofrenda, 2, 6, 60

Olalquiaga, Celeste, 91–92, 98, 313–14
 n. 8, 325 nn. 3–4

ollin: continuous change signified
 by, 41, 45; in Cervántez's *Danza
 Ocelotl,* 84; in Barraza's *Virgen con
 Corazón y Maguey,* 110, 292; "time-
 lessness of movement" and, 160;
 Coyolxauhqui and, 284, 342 n. 42

Ometeotl, 272

oppositional politics, 18–25, 72, 99,
 123, 318 n. 1

Oppositional Wetness, 152

Origen, 261

Orlan, 319 n. 4

Orozco, Cynthia E., 89

Ortiz, Sheila, 225–30

pagan, "pagan," 21, 94

paper fashions, 5, 68–74, 114, 117

Paredes, Américo, 104, 328 n. 16, 123,
 144, 328–29 n. 16, 331 n. 49

penitentes, 134, 331 n. 44

Perez, Gilberto, 129

Pérez, Gloria Osuña, 249

Perez, Irene, 250, 280–81, 289, 342
 n. 43

performance, 5, 51, 158

performance art: by ASCO, 68, 267;
 by Gómez-Peña and Fusco, 82; by
 Rodríguez, 95, by Patssi Valdez, 114;
 What Part Indian Am I?, 151–59;
 The Virgin Vagina, 263; Mexican
 Spitfires' *Ramona,* 292; socially con-
 structed body and, 319 n. 4; López's
 Tableau Vivant, 340 n. 31

performativity, 51, 319–20 n. 5

Pesotta, Rose, 214
phallocentrism, 322 n. 21
photography, 5, 130, 134, 184, 218
pintos, 136
Pisarz, Gabrielle, 229
"Plan Espiritual de Aztlán, El," 25,
 332 n. 3
Plato, 331 n. 48
"politics of place," 148–49, 332–33
 n. 4
Portillo, Lourdes, 15, 122–25, 127
Posada, José Guadalupe, 117, 161
poststructuralism, 85, 144, 297, 345
 n. 1
"power of place," 148–50, 333 n. 5
Prado Saldivar, Reina Alejandra, 160,
 173
primitive, "primitive," 20, 22, 81, 82,
 322
primitivism, 19
Pritikin, Renny, 337 n. 11
Propositions 187, 209, and 227,
 160–61

queers, "queers," 4, 6, 15, 146; spiri-
 tualities writers and, 92, 326 n. 5;
 domestic altars, homosexuals,
 women, and, 123–24; "broth-
 erly love" and, 125–27; concept
 of Aztlán and, 150–51; racialized
 homosexuality and, 331 n. 39;
 Lopez's works and, 176–77, 334
 n. 18; gender-bending Jesus and
 Mary and, 261; bisexual desire and,
 264; dual female and male creator
 and, 272
Quetzalcóatl, 44, 56, 284
Quijano, Aníbal, 144
Quirarte, Jacinto, 264, 325 n. 38

"race," 310 n. 4
Ramirez, Arthur, 316 n. 21
Ramos, Julio, 316 n. 21

Ramuz, C. F., 253
rasquachismo, 14, 98, 99, 114
"Raza, La," 341 n. 39
Raza cósmica, La, 341 n. 39
Rebolledo, Tey Diana, 9, 110, 313 n. 5
Reichel-Dolmatoff, Elizabeth, 50
reliquaries, 112, 300
retablos, 94, 104, 174
reterritorialization of subcultures,
 324–25 n. 32
Richard, Nelly, 303
Riddell, Ada Sosa, 269
Riley, Charles A., 305
Rios, Elba, 247–50
Robbins, Trina, 230–31, 240, 339
 nn. 27–28
Robins, Kevin, 91, 129
Rodríguez, Celia Herrera, 15, 95,
 141–43, 151–59, 200, 292
Rodriguez, Isis, 230–38, 280, 339 n. 29
Rodriguez, Jeannette, 258
Rodríguez, Patricia, 112–14, 187–91,
 200, 326 n. 40
Rodriguez, Roberto, 332 n. 2
Romero, Mary, 54–55, 318–19 n. 2, 319
 n. 3
Rosaldo, Renato, 149
Roswell Museum and Art Center, 211
Royal Chicano Air Force (RCAF), 152
Ruiz, Vicki, 214, 299, 311 n. 7, 332 n. 3
Rushing, Janice Hocker, 312 n. 2
Rusnell, Wesley, 211

Sacred Heart, 75, 80, 134, 286, 289–
 96, 324 n. 31
Said, Edward, 144
saints, 98, 116–22, 125–26, 174–75
Salazar, Aida, 292, 295, 343 n. 49
San Ce Juan (documentary), 332 n. 2
Sánchez, George, 213
Sandoval, Chela, 10
Santería, 8, 93, 98, 299

Santería Aesthetics, 95
Seggerman, Helen-Louise, 303
Self-Help Graphics, 184, 230
self-portraits: by Cervántez, 44, 81–85; by Rodríguez, 114; by Carrasco, 117; by Fernandez, 130; representations of the body and, 281, 283–86
Señorita Extraviada, 124–25, 192
Seriff, Suzanne, 104
sexuality, 4, 300
s/heroes, 68, 81
Shopping For Faith (Cimino and Lattin), 96, 326 n. 5, 326 n. 7
Smithers, Stuart, 319 n. 4
soldadera, 219
Sor Juana Inés de la Cruz (Juana Ramírez), 60–61, 269
soul, soul making, 31–32, 127–28
sound recording, 5
space: gynosocial, 62; desire in Gamboa and, 69; violence in, 75; in Cervántez's work, 84, 160–63; domestic altar as, 93; in Patssi Valdez's paintings, 115; domestic and altar art as, 124; in González's *St. Francis of Aztlán*, 127; gallery or exhibition, 141; political, cultural, and spiritual significance of, 146–51; "social," 150; body as gendered and sexualized, 176; transnational identities and, 324 n. 32
spatial segregation, 61, 245
Spiegelman, Art, 240
Spics and Beaners (exhibition), 160
"spirit glyphs," 22
Spiritism, 95
spirits, 18, 25, 298
"spirit tongues," 22
spiritual, 4, 18, 20, 25, 49
spirituality, 18–24, 92, 118, 297–99, 309 n. 1, 326 n. 4, 345 n. 2

"spirit work," 20
Spivak, Gayatri, 144
Stellweg, Carla, 303
Stevens-Arroyo, Anthony M., 94, 309 n. 1, 326 n. 5
Stravinsky, Igor, 253
Sullivan, Edward J., 303
susto, 21, 314 n. 10
syncretism, 94, 95, 158, 298

taste, 69, 323 n. 27
tattoos: in Gamboa's work, 74–81; other body decoration and, 81–85; social body and Chicana art as, 86–90, 136
Taussig, Michael, 20
Taylor, Mark C., 69, 81, 318 n. 2, 319 n. 4
Taylor, Sandra, 225–30
Teatro Campesino, 25
theologians, 92–93, 326 n. 5
"third world," 314 n. 9
Thompson, Robert Farris, 116
tlacuilo, 13, 22, 27, 289
tlamatinime, 13, 22; Chicana artists as, 25, 28, 34–35; in León-Portilla's work, 26, 315 n. 15; Anzaldúa as, 31; Moraga as, 33–34; healing work and, 46, 143; in Rodríguez's *What Part Indian Am I?*, 158, 247; Perez's *Coyolxauhqui* as, 289
"Toltec," 27–28, 56, 314 n. 12, 315 n. 15
Tonantzín, 33, 56, 249, 260, 273, 317 n. 23
Torgovnick, Marianna, 19
transgendered identities, 75, 82, 324 n.30
translation, 253
transvestism, 61–62, 72, 126–27, 224, 320 n. 6
Trujillo, Carla, 262, 264, 341 n. 38, 344 n. 2, 345 n. 7

Turner, Kay, 91, 94, 97, 326 n. 1, 326
 n. 2, 326 n. 5, 327 n. 9, 330 n. 34

uncanny, 115
uncolonized spaces, 36
Underwood, Consuelo Jiménez,
 163–69
United Farmworkers Union (UFW),
 117–18
U.S. Bureau of the Census, 345–46
 n. 4
"urban royalty," 72, 74, 80–81

Valdez, Patssi, 15–16, 114–16, 231,
 267, 281, 330 n. 32, 342 n. 45
Vale, V., 240
Valencia, Patricia, 263, 292, 295, 328
 n. 14, 343 n. 49
Vargas, Kathy, 15, 134, 136–40
Varghese, Roy Abraham, 262
Varo, Remedios, 116
Vasconcelos, José, 144, 341 n. 39
video, 5
violence, 130
Villa, Raúl, 149, 182, 331 n. 38, 334
 n. 16, 335 n. 21, 343 n. 51
Villarreal, Rosa Martha, 244–46, 334
 n. 13
Virgen de Guadalupe, 33, 94; in
 Hernandez's Immigrant Woman's
 Dress, 57; in Gamboa's Virgin
 Whore Complex, 80; tattoos of,
 82; in López's triptych, 87; Maya-
 huel in composite with, 108; in
 Barraza's Virgen con Corazón y
 Maguey, 110; in Patssi Valdez's

Virgin on Orange Table, 116; in
 Montoya's La Guadalupana, 136;
 in Mesa-Bains's Venus Envy Chap-
 ter III, 321 n. 18
Virgin, 114
Virgin of Montserrat, 66, 164–69,
 176, 219, 231–38, 258–81
Virgin Vagina, The, 233, 263, 281
Visser, Deirdre, 233
voodoo, 98
votive paintings, 328 n. 16
votive practices, 329 n. 22

Warner, Marina, 259, 262
watercolors, 222, 281
weaving, 5
"women of color," 314 n. 9
Wylie, Lindsey, 169

Xipe Totec, 84, 284

Yañez, René, 328 n. 12
Ybarra-Frausto, Tomás, 24–25, 87, 97
yolteótl, 16, 17, 28, 30, 314–15 n. 14;
 in Gamboa's work, 75–80, 82, 97,
 324 n. 31; in Barraza's Trinity, 110;
 in Montoya's work, 133–35, 138,
 324 n. 31; in Cervántez's La Ruta
 Turquesa, 160, 286, 289–96
Yúdice, George, 303

Zapatista National Liberation Army,
 263, 292
zines, 240
zoot suits, 318 n. 1
Zweig, Janet, 215, 240

Laura E. Pérez

is an associate professor of ethnic studies

at the University of California, Berkeley.

Library of Congress Cataloging-in-Publication Data
Pérez, Laura Elisa.
Chicana art: the politics of spiritual and aesthetic altarities /
Laura E. Pérez.
p. cm. — (Objects/histories)
Includes bibliographical references and index.
ISBN 978-0-8223-3852-9 (cloth : alk. paper)
ISBN 978-0-8223-3868-0 (pbk. : alk. paper)
1. Mexican American women artists. 2. Mexican American
arts — Themes, motives. 3. Feminism and the arts — United
States — History — 20th century. I. Title.
NX512.3.M4P47 2007
704´.0420896872073 — dc22 2006034540

Chapter 1 appeared in a slightly different form as "Spirit Glyphs: Reimagining Art and Artist in the Work of Chicana Tlamatinime," in "Contested Spaces in the Caribbean and the Americas," edited by Marcia Stephenson and Aparajita Sagar, special issue, *Modern Fiction Studies* 44, no. 1 (April 1998): 36–76. A shorter version of the chapter was published as "Spirit Glyphs: Reimagining Art and Artist in the Work of Chicana Literature," in *Rethinking Latino(a) Religion and Identity*, edited by Miguel De La Torre and Gastón Espinosa (Cleveland, Ohio: Pilgrim Press, 2006).

Chapter 3 appeared in a slightly different form as "Writing on the Social Body: Dresses and Body Ornamentation in Contemporary Chicana Art," in *Decolonial Voices: Chicana and Chicano Cultural Studies in the 21st Century*, edited by Arturo J. Aldama and Naomi H. Quiñonez, 30–63 (Bloomington: Indiana University Press, 2002).

A brief section of chapter 4 will appear as "Hybrid Spiritualities in Contemporary Chicana Altar-Based Art: The Work of Amalia Mesa-Bains," in *Mexican-American Religions: Essays in Faith and Culture*, edited by Gastón Espinosa and Mario T. Garcia (Durham, N.C.: Duke University Press, 2008).